Praise for *How to Survive and Prosper as an Artist*

"Provides the best overview of political and other aspects of the art world that I have ever come across . . . It is a bible that every artist should have."—Shannon Wilkinson, president, Cultural Communications, New York

"This book should be required reading for every exhibiting artist." —Ellen Rixford, *Graphic News*

"This self-help career book is the pick of the litter. . . . Every page is filled with practical advice and imaginative ways to build your career."—Donna Marxer, *Artists' News*

"Michels is well versed in the business aspects of an artist's career. Her enjoyable book is filled with valuable information and sound advice. . . . Highly recommended."—*Library Journal*

"This is a definitive guide to self-promotion and solid business planning for artists of all disciplines. . . . The best guide I have seen . . . it gives thoughtful, practical advice."—Matthew Brown, *ArtsInk*, Mid Atlantic Arts Foundation

"Looks at art as a profession, not as an indulgence or avocation . . . a wonderful book!"—Laura Foreman, multidiscipline artist

"Michels is an optimistic . . . and supportive ally, someone who dismisses the old cynic's saw that 'you can't make a living as an artist.'" —Marion Wolberg Weiss, *Southampton Press*

"Encourages the pioneering spirit of artists to apply their creativity to the practical aspects of their dreams . . . Caroll Michels has a unique insider's view."—Tess Elliott, *The Arts Journal*

"A successful artist friend said that pretty much everything she knew about making a living as an artist came from this book."—Greg Dixon, shared-visions.com

"An excellent orientation to the artist's life and the art marketplace." —*FYI*, New York Foundation for the Arts

"Michels provides information on art world politics that artists really need. She also gives a lot of straightforward advice on strategizing." —Barbara Schreiber, *Art Papers*

"This book can serve as the bible of marketing for visual artists. . . . It has the best practical and honest information. . . . This is the book you should have on your shelf if you are a visual artist."—Mary Bowmar Richmond, *Creative Women Networking*

Caroll Michels

How to Survive and Prosper as an Artist

· · · · · · · · · · ·

SELLING YOURSELF
WITHOUT SELLING
YOUR SOUL

FIFTH EDITION

AN OWL BOOK
HENRY HOLT AND COMPANY
NEW YORK

This book is dedicated to my parents,

BILLIE AND MAX CHESY.

Henry Holt and Company, LLC
Publishers since 1866
115 West 18th Street
New York, New York 10011

Henry Holt® is a registered trademark of
Henry Holt and Company, LLC.

Library of Congress Cataloging-in-Publication Data

Michels, Caroll.
 How to survive and prosper as an artist : selling yourself
 without selling your soul / Caroll Michels.—5th ed.
 p. cm.
 "An Owl book."
 Includes bibliographical references and index.
 ISBN 0-8050-6800-7 (pb)
 1. Art—Vocational guidance—United States.
 2. Art—Marketing. I. Title.
 N6505 .M46 2001
 706'.8'8—dc21 2001039307

Henry Holt books are available for special promotions and
premiums. For details contact: Director, Special Markets.

Fifth Edition 2001

Designed by Victoria Hartman

Printed in the United States of America

10 9 8 7

Contents

Introduction: An Overview

In 1978 I began counseling visual and performing artists and writers on career management and development. I set up my own business and called myself an "artists' consultant."

Ranging in age from twenty-one to eighty-five, clients have included painters; sculptors; printmakers; fiber artists; poets; playwrights; novelists; cartoonists; journalists; photographers; craft artists; theater and film directors; film and video artists; performing artists; choreographers; dancers; classical, jazz, and pop musicians and composers; and opera singers. They have included well-known artists, unknown artists, emerging artists, self-taught artists, midlife career changers, artists fresh out of school, and college dropouts. My clients have also included groups of artists, artist couples, arts administrators, curators, gallery dealers, art consultants, critics, arts service organizations, and theater and dance companies. I have assisted a rabbi, a retired executive of Macy's department store, a retired host of a television variety show, a gossip columnist, ex-offenders, corporate executives, general physicians, surgeons, architects, psychiatrists, psychologists, lawyers, and editors.

When I first began working with artists the majority of my clients lived in the New York City area. However, today, through phone consultations I help artists nationwide, as well as those who live in Canada, Europe, and South America. I also meet with many artists in person in East Hampton, New York.

Up until a few years ago, I described my profession as an artist's career development consultant. Today, I refer to my profession as

"career coach and artist advocate," a job title that better describes the work that I do.

I have advised and assisted artists in developing such basic career tools as résumés, artist statements, biographies, and brochures. I have provided information and advice on exhibition, performance, and commission opportunities. I have advised and assisted in the preparation of book proposals and grant proposals, and public relations campaigns. I have advised artists on how to negotiate with art dealers and to prepare for studio visits.

I have also counseled artists on complex and seemingly less tangible career problems such as developing goals and helping artists learn to see themselves in relation to the world at large and as a participant in the specific world of art and its various components. I have also counseled artists on handling rejection as well as success and on maintaining momentum and overcoming inertia.

However, the most significant aspect of my work is helping artists to take control of their careers.

Calling myself an artists' consultant and "hanging out a shingle" was not an easy task. For valid and comprehensible reasons, deep-rooted skepticism is intrinsic to all arts communities. Initially, it was difficult to reach artists and convince them that what I had to say and offer was worthwhile.

I jumped this major hurdle when a writer from the *Village Voice* wrote an article about me and why my services were needed and necessary. It was only one journalist's opinion, but the endorsement was set in type, and I was deemed legitimate!

Literally an hour after the *Voice* article hit the newsstands my life changed drastically. I was swamped with phone calls from artists eager to set up appointments.

Nevertheless, after more than twenty-three years of counseling artists, I still find it is not uncommon to be questioned about why I am qualified to give artists advice. Some of my specific accomplishments are sprinkled throughout this book, cited to make or emphasize a point or convey an experience. Although I am no longer doing artwork, I have always been proud that I was able to live solely off my earnings as an artist. I exhibited at museums and cultural institutions throughout the United States and in Europe. I established a solid track record for winning grants and corporate contributions. I developed

and implemented all of my own public relations and publicity. And I was regularly published in newspapers and periodicals.

Managing my own career was something that *no one person* taught me. I learned from several individuals, positive and negative encounters, trial-and-error experiences, and personal intuition. This book contains information and advice derived from these experiences and encounters, as well as those of my clients. I have offered perceptions, observations, and advice that would have been invaluable to me when I first started to make a career as an artist.

What artists need most is objective advice, but what they usually receive is reinforcement of a myth of what it is like to be an artist. All too often artists are characterized as underdogs, and accordingly this image is reinforced throughout their careers. I can't promise that all of my advice is objective, since my personal experiences come into play, but the original incentive to write this book came from realizing how much underdog philosophy was being published under the guise of "nuts and bolts" career management. Much of the reading material published in the 1970s and 1980s flatly stated that the way the art world operates will always remain the same, and it is naive to try to change it. Other publications were more subtle, but the tone was patronizing: "Yes, artists, you might be creative, talented, and have a lot to give to the world, but there are 'others' who *really* know what is going on, *others who know best.*"

Although, in the 2000s, books on career management for artists are more plentiful and some publications emit tones that are more optimistic and empowering, the attitudes displayed by artists and many members of the art world continue to reek of the master/slave and victim/victimizer mentality.

This book addresses artists' roles in advancing and bettering their lot, taking control of their careers, learning to market their work, learning to exercise self-motivation, and approaching and managing their careers as other professionals deal with theirs. In other words, artists should apply many of the same techniques that other self-employed professionals use to make their careers work.

You will rarely find the word *talent* used in the forthcoming pages. The belief that an artist has talent is a subjective judgment, and there is no guarantee that a talented artist will be successful or that a successful artist is talented. When I use the words *success* and *successful* I

am referring to the relative level of achievement within a specific category, not the inherent talent of an artist.

Measuring my success as an artists' career coach is very similar to measuring my success as an artist. In both professions I have achieved immediate success, long-range success, and no success. I have received direct feedback, indirect feedback, and no feedback. I have felt successful in my work when my clients have followed up and used the leads, information, and advice that have enabled some of them to win grants from foundations and government agencies, fellowships to artist-in-residence programs in the United States and abroad, and invitations to exhibit and perform. Clients have received press coverage and have had their work published. In some instances I have been successful in providing information and advice that was put to immediate use, and in other cases it has taken several years to see any new development.

Although many of the examples and anecdotes I use to illustrate or make a point involve visual artists, performing artists and writers will also be able to identify with many of the situations. All artists in all disciplines will get something out of this book.

This book will not provide all of the answers an artist is seeking, nor does it contain everything an artist needs to know about the art world. However, it fills in the gaps that have been omitted, overlooked, or ignored in other publications; it elaborates on subjects that have been inadequately covered and challenges some basic notions about what an artist's career is all about. It contains advice, opinions, and impressions that will not be particularly palatable to members of the art world—*including artists*, the media, funding agencies, patrons, art dealers, administrators, curators, and critics—because it also explores the ills and injustices of the art world and sheds some light on who is responsible.

The art world is in dire need of reforms and structural changes. These changes will not happen overnight, but they *will* happen if more and more artists take control of their careers, reject the image of artists as sufferers, and refrain from practicing a dog-eat-dog philosophy when it comes to competing with other artists.

Some time ago I shared these views with a client who has been seeing me since I began counseling artists. He had been represented by a dealer for more than three years, during which time his work substantially increased in sales and in value.

From the beginning of their relationship, much against my judgment, the artist refused to have a written contract with the dealer drawn up. However, the artist accepted and acted upon my advice to learn to market his work, independent of the annual one-person show he received at the gallery. Eventually, he became highly skilled in initiating new contacts and following up on old ones. Both initiatives resulted in many sales.

When the dealer saw what was happening, she added some new stipulations to their oral agreement, which originally set forth a specified commission on all work sold through the gallery. She began charging "special commissions" for special circumstances, circumstances in which she was not directly involved either in initiating a sale or in doing the legwork or paperwork to make it happen. The artist, who was afraid to challenge the dealer because he felt that it would jeopardize their relationship, acceded to her demands.

I pointed out to the artist that, apart from money, a principle was at stake, and that each time an artist compromises a principle, his or her career and the status of artists in general, now and in the future, are set back another notch.

I advised the artist to confront the dealer with a proposal that was more equitable. If the artist must give the dealer a commission on every work sold, even if the sale did not originate with the gallery, the dealer should give the artist something in return, such as a monthly advance against future sales. I pointed out that if the artist had a written contract, chances are the dealer would never have tried to impose an arbitrary commission formula. I also pointed out that the artist had adequately proved his market value and selling power to the dealer, who was deriving steady revenue from the sale of the artist's work, a situation that the dealer would not want to give up easily. *It had not occurred to the artist that he had bargaining power.*

Such occurrences are common in the art world—unnecessary dilemmas and frustrations created by middlepeople who have usurped power from artists and by artists who allow their power to be usurped.

Artists, by the fact they are artists, have power. *Artists provide thousands of nonartists with jobs!* Examples of nonartists who depend on artists for jobs include dealers; gallery staffs; curators; museum staffs; arts administrators; critics and journalists; corporate art consultants and advisors; federal, state, and municipal employees; teachers; framers; accountants; lawyers; and art suppliers.

Yet more nonartists than artists make a living from art, and nonartists make *more* money from art than artists! This inequity exists, as do many others, because artists, the "employers," individually and collectively have not yet recognized their power.

Another problem among artists is a diffusion of power. Although there are more artists than ever before, as the community of artists multiplies it simultaneously divides into different factions, movements, self-interest groups, and trends. There are artists who segregate themselves into pockets of racial, sexual, and ethnic identity. Everyone is vying for the same bone; no one wants to share it.

On the other hand, some aspects of the art world are in good shape and are getting better all the time. Much headway has been made in art law, legislation, and artists' rights.

More colleges and universities are providing fine-art students with career development information through courses, seminars, and workshops. And more art dealers and arts administrators are entering the art world with degrees in arts administration, and they are better prepared than many of their predecessors with the marketing and business aspects of art. They are also, one hopes, more sensitive to the needs of artists and the public's understanding of art.

If I didn't believe that there is a lot of room in the art world for many artists to make a decent living, I certainly never would have started a consulting service or written a book about art-career management. There is ample opportunity for artists, even within the still imperfect art world.

Most of the structural changes in the art world will come about only through artist pressure, artist initiative, and artist participation. While the prospects of radically changing the art world might seem overwhelming to any one artist, one of the most important contributions that any artist can make is to *restructure and take control of his or her own career*. The following chapters will elaborate on why this is important and provide options, suggestions, and advice on how to make it happen.

Keep in mind that it took me *several years to build a career* as an artist. It also took a lot of time to learn, master, and apply the skills that are described in this book. I mention this to help readers counteract sensations of being *overwhelmed* by all of the suggestions and information that are provided in the forthcoming chapters. My career did not develop overnight; it was a slow but constant buildup. I absorbed

information that I needed to know at the time when I needed to know it. When I listened to my inner voice, I moved forward; when I didn't, I stumbled.

When the fourth edition of this book was being prepared in the mid-1990s, artists were just beginning to use the World Wide Web, and a new chapter was added devoted to the Internet. Since that time thousands of artists now have their own Web sites and/or are using the Web to research new contacts and career-related resources. Because the Internet is impacting artists' careers in far-reaching ways, advice, information, and references pertaining to the Internet are dispersed throughout the book instead of being centralized into one chapter.

The addresses of organizations, programs, publications, software, audiovisual components, and Web sites referred to in the text are listed in the appendix of resources at the back of the book. A new feature of this listing is the inclusion of Web site addresses or e-mail addresses for each resource entry, when applicable.

An adjunct to the appendix of resources is a new Web site that I have created, the Artist Help Network (www.artisthelpnetwork.com), a free information service devoted to resources that will help *artists take control of their careers*. The Web site contains most of the contacts listed in the fifth edition's appendix of resources. Readers can use the Web site to receive updated contact information and listings of new resources that have come to my attention. The Artist Help Network is a work in progress with new information being added on an ongoing basis.

For readers who wish to contact me, I have included my address, phone and fax numbers, e-mail address, and Web site addresses (see "About the Author" at the end of the book).

Launching or Relaunching Your Career: Overcoming Career Blocks

As an artist you have experienced the exuberance of creating something you like, which might be the culmination of a direction in your work or might articulate something new. It felt good. The goodness screamed out. You mastered and controlled. The power felt good. Your expectations were rewarded.

However, producing something you like and believe in does not resolve the question of how to use your creation to survive and prosper. For artists, the question is particularly complex because of the difference between survival and prosperity as defined by artists and those in other professions. For an artist, *survival* often means bare-bones existence; *prosperity* may be keeping your head above water. In other professions, *survival is* keeping your head above water; *prosperity* is success.

Being an artist means believing you are an artist; making a living as an artist requires mastering many of the skills and professional attitudes shared by successful self-employed persons engaged in other occupations. Equally important, it is necessary to overcome the career blocks that are particular and indigenous to the fine-arts field.

In the book *A Life in the Arts: Practical Guidance and Inspiration for Creative & Performing Artists,* the author and psychotherapist Dr. Eric Maisel pinpoints twenty types of creative blocks that artists often experience:

Blocks from parental voices, personality blocks, personality trait blocks, self-censorship, self-criticism, world criticism, world-wariness, existential blocks, conflicts between life and art, fatigue, pressure paralysis, environmental blocks, social blocks, skill deficits, myths and idealizations, self-abuse, anxieties, depression, and incubation and fallow periods.[1]

Although these problems and limitations are presented as *creative* blocks, they are the very same obstacles that encumber *career* development.

Rejecting the Myth of the Artist

Over many years our society has created a myth about what it means to be an artist. Perpetuated consciously and subconsciously by artists and nonartists, this myth is based on trading off many of the things that other people value for the right to be an artist.

For example, the myth tells us that struggle, complexity, and suffering are necessary components of creativity, and without these key elements an artist will stagnate. The myth tells us that the desire for comfortable lives and financial success will ultimately poison and distort art, that a true artist is concerned *only* with art and anyone else is a dilettante. The myth tells us that *real* artists do not discover themselves. Other people do, preferably when the artist is dead!

The myth warns us about *selling out*, although the majority of artists who are concerned about this issue are not in a position to sell out, nor are they quite sure what it means.

The myth says that artists are expected to be flamboyant, provocative, moody, weird, or antisocial. Writer and social critic Tom Wolfe suggests that this stereotyped image of the artist was formed in the nineteenth century, based on the style and behavior of writer and art critic Théophile Gautier. Wolfe writes:

[W]ith Gautier's own red vests, black scarves, crazy hats, outrageous pronouncements, huge thirsts, and ravenous groin . . . the modern picture of The Artist began to form: the poor but free spirit, plebeian but aspiring only to be classless, to cut himself forever free from the bonds of the greedy and hypocritical bour-

geoisie, to be whatever the fat burghers feared most, to cross the line wherever they drew it, to look at the world in a way they couldn't *see*, to be high, live low, stay young forever—in short, to be the bohemian.[2]

Many of the basic problems of artists trying to enter the art world and sustain a career there are created by their feelings of insecurity and helplessness. There is a direct correlation between how artists see themselves and where art-world power is currently centered. For example, the term *stable of artists* is commonly and casually used by both artists and dealers alike. It refers to the artists who are represented by a gallery, but it implies much more, and, unfortunately, as a metaphor it works well. It suggests that artists are like herds of animals that need to be contained in an environment where their master can control their lives.

PERCEIVING "FINE ARTIST" AS A VALID PROFESSION

In our society, there is a myth that suggests that to be antibourgeois, a free spirit, and classless, one should not have an occupation. The myth implies that being an artist is a state of mind and casts great doubts on whether being an artist is a valid profession.

Seeds of doubt suggesting that fine art is not a valid occupation are planted and reinforced, for example, by educators who, under the guise of providing career advice, emphasize *alternatives to fine art* and steer students into applied arts fields. Medical and fashion illustration, set design, graphic design, industrial design, and commercial photography are viewed as viable alternatives to painting, sculpture, and fine-art photography. Students in art school are encouraged to take a lot of education courses to have something to fall back on. If we were educated to believe that being a fine artist is a valid profession, there would be fewer artists needing an occupational backup. Has a law student ever been advised to take a lot of education courses to have something to fall back on?

Even a book offering career advice to fine artists warns, "It is unrealistic, wishful thinking on the part of any fine artist to believe that he is going to earn his living by works of art. Should it happen in the course

of time, it would be a great bonanza—but don't count on it."[3] The implication is that an artist can seriously dabble in art but shouldn't take it seriously as a profession!

Although the cautious advice given to artists comes from people who are trying to be helpful, it is advice based on other people's experiences, as well as on hearsay and myths. Other people's reality should not be your reality, nor can it be.

Believing in other people's perceptions is a disastrous trap. However, artists sometimes find it attractive, hoping that it can be a shortcut on the road to success or shield them from confrontations. Ralph Charell, author of *How to Make Things Go Your Way*, observes:

> If you filter the perceptions you receive through mediators, you deprive yourself of a direct encounter with the event itself. The more you come to depend on the perceptions and opinions of others, the less of yourself you are able to put into the equations of various experiences of your own life. Soon, if the process continues, your life becomes dim and pale and you are eventually at sea, tossed and buffeted, alone under a starless sky, without an internal compass of your own.[4]

Dual careers and low-income expectations

Art educator Ronald H. Silverman clearly sees the correlation between how artists are viewed as low-income producers and the low priority art is assigned in school curriculums. Pointing out that substantial evidence indicates that more than 90 percent of school-age children do not connect art with a means of acquiring money or earning a living,[5] Silverman goes on to say:

> While these figures may reflect pervasive cultural attitudes which stereotype artists as starving Bohemians, they may also be the consequence of current art education practices. Teachers are either ignoring the economic impact of the arts or they are telling their students that an interest in art has little if any economic career implications. Although these approaches may be the honest

view of well-intended teachers, they do not square with the facts. They may also be the key deterrent to art becoming a part of the basic school curriculum.[6]

Low expectations of artists' earning power have given rise to the practice of dual careers. While few question its symbolic implications, the concept of dual careers for artists is a widely accepted norm that is readily encouraged and propagated. For example, the academic dean of an art college condones the practice of dual careers:

> We are teaching [artists] that having a dual career does not necessarily mean that you make less art. After all, what's the point of having all your time free to make art if you have no money for materials and supplies? This no longer means that artists have to wait on tables. There are many more opportunities and diverse choices for the artist today than ever before. They may go into arts administration or arts-related services.[7]

The phrase *dual career* is a euphemism for *holding two jobs*, and under the Judeo-Christian work ethic it is emblematic of fortitude, stamina, dedication, and responsibility. But in reality, and in most cases, anyone engaged in a dual career for any length of time understands that it creates a life-style of frustration, confusion, stress, chaos, exhaustion, and guilt.

INSUFFICIENT TRAINING OF FINE ARTISTS

Even when students persevere and select fine arts against all odds, they may enter their careers questioning the propriety of earning a living as a fine artist. Moreover, they usually haven't the foggiest notion of how to begin.

Artist and author Jo Hanson believes that

> artists are set up for difficult career adjustments by the omissions from art education, and by the self-image projected through the art sub-culture that discourages, and even scorns, attention to business management and competence in it. In attitudes and

preparation, I believe most of us begin with several strikes against us. We find, through difficult experience, that we must work our way up to zero to get in a position to go forward. I speculate that "successful" artists are the ones who figured things out early in their careers and could follow a clear line toward their goals.[8]

In previous editions of this book I described my experience in 1986 when the College Art Association held its annual conference in New York City. Responding to an open call for panel discussion topics, I submitted a proposal suggesting that the conference include a panel focusing on the importance of including career management courses in fine-arts college and university curriculums. Although the response to the idea was less than enthusiastic, I did not receive a total bum's rush, and was given fifteen minutes to state my case at a session called "Special Projects," a potpourri of topics not valued enough to warrant panel discussions.

Five of the fifteen minutes had to be used to establish my credentials to this particularly credential-conscious audience. With a limited time allotment I managed to make the point that hundreds of students are being graduated each year ill equipped to handle the realities of life after art school or navigate the maze of confusion surrounding the art world.

There was polite clapping, and a few members of the audience later told me they were in agreement with my position. But it was apparent that career courses for fine artists were not on most educators' list of priorities.

In many schools even the mention of "career" and "life after school" is discouraged—or, as one recent graduate of an art school in an Ivy League university complained, "My teachers made me feel guilty when I asked questions that were in any way related to the business aspect of art or how to go about finding a gallery. I was chastised for admitting that I was concerned about making a living from photography."

Some academics who discourage career advice at the college level believe that students should be sheltered from real-life survival issues while in school. But many fine-arts faculty members are opposed to career development courses for selfish and self-serving reasons: they are aware that today's student artists will become tomorrow's practicing artists, and eventually artists with whom they will compete for

gallery, museum, and press attention, so there is much resistance to imparting any sort of information that could possibly give these future peers a career edge or jeopardize their own pecking order in the art world.

Career development information is not only opposed by academia for self-serving reasons, but it has also been used as a scapegoat to explain the ills of the art world. For example, the book *Has Modernism Failed?* by Suzi Gablik contains a reprint of a brochure announcing a series of workshops called "The Business of Art and the Artist," sponsored by the Maryland Summer Institute for the Creative and Performing Arts, the University of Maryland, and the U.S. Small Business Administration. Gablik concludes that the workshop was

> another telling example of how much career progress, even in art, now depends on making organizational values an intrinsic part of one's life. . . . The assumption is that success in the higher corporate world of art requires training in the techniques of business administration, and it leaves no doubt that the principles and practices of corporate management now produce the psychological model shaping even the lives of artists.[9]

The development of a program on survival skills for artists—one that covers such topics as health hazards, contracts, copyright, estate planning, insurance, and record keeping—is hardly an indication that artists are motivated by corporate institutional and organizational values. But Gablik is not the only misguided individual who believes in the myth that it is far nobler for artists to drive a cab to support their art than to derive a living from creating art!

Schools that address real-life issues

More and more headway is being made to help fine-art students prepare for the transition from art school to real life.

In 1996, when I was preparing the fourth edition of this book, I contacted 156 schools in the United States with four-year fine-art programs, most of which were accredited members of the National Association of Schools of Art and Design. A letter was sent to each school to inquire whether a required or elected credit or noncredit course or

workshop was offered on professional practices and career planning that were specifically geared for *fine-art students.*

Forty-one of the schools responded, a bit over 25 percent, and out of the forty-one respondents sixteen of the schools *required* students to take a career development course as a prerequisite to graduation. Another sixteen of the respondents offered courses in professional practices as electives. All of the schools that conducted mandatory and elective professional practice courses awarded credit hours ranging from one to four credits. An additional five schools offered noncredit workshops or seminars specifically for fine artists.

In 2001, when preparing for this new edition of my book, I contacted 175 schools in the United States with four-year fine-art programs to inquire whether a required or elected credit or noncredit course or workshop was offered on professional practices and career planning specifically geared for fine-art students. Most of the schools were accredited members of the National Association of Schools of Art and Design.

Eighty-five of the schools responded, or nearly 49 percent, and out of the eighty-five respondents, thirty-nine of the schools *required* students to take a career development course as a prerequisite to graduation, and twenty schools offered courses as electives. The majority of schools in both groups offered courses that specifically focused on professional practices; other schools integrated a career development curriculum into courses that dealt with other issues and topics.

Schools requiring students to take a career development course included the Art Academy of Cincinnati; The Art Institute of Boston; Brescia University in Owensboro, Kentucky; California State University at Long Beach; California State University at Northridge; Carson-Newman College in Jefferson City, Tennessee; Columbus College of Art and Design in Ohio; Dartmouth University in Hanover, New Hampshire; Georgia State University in Atlanta; the Herron School of Art, Indiana University in Indianapolis; James Madison University in Harrisonburg, Virginia; Kent State University in Ohio; Lyme Academy of Fine Arts in Old Lyme, Connecticut; Loyola Marymount University in Los Angeles; Memphis College of Art in Tennessee; Maryville University of Saint Louis; Miami University in Oxford, Ohio; Minneapolis College of Art and Design; Minnesota State University in Mankato; Minnesota State University Moorhead; Mississippi State University;

Montana State University in Bozeman; Oregon College of Arts and Crafts in Portland; Otis College of Art and Design in Los Angeles; Pennsylvania State University in College Station; Ringling School of Art and Design in Sarasota, Florida; San Diego State University in California; San Jose State University in California; Southern Illinois University in Carbondale; Texas Tech University in Lubbock; Thomas More College in Crestview Hills, Kentucky; Tyler School of Art in Elkins Park, Pennsylvania; the University of Alabama in Birmingham; the University of Kansas in Lawrence; the University of Montevallo in Alabama; the University of South Dakota in Vermillion; the University of Southern Maine in Gorham; the University of Tennessee at Chattanooga; the University of Wisconsin in Stout; and Virginia Commonwealth University in Richmond.

Twenty of the respondents offered courses in professional practices as electives. These included Atlanta College of Art in Georgia; Arkansas State University; the California Institute of Art in Valencia; California State University in Fullerton; California State University in Sacramento; the Cleveland Institute of Art in Ohio; the Corcoran School of Art, Washington, D.C.; Indiana State University in Terre Haute; Kendall College of Art and Design in Grand Rapids, Michigan; the Maine College of Art in Portland; the Maryland Institute, College of Art in Baltimore; the School of the Museum of Fine Arts in Boston; Southeastern Louisiana University in Hammond; the Myers School of Art at the University of Akron in Ohio; the University of Arkansas in Little Rock; the University of Minnesota in Minneapolis; the University of Nebraska, Lincoln; the University of Texas at Austin; the University of Texas in San Antonio; and the University of Wisconsin in Madison.

All of the mandatory and elected professional business practice courses conducted by the aforementioned schools award credit hours, ranging from one to six credits.

Schools that offered noncredit workshops or seminars specifically geared for fine artists included the Cooper Union for the Advancement of Science and Art in New York City; East Carolina University in Greenville, North Carolina; East Tennessee State University in Johnson City; the Pennsylvania Academy of the Fine Arts in Philadelphia; Pratt Institute in Brooklyn, New York; and the State University of New York in Purchase.

Most of the required and elected courses covered a range of topics, including marketing, presentation materials and documentation, grant writing, résumés and artist statements, art law and copyright, applying for graduate school, publicity, exhibition installation, and gallery relations.

In addition, Loyola Marymount University's required senior seminar included a forum to help students deal with the issue of professional rejection. At the Cleveland Art Institute, where Professor Matthew Hollern designed and teaches the course Professional Practices, topics include business writing and public speaking. At Miami University, the mandatory course Professional Artist's Portfolio and the Exhibition Experience taught by Assistant Professor Kelly Malec-Kosak, includes the topics of the ethical and moral responsibilities of an exhibiting artist, and art criticism and public review.

The University of Minnesota offers a professional practices course on alternate years. "It is not required but fills to capacity each time we offer it. It is targeted at graduate students and seniors in our undergraduate department," said Mark Pharis, chairman of the art department. In addition, the University of Texas in Austin offers the elective course Visual Arts Careers, which incorporates professional practice information. It was introduced more than fifteen years ago, and each year there is a long waiting list of students. Professor Matthew Hollern's course at the Cleveland Art Institute "is the first to fill every semester."

In 1999, at the University of Wisconsin, graduate students Sophia Allison and Dan LaValley created the Web site Professional Practices in the Arts (see appendix section "Career Management, Business, and Marketing"). It was designed as a final project for a seminar on professional practices conducted by Professor Leslee Nelson. With the assistance and support of Professor Nelson, Allison and LaValley received two grants to maintain the site. Sophia Allison and Dan LaValley have kept the site going and see it as a "repository of knowledge for both art students and professionals alike."

Professor Willem Volkersz of the School of Art, Montana State University, in Bozeman, sees a direct correlation between professional practice courses and career development. In 1989 he developed Careers in Art, a course that he continues to teach. It is required for all B.F.A. studio arts majors. "As a direct result of the course, students have had their work increasingly accepted into regional and national

juried exhibitions, had their work published, received Fulbright awards, and have been more successful in their graduate school and college teaching applications."

In 2000, Professor Michael Warrick, who for several years has taught the required course Professional Skills in the Visual Arts at the University of Arkansas in Little Rock, organized and moderated a two-session panel, "Teach Them to Swim or Let Them Sink," for the joint meeting of the Southeastern College Art Conference and Mid-American College Art Association.

One of the panelists, Stephen Driver, associate professor of art at Brescia University, who teaches a mandatory professional practices seminar in the fine-arts department, presented the paper, "Teach Them to Swim . . . ? How Long Can They Tread Water?" In his presentation Driver pointed out that he developed the seminar "as a response to the lack of preparation for a career in the arts that I received as a student."[10] He went on to say, "Many of my peers who no longer make or teach art fell by the wayside because they just couldn't see their way past all the obstacles."[11]

Panelist Gary Keown, associate professor of visual arts at Southeastern Louisiana University, who also teaches professional practices to fine-art students, concurred with Professor Driver about his postgraduate experiences:

> Marketing and promoting myself after graduate school was a trial-and-error-in-the-fire kind of experience, since I was not prepared for these overwhelming prerequisites to obtain a teaching position or exhibition record. I had no real clue. As I began teaching, I felt it was my responsibility to educate my students by passing on my knowledge and experiences on these issues.[12]

Pamela Overall Price's fine-arts career services program at the University of Texas in Austin received the outstanding program award in 2000 from the National Academic Advising Association. "As a result," said Price, "a few other public schools are looking at redefining service delivery when it comes to preparing visual and performing artists for their transitions out of our ivy-covered halls. We have a long way to go. Higher education in general has done a real disservice in treating the aspirations of our highly creative, imaginative, and talented arts

majors as pipe dreams instead of legitimate goals that can be supported and nurtured."

As college faculty and career service programs see the large impact a career development curriculum can have on fine-art students, Associate Professor Gary Keown points out clear reasons why career development also benefits schools:

> It should be understood that, with university budget cuts, this system is streamlining its various programs. In light of this, we as art studio faculty should realize that upper-administrations look very closely at student success rates after graduation through exit reports. As a result, art departments have a vested interest in the success of their students through career achievement after graduation. Preparing these students is of utmost importance during these pragmatic times.[13]

Although many more art schools are acknowledging the importance of preparing students for real life (certainly many more than in 1986 when I presented my case before the College Art Association), schools that offer career planning courses are still in the minority. Artists who are planning to enter B.F.A. or M.F.A. programs should consider application to those colleges and universities that offer professional practice programs for fine artists.

CONFRONTING MONEY ISSUES

How much do you want to earn as an artist, and how much are you willing to spend in order to earn it? Thoughts of money are ever present and, depending on one's situation, the thoughts are in the forefront of one's mind or are nestled in the subconscious.

How much is my work worth? How much am I worth? How much do I need this year, this month, this week? What can I afford? How much should I be earning?

There are artists who have identified with poverty for so long that when money finally comes their way they are consumed with enormous guilt, a theme that dominates their existence. There are artists who become Little Johnny One-Notes, churning out whatever

made money in the past, in fear that venturing in new directions will bring them back to Poverty City. And there are artists who attach so many stigmas to the concept of prosperity that they undervalue their work, riding the train to martyrdom. And as psychotherapist Annette Lieberman and writer Vicki Lindner state in their book *The Money Mirror: How Money Reflects Women's Dreams, Fears, and Desires,* "Money Martyrs think it is 'morally superior' to ignore their financial needs and often become the victims."[14] They also point out that "artists believe, often with validity, that financial rewards are bestowed on artistic products that are not the best. They say that they have not earned much money for their work because it is 'good' or 'pure.'"[15]

Carol Lloyd, a writer, performer, and author of *Creating a Life Worth Living,* describes the attitudes of many artists who have conflicted relationships with money: "They want a luxurious life but no signs of filthy lucre passing through their hands. They want stability without savings. They want to be poor and righteous and generous of spirit on the one hand and they want to be rich and fabulous on the other. They want to do wonderfully healthy things for the world for free and, at the same time, work in high-powered prestigious fields and get paid by the truckload."[16]

Lloyd goes on to say that "if you have this internal battle with greed and guilt, hedonism and morality, you may be suffering from the effects of extreme thinking. From this black-and-white perspective, the middle ground of getting paid for good, hard work reverberates with negative connotations: borrowing, staid, conventional, capitalist, careerist."[17]

"Almost all of us have struggled at one time or another with money shortfalls and found ourselves face to face with overwhelming fears,"[18] writes author Tad Crawford in another very good book, *The Secret Life of Money: How Money Can Be Food for the Soul.* Through stories and myths from around the world Crawford helps us understand why money is so much more than the useful tool we may think it to be. He discusses how money secretly influences our lives, why money is so easily worshiped, and why money sometimes feels more important than life.[19]

The most common money-related mistake artists make is a reluctance to invest in their own careers. Although artists are willing to

spend relatively large amounts of money on work materials and equipment, they are miserly and skimp when it comes to other important aspects of career development, such as travel, presentation tools, publicity, and mailing lists, and such preventive medicine as using contracts, hiring lawyers and accountants, and engaging the services of other professionals. Subsequent chapters discuss why these expenditures are important. But it simply boils down to this: *If you are not willing to invest in your career, who is?*

An artist's reluctance to make crucial career investments is sometimes spearheaded or aggravated by the attitude of a nonartist spouse or mate, particularly if the artist does have a separate bank account. If "family funds" are being used for career expenditures, an artist might experience subtle or not so subtle pressure to generate art sales in a relatively short amount of time or provide some sort of *tangible* justification that career investments are not a waste of time and money. Although it is not always possible, it is important for artists to sensitize their mates to the reality that earning a decent part-time or full-time income from sales and commissions is certainly possible, but it can take time. Help them understand that when instant gratification occurs, it most likely happens during the process of creating work and not in the early stages of launching a career.

INTIMIDATION OF VISUAL ART

Many people are intimidated by visual art, including many of those who buy and sell art.

The fear of visual art is perpetuated throughout our schooling, beginning as early as kindergarten, as we are bombarded with conflicting messages about the importance and relevance of visual art in our culture. Often visual art is presented as a "filler" subject—not in the same league, for example, as science, mathematics, or history. But by adulthood visual art is perceived as a discipline that can only be appreciated and understood by someone possessing a high IQ or a substantial background in art history.

On the other hand, random interviews with members of the public inquiring about preferences in music will produce immediate and confident responses. People are eager to tell you that they like jazz, country and western, classical, or rock and roll!

But ask the same public about their preferences in visual art, and their responses are laced with hesitation and discomfort. Often defensive platitudes are offered such as "I don't know anything about art but I know what I like."

Art historian and lecturer Carol Duncan described an experience with a department of motor vehicles inspector during a test for her driver's license:

> Upon discovering that I taught art history, he felt compelled to tell me of his dislike for Picasso, probably the only modern artist he could name. For a good fifteen minutes, while I did my turns and stops, he complained steadily about modern art. "I'm not stupid," he kept saying, "but that art doesn't say anything to me." Indeed, there was nothing stupid about him. But he felt that someone was telling him he was stupid by holding up for admiration expensive and apparently meaningful objects he could not comprehend. Students in the state college I teach often indicate such resentment—or else they are full of apology for not liking modern art.[20]

Educational systems that give mixed messages about visual art have contributed to the shaping of a society of individuals who do not value or trust their own opinions and feelings about visual art.

As a result of the public's intimidation by visual art and insecurity about their beliefs and feelings, a power structure has developed within the art world comprised of intermediaries whom we have come to depend on as sources of truth. We actually believe that *good* art can only be determined by the judgments and decisions of art dealers, critics, curators, academics, and art administrators. Unfortunately, many people within the art world believe this myth, including artists!

If members of the public were self-confident about their preferences in art, the strength of the power structure would diffuse. For example, art dealers would be acknowledged as sales personnel, a title that reflects their *real* occupation versus the messiah-like image currently awarded. Arts-related professions would be recognized as occupations that were created around artists, and not, as it often seems, the other way around! Or as arts administrator Ted Potter pointed out: "Curators, administrators, directors and art dealers are all really flight

attendants for this thing called art. . . . Art and the creative artists are what it's all about."[21]

\mathcal{V}ALIDATION AND ARTISTS' INSECURITY

Self-validation has great staying power compared to the type of validation that artists often seek from the art world. Validation awarded from the art world is fickle, volatile, often irrational, and usually short-lived.

When external validation is bestowed, the recipient might feel ecstatic, making one conclude that whatever sacrifices were made, and whatever time and money were spent, it had all been worth it. But for some people, it doesn't matter how much praise, press, exhibitions, commissions, and sales they receive, it will never be enough.

The ability to validate your own artwork does not always come easily nor does it come quickly. When I am called upon to validate an artist's work, I point out that in my capacity as a career coach and as a human being, it is not my role to assess whether an artist has talent. And when put in this position, I pose the question, How would you respond if you showed your work to six artists and half of the group said you are talented and the other half disagreed?

Emphasis on gaining approval from the art world has become so commonplace that few artists question the negative implications of looking for validation from external sources. For example, in her book *The Practical Handbook for the Emerging Artist*, Margaret R. Lazzari, who is an artist, earnestly writes that

> there are two ways to have your artwork validated, that is, recognized as significant and meaningful by others. One way, the "mainstream" method, is to have your work recognized by people within the museum/gallery system, such as curators, dealers, and critics. These people are art professionals who are entrusted by society at large with evaluating, displaying, buying, selling, and preserving artwork.[22]

For artists not seeking mainstream validation, Lazzari goes on to say that "validations for these artists cannot come through the traditional gallery-museum system, but through alternative means. Artists

must identify the audience who is interested in what they make, and find ways to bring the work to them."[23]

The types of validation that Lazzari describes encourage artists to give away their power in deference to "those who know best."

Contrary to Lazzari's message, David Bayles and Ted Orland, authors of the book *Art & Fear*, take a much healthier approach to the issue of validation, reminding us that

> courting approval, even that of peers, puts a dangerous amount of power in the hands of the audience. Worse yet, the audience is seldom in a position to grant (or withhold) approval on the one issue that really counts—namely, whether or not you're making progress in your work.[24]

Awe OF NEW YORK AND SELF-IMPOSED REGIONALISM

Artificial barriers and provincial attitudes about the art market can deeply restrict artists' career development. Preoccupation with regionalism has given rise to the expression "regional artist," a self-limiting phrase that, unfortunately, some artists use to describe their status.

Having moved six years ago from Manhattan to a small town in New York State, I have witnessed firsthand the obsessive desire of many artists to *only* exhibit in local galleries. Sadly, most of these longings will go unfulfilled because the artists have yet to understand the universal law that recognition and support more often come your way first from audiences outside of your neighborhood!

Other artists believe that their market is limited to their city of residence, or that some sort of universal censorship is imposed, illogically concluding that there is no market *anywhere* for their work if they are unable to find a receptive audience in their hometown. Artists living in large cities such as New York, Chicago, and Los Angeles, for example, are as likely to engage in this form of provincialism as artists living in towns and small cities.

The myth of equating career success with exhibiting work in a New York gallery is highly imbued in the minds of artists and nonartists. In all of the many years I have traveled throughout the United States and in Canada to conduct workshops on career development, the

question always arises: *"Do I have to show in New York to make it in the art world?"* Although my answer is always an ardent "no," in most instances members of the audience do not hear me or want to hear me because they have been brainwashed to believe that being represented by a New York gallery is pivotal to career success.

Because of the importance that has been attributed to exhibiting in New York, some artists will *pay anything* to have a show in a New York gallery. Naive attitudes, feelings of neediness, and the extraordinary pervasiveness of the belief of the myth of New York have contributed to the growth of vanity galleries in New York (and in other cities, see page 111).

Adolescent Career Goals

The phrase *successful artist* loosely describes a person who has achieved some degree of fame and/or fortune. Depending on whom you ask, the definitions of fame and fortune can vary considerably.

Although, as previously discussed, some artists equate success with having a show in New York, other artists equate success with being reviewed in a leading art trade publication, while other artists equate success to being featured on the publication's front cover! Some artists describe success as having their works included in the "right" private collections, and other artists believe that success is being represented in the "right" *museum* collection. Some artists define success as having a solo show at a museum, while others view success as nothing less than an invitation to exhibit in the Whitney Biennial or Documenta. To some artists the sale of a work at $5,000 is a sign of success; to other artists anything above $50,000 is an impressive number.

Although attainment of these goals is not insurmountable, it is *naive to believe that achieving any one of these goals, or a combination thereof, will lead to career success that spans a good portion of adult life*. Yet an astonishing number of artists' belief systems is centered around adolescent aspirations, and for many such artists these aspirations have become obsessions.

In practical terms the meaning of the phrase *successful artist* could describe, for example, an artist who earns a living doing what he or she loves doing best: creating fine art. Many artists are able to derive a

healthy part-time or full-time income doing what they love doing best without being swept away with all of the illusions surrounding the mystique of how to be successful in the art world. But because these artists' names are relatively unknown, the existence of alternative forms of career success is also relatively unknown, and adolescent attitudes prevail.

The Myth of Scarcity

Nancy Anderson, in her powerful book *Work with Passion*, points out:

> There are two ways to look at the Planet Earth: (1) It is contracting and shrinking—therefore my chances are scarce. Colloquially put, "there ain't enough to go 'round so I've got to get mine!" (2) It is expanding and growing with opportunity—my chances are based on abundance. The choice is mine, and time is my ally.[25]

Unfortunately, many artists have adopted the philosophy that "there ain't enough to go 'round so I've got to get mine!" The "shrinking" mode of thinking is also reinforced by other members of the art world. The foolish platitudes that *there are too many artists* or *there are too many artists for the number of commercial galleries* throw artists into panic attack or a chronic state of anxiety; some artists develop sharp elbows. A belief in scarcity is played out in many areas of an artist's career. Some artists sell their work at low prices because they have come to believe that the *only buyer* for their work is the buyer who makes himself or herself known at that given time. Some artists exhibit at galleries under unfavorable terms or circumstances because they believe it is their *only chance* to show their work and they must seize the moment. Many artists withhold from fellow artists introductions and referrals to art world contacts because of a *fear there that isn't enough to go around*.

In the long run, if the "community of artists" were truly functioning in a healthy capacity, whether on a national, regional, or local level, my occupation would be deemed obsolete because artists would be exchanging information and banding together to change the many basic inequities in the business of doing art. Unfortunately, a *fear of*

scarcity has created a lack of a sense of community among artists. A fear of scarcity is largely responsible for why artists often feel isolated from one another.

Denying Art Is a Business

Another stumbling block in career development for artists is not realizing or coming to terms with the fact that if you want to sell and/or exhibit work, art becomes commerce and it is a business. The next chapter, "Launching or Relaunching Your Career: Entering the Marketplace," looks at the business aspects of art and examines some of the ways in which artists can successfully enter the marketplace and sustain a career.

To launch or relaunch a career that is earmarked for success, artists must learn to transcend career blocks and emphatically reject the myth of the artist. The myth, like racial and religious prejudice, is subtle and sneaks up without warning. Do not underestimate the extent to which aspects of the myth can affect, influence, and limit an artist's career.

If artists go along with the myth, they must accept the consequences of leaving their careers in the hands of others. If artists do not develop and expand meaningful goals and act on these goals, their careers will be formed, manipulated, and eventually absorbed by people who have goals that are meaningful only to them. Artists become a means to the ends of others.

Launching or Relaunching Your Career: Entering the Marketplace

If you walk, just walk, if you sit, just sit,
but whatever you do, don't wobble.
—*Zen Master Unmon*

An artist who wants to sell work must enter the marketplace, a highly structured world made up of many networks. There are two ways to enter—haphazardly or with a plan. Unfortunately, most artists enter haphazardly, which means short stays and unhappy endings.

As artist and author Jo Hanson points out: ". . . artists have the same need as other people to set goals and plan their careers, and attend to the business of their work—and be good at it."[1] Hanson goes on to say that if artists "fumble through too much of their working life before discovering the need to plan and focus, the possibilities of choice and decision can close down significantly."[2]

Entering the marketplace with a plan means that your tools are lined up (see the next section) and your psyche is tuned up. How well you tune up your psyche depends on how thoroughly you have rejected the myth of the artist, have developed personal goals, and have been willing to act on these goals and get yourself moving. A good plan also includes having a well-thought-out philosophy about money: how much you want to earn as an artist, and how much you are willing to spend in order to earn it.

Artists who are reentering the marketplace must be willing to abandon strategies that didn't work or change attitudes that got in their way during their last incarnation in the art world. As pointed out by

Laura Whitworth, Henry Kimsey-House, and Phil Sandahl, the authors of *Co-Active Coaching*: "The classic definition of crazy is continuing to do things the same way and expecting different results. The truth is: if nothing changes, nothing changes. Something new on the outside, like a new outcome, starts with something new on the inside."[3]

\mathcal{H}OMEWORK: DOWN TO BASICS

The following homework includes basic investments necessary to launch, relaunch, and sustain an artist's career. Some investments require money, some require time, and some require both.

Read, Note, File, and Retrieve

During the last twenty years the art trade publications field has expanded and diversified, with each of the art disciplines having newspapers, tabloids, magazines, e-zines, and Web sites that focus on *real art news* rather than reviews and critical essays. These resources contain valuable information on numerous aspects of the business of art and the business of being an artist, including grant, exhibition, and employment opportunities, legal and accounting advice, health hazards related to the arts, and arts-related legislation.

There are publications with a regional focus, such as *Artweek*, devoted to artists living in the Northwest, Southwest, Alaska, and Hawaii; *Art New England*, geared to artists in the Northeast; *Art Papers*, for artists in the Southeast; *FYI*, for artists in New York City and State; and *Chicago Artists' News*, for artists in the Midwest. There are also publications of national interest, such as *Art Calendar* in the United States and *Agenda* in Canada. In addition, there are periodicals that specialize in various disciplines, such as *The Crafts Report, Sculpture, Afterimage*, and *Surface Design. The Art Deadlines List* is a comprehensive digest of opportunities for artists that is downloaded each month to a subscriber's e-mail address or sent through the U.S. mail. AN Web is an invaluable source of information for artists interested in establishing contacts in the United Kingdom and in Europe. It contains on-line career guides, resources on a variety of arts-related subjects, and career advice. The biweekly on-line publication *The Artist's Resource Letter*, sponsored by the School of the Museum of Fine Arts in Boston, lists hundreds of opportunities for artists. Artsupport is a Web site that

offers photographers career advice, and the Web site Sculptor.org is packed full of resources for sculptors. The addresses of these Web sites and publications can be found in the appendix sections "Career Management, Business, and Marketing" and "Periodicals."

Become aware of the numerous local, regional, national, and international arts service organizations, and take advantage of their various programs, services, and publications. Throughout the appendix, many service organizations are listed that have a regional, national, or international focus.

For example, *Organizing Artists: A Document and Directory of the National Association of Artists' Organizations* lists many of the organizations that offer assistance to visual and performing artists, writers, and filmmakers, with information on services, publications, programs, grants, and facilities. In addition, there is the *Directory of Minority Arts Organizations* published by the National Endowment for the Arts, the *Asian American Arts Resource Directory* published by the Asian American Arts Alliance, Inc., and the on-line *Directory of Hispanic Arts Organizations*, which lists Hispanic organizations involved with the visual arts, dance, literature, media, music, and theater. These publications, as well as other useful references, are listed in the appendix (see "Arts Service Organizations").

Many arts service organizations serve the needs of special-interest groups. Examples include ATLATL, which is dedicated to the growth and development of contemporary and traditional Native American arts; En Foco, a national organization that is devoted to photographers of color; the Society for the Arts in Healthcare; the Arts and Healing Network; the Disabled Artists' Network; and Deaf Artists of America. The addresses of these and other arts service organizations are listed in the appendix sections "Artists with Disabilities" and "Arts Service Organizations."

A valuable resource to artists nationwide is the Visual Artist Information Hotline. Sponsored by the New York Foundation for the Arts, the hotline is a free information service for artists throughout the United States, including Puerto Rico, the Virgin Islands, the Mariana Islands, and American Samoa. The hotline can be accessed by phone or e-mail, and some of its publications are available on-line. The hotline publishes *Information Factsheets*, which details information on thirty-three career-related topics, and *State Factsheets*, which provides information on resources and organizations in the fifty states and the U.S.

territories. *Information Factsheets* and *State Factsheets* are available by mail and on-line. The hotline also publishes The Hotline Directory and The Digital Directory: Art & Technology Resources in New York State. These directories are only available on-line. The Hotline Directory is a comprehensive, alphabetical listing of all organizations, publications, and other programs listed in the *State Factsheets*. It includes phone and fax numbers, e-mail addresses, and Web site addresses. The Digital Directory: Art & Technology Resources in New York State is a sourcebook of low-cost telecommunications, computer, and new media resources for artists and arts organizations. Contact information for the Visual Artist Information Hotline and its various publications and services are listed in the appendix section "Career Management, Business, and Marketing."

With the plethora of information available, there is no excuse for artists not to be well versed in what is going on in their own profession.

Read, note, file, and retrieve—or practice what authors Judith Appelbaum and Nancy Evans refer to as the "pack-rat process."[4] Set up a file and contact system that is imaginative and considers the present and the future. Contacts and information that might not necessarily be of interest or apply to your career now could be important and relevant in the future.

Review the files on a regular basis. Unless you have a photographic memory, you will forget a lot of information that has been clipped and stored away.

Set up files for various categories, choosing those that make sense and have meaning for you. My file system includes the following categories: grants; artist-in-residence programs and art colonies; museums and independent curators; art consultants and art advisors; art service organizations; legal, accounting, and insurance information; contracts for artists; mailing lists; press contacts; employment opportunities; public-art programs; slide registries; vendors that provide services to artists; housing and studio space; health hazards in the arts; and arts-related Web sites.

Mailing Lists—The Usual and the Esoteric

Starting and developing a good mailing list requires a lot of time and energy, but it is well worth the effort. Like a file/contact system, a mailing list can and should be used over and over again. It should be updated on a regular basis to reflect the changes you are making in

your career (new contacts) and the ever-changing scene in the art world (the names usually stay the same, but the institutions and organizations might fluctuate). A good list implies quality more than quantity, meaning that your list should include the names and addresses of people who can do something for your career—directly or indirectly—now or in the future.

Do not wait until you need to use a mailing list to put one together. Develop a list when "nothing's happening" so that when something happens it will not become one of the thousand other chores you have to do in connection with exhibition/performance planning.

When artists are having an exhibition, it is common practice to use the mailing lists of the gallery. Unfortunately, gallery lists tend to include everyone who has signed the gallery guest book, which does not necessarily mean that all of the names are of interest to you. Many gallery lists and lists compiled by arts organizations are not updated on a regular basis. In some cases the lists are shortsighted and they do not contain a comprehensive representation of an arts community.

Following are the major categories that should be included in a comprehensive arts mailing list:

Directors of galleries
Directors and curators of alternative spaces
Museum and independent curators
Curators of corporate art collections
Art consultants and advisors
Directors of public-art programs
Interior designers and architects
Art critics
Editors of international, national, regional, and local arts
 publications, including on-line magazines
Editors of interior design and architecture publications
Arts and culture editors of magazines and newspapers
Producers of local and national arts-related television and radio
 programs
Assignment editors of local and national television and radio
 programs
Editors of trade publications (see page 27)
Fans and collectors

Mailing lists in most of the categories cited above can be purchased. For example, ArtNetwork in Nevada City, California, sells mailing lists in various arts-related categories. Mailing Lists Labels Packages in Weston, Connecticut, offers various mailing-list packages pertaining to public art and percent-for-art programs; and I have mailing lists available for purchase that are updated on a regular basis. These lists include art consultants, national and regional arts press contacts; New York City press contacts; New York City critics; and museum and independent curators. The addresses of mailing list resources are listed in the appendix sections "Mailing Lists" and "Press Relations and Publicity."

If you are using mailing lists to write *cover letters* (see page 53), make sure that the lists you purchase *include the names of specific individuals*. It should not be a list that is addressed to such generic titles as "gallery director" or "curator."

If you are compiling your own mailing list the following resources will be of assistance:

The names of museum curators are listed in the *American Art Directory* and *The Official Museum Directory*. Both of these publications are listed in the appendix under "General Arts References."

The names and addresses of international arts publications can be found in *Ulrich's International Periodical Directory* and *Bacon's International Media Directory*. The Web site NewsDirectory.com links more than sixty-five hundred English-language print and broadcast media from around the world.

The on-line editorial staff of newspapers, consumer magazines, and television, radio, and cable network stations and shows can be found in *Bacon's Internet Directory*. The names and addresses of arts publications and interior-design and architecture publications can be obtained in *Bacon's Magazine Directory*.

The names of newspaper feature and news editors and of journalists who write about the arts can be obtained in *Editor and Publisher Annual Directory of Syndicate Services Issue* and *Bacon's Newspaper Directory*.

For those interested in key press contacts in California and/or New York City, the directories *Bacon's Metro California Media* and *Bacon's New York Publicity Outlets* are excellent resources. Both publications are updated every six months. Information about these publications and the

ones listed above can be found in the appendix section "Press Relations and Publicity."

Listings of art consultants and advisors are contained in the *Art Marketing Sourcebook* and *Art in America Annual Guide to Museums, Galleries, Artists*. Information about these publications can be found in the appendix section "Corporate Art Market."

The names of interior designers and architects can be obtained through local chapters of the American Society of Interior Designers and the American Institute of Architects (see "Corporate Art Market" in the appendix). The names of interior design and architecture publications are listed in the appendix section "Interior Design and Architecture."

One of the most underexplored areas of an arts-related mailing list is the inclusion of trade publications. Trade publications often include articles about new and unusual uses of the materials that they promote. For example, if you are a sculptor working with glass, the names of trade publications in the glass industry can be obtained from *The Encyclopedia of Associations* and *Writer's Market*. Or, by using the Web site Mediafinder.com, you can link to target market trade publications, newsletters, magazines, and directories. Articles in trade publications that feature the work of an artist can lead to corporate commissions, acquisitions, and sponsorships.

If you are living in a place other than where you were born or raised, include the names of newspapers in your hometown. The names of alumni publications issued by the college or university you attended should also be on your mailing list. Always write a cover letter to accompany any material that is sent, pointing out, for example, that you are a native of the area or an alumnus or alumna.

A comprehensive mailing list should also include the names of local publications that offer free listings to announce an exhibition, performance, or cultural event.

Career Advisors

An artist's career advisor is a relatively new occupation, and as in the case of many emerging fields it is still going through the growing pains of defining itself and establishing boundaries. Although I refer to myself as a career coach to artists and an artist's advocate, I am, in effect, a career advisor. During the past twenty-four years I have kept abreast

of some of the activities and business practices of those people who have shared my occupation. Since I have been credited for pioneering this field and I have had the benefit of observing how other career advisors operate, what we share in common, and where we differ, I offer the following pointers and advice:

An artist's career advisor assists artists with various aspects of career planning. A *good* career advisor should be knowledgeable about the many facets of the art world and the many options and opportunities available to artists.

Specifically, a career advisor should be able to provide artists with support for a wide range of career-related responsibilities and tasks. For example, a career advisor should be able to advise on the development of effective presentation materials; public relations and press relations; and establishing prices for artwork. A career advisor should be able to provide an overview of the various art markets and provide assistance with marketing strategies, grant proposals, exhibition proposals, and proposals for commissioned work. And a career advisor should know how to proceed once a dealer makes a verbal commitment to represent an artist.

The job titles of *art consultant* and *art advisor* are often confused with the job title of *artist's career advisor*. However, unlike an art consultant or art advisor, a *career advisor to artists should not buy or sell artwork*. In order to serve artist clients most objectively and ethically, career advisors should not represent any one artist or be involved in any endeavor that is a conflict of interest.

Because conflicts of interest should not happen, it does not mean that they do not happen! Out of all of the services a career advisor should provide, the most important is the role of *artist advocate*. However, the ability of a career advisor to perform an advocacy role is the crux of the problem that involves issues related to conflicts of interest. Career advisors who are *also* art dealers cannot serve artists in an advocacy capacity because they are influenced by factors that they perceive to be in their best interests as a dealer. Moreover, career advisors who are *also* publishers who solicit paid advertising from artists, or charge fees to be included in artist sourcebooks (see page 125), cannot serve artists in an advocacy role because they must be looking out for their best interests as publishers whose livelihood relies, in part, on artist-paid advertising.

Be leery of career advisors who promise to place you in a New York

gallery. In some instances, the gallery of choice will be a vanity gallery (see page 111) or it is engaged in other unsavory business practices. One New York gallery that is regularly used by a career advisor requires artists to guarantee that their work will be sold prior to the exhibition opening! Artists are asked to sell their work to a third party; the purchaser pays the dealer; and the dealer pays the artist and deducts a 50 percent commission!

Some career advisors provide their clients with competent advice and services and rigidly avoid areas where there are conflicts of interest. However, other advisors straddle the gray areas or plunge way over the fence. Other career advisors might not have an impeccable code of ethics but their advice follows more traditional lines, and it tends to encourage artists to maintain a status quo and give away their power to the "powers that be."

There are also career advisors who have had very little experience in the art world, and although their intentions might be honorable, the advice and services they provide reflect their limitations.

Before working with a career advisor, learn more about the person's career background and reputation. This can be accomplished by requesting client references and written materials that describe services, fees, and arts-related credentials. Approximately 90 percent of my clients are referred by other artists who have used my services, or they have read my book, or they have attended a career workshop that I have conducted.

Do not be afraid of changing career advisors or of using different advisors for different purposes depending on their strengths and fields of expertise. Do not expect a career advisor to solve a problem overnight that most likely you have spent the better part of your life creating.

Know the Law

In the early 1960s a friend of mine lost approximately 150 paintings in court. He gave his work to a Washington, D.C., gallery owner on consignment without a receipt or any form of written agreement.

After six months he asked to "borrow" some of his paintings in order to enter a juried show. The dealer said that she didn't have his paintings and didn't know what he was talking about.

The artist hired a lawyer. It took another six months for the case to go to court. On the day of the trial, the dealer brought a majority of the lost paintings to the courtroom. She had a simple explanation: she

told the judge that the artist had given her all of the paintings as a *birthday present*. The judge believed her. She was free to keep the paintings and do with them what she wished. Case dismissed.

With new legislation and changes in laws that protect artists from being victimized, much has changed in forty years. But undoubtedly a day does not pass that some artist is ripped off by an opportunist or discovers a hitch in what seemed a straightforward deal. *The majority of new legislation will not do an artist any good unless he or she bones up on the legal rights of artists and understands how these rights affect or may affect an artist's work and career.*

"Artists should never feel intimidated, helpless or victimized. Legal and business considerations exist from the moment an artist conceives a work or receives an assignment. While no handbook can solve the unique problems of each artist, the artist's increased awareness of the general legal issues pertaining to art will aid in avoiding risks and gaining benefits that might otherwise pass unnoticed,"[5] writes Tad Crawford in his book *Legal Guide for the Visual Artist*, which should be on the top of your list of books to buy. This book is written in down-to-earth language and covers a comprehensive range of subjects that should be near and dear to an artist's heart, including copyright, wills and estates, sales by galleries and agents, income taxation, studios, and leases. It includes examples of sample contracts and agreements for a vast number of situations that an artist might and probably will encounter.

The fourth revised edition of *Legal Guide for the Visual Artist*, published in 1999, addresses issues relating to multimedia art, including work that combines still pictures, text, music, and film or video; digitization of information; delivery of new media, such as CD-ROM, computer networks, and cable television; and interactive projects. It also includes a chapter that is devoted to copyright and the digital revolution.

Legal Guide for the Visual Artist is among several publications available that zero in on the nitty-gritty of art law. It would be superfluous for me to paraphrase or try to cover the ground that has already been covered by people far more experienced and knowledgeable on the subject. However, the "Law" sections of the appendix provide solid lists of references, both publications and organizations. Many of these publications and organizations provide sample contracts, as well as advice for numerous arts-related legal situations. If you require additional information before a contract is signed, or if you find yourself in

the unfortunate situation of needing legal advice after an agreement has been consummated, or for whatever reasons, there are many excellent places to turn to.

Not being able to afford a lawyer specializing in art law is no longer a valid excuse! For example, Volunteer Lawyers for the Arts (VLA) in New York City offers free legal consultation and legal services, at minimal administrative fees, to artists and nonprofit organizations. More than thirty-five Volunteer Lawyers for the Arts offices are located throughout the United States and in Canada, some of which were created by arts councils, arts organizations, state bar associations, law firms, and law schools. Services offered, eligibility requirements, and administrative fees vary. In addition to offering legal assistance to individuals, many VLA groups offer seminars on various art-law-related topics and publish resource books, such as *An Artist's Guide to Small Claims Court*, which is applicable to artists in New York City, and the *VLA Guide to Copyright for the Visual Arts*. The "Law: Organizations" section of the appendix lists Volunteer Lawyers for the Arts groups and publications, including the *VLA National Directory*, which describes VLA programs in the United States and in Canada.

COPYRIGHT

Without a copyright, once a work of art enters the public domain, the artist loses all rights to that work. This means that if a work of art is sold or exhibited without a copyright it can be freely published and reproduced. The artist has nothing to say about it and is not eligible for any kind of financial remuneration. Therefore, it is imperative that all work have a copyright.

The 1978 Copyright Act has made copyright procedures very simple. It is not retroactive, so all copyright transactions prior to January 1, 1978, are governed by the old law. But the 1978 law is straightforward and easy to comply with. Simply stated, *any artwork is protected by copyright as soon as it comes into being* as long as an artist places a copyright notice on the work. This consists of "Copyright," "Copr." or "©," the artist's name (or abbreviation by which the name can be recognized or an alternative designation by which the artist is known), and the year of creation. The copyright lasts for the duration of the artist's life plus fifty years.

Copyright protection is available to artists working in every medium, including printing, photography, painting, sculpture, drawing, graphics,

multimedia, models, diagrams, film, tapes, slides, records, and compositions.

Although you are not required to formally register your copyright, there are certain advantages that mainly concern your rights if anyone tries to infringe on your copyright. And particularly with the advent of the Internet, copyright registration has become more important. Registration forms can be downloaded from the Web site of the Copyright Office or you can request a Copyright Information Kit from the Copyright Office. Be sure to specify that you are requesting the kit for visual artists.

The ins and outs of copyright and how it affects the visual and performing arts are covered in many publications, including *Legal Guide for the Visual Artist, VLA Guide to Copyright for the Visual Arts*, and *VLA Guide to Copyright for the Performing Arts*. The appendix section "Law: Copyrights, Patents, and Trademarks" includes contact information about these publications and Copyright Office registration forms.

CONTRACTS

Most visual artists do not use contracts. Performing artists and writers use contracts as regular parts of their professional lives. Why are visual artists reticent about using contracts?

Some artists are averse to the use of contracts because they naively believe that people who sell, buy, and exhibit art are good, kind, and trustworthy by virtue of their involvement with art. However, most artists who resist using contracts are struggling with the issue of psychological leverage and erroneously believe that they have not achieved a level of recognition or success that permits them to ask for what they want.

Requiring art dealers, art consultants, exhibition sponsors, and clients to use contracts is not a sign of mistrust. Rather, it shows that you take yourself and your work seriously, and you are demonstrating good faith in wanting to maintain a smooth working relationship by ironing out in advance any possible conflicts or misunderstandings.

If an art dealer, art consultant, exhibition sponsor, or client is opposed to using a contract, it usually indicates either that the individual is extremely naive and unenlightened in professional business practices, or that he or she is engaged in unethical business practices and does not want anything in writing that could be used against him or her in court. Another reason dealers and art consultants resist using

contracts is that they prefer to see themselves as mentors rather than as business professionals, and they find the use of contracts is not in keeping with their self-image.

If your dealer dies, is your artwork protected from becoming part of his or her estate? If your dealer files for bankruptcy, is your work protected from being used to pay creditors? Is your work insured while it is in a dealer's possession, and is it insured for the full retail value? Is a dealer entitled to a commission on studio sales under all, some, or no circumstances? Should artists split dealer/client discounts? Is an artist required to pay advertising expenses for an exhibition? If so, how much? A good contract should be comprehensive and farsighted.

Protect yourself and your artwork by using contracts when you deal with galleries, art consultants, collectors, exhibition sponsors, and clients. Specific contracts such as consignment agreements, exhibition agreements, and agreements for commissioned work will be discussed in subsequent chapters. The appendix section "Law: Contracts and Business Forms" lists publications that provide sample contracts, including *Business and Legal Forms for Fine Artists*, *Business and Legal Forms for Crafts*, and *Business and Legal Forms for Photographers*. Each of these publications also includes instructions for preparing contracts for a variety of situations and a kit of tear-out contracts. A great advantage is that each also comes with a CD-Rom.

ARTISTS' ESTATES

On a number of occasions I have been contacted for advice by family or friends of deceased artists who left no instructions regarding the disposition of their artwork. Particularly when many pieces of artwork are involved, it can be an overwhelming responsibility to make decisions without guidance, instructions, or suggestions from the artist. On the other hand, if a deceased artist's friends and relatives are not conscientiously seeking a solution that is in the best interest of the artist, there is a good chance that the artwork will not long survive the artist's death.

In the publication *Future Safe: The Present Is the Future,* published in 1992 by the Alliance for the Arts, the authors point out:

> As an artist, you are used to being your own best resource, so it will come as no surprise that you must take the initiative in planning for the survival of your work. You must give yourself time.

The process of making a will and planning for the care of your work can be seen as an act of self-respect. The commercial success of your art should not be a factor in your planning—you have spent a lifetime making this art and it deserves to survive.[6]

It is important to come to terms with estate planning, preparing a will, deciding on a beneficiary or beneficiaries, and providing the beneficiary with instructions or guidelines on the disposition of your artwork.

Depending on various career-related factors, estate planning for artists can be relatively simple or quite complicated. It is wise to consult an attorney and/or an accountant who is experienced in estate planning for *artists*.

To learn more about the subject of artists' estates there are good resources available. In addition to *Future Safe*, which is now only available on-line, the Marie Walsh Sharpe Art Foundation has published *A Visual Artist's Guide to Estate Planning*. The Women's Caucus for Art has published the workbook *Estate Planning for Artists*, and Canadian Artists' Representation Ontario (CARO) has published *Estate Planning for Visual Artists*. In *Legal Guide for the Visual Artist* an entire chapter is devoted to the artist's estate.

Volunteer Lawyers for the Arts in New York City has initiated the Artist Legacy Project, which provides free and specialized estate-planning services to visual and performing artists and writers. The Alliance for the Arts sponsors the Estate Project for Artists with AIDS. Organizations and publications cited in this section and other resources are listed in the appendix under "Law: Estate Planning."

Accounting

Closely allied to the subject of law is accounting—your tax status, or lack of status, whichever may be the case.

A few years ago I was invited to speak at a conference dedicated to the business of being an artist, sponsored by a college in an affluent suburb of New York City. The audience was comprised of artists from the area, and from the tone of questions and concerns I quickly ascertained that this was not a group of full-time artists but rather of "Sunday painters." The college had also invited guest speakers from the visual and performing arts and from the publishing industry. During

the discussion period I was surprised to find that the person who received the most questions was the guest accountant, and from the level and content of questions it was easy to tell that this audience was abreast of tax laws governing artists, particularly those related to deductions.

This situation is quite a contrast to the attitude of the many full-time artists I am in touch with. How often I encounter serious and devoted artists who are living underground as far as the IRS is concerned, afraid to prepare a tax return for fear they will have to pay taxes on meager earnings. It is ironic that the artists who probably have the hardest time proving themselves "professional" versus "hobby" artists in the eyes of the IRS are the ones most up-to-date and knowledgeable on tax issues.

I am not going to expound on the morality or virtues of paying or not paying taxes, but what is of concern is that too many artists are spending too much energy agonizing over taxes, energy that takes them away from being artists.

One of the reasons artists are squeamish about taxes is the deep-seated myth that being an artist is not a valid occupation and the government will tax an artist in an arbitrary way. The fact is that the occupation of artist has been duly recognized by the IRS for a number of years, most specifically in the 1969 Tax Reform Law.

"An artist actively engaged in the business or trade of being an artist—one who pursues art with a profit motive—may deduct all ordinary and necessary business expenses, even if such expenses far exceed income from art activities for the year,"[7] writes Tad Crawford in *Legal Guide for the Visual Artist*. "The regulations set forth nine factors used to determine profit motive. Since every artist is capable, in varying degrees, of pursuing art in a manner which will be considered a trade or business, these factors can create an instructive model. The objective factors are considered in their totality, so that all the circumstances surrounding the activity will determine the result in a given case. Although most of the factors are important, no single factor will determine the result of a case."[8] (The nine factors are listed in Crawford's book.)

"The working artist who is not yet making a profit from art activity has an alternative to being taxed as a hobbyist,"[9] writes artist and author Jo Hanson in the preface of the excellent publication *Artists' Taxes: The Hands-on Guide* (see "Accounting and Bookkeeping" in the

appendix). Hanson, who endured five tax audits in the 1980s, parlayed her experiences into a book that presents clear and detailed advice to artists.

Federal tax laws frequently change, and many of the changes directly affect artists. The Tax Reform Act of 1987 is having an adverse effect on artists in many ways. For example, income averaging (which was very helpful to artists whose income varied widely from year to year) has been abolished. Under the old law a business had to be profitable two out of five years to avoid being treated as a hobby. Under the new law the business has to be profitable *three out of five years*; and the new law makes it tougher for self-employed artists to take their home-office expenses as a deduction. This deduction cannot exceed an artist's net income from the art business, as opposed to the gross income limit under the old law, and the portion of home space claimed as an office or studio must be used *only* for the art business, and on a regular basis.

Some business-related tax deductions artists should be aware of include insurance premiums; studio and office equipment; telephone bills; telephone answering service (on a separate business line); attorney's and accountant's fees; dues in professional organizations; books and professional journals; admission charges to museums and performances; protective clothing and equipment as well as associated laundry bills; commissions paid to dealers and agents; promotion expenses, including Web site design and hosting fees, photographs, ads, résumés, and press releases; repairs; training and education expenses and tuition for courses that improve or maintain skills related to the profession; shipping and freight charges; the cost of business meetings (such as meals) with agents, patrons, professional advisors, dealers, et cetera, regardless of whether the relationship is established or prospective; business gifts; and automobile expenses for traveling to an exhibition or performance, delivering or picking up work at a gallery, purchasing supplies, driving to courses and seminars, et cetera.

These are only some of the tax deductions that affect artists. The list certainly is not all-inclusive, and there are special rules and regulations governing the application of many of the deductions listed above. Because of the intricacies involved in knowing tax regulations and tax-law changes, if you personally do not keep abreast of the ins and outs and changes, it is very important to *maintain a relationship with an accountant who specializes in the tax problems of artists*.

Art tax law is a special field, and not all accountants are familiar

with the various intricacies. Case in point: Barbara A. Sloan, the author of the *Do-It-Yourself Quick Fix Tax Kit* and other related publications, is an artist, an attorney, and an art business consultant. Although she is *not* an accountant, she is called upon by certified public accountants for advice in behalf of artist-clients.[10]

Many accountants who specialize in the arts are affiliated with organizations such as Business Volunteers for the Arts (see appendix under "Accounting and Bookkeeping"). Some accountants who specialize in the arts often advertise their services in art trade publications, such as the ones listed in the "Periodicals" section of the appendix. If you are unable to find an accountant through a good recommendation, do not hesitate to ask the accountant you do find for a list of references of artists whom he or she has helped in the past. Check out the references to make sure that the clients have been satisfied customers.

Insurance: Insuring Your Health, Work, and Future

HEALTH INSURANCE

One of my clients broke his leg. He was in the hospital for three weeks and then was an outpatient for several more weeks. During the first week he was hospitalized he learned that he had won an art competition with a cash award of $5,000. But his jubilation over the award was eclipsed when he also learned that his barebones hospitalization policy (a so-called fringe benefit of the college where he was teaching) would pay only meager benefits toward his hospital bills and doctors' fees. Thus, he had to use his entire cash award to pay the bills.

One could elaborate for pages about similar and even worse stories involving artists who do not have health insurance or who are not adequately covered. For many years artists were subjected to exorbitant *individual* rates for health insurance. They were ineligible for *group* rates because of the nature of being a self-employed artist, a unit of one. However, times have changed and many organizations offer group plans. Some of the national and regional organizations that offer group rates to members are listed in the appendix section "Health Insurance and Medical Plans."

The book *Health Insurance: A Guide for Artists, Consultants, Entrepreneurs and Other Self-Employed* by Lenore Janecek is a comprehensive handbook on the subject of health insurance. It discusses various types of insurance programs, what to look for in a health-care policy,

and various insurance options. It also covers insurance needs that are particular to self-employed individuals, including disability insurance and pension programs (see below).

STUDIO AND WORK INSURANCE

"All-risk" insurance policies are specifically designed for artists and their particular needs. "All-risk" policies cover insured work on your premises, on exhibit, and in transit. The Chicago Artists' Coalition offers studio insurance to members through the American Phoenix Corporation Insurance Program, and the American Craft Council offers members property/casualty insurance. The Ohio Arts and Crafts Guild offers business and liability protection to members in Ohio, Pennsylvania, Indiana, and Michigan.

In addition, the Artist/Craftsman Protection Plan offers individual artists liability insurance and all-risk property protection for artwork at home, in the studio, on exhibition, and in transit. The companies Huntington T. Block; Connell Insurors, Inc.; Flather Perkins, Inc.; and Trinder & Norwood, Inc. also offer various forms of studio insurance.

The addresses of the above-mentioned organizations and companies are listed under "Studio Insurance" in the appendix.

PENSION PLANS: INSURING YOUR FUTURE

Not everyone is going to retire. Some of us reject the notion on principle, and others will not have any choice in the matter because they will not have stored up a nest egg. If you are heading for the latter category, or if you fall into the first category and are forgetting that bad health might necessitate a change in your plans, or if you are in neither category and basically haven't thought about retirement because you are just getting started, consider this: artists can now participate in pension plans, a fringe benefit once bestowed only on members of society who were willing to devote most of their lives to working for someone else. Now there are pension plans for self-employed persons that *offer financial security for your future.*

Keogh plans are pension plans for the self-employed. However, even if you are employed by a company with a retirement program, you may maintain a Keogh plan and make an annual contribution of up to 20 percent of your net self-employment income, or $30,000 (whichever is less), to the plan. Your money can be invested in a trust, an annuity contract from an insurance company, a custodial account,

a special U.S. government retirement bond, or one of certain face-amount certificates purchased from investment companies. Money contributed to a Keogh plan is tax deductible and no taxes are levied on the growth of your investment until the funds are withdrawn. There are penalties if you withdraw the money before the age of 59½, unless you are disabled.

Another kind of pension plan, an Individual Retirement Account (IRA), is available to anyone who is not covered by a company retirement plan, or anyone who is covered by a company plan but has an adjusted gross income of less than $25,000 ($40,000 for a married couple). In an IRA you can invest up to 15 percent of your adjusted gross income, with a ceiling of $2,000 per year ($4,000 for a married couple who are both working; or $2,250 for a married person with a nonworking spouse). As in a Keogh plan, the money you place in an IRA is tax deductible. There are penalties if you withdraw the money before the age of 59½, unless you are disabled. A Roth IRA is another type of personal savings plan that provides tax advantages for setting aside money for your retirement. If you satisfy certain requirements, distributions from a Roth IRA, unlike a traditional IRA, are not subject to income tax. You can contribute to a Roth IRA regardless of your age (even after the age of 70½) if you are receiving compensation and your adjusted gross income is under $95,000 if you are single or under $150,000 if you are married and filing a joint return. However, unlike contributions to a traditional IRA, contributions to a Roth IRA are not tax deductible.

For further information on self-employment retirement plans, write to your local Internal Revenue Service office. The addresses of other pension-plan resources are listed in the appendix under "Pension Plans and Savings and Loans Programs."

Credit Unions

Credit unions are financial cooperatives that are owned and controlled by their members and offer a range of services. For example, the Artists Community Federal Credit Union (ACFCU) is a federally insured credit union that offers special loans to help artists establish a national credit rating. The ACFCU also provides bridge loans to assist artists who have been awarded grants. If an artist's cash-flow needs are not in sync with the funding sponsor's payment schedule, the ACFCU will advance the needed money, using as collateral grant

award letters from established funding agencies. Artists in all disciplines are eligible for ACFCU membership, as are people employed in the arts community.

In addition, The Chicago Artists' Coalition has a credit union for its members that offers regular savings accounts; vehicle, home equity, and student loans; and IRAs. The addresses of both organizations are listed in the appendix section "Pension Plans and Savings and Loans Programs."

Artists' Health Hazards

Health hazards to artists is a relatively new area of study, because it has only been recognized in recent years that various materials used by artists are directly responsible for a multitude of serious health problems, including cancer, bronchitis, and allergies.

Solvents and acids used by printmakers are responsible for many health problems; dirt and kiln emissions have created problems for potters; resins and dirt in a sculptor's working environment and gases and vapors used in photography are also responsible for various ailments. Toxic chemicals in paints are directly linked to cancer, including pigment preservatives used in acrylic emulsions and additives such as those used to protect acrylic paints during freeze-thaw cycles. In addition, improper ventilation is a common abuse, and its side effects are directly responsible for temporary discomfort as well as permanent damage.

Performing artists are also directly affected. Toxic chemicals are found in concert halls and theaters, onstage, in dressing rooms, in makeup rooms, et cetera. Health problems are created by such things as poor ventilation; certain types of aerosols, acrylics, and plastics used in sets and costumes; photographic chemicals; asbestos; sawdust; gas vapors; dust; and machine oil.

If you are not already aware that the materials you might be using in your studio or work environment are considered taboo, it is time to investigate.

The Art and Craft Materials Institute, Inc., certifies 90 percent of all art materials sold in the United States. The institute provides information on hazardous products and publishes a newsletter. Arts, Crafts and Theater Safety (ACTS) is a not-for-profit organization that provides information on health and safety in the arts. Serving artists and arts organizations worldwide, ACTS answers inquiries and provides copies of educational and technical materials. It also publishes a monthly

newsletter. ACTS was founded by Monona Rossol, who wrote the very informative book *The Artist's Complete Health and Safety Guide*.

The Center for Safety in the Arts, founded by Dr. Michael McCann, pioneered the dissemination of information on health hazards in the arts. Dr. McCann is also the author of the important book *Health Hazards for Artists*. Due to funding cutbacks, the center no longer exists.

Various Web sites are devoted to exposing arts-related health hazards. These sites include Health Hazards in the Arts, produced by the Rochester Institute of Technology, and Health Safety in the Arts & Crafts, produced by the Nebraska Cooperative Extension. In addition, the Web site of the Artists Foundation provides information and warnings surrounding printmaking, ceramics, painting, sculpture, photography, and jewelry metalworking.

Information about the above-mentioned organizations and the names of other excellent publications that are available on the subject of health and safety in the arts are listed in the appendix section "Health Hazards."

\mathcal{M}INIMIZING EXPENSES

There are many ways to keep expenses low in order to afford the necessary initial financial investments to launch and sustain your career. Some of the ways are described below.

Bartering

Bartering has been in existence for thousands of years. Artists can trade their artwork and special skills for career-related supplies, materials, and equipment. You can also save money on various daily living expenses so that you can allocate more funds for your career.

Some of my clients have bartered with doctors, dentists, printers, restaurants, food stores, plumbers, carpenters, and electricians.

TradeArt, Inc., is a not-for-profit membership organization that sponsors the bartering program The Art Exchange. It also publishes the bimonthly publication *TradeArt: A Cooperative Arts Information Exchange*.

The bartering phenomenon has expanded into big business, and barter organizations and clubs exist throughout the United States. The names of barter organizations can be found in the Yellow Pages Business-to-Business Directory under "Barter and Trade Exchanges."

In addition, Barter.Net, a Web site on the Internet, provides a listing of bartering networks. For information about Barter.Net and other bartering resources, see the appendix section "Bartering."

Using Apprentices

You can save money and time by using the services of an apprentice. Apprenticeship programs provide artists with students who want studio or work experience. Some apprenticeship programs are structured as a barter: free assistance in return for learning and developing new skills; other programs require an artist to pay an apprentice a reasonable hourly wage.

Local and state arts councils can provide information on apprenticeship programs. In addition, the New York arts program of the Great Lakes Colleges Association sponsors a student-intern apprenticeship program that makes available apprentices in the visual arts, theater, writing, music, dance, and media. In the visual arts, apprentices are available in painting, sculpture, photography, crafts, all areas of design and commercial art, and architecture.

The *National Directory of Arts Internships* lists the names of artists throughout the United States who use apprentices. Each listing describes eligibility requirements, applications procedures, and a description of what the position entails. On the Internet, the Web sites Artist Resource.org and Artjob.org list internships.

For additional information about apprenticeship programs see the appendix section "Apprenticeships and Internships."

Materials for the Arts Programs

You can save money on materials, supplies, and equipment by participating in materials for the arts programs that are sponsored by municipal government agencies. The Materials for the Arts program in New York City provides artists who work with a registered New York City cultural organization with free office equipment and supplies, furnishings, art materials, and other items. The Materials for the Arts program sponsored by the Black Hawk County Solid Waste Management Commission in Waterloo, Iowa, donates goods, supplies, and equipment to individual artists. For information about these and other programs, see the appendix section "Materials for the Arts Programs."

Presentation Tools and Packages

The first chapter of this book, "Launching or Relaunching Your Career: Overcoming Career Blocks," covers some of the difficulties artists encounter in career development, including the cause and effect of the public's fear of visual art. It points out that many people *in the art world* are also intimidated by visual art, although they are unlikely to admit it. Consequently, presentation materials such as résumés (see below), press clippings or excerpts (see page 50), artist statements (see page 51), and cover letters (see page 53) are important props because they help insecure people determine that it is okay to like your work!

This chapter will present guidelines for preparing presentation materials and suggestions for maximizing their effectiveness.

An Artist's Résumé

The specific purpose of an artist's résumé is to impress gallery dealers, curators, collectors, grant agencies, juries, and anyone else in a position to give an artist's career upward mobility. However, since an artist's résumé has purposes other than seeking employment, it requires its own special structure.

A résumé should reflect your achievements in the arts field. It should not be a thesis about what you hope to achieve or an explanation of the meaning of your work. Keep résumés pure—free of narratives that justify or describe your work's inner meanings.

Keep in mind that the *intrinsic purpose of a fine-arts résumé* is to impress people with your credentials. Therefore, if your achievements amount to more than can be listed on one sheet of paper, use another sheet or several sheets. *Who said that our lives have to be limited to one page?* One-page résumés were created for the purpose of obtaining employment, giving a potential employer an overview of one's employment history prior to a personal interview. However, obtaining employment is not the purpose of a fine-arts résumé.

On the other hand, if you have substantial achievements, consider a résumé as a tool that highlights your accomplishments and eliminates minor credits. Use such phrases as *exhibition highlights* or *selected exhibitions, selected collections,* and *selected bibliography* to convey that this is only a sampling.

If you use the format of exhibition highlights or selected exhibitions, make sure that you keep for your own use a complete résumé that lists *all of your accomplishments.* This documentation is important to a curator, for example, who is preparing a catalog to accompany a retrospective exhibition.

If you are applying for a teaching job in the art field, a fine-arts résumé should accompany your teaching résumé.

The following are suggestions for structuring a résumé and the order in which categories should be listed:

NAME, ADDRESS, AND PHONE NUMBER.

PLACE OF BIRTH. Your place of birth can be a good icebreaker. You might share a regional or local background with the reader.

BIRTH YEAR. Some artists object to putting their birth year on a résumé in fear of the stigma of being considered too old or too young. If a person is negatively influenced by your age, it is a strong indication that his or her judgment is poor, and you wouldn't want to be associated with that person under any circumstances.

EXHIBITIONS/PERFORMANCES. List the most recent exhibitions/performances first. Include the year, exhibition/performance title, name of the sponsor (gallery, museum, or organization), city, and state. In addition, list the name of the curator and whether it was an invitational or a juried show. (If you won an award, mention it in the "Awards and Honors" category described below.)

If you have had three or more one-person shows, make a special category for "Solo Shows" and begin the "Exhibitions/Performances" section of the résumé with this category. Make another category for "Group Exhibitions." If you have had fewer than four one-person shows, include the shows under the general heading "Exhibitions/ Performances," but code the one-person shows with an asterisk (*) so they stand out, and note the code on the résumé. For example:

EXHIBITIONS. (*Solo Shows)

2002 *Objects and Images*, Alternative Space Museum, New York City. Curated by Charlie Critic. Invitational.

*Smith Wheeler Gallery, Chicago, Illinois.

Spring Annual, Hogan Gallery, Detroit, Michigan. Juried by Peggy Panelist and Joe Jurist.

COMMISSIONS. List projects or works for which you have been commissioned, including the name of the project or medium, the sponsor (institution, company, or person), and the date.

COLLECTIONS. List the names of institutions that have purchased your work, as well as corporations and well-known collectors. If you haven't been "collected" by any of the above, omit the category (unless you need to pad the résumé with the names of relatives and friends).

BIBLIOGRAPHY. List all publications in which you have been mentioned or reviewed and any articles that you have written related to art. Include the name of the author, article title, name of the publication, and publication date. If you have been published in an exhibition catalog, include the name of the exhibition and the sponsor. If something was written about you in the catalog, credit the author.

AWARDS AND HONORS. Include grants or fellowships you have received. List any prizes or awards you have won in exhibitions or competitions. Include artist-in-residence programs or any other programs that involved a selection process. If you won an award that was associated with an exhibition, repeat the same information that was listed in the "Exhibitions/ Performances" category, but begin with the award. For example:

First Prize, *Spring Annual*, Hogan Gallery, Detroit, Michigan. Juried by Peggy Panelist and Joe Jurist, 2002.

LECTURES/PUBLIC-SPEAKING ENGAGEMENTS. Use this category to list any lectures you have given and/or radio and television appearances.

EDUCATION. This should be the *last* category. Many artists make the mistake of listing it first. This suggests that the biggest accomplishment in your life was your formal education!

The following is a sample résumé:

Terry Turner
15 West Main Street
Yourtown, U.S.A. 12000
500-832-4647
Born: Washington, D.C., 1969

*Selected Exhibitions (*Solo Shows)*

2002 WINTER INVITATIONAL, Whitehurst Museum, Whitehurst, Illinois. Curated by Midge Allen.

OBJECTS AND IMAGES, Alternative Space Museum, New York City. Curated by Charlie Critic. Invitational.

*Smith Wheeler Gallery, Chicago, Illinois.

SPRING ANNUAL, Hogan Gallery, Detroit, Michigan. Juried by Peggy Panelist and Joe Jurist.

2001 ILLUSIONS, Piper College, Lakeside, Pennsylvania. Curated by Abraham Collins.

2000 *Pfeiffer Gallery, Düsseldorf, Germany.

*Limerick Gallery, San Francisco, California.

TEN SCULPTORS, Kirkwood Park, Denver, Colorado. Sponsored by the Denver Arts Council. Invitational.

1999 PITTSBURGH BIENNIAL, Pittsburgh Cultural Center, Pittsburgh, Pennsylvania. Curated by Mary Clark and Henry North.

HANNAH, WRIGHT, AND TURNER, Covington Gallery, Houston, Texas.

1998 THE DRAWING SHOW, traveling exhibition organized by the Southwestern Arts Center, Tempe, Arizona: Seattle Museum, Seattle,

Washington; Minneapolis Museum, Minneapolis, Minnesota; Virginia Museum, Richmond, Virginia; and Miami Museum, Miami, Florida.

Commissions

Plymouth Airport, Plymouth, Massachusetts. Sponsored by the Plymouth Chamber of Commerce, 2002.

Bevington Department Store, New York City. Sponsored by the Bevington Corporation, 2002.

Hopewell Plaza, Chicago, Illinois. Sponsored by the Downtown Citizens' Committee in conjunction with the Chicago Arts Council. 2001.

Public Collections

Whitehurst Museum, Whitehurst, Illinois.
Pittsburgh Cultural Center, Pittsburgh, Pennsylvania.

Corporate Collections

Marsh and Webster Corporation, New York City.
Avery Food Corporation, New York City.

Bibliography (*Reviews)

*Bradley Mead, "Terry Turner Opens at Smith Wheeler Gallery," *Chicago Artist News*, February 2002.

*John Short, "Emerging Artists Featured at Whitehurst Museum," *Whitehurst Daily News*, January 16, 2002.

Nancy Long, "Winter Invitational at Whitehurst Museum," *Museum Quarterly*, Winter 2002.

Midge Allen, *Winter Invitational Catalog*, Whitehurst Museum, Whitehurst, Illinois, 2002.

Beth Ryan, "Ten Sculptors Show at Kirkwood Park," *Sculptor's Monthly*, June 2000.

Mary Clark and Henry North, *Pittsburgh Biennial Catalog*, Pittsburgh Cultural Center, Pittsburgh, Pennsylvania, 1999.

Awards and Honors

First Prize. Spring Annual, Hogan Gallery, Detroit, Michigan. Juried by Peggy Panelist and Joe Jurist, 2002.

Fellowship. Denver Arts Council, Denver, Colorado, 2001.

Fellowship. Minerva Hills Artist Colony, Minerva Hills, Montana, 2001.

Second Prize. International Sculptor's Competition, Essex, Ontario, Canada, 2000.

Project Grant, Pittsburgh Cultural Center, Pittsburgh, Pennsylvania. Juried, 1999.

Lectures/Public-Speaking Engagements

Lecture, Pratt Institute, Brooklyn, New York, 2002.

Lecture, Art Department, University of Colorado, Boulder, Colorado, 2001.

Interview, "Culture Hour," WRST TV, Detroit, Michigan, 2000.

Lecture, Covington Gallery, Houston, Texas, 1999.

Interview, "The Drawing Show Artists," WXYZ Radio, Tempe, Arizona, 1998.

Education

Art Department, Ross College, Huntington, Iowa, B.F.A., 1991.

Thin Résumés

Few of us can begin careers with heavyweight résumés full of fancy exhibition/performance credits and citing articles and reviews in leading publications. But the anxiety of having a thin résumé should not prevent you from putting a résumé together. I like the reaction of a painter whom I was assisting with a résumé. She studied the various category headings and replied: "How exciting. I can't fill in all of these categories, but look at all of the things I can look forward to."

While it is not advisable to pad résumés with insignificant facts and data, a few things can be done to fill up a page so that a résumé does

not look bare. For example, double-space between each entry and triple-space between categories. Use "Collections" to list the names of any well-known people or institutions who have your work, even if they did not purchase it. Include student shows in the "Exhibitions/ Performances" category and use "Awards and Honors" to list any scholarships or teaching assistantships you have received in graduate or undergraduate school. If you have teaching experience in the arts, list this experience in a new category, "Career-Related Experience" or "Teaching Experience."

Less Than Thin Résumés

Over the years I have had many clients who had no formal art training, and/or when they first came to me they had no exhibition history nor had they sold any work. In other words, when they were in the beginning stages of marketing their work, none of the suggested categories in a fine-arts résumé would have been applicable.

In such cases I always recommend dealing with the dragon head on! Abandon the use of a formal résumé and prepare a narrative entitled "Background Information" that states that you are self-taught. The narrative should combine a biographical statement (see page 50) and an artist statement (see page 51).

This format was used by one of my clients, a self-taught artist who began painting at the age of forty. His "background information" narrative contained three short paragraphs, or a total of sixty words. It stated that he had no formal training; it mentioned where and when he was born; and it included a few sentences about his work.

Once he began a focused effort to gain exposure, his lack of academic and art-world credentials was of no consequence. As a result of his first group show, he received an enthusiastic review from an art critic in *The New York Times*. By the end of the second year he had a one-person show in an alternative space in New York City; and by the third year he had a two-person show in a New Jersey museum.

Updating Résumés

The following advice might sound silly, but artists are often negligent about résumés: a career changes and accomplishments occur; update your résumé. If you have been invited to participate in an exhibition/event in the future, add a new category to the résumé,

"Forthcoming Exhibitions." If an article is planned in the future, add a new category, "Forthcoming Articles."

A résumé should be word-processed on a computer. Once the information is stored, it can be updated in a matter of minutes.

Excerpts from Publications

If you have received good reviews, excerpt the most flattering quotes on a separate sheet of paper and attach it to your résumé. Credit the author, article, and publication, and give the date. If you have not been reviewed in a periodical but an exhibition catalog contains prose about your work, include the relevant quotes on a separate sheet of paper, credit the author, and give the exhibition title, sponsor, and date. Although many artists present an entire article, unless the key phrases about you are *underlined* or *highlighted*, chances are the article will not be read.

Biographies

A biography is a synopsis, written in prose, of your career accomplishments. It highlights various credits listed on your résumé. In certain instances, a bio is used in lieu of a résumé, such as for a handout at exhibitions and to accompany a press release (see page 82). (The narrative style makes it easy for a writer to include biographical information.) A biography can also be used to accompany a résumé when you are submitting slides to dealers, curators, and corporate art consultants and advisors. Following is an example of a biography, based on the sample résumé on pages 46–48.

Terry Turner's paintings have been exhibited in solo and group exhibitions in galleries and museums throughout the United States and abroad, including the Whitehurst Museum in Whitehurst, Illinois; the Smith Wheeler Gallery in Chicago; the Limerick Gallery in San Francisco; and the Pfeiffer Gallery in Düsseldorf, Germany.

In addition, her work is in public and corporate collections, including those of the Pittsburgh Cultural Center and the Avery Food Corporation in New York City.

Ms. Turner is the recipient of numerous awards and honors. She received fellowships from the Denver Arts Council and the Minerva Hills Artist Colony in Minerva Hills, Montana.

> Terry Turner was born in Washington, D.C., in 1969. She re-
> ceived a B.F.A. from Ross College in Huntington, Iowa.

Like a résumé, a biography should not be a thesis that explains the meaning of your work. Save such explanations for an artist statement.

Artist Statements

Many artists assume, somewhat naively, that everyone is automatically going to "get" or comprehend their work on the exact level on which they intend it to be perceived. Although an artist statement can be an effective tool in helping insecure people better understand your work, one does not have to be insecure about visual art to appreciate the aid of an artist statement.

But translating visual concepts into clear prose is an exercise that often meets with much resistance. For several years, I have conducted workshops on a variety of career-related subjects, including developing artist statements. Many workshop participants anticipate preparing an artist statement as eagerly as they might a tooth extraction. And I often find the task of getting artists to describe their own work in a meaningful and interesting way not unlike pulling teeth!

As a warm-up exercise, participants are asked to describe the work of an artist whom they admire. For the most part, passionate adjectives and poetic phrases flow with unrestrained ease. But after the warm-up, when artists are asked to describe their *own* work, dry abstractions and clichés fill the page.

Although artists vehemently criticize the overintellectualized style of writing used in leading art magazines, many believe that their work will not be taken seriously unless they *imitate what they despise.*

An artist statement can be used as a tool to help dealers, art consultants, and advisors sell your work, and as background information in helping writers, critics, and curators prepare articles, reviews, and exhibition catalogs. In addition, an artist statement can be incorporated into a cover letter (see page 53) and into grant applications (see chapter 8).

An artist statement can focus on one or more topics, such as symbols and metaphors, materials and techniques, or themes or issues underlying or influencing your work.

Avoid using weak phrases that reflect insecurities, confusion, or doubt, such as "I am attempting," "I hope," or "I am trying." The statement should be coherent, direct, and energetic. Here are some examples:

My paintings grow out of a sudden perception of the striking beauty I see in a scene or subject. I am moved less by a subject's physical reality than its underlying nature and surrounding environment—such as moods, seasons, weather, light, and time. My paintings express the emotional impact of these perceptions intertwined with my attitudes, beliefs, and history. *Michael Molly*

I create photographs of assemblages constructed from pieces of ordinary paper. Twisting, tearing, and crumbling paper into various shapes, I produce visual imagery that forms intriguing illusions and relationships between my objects when light, shadow, and forms merge. At first glance, a photograph might appear as an exotic flower, but on taking a closer look viewers will see the familiar scalloping and rippling of a paper plate. *Leonard Morris*

When a piano is beyond repair I rescue it from the trash. I detach the parts from their original role in this instrument of sound and combine them into another reality. The forms have organic and sometimes creaturely characteristics. In this series, "Piano Revival," I am influenced by my father who began a twenty-two-year career as a piano technician at the age of seventy. *Bea Mitchell*

My processing of creating monotypes reflects the energy present in the gestural movements I see in landscapes, gardens, rock coasts, and churning seas. While conveying the essence of a scene, details are left to the viewer's imagination. Flowing color impressions are interspersed with fleeting bursts of pigment that dance around the image, capturing the beauty and drama of nature. *Margaret Weissbach*

My portraits are another way of telling stories of people, about their optimism or introspection, their innocence or wisdom, their grace and complexity. They also speak about me—and how I read the world and the people in it. More than just a likeness, they are my interpretation of a unique individual using the language of sculpture. *William Hanson*

The inner space of common materials holds great mystery, drama, and beauty. Using an optical polarizing microscope with a built-in camera, I photograph the interior life of familiar objects and elements. Crystals, minerals, concrete, chemicals, plastics, vitamins, ceramics, metals, alloys, and biological and pharmaceutical materials, for example, are rich sources of exploration and discovery. I record and capture the natural designs, inherent colors, symmetry, and the intricately composed internal structures lying deep within these minute and unchartered worlds. *Arnold Kolb, Midland, Michigan*

*C*OVER LETTERS

The use of a cover letter is more than a courtesy; it can provide a context to help people view your work. Some people need the context of art-world validation, such as the information provided in a résumé (see page 43). Some people are not concerned with glitz but want to know what your work is all about. Others need a combination of glitz and substance. An effective letter can cover all grounds.

It should include the following:

(1) *An introductory paragraph* stating who you are and the purpose of the letter. For example:
I am an artist and am writing to acquaint you with my work. Enclosed is a brochure [card, photographs, slides, etc.] featuring examples of recent paintings.

(2) *A brag paragraph* that plucks from your résumé a few credentials. For example:
I have had solo exhibitions at the Wallace Gallery in Chicago, and my paintings have been included in group exhibitions at the Contemporary Art Museum in Fairfield, Arizona, and the Ridgemont Museum in Spokane, Washington. In addition, my work is in public and corporate collections, including those of the Whitehurst Museum in Whitehurst, Illinois, and the Marsh and Webster Corporation in New York City.

Or:

My photographs have been exhibited at museums and galleries, including the Alternative Space Museum in New York City; the

Hogan Gallery in Detroit; and the Covington Gallery in Houston. In addition, my work is in various public and corporate collections, including those of the Whitehurst Museum in Whitehurst, Illinois, and the Marsh and Webster Corporation in New York City.

(3) *A short artist statement.* For example:

My portraits are another way of telling stories of people, about their optimism or introspection, their innocence or wisdom, their grace and complexity. They also speak about me—and how I read the world and the people in it. More than just a likeness, they are my interpretation of a unique individual using the language of sculpture.[1]

(4) *A concluding paragraph.* For example:

If you find my work of interest, I would be pleased to send additional visual materials and background information.

Or:

If you find my work of interest I would be pleased to arrange a studio visit in the near future.

If applicable, include a paragraph listing the reasons you are contacting a particular gallery or curator. For example:

"I have visited your gallery on several occasions and believe my work shares an affinity with the work of the artists featured."

Or:

"I have visited your Web site and believe my work shares an affinity with the work of the artists featured."

Or:

"I attended the exhibition *Modern Dreams* and, judging by the selection of artists featured in the show, I thought that you would be interested in my work."

Depending on your career stage, it might not be possible to include a brag paragraph, reviews, or essays, but an artist statement can be integrated into the letter regardless of whether you have been working as an artist for ten months or ten years.

Writing a cover letter and including any one or all of the elements outlined above is no guarantee that you will get what you want. However, with a well-written cover letter you have a better chance of making an impression and setting yourself apart from the hundreds of artists who send packages to dealers, curators, collectors, and exhi-

bition sponsors with form letters, insipid letters, or no cover letters at all.

\mathcal{V}ISUAL PRESENTATIONS

Since few dealers and curators will view original work at a first meeting, most artists have been stuck with the slide package system. This system was designed for the convenience of dealers and curators. It is certainly not in the best interest of artists.

It is also an absurd method of presentation. With few exceptions, your slides are examined without the aid of a slide projector, light box, or hand viewer, and while glancing at a group of tiny images the person viewing your slides makes a decision in about fifteen seconds on whether your work is of interest.

Thus, after completing a work, you must create an artificial viewing situation that will present the work advantageously in a slide or photograph. Unless the work happens to *be* a photograph, this is not the way it was intended to be viewed or experienced. (The idiocy of the slide system is further heightened when photographers are requested to present slides of their prints!)

Often, because of the importance placed on good photographs, an artist is guided and influenced during the creation process by how well the work will photograph!

The section "Rethinking Presentation Packages" (see page 57) suggests some other ways of presenting visual materials. But if you are unable to change immediately to a new presentation form, following are some pointers on how the slide system can work best for you.

Slides and Photographs

"Artists are being rejected who would be accepted into many galleries with more representative slides. They are shooting poor slides because they haven't taken the time to find out how to do it right. They haven't learned that it is as easy to shoot good slides as it is to shoot bad ones," points out artist Nat Bukar, the author of the informative book *How to Photograph Paintings*.[2]

When artists photograph their own artwork, there are some advantages, namely, saving money, documenting work on your own schedule, and not relying on another person's vision of how the work

should appear in photographic form. However, only photograph your work yourself if you can really do it justice. *How to Photograph Paintings* and other books that present guidelines and tips for photographing artwork are listed in the appendix section "Photographing Artwork."

If you are unable to take professional-quality slides and photographs, use a photographer experienced in *art* photography. Decide before the shooting how you want the work to look in a photograph and what features you want emphasized. If the final result falls short of your expectations, reshoot, and, if necessary, continue to reshoot until you have what you want. If your work contains details that get lost when the piece is photographed as a whole, shoot separate photographs of the details you want emphasized or clarified.

Since you are going through the time and expense of a photography session, shoot in color and in black and white. Color slides and prints can be used immediately (for dealers, curators, grant applications, slide registries, and other presentations). Black-and-whites, as well as color prints, can be used later for public relations and press packages (see page 89 for requirements).

Since slides and photographs are lures to get dealers and curators to see your work in person, if they are unimpressed with the work as it appears in photographs, it is unlikely that they will get to your studio. However, for photographic purposes, do not glamorize a piece of work with special effects that misrepresent what the viewer will actually see in person. Ultimately, the deception will catch up with you.

When preparing slide presentations to dealers and curators, artists tend to submit many more slides than are necessary, and without discrimination. If you have never had your work photographed, shoot all of the work, but reserve the older work for personal documentation and future use. Dealers and curators are interested in your current direction and do not want to see a slide retrospective in the initial presentation. It is also important that you *show slides of only one medium*. If you paint and draw, show slides of your paintings or drawings, but not both. This advice sounds strange, and it is, but dealers, curators, and jurists want consistency. Keeping art media separate is part of their definition of consistency! However, you can work around this illogical rule by showing one dealer slides of paintings and another dealer slides of drawings.

What you show to whom depends on the particular dealer or cura-

tor. If you are living in an area where there are relatively few galleries, art centers, or museums, it is relatively easy to ascertain who is interested in what. But in order to implement an effective marketing program it is necessary to expand your efforts beyond your home city or town. The section "Rethinking Presentation Packages," below, explains how this outreach is possible.

One of the biggest problems with slides is that many people do not really know how to read them. Therefore, a viewer should be spoonfed. All slides and photographs should be labeled with the dimensions of the work, the medium, the title (if any), your name, a copyright notice, and the year the work was created. Notations should be made on the frame or margin to indicate the direction in which the slides or photographs should be viewed. It is intimidating for a viewer to have to hem and haw over the right way to view work. The viewer's embarrassment can create a negative atmosphere, meaning that your work is not being viewed under the best circumstances, and this can lead to a negative response.

The number of slides that you submit will depend on the circumstances in which you are submitting slides. This information is discussed in "Rethinking Presentation Packages" and in chapter 8, "The Mysterious World of Grants: Fact and Fiction."

An excellent source for duplicating slides is Citizens Photo in Portland, Oregon. It produces high-quality and cost-effective duplicates. For a small additional charge, labeling information and viewing notations are imprinted directly on the slides. The address of Citizens Photo is listed in the appendix section "Photographing Artwork."

RETHINKING PRESENTATION PACKAGES

A few years ago I began keeping track of the number of presentation packages my clients annually sent to galleries, art consultants, and curators. I learned that generally it takes *fifty* exposures of the *same body of work* to generate *one* positive response.

This means that on the average, fifty people must see slides, photographs, or other visual representations of the same work in order for an artist to receive an invitation to exhibit or spur interest in establishing a consignment relationship, sale, or commission opportunity. Although artists have sent fewer than fifty packages and received

good feedback (in one case three packages led to the sale of three paintings), such experiences are by far the exception rather than the rule.

The *good news* is that the number of packages most artists send—between twelve and fifteen a year—does not even begin to approach an effective market penetration level that justifies any sense of defeat or rejection if the response is unfavorable.

The *bad news* is that preparing fifty packages that contain traditional presentation materials, including slides, a résumé, an artist statement, press clippings, a cover letter, and a self-addressed stamped envelope, can be unwieldy, costly, and time-consuming.

Artists spend an average of $12 to $25 on a typical presentation. The high cost factor coupled with much wasted time (waiting for packages to be returned by uninterested parties or tracing lost material) makes it apparent that *there has to be a better way*!

The following section discusses some of the *better ways*, including the use of brochures, digital technologies, the Internet, and videotapes. When considering visual alternatives to traditional slide packages, be prepared for negative criticism from peers as well as others in the art world who suffer from petty jealousies or a lack of understanding of basic marketing principles. Many artists, as well as dealers, are afraid of making a move outside of the archaic and illogical rules of art-world etiquette. But there are also many people in the art world who are looking for fresh, imaginative, and effective ways to find new audiences.

Brochures

One of my first clients to publish a brochure did so in conjunction with an open-studio event (see page 139). She had considered using a brochure for a long time, but was troubled by its negative connotations—unfortunately, some people sneer at brochures as a marketing tool, another one of those groundless taboos that have crept into art-world protocol.

One thousand brochures were printed, one third of which were used to accompany an invitation to her open studio. The brochures were sent to New York area galleries, private dealers, art consultants, curators, friends, and people who had previously expressed interest in or purchased her work. In the months following the open studio she sent brochures to galleries, private dealers, art consultants, and curators nationwide. With each brochure she sent a cover letter in which

she offered to send a set of slides if the recipient found her work of interest.

I asked the artist to keep track of the response generated from the brochure for a twelve-month period. Here are the results:

- Brochures were sent to 329 art consultants, private dealers, and galleries. She received 48 responses.
- Out of 48 responses, 12 people requested slides; 7 people retained the slides for future consideration.
- The artist developed consignment relationships with two galleries in California and one gallery each in New Jersey, Connecticut, and Alabama.
- She was invited to have a one-person exhibition at an alternative space in New York City.
- Two paintings were sold at the open-studio event, another painting through the art dealer in New Jersey, and another piece at the one-person show.
- In addition, several copies of the brochure were sent to dealers and art consultants with whom she had previously worked, resulting in the sale of two additional paintings and a corporate commission.

Translating the results into dollars and cents, in one year the artist quadrupled her income from the sale of artwork as a result of using a brochure.

The cost of the brochure, including printing, layout, and design for one thousand copies and envelopes, was $2,392. The artist spent another $533 for the design and printing of a letterhead for cover letters, making the total cost of the project $2,925. The brochures were sent via first-class mail, which, at the time of the mailing, came to a postage rate of fifty-two cents each. Thus, the final cost of each package was $3.44.

If the artist had continued to use traditional slide packages, which cost her $25 each, she would have spent $8,225!

Various factors will determine the cost of a brochure, including the number of color images, the paper stock, the size and shape, and the print run. Another consideration is where the printer is located. (Generally printers located in cities where real estate is expensive tend to charge higher prices because of their high overhead.) Although the

artist cited in the above example spent $2,392 for one thousand copies of a 7½-by-9-inch brochure and one thousand envelopes, it is very possible to produce a well-designed brochure for considerably less money.

In addition to drastic cost savings, there are other important benefits of using a brochure rather than a slide package:

- Compared with a slide package, which generally pulls a 2 percent response rate, the response rate of a brochure is generally between 6 and 14 percent.
- A brochure allows work to be reproduced in a larger format. The visual impact is much more effective than the tiny image of a slide.
- The use of a brochure also resolves the problem of having to wait for materials to be returned for recirculation. Often several months pass before material is returned, creating false hope that you have won someone's interest, when in reality the package is accumulating dust, the victim of a forgetful or disorganized dealer.
- Brochures are easier to handle and quicker to assemble, though each brochure must be accompanied by a cover letter (see page 53). It is likely that you will follow up on more leads or contacts and send out more large mailings when your time involvement is minimized.
- Brochures can also serve as sales tools for dealers and consultants.

It has now been well over fourteen years since my clients began using brochures (see page 58) and postcards (see page 63) to make initial contacts with dealers, curators, corporations, potential collectors, and the press. Through a process of trial and error and tracking the results, I offer the following pointers:

A small, basic brochure is as *effective* as one that is large in format and has been lavishly designed. A basic brochure can have one or two folds and, for example, be in a size range of 5 by 7 inches or 6 by 9 inches. It can contain one to three four-color visual images, a short biographical narrative (see page 50), and an artist statement (see page 51). It should also include the artist's name, address, and phone number (and fax number and e-mail and Web site addresses). As an option, it can also include a photograph of the artist and excerpts from reviews (see page 50).

The use of a short biographical text in lieu of a résumé is a good way to avoid the use of dates (which ultimately can *date* the brochure), and more information can be packed into a prose format. A biographical narrative is also a helpful tool for those artists who are at the beginning stages of their career and have a relatively small amount of career-related credits.

Some artists are under the false impression that a brochure needs the validation of an art critic. In fact, some artists have actually resorted to paying critics to write an essay for their brochures. If the notion were true that it is imperative for a brochure to contain a critical essay, this would imply that a brochure lacking an essay is ineffective. *This is most definitely not the case!*

Shannon Wilkinson, president of the New York–based Cultural Communications Corporation, a public-relations firm that publicizes and promotes clients, exhibitions, and special projects in the fine arts, points out that some of the critics who are commissioned to write essays for artists are "becoming highly overexposed."[3] The negative consequence of this overexposure is that dealers and curators are able to recognize quickly those artists who are participating in the distasteful syndrome of paying for a review, otherwise known as "vanity press."

Ill-advised artists are spending large amounts of money to secure the seal of approval from critics, and, as Wilkinson also points out, some critics and career consultants "are making substantial profits from artist-commissioned essays . . . and will have far easier retirements because of artists."[4]

Keep in mind that the recipient of the brochure is most interested in *visual information*, and in most instances long essays are distractions and they go unread.

Brochures must be accompanied by a cover letter (see page 53). Without a cover letter the brochure can easily be misconstrued as an exhibition announcement that requires no response.

When you receive a request for a slide package as a result of using a brochure, include with the slide package and self-addressed stamped envelope another copy of the brochure and a short letter reminding the person that he or she requested slides. Resubmitting the brochure a second time is necessary because often there is an incongruity between the image portrayed in a slide as compared to an enlarged version in the printed format. The viewer might not recognize that it is the same piece of artwork.

Select visual images that will translate well in a printed format. If you are inexperienced in having your work reproduced, a good printer will be able to advise you of the suitability of the image or images you have selected and the likelihood of technical problems.

If you are planning a brochure with more than one visual image, all of the visual images should be from the *same body of work*, and the work should reflect your most current direction.

Avoid "kiss of death" phrases or information that can sabotage your efforts. Such "no-no's" can include, for example, mentioning that you are *currently* taking art courses, or comparing your work to other artists'. And if you are involved in a dual career that has no bearing on the work you are doing as a fine artist, do not refer to your other occupation.

Order a *minimum* of two thousand brochures. To maximize the effectiveness of a brochure it is necessary to *keep the momentum going* and send out brochures on a continuing basis. Do not get discouraged if you do not receive an instant response. As previously mentioned, brochures bring in a higher response rate than a slide package, but responses can sometimes be immediate or come in dribs and drabs over a long period of time.

For many artists, career advancements and art sales can be attributed to the use of a brochure. For example, a painter who had been employed as a legal secretary for many years gave her brochure to the law firm's partners. Although the partners knew that she was an artist, interest in her work was spurred when they saw her work "in print." One partner purchased three paintings.

As a result of a brochure, another painter received invitations for eight solo and group exhibitions at galleries throughout the United States during a twelve-month period.

For another painter, the brochure helped a collector make a decision in the artist's favor. Trying to decide between the work of two artists, the collector asked the dealer if she had any written information available on the artists. When the dealer presented the collector with my client's brochure, he was thoroughly impressed and made a quick decision in favor of the artist with the brochure.

Slide Packages

If you are not ready to publish a postcard or brochure to make *initial* contacts with dealers, curators, and potential collectors, limit the number of slides that you send to three. Your package should also include a

résumé (see page 43), an artist statement (see page 51), and a cover letter (see page 53). In the cover letter, offer to send additional slides if the recipient finds your work of interest. Depending on the price of the slides, it may or may not be cost-effective to enclose a self-addressed stamped envelope.

Postcards

Many artists have successfully generated interest in their work by using a single-image, 3-by-5-inch postcard. If you want to feature more than one image in an initial presentation, an oversized postcard can be used. For example, a 4-by-9-inch card provides sufficient space for two or three images on one side and room to provide background information on the reverse side. A 4-by-9-inch format fits perfectly into a number-ten envelope. As in the case of a brochure, *postcards must be accompanied by a cover letter* (see page 53).

Web Sites

In another ten years the use of slides as a standard presentation medium will probably be considered archaic. Many artists have already embraced digital technology, integrating the use of digital cameras, scanners, laser printers, CD-ROMs, and Web sites to present bodies of work. However, this first decade of the twenty-first century is a transitional period. Many gallery dealers, art consultants, curators, collectors, art-organization personnel, and artists are not yet computer savvy. Until slide packages are deemed a relic of the twentieth century, *artists need to offer a flexible range of presentation materials*.

Once a relationship with galleries and art consultants has been established, your Web site can be used to feature new work that is available for consignment and exhibition. Several of my clients are using their Web sites for this purpose. It is very effective and has reduced the use of follow-up slide packages.

What a visitor sees on your site when they arrive is very important. Some artists have had a tendency to overdesign the site with various high-tech gizmos that shower viewers with visual and auditory distractions. Keep in mind that you are inviting visitors to view your site for the *primary* purpose of seeing your artwork. Make it easy for them to visit, and needless to say, make sure that the images of your artwork are top-notch. The artwork should be labeled with the title, dimensions, and medium or media.

The visual presentation should be very focused. In selecting images for your Web site, follow the same guidelines as those suggested for preparing slide presentations (see page 55). The artwork should be consistent in terms of style and medium. Don't overwhelm viewers with a retrospective of your own art history. Your site can (and should) be updated, replacing older images with new work.

If you are involved with more than one medium, as is the case for many artists, unless the mediums are thematically related, you are taking a chance presenting different bodies of work on the same Web site, the risk being that you could be subjecting yourself to accusations of being a dilettante, or having work that is unfocused or "all over the place."

If your work is in more than one medium and is not thematically related, a practical way around this challenge is to have more than one Web site.

If you are hiring a designer to create your site, work with one who specializes in Web site design for artists. Work with a designer who encourages your participation so that you are comfortable articulating ideas, concepts, and atmospheric feeling that you want your site to convey. It is a good idea to interview several designers before you take the plunge to ensure that your personalities are compatible and that you are not working with a dictator. Web site designers advertise in various arts-related publications and on the Internet. When you come across an artist's Web site that is particularly attractive, contact the artist to inquire about the designer's name if the designer is not identified on the site.

For tips and advice on Web site design, refer to the *Arts Wire Web Manual* published by the New York Foundation for the Arts and *The Photographer's Internet Handbook* by Joe Farace, published by Allworth Press. In addition, the e-book *Selling Art on the Internet* by Marques Vickers includes information on Web site design. Also, the Web site Open Studio: The Arts Online, sponsored by the Benton Foundation and the National Endowment for the Arts, is a national network that provides training, resources, and leadership to help artists and arts organizations use the Internet. For information about these and other contacts, see the section "Web Site Design" in the appendix.

In addition to visual images, basic Web site text should include an artist statement (see page 51) and a biography (see page 50) or a résumé (see page 43). If you are providing prices of artwork on the site, it is preferable to devote a Web page to a retail price list (see page 73)

instead of placing prices on the same page as the artwork. Prices next to the artwork can be a distraction. Avoid designing a site that has the look of a mail-order catalog, with many images grouped together and prices underneath.

There are many ways of marketing work on the Internet with or without your own Web site. Some of the specific vehicles and resources for learning more about the ins and outs of Internet marketing are described in chapter 6, "Exhibition and Sales Opportunities: Using Those That Exist and Creating Your Own" (see pages 142–145).

Other Digital Technologies

Art consultants (see page 122) frequently use a CD-ROM to feature the work of artists because their clients and potential clients are corporations that have the equipment to support this type of presentation. Although a CD-ROM is an effective presentation tool, at the present time its use is limited because many gallery dealers, art consultants, curators, collectors, arts-organization personnel, and artists are not yet computer savvy.

For the purpose of presenting artwork to members of the art world who have not yet entered the Computer Age, laser prints of excellent quality can be generated from your computer. If the prints are generated from your computer, as opposed to a printshop, they will be very cost-effective, after an initial investment in a good printer and scanner (and a digital camera if you plan to photograph your own work). Because of the rapid advances in technology, if you are considering the purchase of digital equipment, check with publications, such as *Art Calendar* and *studioNOTES*, that provide tips and advice on using digital technology for suggestions and recommendations. Information about these publications can be found in the appendix section "Career Management, Business, and Marketing." In addition, the book *Re-Engineering the Photo Studio: Bringing Your Studio into the Digital Age* by Joe Farace includes suggestions for buying or upgrading a computer for digital imaging, tips for purchasing a digital camera, and other helpful information (see appendix section "Presentation Tools").

Videotapes

Using the medium of video to present work is another effective alternative to slides and photographs. It is particularly advantageous to

sculptors and other artists who have difficulty showing work in still photographs or slides.

Dick Termes, who paints on spheres, is an artist who had difficulties presenting his work through slides. He resolved the problem by using videotapes, and eventually developed three separate presentations. The shortest tape is seven minutes long and includes an overview of his work, background music, and a narration by the artist, who also appears on camera. The tape also features shots of Termes's home and studio, a geodesic dome he built himself in rural South Dakota. He offers a longer tape to those interested in seeing detail shots of the paintings. A third presentation was developed for the purpose of introducing his work to museums and university galleries.

As a result of the video presentations, Termes was invited to exhibit in museums and university galleries throughout the United States and in Japan. He has sold work to museums and corporations, and various public art programs have commissioned him to do projects.

Generally, it costs $1,000 per minute to produce a videotape, but Termes was able to keep costs at a minimum by recycling leftover footage from television programs in which his work had been featured. In addition to production studio rental costs and editing expenses, each videotape copy cost him $2 plus postage. His package also contains a résumé, a cover letter, and a brochure.

Dick Termes points out that the biggest advantage of using video presentations is that "you can control what the viewer is seeing, including details that might ordinarily be missed in a photograph, and to a certain extent create a mood in which the work is being viewed, through the use of background music."[5]

If you are considering the use of videotape to present your work outside the United States, keep in mind that the videotape must be compatible with foreign systems. For example, if you are contacting galleries and museums in Europe, it is necessary to convert a video formatted for use in the United States to the PAL system (except in France, which uses the SECAM system). Although most countries have facilities to do the conversion, generally it is more economical if you do the conversion in the United States. And, needless to say, it would not make a good impression if you sent a museum or gallery an unsolicited videotape that had to be converted before being screened.

In recent years I have seen videotapes produced by art consultants that show a range of work by artists they represent. No doubt, in the

near future, dealers will use videotapes to feature the work of gallery artists. Video presentations, CD-ROMs, and Web sites will make it possible for dealers to represent more artists without actually keeping artwork on the premises, thus resolving the issue of limited space and reducing insurance costs.

STREAMLINING PAPERWORK

This chapter and the previous chapter, "Launching or Relaunching Your Career: Entering the Marketplace," outline various tasks, tools, and homework assignments for career development. One of the surest ways to set yourself up for defeat is to become overwhelmed by administrative work.

In the book *Conquering the Paper Pile-Up: How to Sort, Organize, File, and Store Every Piece of Paper in Your Home and Office*, author Stephanie Culp describes a situation that is shared by many artists:

> They say we are living in the Information Age, and indeed, there does seem to be a staggering amount of information to be gleaned from every imaginable source. . . . This abundance of information has given rise to the phrase "information anxiety. ". . . As the paper arrives, the information-anxious folks adjust their level of anxiety upward several notches with every few inches of papers that get added to the existing piles of papers with information yet to be absorbed. The overworked and understaffed small business watches the papers multiply at a frenzied rate.[6]

You can avoid a state of inundation if you aim to accomplish one goal or task at a time, if you do not attempt to do everything simultaneously, and if you learn to streamline paperwork. This is possible if you use a computer, or hire someone to use a computer for you.

Computers can drastically reduce paperwork and repetitive chores. Résumés, cover letters, mailing lists, and artist statements can be stored on a computer and updated in a matter of minutes. A computer can be used to store a variety of information and perform many services, from storing inventories and price lists to creating invoices and contracts. In addition, most word processing programs are capable of creating slide labels.

Special software programs are also available that are tailored to the needs of artists. For example, WorkingArtist: The Artist's Business Tool is a Windows program that was created to help artists manage the business side of art. It catalogs artwork, creates consignment invoices, mailing lists, price lists, price grids, and slide labels, and provides other services. MangoArts is another software system designed for artists who want to streamline and use technology to help with career management. The Art & Craft Organizer is a software program for PC users that tracks inventory records, business expenses, sales tax, and sales. It also includes a database for establishing a mailing list. Artstacks offers various software packages, including ArtStacks for Photographers and ArtStacks for Artists.

The use of business forms, specially designed for artists, is another good time-saving tool. Attorney and publisher Tad Crawford has produced a large series of business and legal forms for artists with many ready-to-use forms for varied circumstances. These include *Business and Legal Forms for Crafts, Business and Legal Forms for Fine Artists, Business and Legal Forms for Illustrators,* and *Business and Legal Forms for Photographers.*The most recent editions of each book include a CD-ROM.

And, yes, artists can have secretaries! Once a system is developed for disseminating presentation materials and reaching various markets (see chapters 3, 5, and 6), an assistant can take over. A workable system does not require full-time energy. This is something that can be accomplished in a few hours a week.

For additional information about publications, computer software programs, and the other organizational aids cited above, see the appendix section "Organizing Paperwork."

Pricing Your Work:
How Much Is It Worth?

Within the same week, two artists called me for appointments. Marsha was in her forties and had a successful career as a real estate agent, but planned to leave her job to paint full-time. She arranged to have a one-day weekend exhibition at a suburban library located outside of New York. In one afternoon she sold $18,000 worth of work. The highest-priced painting sold for $6,000. Prior to the library show, she had never had an exhibition or sold work.

Katherine was also in her forties, but had worked full-time as an artist for more than twenty years. She had exhibited in many well-known museums and was represented by galleries on the East and West Coasts. She had received fellowships from the National Endowment for the Arts and grants from state agencies and private foundations. Her work had been reviewed in leading American and international arts magazines. Katherine's paintings ranged in price from $5,000 to $7,500.

Why is an artist new to the art world and without art-world recognition able to sell work in the same price range as an established artist whose six-page résumé is filled with impressive credentials?

Marsha brought to her new career the philosophy and concerns she had learned in the business world. She recognized the value of her time and valued her talent. Her goal was clear: to derive a decent income from doing what she liked doing best. It was inconsequential whether her work found a home on the walls of a museum or over a living-room couch. Unlike Katherine, she was naive about the criteria

used by the art world in pricing work. In this case, ignorance was definitely bliss!

Fear-based thinking is responsible for the difficulties artists have in establishing prices for their work. Establishing prices for artwork in which you compensate yourself fairly has everything to do with self-confidence and a willingness to defend your prices and take some risks.

In the book *Creating a Life Worth Living*, author Carol Lloyd asks readers to "consider for a moment the positive aspects of doing work you love and value in return for fair compensation. Money, when coupled with genuine interest, can give you permission to do something well. In fact, it often *demands* that you do."[1] Lloyd also points out:

> The transition from being a wage slave (making money from things you don't like to do) to a self-employed creative person (making money from things you love to do) is the most difficult transition for many people to make. Exiled from the small, protected space of a conventional job, it's often hard to comprehend the expansiveness of the new terrain. Just as chemicals in the brain block perception to prevent sensory overload, you may unknowingly avoid the idea of earning a living from your creative work as a way of defending yourself against the vertigo of possibilities.[2]

CONFLICTING AGENDAS AND CONFLICTING ADVICE

Setting a price on a work can be a grueling task. Many artists tend to undervalue their work, with the belief that their careers haven't measured up to the criteria necessary to justify charging higher prices or a fear that, by setting prices that compensate them fairly, their work will not sell. Unfortunately, these myths are reinforced by some artist career advisors and the advice contained in artist career management books. But when artists set low prices on their artwork, it is a public declaration of their insecurities and lack of confidence.

The tendency of advising artists to sell work at low prices is also reinforced by dealers and art consultants whose pricing agendas are rarely in an artist's best interest.

A primary concern of many dealers is to move work quickly, and, unfortunately, low prices are correlated with making a fast buck. The pricing policies of the majority of dealers basically reflect the amount of money *they think* their constituencies will spend on art.

Few dealers understand that they could sell more work, and at higher prices, if they took the time to help the public understand an artist's vision and the multilayered process and rigorous discipline involved in creating visual art—from conceptualization to actualization.

Most dealers establish a price range based on the hearsay of other dealers or fall into the trap of believing the myth that the work of unknown artists has little value. Reluctant to move out of established parameters, few dealers will admit that they are vying for a particular price market. They camouflage the "fast buck" philosophy and adherence to a pricing system based on the status quo by using various gimmicks aimed at undermining an artist's work and/or career. For example, an artist is told that his or her résumé does not have the "right" credentials to justify selling work at a higher price. Or the work is attacked on the basis of size, materials, or subject matter. One of the typical ploys used to weaken an artist's self-confidence is an accusation that the work is derivative.

More often than not, artists heed a dealer's self-serving pricing advice, erroneously believing that dealers know best.

PRAGMATIC PRICING, MARKET VALUES, AND SELF-CONFIDENCE

Setting a price on artwork necessitates homework. You need to consider and integrate three factors: *pragmatic pricing*, understanding how much it is really costing you to create a work of art; *market value* considerations; and *confidence* in the price you set. Self-confidence is of paramount importance if you hope to get what you want and negotiate with strength.

You can achieve pragmatic pricing by maintaining careful records and keeping tabs on the amount of time you spend creating work, from conceptualization through development to completion. Pragmatic pricing must also include the cost of overhead and materials, prorated accordingly.

For example, if work-related costs, such as studio rental, utilities, professional fees, transportation, dues and publications, postage, documentation, and materials, total $10,000 per year, and you create an average of fifteen pieces of work each year, the overhead expense per work is approximately $667.

After calculating an overhead cost per piece, assign an hourly or weekly value to your time. For example, if one piece required twenty hours and you want to be paid $25 an hour, assign a labor charge of $500. Total the overhead cost and labor cost. In the examples cited above, the total of the overhead and labor costs is $1,167.

Be sure that the price set for your work includes a 100 percent reimbursement of labor, overhead, and material expenses *in addition to* any obligatory sales commission. In other words, a commission should not be paid on labor, overhead, and materials. For example, if labor, overhead, and materials total $1,167, and the work is sold at $2,000 *without a dealer*, your profit is $833. However, if the work is sold for $2,000 through a dealer who charges a 50 percent commission, you are losing $167.

In many instances, after determining the costs of time, overhead, and materials and comparing the proceeds of a sale, artists discover they are working for less than a dollar an hour!

Set a price that builds in a sales commission and profit margin, regardless of whether you sell with a dealer. The amount of profit is a personal decision.

If fabrication costs (for example, foundry fees) are high, these costs must be deducted *before* a dealer's commission is calculated (see page 74). This "understanding" should not be left to an oral agreement. It must be stated in a contract (see page 32).

You can determine a seemingly elusive market value by visiting many galleries, finding work that is allied to your own, looking at prices and the artists' résumés, and comparing their career levels to your own. But keep in mind that other artists' price ranges should serve only as guidelines, not as gospel, because many artists make the mistake of letting dealers determine the value of their work.

Knowing the amount of labor, materials, and overhead spent on creating work and becoming familiar with market values can help you build confidence for establishing prices. But, of course, the process of gaining self-confidence is quickly accelerated when work is sold at the price you want.

On several occasions I have assisted artists in negotiating prices with dealers. In one case, although a dealer thought the artist was overcharging, the artist would not budge from her position. The dealer passed, only to return to the artist's studio six months later with a client who paid the original asking price.

Another situation involved a better-known artist who had consistently sold a minimum of 75 percent of his work in previous one-person shows. A new show was planned and he wanted to double his prices. However, the dealer was afraid the artist was pricing himself out of the market. A compromise was reached: the artist doubled the prices of the pieces that were near and dear to his heart and increased the prices on the other works by 50 percent. He sold work in *both* price ranges.

I also advise artists to set a value a few hundred dollars over the price they actually want. This way there is bargaining leverage and dealers believe they are participating in pricing decisions.

No MORE REGIONAL PRICING

Artists sometimes wonder if they should charge certain prices in large cities but lower the prices if the work is shown in the boondocks. The answer is an emphatic no. Regional pricing is insulting. It penalizes your market in large cities and patronizes your market elsewhere. It also supports elitist notions that people in small cities or rural areas are incapable of valuing art.

The chances are, if you are an artist in a rural area or small city and are affiliated with a local gallery, you have been persuaded to price work at what the dealer thinks the local market will bear. If you also connect with a gallery in Chicago, for example, make sure the prices in the local gallery are in accord with what the dealer in Chicago is charging. Prices must be universally consistent, whether your work is sold in Vienna, Virginia, or Vienna, Austria.

Developing PRICE LISTS

When assembling a price list, *always* state the retail price, and make sure the word *retail* appears on the price sheet. The danger in stating a

"wholesale price" or "artist's price" is that it gives dealers carte blanche to price your work in any way they see fit. The "wholesale price" is construed as an artist's bottom line, and many dealers feel justified in selling work for as much as several hundred percent above the wholesale price and pocketing the difference. Recently a gallery in New York known for requiring artists to state their wholesale prices sold a sculpture for $25,000. The artist received $2,500! The transaction was completely legitimate because the artist stated in writing a wholesale price of $2,500.

Another problem with wholesale pricing is that it prevents artists from establishing a *real* market value. For example, if you are using wholesale prices and have relationships with more than one gallery or art consultant, it is highly conceivable that your work will sell for vastly different prices in different cities or within the same city.

When establishing a retail price, assume a dealer will take a 50 percent commission. Do not adjust the retail price if a dealer's commission is lower. Do not work with dealers who require a commission higher than 50 percent.

A price list should state the name of the artwork, medium, size, and retail price. A dealer's commission is generally based on a percentage of the retail price. However, in some instances it is imperative that large overhead expenses are separated out on the price list so that an art dealer or consultant is not paid a commission on your overhead.

For example, some forms of sculpture involve expensive foundry fees. One pricing solution is to set a retail price on a piece by multiplying the foundry costs by three, with the gallery receiving one-third. Gallery dealers who are experienced in selling sculpture have no problem accepting this formula. Dealers and consultants who are not experienced create problems when they insist on receiving a commission based on 40–50 percent of the retail price.

For photographers, laboratory processing fees can be high. Dealers knowledgeable about photography take these high overhead fees into consideration and accept a commission based on the retail price of a print less overhead. But more often one encounters dealers who balk at this proposal. For example, a photographer submitted a detailed price list that separated out his overhead costs for various-sized color prints. He outlined the consultant's commission after the overhead costs were deducted from the retail price. When she saw that her 50 percent commission was not based on the retail price, she threw a

tantrum. After she cooled down, the artist explained that his lab fee on 72-by-96-inch color print was $1,000. The retail price of the photograph was $6,000. If he agreed to give her 50 percent of the retail price, she would receive $3,000, the lab would receive $1,000, and he would receive $2,000. The consultant finally understood the logic of why a traditional commission based on the retail price would not be equitable.

For artwork that has a high overhead, a special type of price list is required. In such instances, a suggested price-list format follows:

Artist's Name
Retail Price List and Commission Policy
Medium: Color Photographs

Title	Size	Lab Fees	Base Price*	Retail Price
Untitled 1	40"×60"	$350	$1,950	$2,300
Untitled 2	48"×60"	$400	$2,300	$2,700
Untitled 3	72"×96"	$1,000	$5,000	$6,000
Untitled 4	72"×180"	$1,800	$8,400	$10,200

*Commissions are paid on base price.

A price list can also state your discount policy. Guidelines for developing a discount policy are described in the following section.

DEVELOPING A DISCOUNT POLICY

Shortly after beginning a consignment relationship with a gallery, an artist named Steven was informed by the dealer that a client was interested in buying one of his paintings. The client had previously purchased work from the gallery, and the dealer offered a 20 percent discount, which she asked Steven to split.

New to the gallery world, Steven was unfamiliar with discounts, an issue that had not been addressed in a consignment agreement issued by the gallery. Steven was confused and talked to a friend with more gallery experience. The friend confirmed that artist/gallery discount splits are usual occurrences.

Steven complied with the dealer's request. The painting was sold

and he received a check equaling 40 percent of the retail price—the dealer had deducted a 50 percent commission and another 10 percent that represented Steven's share of the discount.

Many artists split discounts without analyzing what discounts actually symbolize or represent. For a gallery, the main purpose of giving discounts to a collector is to reward loyalty and patronage, and to create an incentive for the collector to remain a client. As a token of gratitude, awarding a discount is a public-relations gesture. But is it logical or ethical for artists to be required to share or absorb public-relations expenses of a gallery, and if so, under what circumstances?

Steven was a new gallery artist, and the discount he allowed was a public-relations token that directly rewarded the collector's *previous* patronage of the gallery and of *other* gallery artists. How would Steven have responded if he had been required to contribute 10 percent of the painting's sale price toward exhibition announcements for other gallery artists, or toward a generic brochure tooting the horn of the gallery?

If the 50 percent commission charged by most dealers can in any way be justified, this hefty amount provides a very adequate cushion that enables dealers to offer clients discounts without infringing on an artist's profit. It also provides enough flexibility for dealers to split commissions with art consultants and interior designers.

The time to discuss discount splitting is *before* beginning a gallery relationship. This means *before* any work enters the gallery for exhibition and/or consignment and *before* an agreement has been signed. If a dealer insists on splitting all discounts, you have the option of not working with the gallery or suggesting a compromise of splitting discounts only if (1) the client has previously purchased *your* work and/or (2) the client is simultaneously purchasing more than one piece of *your* work. If a dealer is in agreement with this arrangement, it *must* be stated in writing.

Some dealers have been known to deduct a discount from an artist's share of a sale when in actuality a discount has not been given. This situation can be prevented if an artist requires a copy of a *bill of sale* or *invoice* or uses an *artist sales contract*. An artist sales contract is a contract between an artist and a collector that not only covers important copyright issues but also states the purchase price of the artwork. Examples of a bill of sale, an invoice, and an artist sales contract can be found in *The Artists' Survival Manual* by Toby Judith Klayman, with

Cobbett Steinberg. The forms are also included in the following books by Tad Crawford and are available as tearout sheets and on a CD-ROM: *Business and Legal Forms for Crafts, Business and Legal Forms for Fine Artists, Business and Legal Forms for Illustrators,* and *Business and Legal Forms for Photographers.* These resources are listed in the appendix section under "Law: Contracts and Business Forms."

Of course, an unscrupulous dealer overpowered by greed can always find ways of deceiving both artists and clients even when a sales contract or bill of sale has been used. Once the deed is discovered, however, it is much easier to go to court with a good contract in hand than with a handshake or spoken understanding.

Gallery discount policies vary as much as commission policies. A survey of ninety-five commercial galleries in Chicago indicated that 46 percent of the galleries split discounts with artists, 22 percent of the galleries fully absorbed discounts, 2 percent of the galleries required artists to fully absorb discounts, and 30 percent of the galleries either did not address the discount issue or offered miscellaneous comments.[3]

The survey also revealed that galleries that fully absorbed discounts tended to charge artists less of a commission. For example, of the galleries that required splitting discounts, 2 percent charged commissions higher than 50 percent; 73 percent charged commissions of 50 percent; 11 percent charged commissions ranging from 25 to 40 percent; and 14 percent charged varied commissions, but the range was not indicated. Of the galleries that fully absorbed discounts, none charged commissions over 50 percent; 43 percent charged commissions of 50 percent; 33 percent charged commissions ranging from 25 to 45 percent; and 24 percent charged varied commissions, but the range was not indicated. Galleries that required artists to fully absorb discounts charged commissions of 50 percent.

Discounts on Studio Sales

Awarding discounts on studio sales is another issue about which there is much confusion. Over the years a strange protocol has developed according to which artists are *expected* to offer clients a 50 percent discount on work sold from their studios. It is one of those chicken-or-egg situations: which came first, artists volunteering a 50 percent discount or clients demanding a 50 percent discount because the artwork was not being sold in a gallery or through an agent? Regardless of how this precedent started, it should be abolished with haste.

When a studio sale is imminent, it is easy for an artist, seduced by the excitement of the moment, to abandon powers of logic and reason and succumb to some rather unreasonable requests concerning the terms of a sale, such as granting a large discount. To avoid being caught off guard, vulnerable, or tongue-tied, always keep a price list on hand that states *retail* prices and your *discount policy*. For example, your policy could be the same as that offered to dealers: 10 percent if more than one piece of work is simultaneously purchased, and 10 percent for clients who have previously purchased work.

There are other options, such as offering different discounts to collectors who have previously purchased work and to collectors who are simultaneously purchasing more than one piece. Or you can give discounts based on a sliding scale according to the retail value, say, 10 percent for work priced up to $2,000 and 15 percent thereafter. Or you can have a policy of offering no discounts under any circumstances!

A discount range of 10 to 15 percent provides the flexibility needed to negotiate with clients who insist on a larger discount. Whether or not you acquiesce is a personal decision, but studio discounts should not exceed 25 percent.

Clients who expect a 50 percent discount on studio sales and balk at a lower rate need to be reminded that artists have overhead expenses just like all other businesspeople—and just like art dealers. Consequently, granting discounts of 50 percent is unrealistic and impracticable.

Unfortunately, within the art world, guidelines regarding discounts do not exist. Much of the time, dealers' policies are based on hearsay or greed, and artists' policies are manifestations of confusion and feelings of powerlessness. But although the results of the Chicago survey[4] illustrated that most galleries require artists to split discounts, some dealers are fair and seem to understand a discount's intrinsic meaning. At least this is a beginning, a beginning that could quickly become a norm if more artists refuse to split discounts, or at least specify the circumstances under which they will agree to this practice.

Set the same high standards for pricing work as you do for creating the work. Do not be afraid to negotiate. The extent to which you compromise is a personal decision and greatly depends on the status of your ego and bank account, and how well you are able to exercise powers of logic.

Odds and Ends

Questions regarding pricing also arise when artists are presented with opportunities to have photographs of their work used in periodicals, annual reports, books, posters, calendars, and other print media. *Pricing Photography: The Complete Guide to Assignment & Stock Prices* by Michal Heron and David MacTavish is an excellent resource for establishing prices for a multitude of situations. Although it is geared for photographers, art directors, and graphic designers, the book can be very helpful to fine artists for establishing prices and fees for various circumstances when a photograph of their artwork is used for commercial purposes.

Closely aligned to the subject of pricing are commissions paid to dealers for the sale of work. This topic is discussed in chapter 7, "Dealing with Dealers and Psyching Them Out." Resources for additional information about pricing can be found in the appendix section "Pricing Artwork."

Public Relations: Keep Those Cards and Letters Coming In and Going Out

In the early 1980s, choreographer and artist Laura Foreman and composer John Watts distributed a poster throughout New York City announcing an upcoming collaboration called *Wallwork*. The poster included the dates, place, and times of the performances, as well as a phone number for reservations. However, if you called the number you were informed that there were no seats available and no new names were being added to the waiting list.

The fact was that *Wallwork*, as a dance and music performance, *did not exist*. However, *Wallwork* did exist as a conceptual performance: "a performance which completely emancipated itself from the performance medium. What you see—the poster, the sign, the image, the expectation, the media fantasy—is what you get."[1]

Wallwork could have quietly taken place, its purpose and existence known only to the artists who conceived it. But in order for *Wallwork* to achieve optimum effectiveness, its message had to reach a large audience. So, as posters were being distributed, Foreman and Watts sent out a special news release to members of the press, defining *Wallwork* and its purpose:

> WALLWORK aborts the audience's expectations and critiques the medium of performance while using it; . . . creates a found audience of thousands of people—all those who pass by the posters become participants in the (conceptual) creation of the performance.

WALLWORK asks questions such as these: Is art what the artist says it is? Is it publicity or is it "art"? Is art beckoning you into a vacuum? What is the nature of performance? Do the fantasies of artists feed the expectations of an audience? Who is the audience? Why do people most desire that which they can't have? How does an artist "perform"? After a performance, is there anything left? Can an artist create a performance of the mind?[2]

Although it was not the intention of the artists to use *Wallwork* as a self-promotion vehicle, publicity was a key part of the performance and a key to making it a success. Several newspapers in New York covered the story, including *The New York Times*. Critic Jack Anderson wrote:

The final paradox of a paradoxical situation is that *Wallwork*, a non-existent dance, is more interesting than many dances that do exist. It stimulates thought. It conjures up ideas. And one does not have to sit through it in an airless studio on a hot night. One can think about it at leisure. *Wallwork*, though something of a hoax, has its own strange validity.[3]

Many artists are offended by self-promotion because they believe it taints their work and self-image. Others are offended by some forms of publicity but accept other forms that they consider in good taste. Still others are averse to publicity only because they are not receiving it. And some artists are offended by self-generated publicity but do not question publicity generated by an art gallery, museum, or organization on their behalf. Often, in such cases, an artist does not believe that the gallery, museum, or organization is doing enough.

Writer Daniel Grant gives two perspectives on the publicity issue:

Publicity has become a staple in the art world, affecting how artists see themselves and how dealers work. On its good side, this publicity has attracted increasing numbers of people to museums and galleries to see what all of the hullabaloo is about and, consequently, expanded the market for works of art. More artists are able to live off their work and be socially accepted for what they are and do.

On the other hand, it has made the appreciation of art a bit shallower by seeming to equate financial success with artistic

importance. At times, publicity becomes the art itself, with the public knowing that it should appreciate some work because "it's famous," rather than because it's good, distorting the entire experience of art.[4]

The questions that Grant raises about what constitutes art appreciation and good art and what distorts the art experience have been asked for hundreds of years, many years before the great media explosion came into being. They are questions that will continue to be debated and discussed, within the context of publicity and without. In the meantime, this chapter will discuss basic public-relations tools and vehicles for developing an ongoing public-relations program for your career.

Public appearances, demonstrations, and lectures are vehicles that offer excellent exposure and can also provide income. They are discussed in chapter 9, "Generating Income: Alternatives to Driving a Cab."

THE PRESS RELEASE

A press release should be written and used to announce and describe anything newsworthy. The problem, however, is that many artists are too humble or too absorbed with aesthetic problems or the bumps of daily living to recognize what about themselves is newsworthy, or they view the media as an inaccessible planet that grants visas only to famous artists.

A press release should be issued when you receive a prize, honor, award, grant, or fellowship. It should be issued if you sell your work to an important local, regional, national, or international collector. Use a press release to announce an exhibition, regardless of whether it is a single show in a church basement or a retrospective at the Whitney Museum or a group exhibition where you are one of two or one of one hundred participants. A press release should be issued to announce a slide and lecture show, demonstration, performance, or event. It should also be issued to announce a commission.

In addition, a press release should be issued after you have lectured, performed, demonstrated, exhibited, or completed the commission.

Some publications are primarily interested in advance information, but others are interested in the fact that something took place—what happened; what was seen, said, and heard; and who reacted.

A press release should also be issued if you have a new idea. New ideas are a dime a dozen, particularly if you keep them to yourself. What might seem humdrum to you could be fascinating to an editor, a journalist, a host of a radio or television interview program, or a filmmaker looking for a subject. Personality profiles also make their way into the news.

Internal Press Releases

A press release has many uses. It *does not have to be published to generate a response*. In some instances, distributing a press release to friends, acquaintances, collectors and potential collectors, gallery dealers, art consultants, and curators is more appropriate than sending it to the press. I refer to this type of press release as an *internal* press release. Events that might warrant the publication of an internal press release include the announcement of an award or honor, a public or corporate commission, acceptance as an artist-in-residence or at an art colony, and sale of work to a public or corporate collection.

Although the press might not consider any of these events newsworthy, an internal press release can be of interest to others. For example, an internal press release can lead to an invitation from a curator to participate in an upcoming theme show, or it can generate a response from an art consultant interested in commissioning you for a project. This internal use of a press release can bring tangible and intangible rewards by reminding people that you exist and that your career is moving forward.

Why Bother?

Press releases can lead to articles about you. Articles can help make your name a household word, or at least provide greater recognition. Articles can lead to sales and commissions. Articles can lead to invitations to participate in exhibitions or performances, and to speaking engagements. Articles can help you to obtain fellowships, grants, honors, and awards.

Keep in mind that recipients of a press release should not be limited to national art trade publications. Certain consumer publications and

television programs should also be included in your mailing list. This point is well taken by Shannon Wilkinson, a public-relations specialist in the arts:

> There is an entirely new generation of art consumer in the U.S., and its members do not read art magazines or critical reviews. The birth of the blockbuster exhibition in the 1970s educated an entirely new audience of art consumers. These baby boomers, who were entering college when the visual arts were thrust into the popular media through blockbusters, and corporate support of the arts, are now approaching their 40s. They are the largest segment of new home buyers in America. They are making money. They read popular consumer magazines. And, they watch television. Artists need to think beyond the traditional art media for coverage, increased visibility, and sales. Besides, television, popular four-color magazines, and high-circulation daily newspapers throughout the country have more general arts coverage—artists' profiles, features, and soft stories—than ever before.[5]

Resources for obtaining arts press and consumer press mailing lists are included in the appendix sections "Mailing Lists" and "Press Relations and Publicity." In addition, you can use a press release distribution service. For example, eReleases delivers press releases to general and targeted media contacts by e-mail; Gebbie Press links to thousands of newspapers, magazines, and radio and television stations that are on the Internet; Pressbox and PRWeb post press releases free of charge on the Internet; and iMediafax faxes press releases to editors and producers nationwide. Contact information about these services are included in the appendix section "Press Relations and Publicity."

Press releases that I wrote and distributed concerning some of my own projects generated an interview on *Bloomberg Radio News* and led to articles in the *New York Times*, the *Washington Post, Life, House and Garden, Playboy, Metropolis, New York* magazine, the *Crafts Report*, and the *Village Voice*, and syndicated articles in more than one hundred newspapers throughout the United States (via the Associated Press and United Press International). In Europe, my press releases generated articles in the *International Herald Tribune, Paris Match, Der Spiegel, Casabella*, and *Domus*. These articles then generated invitations to ex-

hibit at museums and cultural centers throughout the United States and in Europe. In addition, some articles led directly to commissions and sales.

An excellent way of keeping track of whether your press release was reprinted, or whether you were mentioned or featured in publications, is to use a clipping service. For a reasonable fee, a clipping service will monitor specific geographic regions and send you copies of articles that mention your name. The names of clipping services can be found in the Yellow Pages under "Clipping Bureaus" and on the Internet.

Dos and Don'ts

A press release should tell the facts but not sound like Sergeant Friday's police report. It should whet the appetite of the reader, inspire a critic to visit the show, inspire an editor to assign a writer to the story, inspire a writer to initiate an article, inspire television and radio stations to provide coverage and interviews, and get dealers, curators, collectors, influential people, and the general public to see the exhibition or event.

The fact that an exhibition or event is taking place is not necessarily newsworthy. What the viewer will see and who is exhibiting can be. A press release should contain a *handle*, a two-sentence summary that puts the story in the right perspective. A handle does not necessarily have to have an aesthetic or intellectual theme. It can be political, ethnic, scientific, technological, historical, humorous, and so on. Editors and writers are often lazy or unimaginative about developing handles. Give them some help.

Although a reporter might not want to write an article exclusively about you or your show, your handle might trigger a general article in which you are mentioned.

Press releases have an amazing longevity. Writers tend to keep subject files for future story ideas. Although your release could be filed away when it is received, it could be stored in a subject file for future use. My releases have resulted in articles or mentions in books as much as six years after they were issued!

If writing is not your forte, do not write a press release. Get someone to do it who is good with words, understands the concept of handles, likes your work, and finds the experience of writing in your behalf enjoyable. *You serve as editor.* Too often artists are so excited about a press

release that they relinquish control of its content and let a description pass that understates or misinterprets their intentions. On its own, the press has a field day in this area. It does not need any encouragement.

Many artists believe that they do not have anything to say. Use a press release to articulate your thoughts about your work and motivations (see "Artist Statements," page 51). Learning to do so is particularly useful for preparing grant applications and for face-to-face encounters with people who are in a position to advance your career. It is also a good way to prepare for interviews.

A press release should be written in an appropriate journalistic style so that it can be published verbatim. In fact, many press releases that meet professional standards are published word-for-word in newspapers and magazines. "Meeting professional standards" means that your press release is grammatically correct and contains no spelling or typographical errors. It should be free of critical content or boastful prose about your work. Although it is completely acceptable to include a quote or quotes from critics and art world personalities that praise your talents, this type of information should appear *in quotation marks* along with the name of the quoted source. It should also be free of flat sentences that are empty in content such as the popular phrase that all too often appears at the very beginning of some press releases: "The Ajax Gallery is pleased to present the work of John Doe." And as a courtesy to editors, a press release should be double-spaced so that, if necessary, it can be easily edited.

Do not use a press release to exercise your closet ego or show off your academic vocabulary. Who wants to read a press release with a dictionary in hand? Avoid using art criticism jargon and long sentences that take readers on a wild-goose chase. Writing over the heads of readers is guaranteed to breed intimidation. This kind of release ends up being filed under "confusion"—in the wastebasket. Here is an example:

> The . . . exhibition presents the work of six differently motivated artists. . . . They each arrive at their own identity through an approach based on the dynamic integration inherent in the act of synthesis, synthesis being the binding factor which deals comprehensively with all the other elements involved in the creative process, leading ideally to an intuitively orchestrated wholeness which informs both the vision and the process.[6]

What to Include

The headline of the release should capture the handle and announce the show, award, commission, or event.

The average arts-related press release that I receive is destined for the wastebasket because it loses my attention in the first paragraph. For example: "A group exhibition featuring the work of sixteen abstract artists opens at Highgate Gallery on June 1, 2001. The exhibition features paintings, drawings, and sculpture." Although this opening paragraph provides basic information, it does not spur interest in attending the show, except perhaps for the sixteen artists' parents, relatives, and friends.

The first paragraph should contain the handle; use strong sentences that capture reader interest. For example:

> Imagine dirigibles hovering over the World Trade Center or a NASA space shuttle parked on your block. These events would never happen in real life unless, of course, they were a project of an ambitious sculptor. Even then, the construction would be very daring if not too costly; however, The Rotunda Gallery's new show, "Sculptors' Drawings," provides sculptors with the opportunity to indulge such fantasies.[7]

> In 1979, during performances, New York artist Francine Fels began sketching Alvin Ailey's dance "Revelations." "It had such an ongoing magical effect that I wanted to hold the moment forever, to make the experience constantly alive and give its impact permanency," said the 65-year-old artist. Six years later, Fels completed fifty paintings based on hundreds of her sketches.[8]

> Ever wonder what to do with that old wedding dress that's taking up so much room in the closet? Maybe the dress could enjoy a second honeymoon, so to speak, recyled into art. Artists in this show use a previously worn white bridal gown and let their imaginations run wild to create everything from straitjackets to braided welcome mats.[9]

The lead or second paragraph should also contain information known in journalism as the "five Ws": who, what, when, where, why, and sometimes how.

Subsequent paragraphs should back up the first paragraph. They should contain quotes from the artist and, when possible, from critics, writers, curators, and others. Let them toot your horn; it is more effective.

A short biography should also be included (see "Biographies," page 50). The biography should highlight important credits such as collections, prizes, awards, fellowships, exhibitions, and other significant accomplishments. In addition, it can mention where you were born and/or where you went to school.

Letterhead

When possible, a press release should be issued by the sponsor of your exhibition, event, prize, award, or commission. If the sponsor routinely issues press releases, provide the sponsor with resource materials including an artist statement (see page 51), a biography (see page 50), a résumé (see page 43), and, if available, press excerpts about your work (see page 50). If the press release focuses on an upcoming exhibition, provide a description of the work that will be included in the show. If the press release focuses on a commission, provide a description of the project. Ask the sponsor to provide you with a draft of the press release before it is issued.

However, if the sponsor does not issue press releases, request permission to use its letterhead with an understanding that the sponsor can approve the final copy. The release should include, as a courtesy, a paragraph about the sponsoring organization or gallery—for example, a historical sketch and a description of its activities or purpose.

If the sponsor does not have a qualified person to handle public relations, provide your name and home telephone number and identify yourself as the press contact. To determine whether the sponsor's public-relations representative is qualified, use the following criteria: the person is willing to cooperate and is not threatened by your aggressive pursuit of good press coverage; you have a good rapport with the person; and he or she *really* understands your work.

If you are unable to use the sponsor's letterhead, issue a press release using your own stationery, and identify yourself as the press contact.

Press Kits

In many ways a press kit is similar to presentation packages that are described in chapter 3 (beginning on page 43). It is a package of material that is usually enclosed in a sturdy folder with pockets. It includes, for example, a biography; a glossy 5-by-7-inch or 8-by-10-inch photograph of the artist with caption and photo credit; a glossy 5-by-7-inch or 8-by-10-inch black-and-white and/or color photograph(s) of your work with captions and photo credits; if available, a brochure (see page 58); copies of articles by you or about you; copies of reviews that you have received; a quote sheet with press excerpts; and a business card.

A press kit is a flexible tool that can be adapted for many purposes. For example, it can be used to publicize an exhibition, performance, or commissioned project. It can also be used to publicize a lecture series or workshop (see page 203). If a press kit is being used to publicize a particular event, it should include a press release (see page 82) devoted to that event. The press release can also be used to help generate a feature article about you and your work.

A press kit is not intended to be sent to everyone on your mailing list. For example, the press list that I make available to artists (see appendix section "Press Relations and Publicity") contains more than 360 names of national and regional art and consumer publications and television and radio contacts. Because of the focus or format limitations of the publication and broadcast media, it would not be appropriate to send everyone on the mailing list a press kit. Deciding who should receive a press kit depends on the goals you want to accomplish. It also depends on the suitability of publication or broadcast media. In most cases, a list of prime contacts can be narrowed down to twenty to twenty-five names.

If the press kit is being used to generate publicity about a particular event or if it is being used to generate interest in a feature article about you and your work, it should be accompanied by a special cover letter known as a "pitch letter" (see page 90).

Other Types of Press Packages

Most of the names on your mailing list should receive a basic promotion package that contains an exhibition announcement and a press release. Although many artists only send out an exhibition announcement,

accompanying it with a press release is very important, particularly when contacting people who are unfamiliar with your work.

The basic press package can be enhanced and customized for specific markets. For example, along with the press release and exhibition announcement, you might want to send photographs, slides, and/or a brochure (see pages 55–63) to a select group of critics and curators.

Pitch Letters

Pitch letters are easier to compose after a press release has been written because it can incorporate the "handle" (see page 85) that has been prepared for the press release. To illustrate this point, excerpts from a press release succeeded by a pitch letter follow:

<div style="text-align:center">

"CHOCOLATE THROUGHOUT THE LAND!"

FEATURING ARTIST PETER ANTON

OPENS AT THE BRUCE R. LEWIN GALLERY,

NEW YORK CITY

</div>

The United States ranks 10th in chocolate consumption with the average American consuming approximately ten pounds a year. Artist Peter Anton's passion for chocolate far exceeds the national average. Through his sculptures he pays homage to his addiction by dedicating his next one-person exhibition to "the food of the gods" at the Bruce R. Lewin Gallery in Manhattan. Entitled CHOCOLATE THROUGHOUT THE LAND! the exhibition opens on April 26, 1996.

"Chocolate is rich in taste and equally rich in history," said Anton, pointing out that the Aztec Emperor Montezuma drank 50 goblets of cocoa a day. Louis XIV discovered chocolate when he was given a wedding gift of cocoa imported from Mexico. He was so enthusiastic he created the official court position of "Chocolate Maker to the King."

"CHOCOLATE THROUGHOUT THE LAND!" will present a selection of familiar chocolate forms that are sculpturally interpreted with ceramic-like plaster material. It will include giant boxes of assorted chocolates, approximately 4' x 3' x 9". The character and properties of each boxed chocolate are portrayed in Anton's sculptures. Some of the candies are randomly pinched or bitten open to reveal various centers including creams, nuts, jellies, and caramels.[10]

The following is a pitch letter that evolved from the press release:

Dear (name of editor):
The United States ranks 10th in chocolate consumption with the average American consuming approximately ten pounds a year. My passion for chocolate far exceeds the national average. I am an artist and through my sculptures I pay homage to my addiction by dedicating my one-person exhibition at the Bruce R. Lewin Gallery in Manhattan to "the food of the gods." Entitled CHOCO-LATE THROUGHOUT THE LAND! the exhibition opens on April 26, 1996. I believe the exhibition will be of interest to your readers.

Chocolate is rich in taste and equally rich in history. For example, the Aztec Emperor Montezuma drank 50 goblets of cocoa a day. Louis XIV discovered chocolate when he was given a wedding gift of cocoa imported from Mexico. He was so enthusiastic he created the official court position of "Chocolate Maker to the King."

"CHOCOLATE THROUGHOUT THE LAND!" will present a selection of familiar chocolate forms that are sculpturally interpreted with ceramic-like plaster material. It will include giant boxes of assorted chocolates, approximately 4' x 3' x 9". The character and properties of each boxed chocolate are portrayed in my sculptures. Some of the candies are randomly pinched or bitten open to reveal various centers including creams, nuts, jellies, and caramels.

Enclosed is a press release that describes all of the work that will be featured in the exhibition, and other background materials.

I have participated in exhibitions in museums and galleries throughout the United States, including the Austin Museum of Art in Texas; the Castellani Art Museum in Niagara, New York; the Aldrich Museum of Contemporary Art in Ridgefield, Connecticut; and the Allan Stone Gallery in New York City. I have also had a one-person show at the Henri Gallery in Washington, D.C. This is my second one-person show in New York City.

Please let me know if you require additional information.

Sincerely,
Peter Anton

Keep in mind that if you are preparing a pitch letter to entice a publication or television program to do a feature story about your

work (when an exhibition, performance, or other event is not the focus), a pitch letter can be sent without an accompanying press release. However, it would be appropriate to include other support material, such as a press kit, with the pitch letter.

Additional sources of information about press releases, press kits, and pitch letters can be found in the books *Six Steps to Free Publicity* by Marcia Yudkin, *Fine Art Publicity: The Complete Guide for Galleries and Artists* by Susan Abbott and Barbara Webb, and *Presentation Power Tools for Fine Artists* by Renée Phillips. For assistance in planning publicity campaigns on the Internet, the book *Publicity on the Internet: Creating Successful Publicity Campaigns on the Internet and the Commercial Online Services* by Steve O'Keefe provides strategies for creating successful e-mail news releases. The above-mentioned books and other resources are listed in the appendix "Press Relations and Publicity."

PUBLICITY FOR UPCOMING EXHIBITIONS AND PERFORMANCES

If you are invited to exhibit or perform, do not rely or depend on the sponsoring organization to do your public relations. Create an auxiliary campaign (which might end up being the primary campaign). Try to persuade the sponsor to cooperate with your efforts. If the sponsor agrees to collaborate, volunteer and *insist* on overseeing the administration.

Doing your own public relations or taking control of the sponsor's operation is important because of the following: (1) For various illogical reasons, sponsors can be lax, disorganized, and unimaginative in the public-relations area. Many sponsors do not realize that if they develop an effective, ongoing public-relations program they not only promote their artists but also make their institution or gallery better known—both of which can offer prestige, and financial rewards in the present and future. (2) If you are in a *group* show or performance, the sponsor will probably issue a "democratic" press release, briefly mentioning each participant, but little more. Your name can get lost in the crowd. Sometimes participants are not even mentioned. (3) Sponsors' mailing lists are usually outdated and full of duplications, and very

few lists show any imagination for targeting new audiences. (4) Sponsors can be negligent in timing press releases and announcements so that they coincide with monthly, biweekly, weekly, and daily publication deadlines. Sometimes they do not take advantage of free listings, or if they do they send only one release prior to the opening of the exhibition or performance, even though the show runs for several weeks.

Designing Announcements

A few years ago Braintree Associates of New Jersey, a company that uses Jungian symbolism in fund-raising, placed a small broken-egg symbol on a direct mail solicitation to raise money for a charitable organization. As a result, the dollar amount of contributions its client received increased 414 percent. The broken egg was not mentioned in the fund-raising letter, and, according to a follow-up poll, donors claimed not to have noticed it.

Each month I receive hundreds of exhibition announcements from artists nationwide. But the vast majority of communiqués contain neither a subliminal nor a conscious message that would stimulate my interest in attending the show or inspire me to pick up the phone to request additional information.

This is not to suggest that symbols of broken eggs should be incorporated into exhibition announcements, but the results of the Braintree campaign illustrate the importance of visual information in getting a message across.

The use of exhibition announcements as an extension of an artist's creativity and very special way of looking at the world is all too often a neglected aspect of public relations. For various reasons, artists, curators, dealers, and other exhibition sponsors do not analyze the purpose of an announcement, the results it should achieve, or what it should communicate.

There is a direct correlation between announcement design and exhibition attendance. Well-executed announcements can stimulate interest in an exhibition, and the more people that are in attendance, the greater the chances are of increasing sales and commission opportunities. Creative announcements can also generate press coverage and invitations for more exhibitions.

Generic invitations, those that omit visual information and merely

list the name(s) of the artist(s), exhibition title, location, hours, and dates, are frequently used for group exhibitions to resolve the problem of selecting one piece of work to represent all of the exhibiting artists. A generic solution may also be used because some artwork is not photogenic and loses its power when reproduced in photographic form. But the most common reason generic announcements are used is to save money.

Granted, generic announcements are less expensive than four-color cards, but a successful announcement does not need to be in color or contain a photograph of actual work. For example, for an exhibition entitled *Reflections*, organized as a memorial to artist Jane Greengold's father, a square of reflective paper was attached to a card accompanied by a text describing *reflections* as a metaphor for her feelings and thoughts after her father's death.

For an exhibition entitled *Paintings at the Detective Office*, artist Janet Ziff's announcement contained a drawing of a mask to which two actual sequins were attached.

Taking a more minimal approach, for the exhibition entitled *Lost Watches*, artist Pietro Finelli's announcement contained only basic who, when, and where information, but the intriguing exhibition title and text were printed in silver ink on a thick piece of gray cardboard that was pleasurable to read and touch.

To announce the group exhibition at the Educational Testing Service in Princeton, New Jersey, entitled *Myth America: Selling the American Woman: Through Her, to Her, and Short*, artist Debora Meltz, who also served as the show's curator, designed a black-and-white announcement shaped as a reminder tag for a doorknob, with a string inserted into the hole.

In each of the above examples, without using photographs of actual exhibition artwork or costing a lot of money, the invitation did more than announce a show. Each invitation also gave the recipient a sense of the artist and was in itself an *invitation to respond to the artist's message* with intellect, humor, compassion, pleasure, or whatever emotions and sensations were evoked.

Exhibition announcements should be given tender loving care. Cutting corners might ease time and money pressures in the short run, but short-term thinking can backfire. Boring publicity tools usually bring boring results.

Advertisements

Dealers pour thousands of dollars into advertising each year. "The art magazines . . . are publicity brochures for the galleries, sort of words around the ads, and [they create] total confusion between editorial and advertising," observes writer and critic Barbara Rose. "The only way you can really get your statement, your vision, out there to the public is to put it up on the wall. And to be willing to be judged."[11] If Rose's observation is correct, and I am convinced it is, it implies that whoever is buying or exhibiting art on the basis of seeing it published in art magazines cannot differentiate between a paid advertisement and a review or article. Thus, everything that is in print becomes an endorsement.

But according to Nina Pratt, a former art-market advisor, many dealers are misguided when choosing advertisement content and design and when selecting publications where advertisements are placed. She criticizes the use of "tombstone" ads, those without visual information (what I have referred to as generic advertising), and she believes that many galleries lack an overall or specific advertising strategy and rarely employ important target marketing concepts. Dealers repeatedly place ads in the same art periodicals without analyzing whether the readership is actually the primary market or the only market a gallery wants to reach. There is an excellent potential market in non-arts-related publications. For example, a dealer who already has collectors from the business community, or wants to develop such a clientele, would find it advantageous to advertise in publications that businesspeople read, such as the *Wall Street Journal*.[12]

If you have to pay for your own advertising space to announce an *exhibition*, think twice about spending your money. (Paid advertising to announce a performance or event for which tickets or reservations are required is entirely different.) Unless you are willing and able to buy multiple ads, month after month, bombarding the public and art world with your name (just as an ad agency launches a campaign to promote Brand X), I am not convinced that paid advertising is a worthwhile investment for an *individual artist*.

In recent years an unfortunate precedent was established with galleries requiring artists to split the cost of an advertisement or pay the entire amount. In most instances galleries have a monthly contract with one or two art trade publications. Therefore, an ad *with the*

gallery's name appears month after month. The gallery benefits from the name repetition, but an artist, whose name only appears once in an ad (during the one month the exhibition is up), derives no benefit from the multiple-insertion approach.

However, if you have no qualms about participating in bribery, sometimes an ad will guarantee that your show will receive editorial coverage. Some of my clients have had firsthand experience in this area. For example, a sculptor telephoned a weekly New York paper about getting press coverage for a group exhibition. She was transferred from department to department until someone in advertising told her that if she bought a display ad there was a good possibility the show would be covered. Another client was approached by the editor of an art publication after he had written an excellent review of her work. He asked her for a payoff. Instinct told her no, and she politely turned down his request, but she had many misgivings about whether she had done the right thing.

On the other hand, if your gallery or sponsor is willing to buy advertising space in your behalf, by all means tell them to go ahead. As I previously mentioned, many galleries have annual advertising contracts with arts publications (and some publications make sure that their advertisers are regularly reviewed, a corrupt but accepted practice).

For additional thoughts and ideas about paid advertising, the sections "Advertising," "Choosing Media," and "Ad Content" in Nina Pratt's book *How to Find Art Buyers* provide excellent insights and tips (see the appendix "Career Management, Business, and Marketing").

Step by Step

The following schedule is based on a six-month time period. Not everyone has six months to plan a public-relations campaign. If you have a year, all the better. Spread the responsibilities accordingly, but don't start the two-month or three-week plan (for example), until two months or three weeks before the actual opening. If you have only a month to get your plans together, the schedule will have to be condensed, but do not eliminate the following tasks.

SIX MONTHS BEFORE OPENING

ESTABLISH A PUBLIC-RELATIONS BUDGET. Find out what the sponsor is doing about public relations so that your efforts are not duplicated. Try to

coordinate efforts. Make it clear what the sponsor is paying for and what you are paying for. Budgetary considerations should include postage, printing (press releases, press kits, photographs, duplication of mailing lists, invitations, posters, catalogs, or any other printed materials), and the cost of the opening. If you are involved in a group show, try to coordinate your efforts with other participants. If the sponsor has little money to appropriate toward public relations, take the money out of your own pocket. Don't skimp. But squeeze as many services out of the sponsor as possible (administrative, secretarial, and clerical assistance; photocopying; use of tax-exempt status for purchasing postage, materials, and supplies).

PREPARE MAILING LISTS. (See "Mailing Lists—The Usual and the Esoteric," page 24.) Study the mailing lists and decide how many press releases, invitations, posters, and catalogs you need. Information listed under "Two Months Before Opening," "Three Weeks Before Opening," and other time frames will help you ascertain who should get what.

WRITE A PRESS RELEASE. (See the section "The Press Release" earlier in this chapter.)

WRITE FREE-LISTING RELEASES. Many publications offer a free-listings section. Special releases should be written for these publications and a listings release should be sent to the attention of each publication's listings editor. Free-listings columns use very few words to announce an event. Therefore, your release should contain the basic who, what, where, and when information. Why and how can be included if you can succinctly explain them in one or two short sentences. Otherwise, the description will not be used. Several free-listings releases might be necessary. Write a release for each week the event will take place. For example, if the exhibition or performance is for four weeks, write four listings releases and date each release with the date you wish to have the free listing appear. These dates should correspond to the publication's cover-date schedule.

DETERMINE THE CONTENTS OF PRESS KITS AND PROMOTION PACKAGES. (See the sections "Press Kits" and "Other Types of Promotion Packages" earlier in this chapter.) Determine the materials to include in the press kit. Also select the names on your mailing list to which to send press kits and those to which to send promotion packages.

COMPOSE A "PITCH LETTER" AND WRITE COVER NOTES. (See the sections "Pitch Letters" and "Other Types of Press Packages" earlier in this chapter.) Compose a pitch letter for appropriate members of the press to accompany a press kit or a promotion package. Accompany the press kit and promotion package with a short note to a select group of people with whom you have been in contact. Remind them of who you are and where you met or how you know them, and tell them that you hope they can attend the exhibition.

PLAN AND DESIGN INVITATIONS, POSTERS, AND CATALOGS. (See the section "Designing Announcements" earlier in this chapter.)

SELECT PHOTOGRAPHS OF YOUR WORK. Choose photos that you want disseminated to the press (see "Slides and Photographs," page 55). Publications require glossy 8-by-10-inch or 5-by-7-inch photographs. If a publication uses both color and black-and-white photographs, send a selection of both types. Many free-listings columns and gallery guides also publish photographs, so include these publications in your photo mailing.

RESOLVE THE ISSUE OF PAID ADVERTISEMENTS. (See the section "Advertisements" earlier in this chapter.) If you are planning to buy advertising space, decide on the publication(s) and obtain all of the relevant information pertaining to closing dates for text and artwork.

PREPARE A MAILING SCHEDULE. Decide who gets what and when. You may use the following guidelines to help establish the exact mailing dates, but it is important to check with the publications to confirm their closing-date schedules.

FOUR MONTHS BEFORE OPENING

GO TO PRINT. Print photographs and press releases.

MAIL PROMOTION PACKAGES TO MONTHLY PUBLICATIONS THAT HAVE A THREE-MONTH LEAD. Send pitch letters with press kits and other promotion packages to select monthly publications so that they will be able to cover your exhibition or performance *prior to the opening and/or while the exhibition or performance is in progress.* For this type of press coverage, monthly publications usually have a deadline of three months

before the cover date, but check with each publication. (Invitations and press releases to critics and staff members of *monthly* publications that *review* work should be sent *three weeks* prior to the opening.)

THREE MONTHS BEFORE OPENING

GO TO PRINT. Print invitations, posters, catalogs, and any other printed matter that you are using.

MAIL PROMOTION PACKAGES TO MONTHLY PUBLICATIONS THAT HAVE A TWO-MONTH LEAD. Send pitch letters with press kits and other promotion packages to select monthly publications so that they will be able to cover your exhibition or performance *prior to the opening and/or while the exhibition or performance is in progress.*

ONE MONTH BEFORE OPENING

SEND PROMOTION PACKAGES TO WEEKLY PUBLICATIONS.

SEND LISTINGS RELEASES TO WEEKLY PUBLICATIONS. Also send photographs to the publications that publish photographs in their listings sections.

THREE WEEKS BEFORE OPENING

SEND PROMOTION PACKAGES TO EVERYONE ELSE ON YOUR LIST. Include critics, curators, art consultants, gallery dealers, collectors, friends, and staff members of monthly, weekly, and daily publications that review shows. If appropriate, send cover notes.

SEND SECOND LISTINGS RELEASES TO WEEKLY PUBLICATIONS.

TWO WEEKS BEFORE OPENING

SEND PROMOTION PACKAGES TO DAILY PUBLICATIONS.

SEND PROMOTION PACKAGES TO RADIO AND TELEVISION STATIONS.

SEND THIRD-LISTINGS RELEASES TO WEEKLY PUBLICATIONS.

ONE WEEK BEFORE OPENING

SEND FOURTH-LISTINGS RELEASES TO WEEKLY PUBLICATIONS.

Press Deadlines

The above schedule is a general guide, and it is very important to check with the various publications regarding their copy deadlines. For example, some weeklies require listings releases to be submitted ten days before an issue is published, while other weeklies have deadlines as much as twenty-one days before publication.

Generating a Feature Article in Consumer Publications

If you are aiming to generate a feature article in a monthly consumer publication to coincide with the opening of an exhibition, this task should begin at least a year before the exhibition opens. Time and planning are required to solicit the interest of a freelance journalist or to have an editor assign a journalist the story. Once a writer is selected, an interview or series of interviews will be conducted, and the writer will prepare a draft of the article and will usually have more questions to ask. Photographic sessions will also need to be arranged.

The names of freelance writers are published in various media directories. For example, *Bacon's New York Publicity Outlets* lists the names of freelance writers who are based in New York. The listing includes contact information, a description of topics of interest, and the names of publications for which they write.

OPENINGS

Many artists would rather have open-heart surgery than go to their own openings, or to any openings for that matter, and many guests feel the same way. Most openings are lethal: cold, awkward, and self-conscious. But they don't have to be that way. You worked hard to open. Your opening should be your party, your celebration, and your holiday. Otherwise, why bother?

Do not look at the opening as a means to sell your work or receive press coverage. If it happens, great, but many critics boycott openings, and rightfully so, for with all of the people pressing themselves against the walls (hoping they will be absorbed in the plaster), how can anyone really see the art? And many serious buyers like to spend some quiet time with the work, as well as with the artist and dealer, and an opening is not the time or place to do it. Some openings are planned

around a lot of booze to liven things up, and while things can get peppy, often in the high of the night people make buying promises they don't keep.

When the exhibition *11 New Orleans Sculptors in New York* opened at the Sculpture Center, the eleven New Orleans artists surprised their guests with a creole dinner. It was an excellent opening, and some of the best openings I have attended (including my own) involved the serving of food (other than cheese and crackers). The menus were not elaborate, but something special, which indicated that the artists actually liked being there and liked having you there; that the artists were in control and were "opening" for reasons other than that it was the expected thing to do. In addition, the breaking of bread among strangers relieved a lot of tension.

Choreograph your opening and be involved in the planning as much as possible. Not all dealers are willing to relinquish control and try something new, but push hard. The opening shouldn't be a three-ring circus structured for hard sell with a little goodie (glass of wine) thrown in as a fringe benefit. This is your show, and the opening should be structured accordingly.

CRITICS AND REVIEWS:
THEIR IMPORTANCE AND IRRELEVANCE

Many idiosyncrasies, ironies, and irrationalities surround art reviews and art criticism, beginning with the "words without pictures" approach used by newspapers and periodicals. Although a publication might publish as many as ten reviews, in most instances nine of the reviews are unaccompanied by photographs of the artwork being described. Paintings, sculptures, drawings, and other visual media, unlike other art forms, such as concerts, can be reproduced in print! But for illogical reasons most reviews about visual art are unaccompanied with *visual* documentation, a less than subtle message that the words surrounding the artwork are more important than the work itself!

In a typical issue of the periodical, *Review: The Critical State of Visual Art in New York* (which is no longer in print and only available online), out of thirty-two exhibitions reviewed, not one photograph of the artwork under discussion was reproduced.[13] In the same issue, a review of a group exhibition, *Abstraction: A Pleasured Reticence*, only

included the names of the sponsoring gallery and the art critic. The names of the six participating artists were omitted,[14] another less than subtle message that exhibiting artists are less important than the gallery and art critic.

"All these years . . . I had assumed that in art, if nowhere else, seeing is believing. Well—how very shortsighted!" wrote author Tom Wolfe. "Not 'seeing is believing' . . . but 'believing is seeing,' for *Modern Art has become completely literary: the paintings and other works exist only to illustrate the text.*"[15]

Pontificating about art is not a new phenomenon. The smug and pretentious prose that is published in magazines, newspapers, and catalogs has become a norm in art-world communication.

In 1986, *The New Yorker* published an interview with Ingrid Sischy, who was then the editor of *Artforum*. The interview was conducted by *The New Yorker* staff writer Janet Malcolm. Said Sischy:

> Even now, if I wasn't forced to edit them I probably wouldn't read some of the things we publish. . . . It's always been a problem, this troublesome writing we print. . . . That is probably why I was brought in as editor—because I found much of *Artforum* unreadable myself. . . . An object lesson I keep before me all the time is that of my mother, who picks up *Artforum*, who is completely brilliant, sophisticated, and complex, who wants to understand—and then *closes* it.[16]

"[Criticism] adopts its own mechanistic modes," wrote art critic Nancy Stapen, "and all too often produces its own sectarian dialect, resulting in the sort of obfuscated, impenetrable verbiage that, as we have seen, even a mother cannot love."[17]

Through layers of verbose ramblings, filled with obscure meanings, symbols, and theories, art is stripped of its own visual language. And although most artists agree that this form of writing is incoherent and repulsive, many artists would not be averse to having their artwork dissected in the press in a similar manner. Even gibberish is viewed as a source of validation!

Although not all critics choose to write in a style of opaque discourse, the emphasis on the importance of being reviewed has grown out of proportion to the intrinsic value of art criticism.

Granted that some artists have gained more "recognition" as a re-

sult of their work being praised by the arts press, there is an unfounded perception among artists that having an exhibition reviewed is tantamount to career success.

Critic and curator John Perrault comments:

> I know that artists in general will do almost anything to get a review. I have had artists tell me, "Please write about my show. I don't care if you hate it but write something about it." It's very important for artists to have that show documented in print somehow. Often artists don't think that they exist unless they see their names in print.[18]

The fact of the matter is that an artist can have a substantial and sustaining career with or without reviews.

Artists are not alone in equating reviews with career success. Some dealers, curators, and collectors don't think an artist exists unless the artist's name is in print.

Recognizing that the art world contains a preponderance of insecure individuals who depend on the printed word to form their opinions or convictions about artwork and to decide whether or not you're a good bet and someone to watch in the future, artists should consider the pursuit of a review a *routine* task using some of the public-relations channels suggested in this chapter. *Pursuing a review is not worthy of obsession.*

My own good breaks came from several different circles: insecure people with power, secure people with heart, and those with both heart and power. Ultimately, I have to take credit for putting this kind of constellation together because dealing with the review system also means putting together a backup system so that *your career can flourish with or without reviews.*

MAKING NEW CONTACTS AND KEEPING IN CONTACT

Making new contacts and keeping in touch are very important aspects of public relations. Establishing new contacts and reviving old contacts can begin with a few first-class stamps.

It is also important to keep your contacts warm and remind people that you exist. For example, at my urging, a client who was literally

destitute, out of work for several months, and being evicted from his apartment contacted a music critic at *The New York Times*. Two years before, the critic had written a highly enthusiastic and flattering review about the musician. He reminded the critic of who he was and laid on the line his current dilemma. Consequently, the critic was instrumental in finding the musician work, which not only helped him over a huge financial crisis, but also helped him restore faith in himself, in his work, and in humanity.

Set aside time each week to make new contacts, by using the telephone or sending presentation packages and letters to solicit and generate interest in you and your work. The more contacts you make, the greater the chances that you will find yourself at the right place at the right time.

Do not underestimate the value of this phenomenon. For example, a sculptor who had recently moved to New York from the West Coast asked me to assist her with contacts. I provided her with a list of exhibition spaces that I thought would be interested in her work. The first alternative space she contacted immediately accepted her work, as it precisely fit into the theme of an upcoming show. Both the sculptor and the show received excellent reviews. The sculptor was then invited to participate in a group exhibition at a museum (as well as another alternative-space gallery); a dealer from a well-known gallery saw the museum show and singled out the sculptor and invited her to exhibit at his gallery. This all took place in less than three months!

Once a rhythm is established for a consistent approach to public relations, the job becomes easier and less time-consuming. The letter that once took you hours to compose will become a snap. And if you keep up on your homework (see "Read, Note, File, and Retrieve," page 22), you will never exhaust the list of people, organizations, and agencies to contact.

Keeping in Touch

There are many ways to keep in touch. Press releases and exhibition/performance announcements are two such ways. But there are other vehicles. One sculptor sends a newsletter a few times a year to collectors, people who have expressed interest in his work, and people in the art world whom he knows personally. The newsletter announces upcoming exhibitions and recaps recent activities.

Another artist recycled a postcard featuring a color photograph of a painting, which had been used as an exhibition invitation, to announce a grant she had received from a private foundation. The postcard was sent to collectors, various art-world associates, and dealers with whom she had been in contact.

The use of an internal press release described earlier in this chapter (see page 83) is another effective way of keeping in touch. It can bring tangible and intangible rewards by reminding people that you exist and that your career is moving forward.

The Law of Averages

One of the most important factors about the effectiveness of public relations and marketing is that it is based on the *law of averages*. Regardless of your talents, abilities, and vision as a fine artist, no one will know about you unless you contact many people and do it on a continuing basis. The more contacts you make (and reestablish) and the more opportunities you create to let people know that you and your work exist, the greater the chances that events and situations will occur that accelerate your career development.

As previously mentioned, a presentation package that is based on a brochure generally produces a 6–14 percent response; a slide package averages around a 2 percent response. Much less predictable is the response rate of a press release that is targeted to generate press coverage. But what is predictable is that if you do not issue a press release, it is unlikely that press coverage will transpire!

Each time you receive a letter of rejection (or of noninterest), initiate a new contact and send out another package. The "in and out" process feeds the law of averages and increases your chances of being at the right place at the right time. It also wards off rejection and puts it in a healthier perspective (also see chapter 10, "Rationalization, Paranoia, Competition, and Rejection").

Exhibition and Sales Opportunities: Using Those That Exist and Creating Your Own

*M*ore than ever before, there are many opportunities to exhibit and sell work. This chapter describes various exhibition and sales markets, including national and international resources, available to artists outside of the commercial-gallery system (which is discussed in chapter 7, "Dealing with Dealers and Psyching Them Out"). The last section of this chapter covers marketing art on the Internet, including the use of on-line galleries. It also discusses the benefits of having your own Web site.

ALTERNATIVE SPACES

During the 1970s the *alternative-space movement* emerged in reaction to the constrictive and rigid structure of commercial galleries and museums. Artists took the initiative to organize and develop their own exhibition spaces, using such places as abandoned and unused factories and indoor and outdoor public spaces that previously had not been considered places to view or experience art. Some alternative spaces acquired a more formal structure, such as artists' cooperatives, and became institutionalized with tax-exempt status.

Alternative spaces mushroomed throughout the United States under such names as the Committee for Visual Arts, the Institute for Art and Urban Resources, and the Kitchen, all in New York City; the Los

Angeles Institute of Contemporary Art; the N.A.M.E. Gallery in Chicago; the Washington Project for the Arts in Washington, D.C.; and the Portland Center for the Visual Arts in Oregon.

The alternative-space system continues to spread, providing general exhibition and performance opportunities, as well as exhibition opportunities for specific artists. For example, there are alternative spaces dedicated to black artists, women artists, black women artists, Hispanic artists, and artists born, raised, or living in specific neighborhoods of cities. There are alternative spaces dedicated to mixed media, photography, performance, sculpture, and so forth.

When the original alternative spaces were established, their goals were simple and direct: to "provide focus for communities, place control of culture in more hands, and question elitist notions of authority and certification."[1] While on the surface the goals of the newer alternative spaces might appear to be in harmony with those of their predecessors, many, unfortunately, have other priorities. Although some spaces are still being run by artists, others are being administered by former artists who have discovered that being an arts administrator or curator is a quicker route to art-world recognition and power.

Consequently, some alternative spaces are being administered and operated with a hidden agenda that is not in the best interests of artists or the communities they were originally intended to serve. An *alternative elite* has arisen, so it should not surprise an artist that the reception he or she receives when contacting an alternative-space gallery could well be reminiscent of the reception encountered at a commercial gallery.

Of course, there are alternative spaces that remain true to the ethic and purpose of what an alternative space is, and generally the alternative-space system has many good attributes.

The biggest and most important difference between an alternative space and a commercial gallery is that the former is nonprofit in intent, and therefore is not in business to *sell* art or dependent on selling for its survival. Basically, its survival depends on grants and contributions, which impose another kind of financial pressure. But without the pressure of having to sell what it shows, the alternative space is able to provide artists with exhibition space and moral support, and feature and encourage *experimentation* (a work that can cause cardiac arrest for many dealers). This is not to imply that work is not sold at alternative spaces, for it is, but an artist is not obligated to pay the

ungodly commissions required by commercial galleries. If an alternative space charges an artist a commission, it is usually in the form of a contribution.

Alternative spaces have many other good points. For example, they offer an artist a gallery-like setting in which to show his or her work. This can help a dealer visualize what the work would look like in his or her gallery. Do not underestimate the value of this opportunity: many dealers have remarkably little imagination. Also, alternative spaces are frequented by the media and critics, providing artists with opportunities for press coverage, which, as discussed in chapter 5, can often be an important factor in career acceleration. And alternative spaces provide artists with a chance to learn the ropes of what exhibiting is all about.

Curators and dealers include alternative spaces in their regular gallery-hopping pilgrimages, for glimpses into *what the future might hold* as well as to scout for new artists. Some of my clients' alternative-space experiences skyrocketed their careers or took them to a new plateau.

Many artists have misconceptions about the value and purpose of an alternative space and regard it as a stepchild of the commercial-gallery system. They think that it should be used only as a last resort. This is not true. While alternative spaces provide valuable introductory experience into the art world and exhibition wherewithal, *it is counterproductive to abandon the alternative-space system once you have been discovered by a gallery*. Balance your career between the two systems. Until a commercial gallery is convinced that your *name alone* has selling power, you will be pressured to turn out more of what you have thus far been able to sell. You might be ready for a new direction, but the dealer won't want to hear about it. Those offering an alternative space do!

Alternative spaces are not closed to artists who are already with commercial galleries. In fact, including more established artists in alternative-space exhibitions adds to the organization's credibility, and for an alternative space whose survival depends on grants and contributions, there is a direct correlation between reputation and financial prosperity.

The names and locations of alternative spaces throughout the United States are listed in the *Art in America Annual Guide to Galleries, Museums, Artists* and in *Organizing Artists: A Document and Directory of the*

National Association of Artists' Organizations (see the appendix section "Exhibition and Performance Places and Spaces").

Other Alternative Sites and Spaces

In addition to the traditional types of exhibition spaces in commercial galleries and museums, there are many other kinds of spaces available for artist-initiated exhibitions. Mimi and Red Grooms's *Ruckus Manhattan* exhibition opened in a warehouse in lower Manhattan and ended up at the Marlborough Gallery. Artist Richard Parker turned the windows of his storefront apartment into an exhibition space for his work and received a grant from the New York State Council on the Arts to support the project. Bobsband, a collaborative of artists, convinced New York City's Department of Transportation to let them use the windows of an unused building in midtown Manhattan to exhibit their work and the work of other artists. They started the project with their own money and eventually received financial support from federal and state arts agencies. Banks, barges, restaurants, parks, alleys, rooftops, building facades, and skies are only a sampling of other alternative sites and spaces that artists, dancers, performers, and musicians have used as focal points, props, and backdrops for projects.

Cooperative Galleries

Cooperative galleries are based on artist participation. Artists literally run a cooperative gallery and share in expenses (in the form of a monthly or annual fee) in return for a guaranteed number of one-person shows and group exhibitions within a specified period. Gallery artists make curatorial decisions and select new artists for membership.

Because of its participatory structure, the cooperative system, at its best, offers artists a rare opportunity to take control, organize, and choreograph their own exhibitions and be directly involved in formulating goals, priorities, and future directions of the gallery. At its worst, since a member must accept group decisions, you might find yourself in compromising situations, having to abide with decisions that are in conflict with your own viewpoints. And you might also find yourself spending more time squabbling and bickering over co-op–related matters than on your artwork!

It is always difficult to know what you are getting yourself into, but

before rushing into a cooperative, talk to the members to ascertain whether you are on the same wavelength. Obviously, if you receive an invitation to join a co-op, the majority of members approve of you and your work. You should determine whether your feelings are mutual.

Co-op memberships are limited and correspond to the single-show policy and space availability of the gallery. For example, if the co-op agrees that members should have one-person shows for one month every eighteen months, the membership will be limited to eighteen artists. Or if the gallery has the facilities to feature two artists simultaneously, the membership might be limited to thirty-six artists. Some co-ops have membership waiting lists; others put out calls for new members on an annual basis or when a vacancy occurs. In addition, some co-ops have invitationals and feature the work of artists who are not members.

Some cooperatives do not take sales commissions; others do, but the commissions vary and are far lower than those charged by commercial galleries. If commissions are charged, they are recycled back into the gallery to pay for overhead expenses.

In *On Opening an Art Gallery*, Suzanne K. Vinmans describes with refreshing honesty and humor the evolution, trials, and tribulations of a co-op gallery, as well as the events leading up to its demise. Although problems with a landlord were a contributing factor to the closing of the gallery, most of the difficulties were created by the gallery's artists, many of whom shirked responsibility, suffered from an acute case of stinginess, and were overpowered by negative attitudes. "If I had it all to do again, I would . . . make myself the director from the outset. As the person who did most of the work and made most of the decisions, I should have received that recognition," writes Vinmans. "I would search for more committed artists. . . . A gallery such as ours could have worked if each member was committed to the fullest degree."[2]

If you join a co-op gallery, it is important to *know when it is time to leave*. Since artists are guaranteed a set number of single and group exhibitions within a specific time frame, all too often a co-op serves as a security blanket for members afraid to venture out into the world and risk the possibility of being rejected.

To subsidize the operating costs of a gallery, many cooperatives sponsor "invitationals." It is a juried procedure, and artists who are selected are also required to pay some sort of fee. Although some artists

have had positive experiences participating in cooperative-sponsored invitationals, artist Donna Marxer's ordeal in New York was less than positive:

> Five years ago, needing a show, I got an "invitational" to show in the secondary room of one of the best co-ops around—one that was frequently reviewed and well-located. I also had to undergo rigorous review of my work to be accepted. The cost of that back room was $2,000 for three weeks.
>
> The director and committee were adamant about their standards. They insisted on hanging the show, leaving out a third of my work. They rewrote my perfect news release in their one-paragraph format—fine for someone with nothing to say, but dear reader, that is not me. They gave me a huge out-of-date mailing list that yielded nothing. $4,500 later, I had not made even one sale, had lured no one of importance into the gallery (in spite of promises), and went unreviewed. The only thing I got out of that show was one line on my resumé."[3]

Vanity Galleries: Artists Beware

Vanity galleries are *for-profit* galleries that require artists to pay an exhibition fee and/or an assortment of other exhibition-related expenses. In addition, many vanity galleries also require a commission on work that is sold. For the most part there are no exhibition standards as long as an artist is willing to pay for an exhibition.

Cooperative galleries are often confused with vanity galleries because in co-ops artists are required to contribute to the galleries' overhead and administration costs through monthly or annual dues or fees. And as previously mentioned, cooperative galleries also sponsor "invitationals" that require artists to pay exhibition fees.

Adding to the confusion, some alternative spaces also require artists to contribute to exhibition overhead. And, of course, as discussed in chapter 7, "Dealing with Dealers and Psyching Them Out," some commercial galleries are also requiring artists to contribute to exhibition expenses.

Although all too often there were some fine lines between the

practices of a vanity gallery and a nonvanity gallery, keep in mind that, unlike cooperative galleries and other alternative spaces, a vanity gallery has no exhibition standards, it is not in business for educational purposes, and it does not have an artist's best interests in mind.

Vanity galleries that are located in large cities are particularly seductive. They appeal to naive, and often desperate, artists who believe, for example, that having a show in a New York gallery, even if you have to pay for it, provides the path to fame and fortune. Many foreign artists also resort to using a vanity gallery in New York to seek validation in their home countries.

Through advertisements in regional and national art publications, vanity galleries entice artists with tempting come-ons such as "New York gallery looking for artists." Artist sourcebooks (see page 125) are also used by vanity galleries to locate potential prey. For example, the Agora Gallery in New York contacts artists with a form letter stating that "we have noticed your work in the *Encyclopedia of Living Artists* and are very impressed."

For a *Village Voice* article, journalist Lisa Gubernick posed as an artist and went undercover to learn more about what artists experience when making the gallery rounds. With a set of borrowed slides, she contacted numerous galleries in New York City, including the vanities. At the Westbroadway Gallery, she was offered a show in the gallery basement, which was called the "Alternative Space Gallery," for $850. In addition, she described her experience at the Keane Mason Woman Art Gallery as follows:

> I had a draft contract in my hands within 20 minutes . . . $720 for 16 feet of wall, a mini-solo they called it. The date . . . was contingent upon "how I wanted to spread out my payments," according to the assistant director. In an embarrassingly blatant ploy she put red-dot adhesive stickers—the international "sold" symbol—on each of the half-dozen slides she deemed suitable for my show, all the while emphasizing various corporations' interest in the gallery. . . . The shows I saw at Woman Art were hung poorly. Wall labeling was crooked, and the gallery gerrymandered with partitions to eke out more space.[4]

Vanity galleries use an assortment of schemes and methods for getting artists to spend vast amounts of money to exhibit. For example, a

gallery in Washington, D.C., charges $95 per month for a one-year contract that entitles an artist to participation in three group shows and inclusion in a slide registry. Artwork is *not* insured, so artists must either carry their own policies in the gallery's plan, for which there is an *additional monthly fee* of 1½ percent of the declared value of each work of art. For example, for a piece of work valued at $2,000, insurance would cost $30 extra per month. In addition, the gallery charges a 50 percent commission if work is sold! So, if a $2,000 piece takes six months to sell, the artist will have paid $750 in insurance and exhibition fees and a $1,000 commission to the gallery, and will be left with a net profit of $250. And on top of paying a monthly gallery fee, insurance charges, and a commission, the artist is responsible for round-trip packing, transportation, and delivery fees, and any installation costs.

In "Zero Gravity: Diary of a Travelling Artist," the author and artist Elizabeth Bram describes a phone conversation with the owner of a vanity gallery in New York:

> He had a smooth voice like a used car salesman. He told me that his gallery was near the Soho Guggenheim Museum. He went on about how I would get listed in the *New York Gallery Guide* if I showed at his gallery. And how he would host an opening complete with uniformed waitresses. I listened patiently, humoring him.
>
> "Tell me about yourself," he said. This was my cue to be flattered and to excitedly tell him all my dreams and fantasies about showing in a gallery near the Soho Guggenheim Museum. He would have listened to anything that I wanted to say then about my childhood or my schooling or the way that I paint.
>
> "How much are you charging?" I asked, cutting to the chase.[5]

She was told that for a $1,000 fee she could exhibit three paintings for a month, along with the work of nine other artists, and have her work in a computer file for one year. "A quick mathematical accounting told me that the Abney Gallery was collecting $10,000 a month from artists. That would be over $100,000 a year without even selling my paintings."[6]

Once, when a gallery dealer deflated the ego of one of my clients, he trod over to a (now-defunct) vanity gallery, much against my advice,

guy who discovers his mate has been unfaithful and marches prostitute. He signed up for a show, signed the dotted line on the contract, and wrote a check for several hundred dollars. In addition to the "exhibition fee," he had to pay for all of the publicity, including invitations, announcements, press releases, and postage, and for the wine served at the opening. Although the show did nothing for his career, he felt victorious. He had shown the dealer!

Although exhibiting in a nonvanity New York gallery does not guarantee recognition or financial success, the Herculean strength of the mythology surrounding the importance of exhibiting at a New York gallery enables vanity galleries to flourish. In New York and elsewhere, stay clear of vanity galleries and related schemes that place all of the financial risks on artists. If artists made a concerted effort to boycott vanity galleries, these galleries would disappear.

JURIED EXHIBITIONS

Hundreds of local, regional, national, and international juried exhibitions are held each year. Juried shows can offer artists opportunities for recognition and exposure, as well as cash prizes and awards. If you were so inclined, you could enter a juried exhibition every day of the year.

But there are drawbacks, one of which is the expense involved in entering juried exhibitions. Most shows require entry fees, and these fees continue to increase dramatically.

"What would you think of a theater that charged the performers rather than the audiences?"[7] asked art critic Joan Altabe in an article about juried shows in the *Sarasota Herald-Tribune*. "Crazy, right! Behold the crazy art world. The arrangement described above is one of the ways many exhibit halls support themselves. . . . "[8]

In the article Altabe interviewed various not-for-profit arts organizations who justify charging entry fees because the fees pay for the group's overhead. "We couldn't survive without entry fees,"[9] declared a representative of one of the organizations. Altabe responded by offering a practical and intelligent suggestion: "Charge the audience, not the artists."[10]

The issue of charging fees and other related matters have made juried shows so controversial that the National Artists Equity Associa-

tion has prepared a positive paper, "Recommended Guidelines for Juried Exhibitions." It states that

> while certain circumstances might necessitate asking the artists who are chosen to share in some of the costs, National Artists Equity suggests that this be done only as a last resort and that the amount to be charged should be published in advance. However, charging fees to *all* prospective artists (entry fees) is considered to be inappropriate and unprofessional.[11]

The National Endowment for the Arts has also had a long-standing position against the charging of fees. A spokesperson for the NEA has stated that "if a show promoter charges fees . . . top caliber artists won't enter the show, and . . . shows requiring entry fees generally don't have good reputations."[12]

However, art critic Joan Altabe's suggestion to charge the audience a fee to attend an exhibition instead of charging artists a fee to participate[13] brings to mind how convoluted the justification actually is for artists to pay for an organization's overhead.

Sponsors of juried shows that are for-profit and not-for-profit organizations have overhead costs related to juried exhibitions. But because the sponsors experience little resistance from artists to pay entry fees, they have not been forced to develop more creative ways of keeping their organizations and businesses alive. In most instances, in addition to entry fees, sponsors also receive a commission on work that sells during a juried exhibition.

Some juried shows that are sponsored by *for-profit* enterprises use only a small percentage of fees for legitimate expenses, with the bulk of the money going directly into the pockets of the organizers.

For example, one New York gallery sponsors a juried competition in which artists are required to pay a registration fee of $35 for up to four slides, $5 for each additional slide, a $10 nonrefundable fee for repacking and handling artwork "even if hand-delivered," and a 40 percent commission on all sales!

The artist Richard S. Harrington was so outraged after reviewing the prospectus of a national juried competition sponsored by the No-BIAS Gallery in North Bennington, Vermont, he sent a letter to the gallery's executive director pointing out:

In addition to generating income by the charging of entrance fees you are also benefitting by charging a 25% commission on all sales. While it is not uncommon for galleries to charge a commission on sales it is excessive to expect an artist to pay twice to be included in an exhibition. Your prospectus states that you are ". . . devoted to strengthening the dialog between artist and audience." Shouldn't this include having the "audience" share part of the financial demands of organizing a juried exhibition from which they directly benefit. . . .[14]

Harrington believes that artists should always be thinking on a larger scale of how they can make their voices heard, and he sent copies of his letter to the executive directors of the Vermont State Arts Council and the National Artists Equity Association. All three letters went unanswered.

Another drawback of juried shows is that many of their sponsors do not insure artwork, and many sponsors take little or no precautions to protect the work from theft, vandalism, and loss.

Some juried shows *appear* to be very prestigious because the jury is composed of art-world personalities. But keep in mind that *jurors are paid* to lend their name to exhibitions. The fact that a famous critic, curator, or gallery dealer is on the jury is *absolutely no indication* that the show has been organized with high standards and that it is in the best interest of artists.

I have not seen any overwhelming evidence to support a correlation between juried shows and meaningful and lasting career development. In fact, the biggest illusion about juried shows is that award-winning artists benefit in ways that provide tangible career acceleration. For example, many artists who have won awards in shows that were judged by art-world figures are astonished and disappointed to discover that in most instances a juror's interest in the artist ends after the awards have been given. Although there are a few exceptions, rarely will a juror follow through by providing an artist with some sort of entry into the art world.

The majority of artists who benefit from juried shows are those not particularly concerned with long-range career development. They approach a juried show as a means to an end in gaining respect and recognition in their *local communities*. But for artists who have more

ambitious and professional goals, there are many more productive and effective ways in which to use time, energy, and money.

In some arenas the juried show is such a common appendage of the art world that it will take quite a while to change thinking about the relevance of juried exhibitions. If you are convinced that juried shows will help provide a means to your end, use the following guidelines before plunging in.

Before submitting work to a juried exhibition, even if it is sponsored by a museum or reputable institution or organization, do your homework. Make sure the sponsor will provide a contract or contractual letter outlining insurance and transportation responsibilities, fee structures, submission deadlines, and commission policies. If you pay an entry fee, you should not have to pay a commission on work that is sold, and you should not participate in exhibitions that do not insure work while it is on the sponsor's premises.

The appendix section "Competitions and Juried Exhibitions" includes a list of resources from which you can obtain additional information on juried exhibitions.

\mathcal{S}LIDE REGISTRIES

Slide registries are sponsored by artists' organizations, museums, alternative spaces, and public-art agencies throughout the United States. An active slide registry is used by many people: by curators and dealers to select artists for exhibitions, by collectors for purchases and commissions, by critics, journalists, and historians for research, and by federal, state, and municipal public-art agencies to purchase art and select artists for site-specific commissions.

It makes sense to participate in the registry system, but not all registries are equally used. Before going through the expense and energy of submitting slides, find out if the registry is really active.

Artists Space in New York sponsors a digitized-image database and slide registry, which is one of the largest and most comprehensive registries in the United States. The registry is also reviewed by Artists Space curators for in-house exhibitions and virtual exhibitions on the organization's Web site. The National Museum of Women in the Arts' Archives on Women Artists is a registry that is open to women who

have had at least one solo show in a museum or gallery. Maryland Art Place maintains a slide registry of more than 1,500 artists from the region. The Georgia Artists Slide Registry features the work of more than 500 Georgia artists. Hallwalls Contemporary Arts Center has a slide registry of artists living in western New York. The Oklahoma Visual Arts Coalition sponsors a slide registry for visual artists living and working in Oklahoma. Information about the above-mentioned organizations and other slide registries can be found in the appendix section "Slide Registries."

My first encounter with a registry occurred when I was preparing an exhibition at a museum in New York City and spent a lot of time in the curatorial chambers. The curators meticulously went through their registry, on the lookout for artwork that would fit into a theme show they were preparing (eighteen months in advance). When they found something they liked, regardless of whether the artist lived in Manhattan, New York, or Manhattan Beach, California, they invited the artist to participate.

It is very important to *continually update the slides you submit so the registry reflects your most recent work.* A person reviewing the registry will assume that whatever is there represents your current work, but, unless your slides are up-to-date, this might not be the case. For example, one of my clients was invited to participate in a museum exhibition by a curator who had seen her work in a registry. It would have been her first museum show, but she learned that the curator wanted to show only the work that she had seen in the registry. The artist was mortified: a year earlier she had destroyed the entire body of work, and the curator was not interested in her recent work. It was a big letdown, and the artist was depressed for weeks.

ℳUSEUMS

Generally speaking, museums are leaving their doors more open to new and emerging artists. Some museums are actually leaving their doors ajar. My first exhibitions were sponsored by museums, contrary to the notion held by many artists that one must be affiliated with a commercial gallery before being considered by a museum. In many instances, what initially led to an exhibition at a museum was a set of slides, a résumé, and a show proposal (see the section "Develop and

Circulate a Proposal" in this chapter). Other exhibition invitations came as a result of both long- and short-term professional relationships with museum directors and curators.

My own experience in gaining museum shows is not unlike the steps Patterson Sims outlined when he was associate curator of the Whitney Museum:

> On the basis of slides and exhibition notices the curators will call for appointments with individual artists for studio visits. . . . Calls from friends, collectors, and gallery owners about the work of an artist are another means of introduction. . . . Conversations with artists, art writers, and museum personnel will bring an artist's name to a curator's attention.[15]

Sims also described how artists are actually invited to exhibit at the Whitney: "Decisions . . . [are] made at curatorial staff meetings. It is up to the individual curators to promote the work of an artist they feel has a fresh style, a sense of quality, and a provocative outline. If a curator can convince others . . . the group will decide to invite an artist to participate."[16]

The unilateral support system that Sims describes is one of the biggest snags in the exhibition process of some museums. It is debatable whether the artist who is presented for consideration on the basis of slides and a studio visit has the same leverage as an artist who was brought to the attention of curators by "friends, collectors, and gallery owners." Many artists believe that the Whitney, for example, is a closed shop to artists not affiliated with well-known commercial galleries. Judging from who *is* invited to participate in the Whitney Biennials, this is a logical conclusion. On the other hand, one of my clients who had no particular gallery affiliation was invited to participate in a Whitney Biennial. She concluded that she was a "small fish that slipped through the net!"

There are curators who have autonomous power and are able to make their own decisions rather than succumb to peer or dealer pressure. Do not let hearsay discourage you from contacting curators, nor should you be fooled by the myth that only artists connected to prestigious commercial galleries can exhibit in museums.

Curators organize exhibitions, assemble collections, and write catalogs and articles. They are under pressure to put contemporary art

into a historical context, discover "new movements," and develop thematic exhibitions, and they cannot rely solely on well-known artists to accomplish their goals. And if they are aggressively pursuing a reputation in the art world, they are on a constant quest to discover artists who will reinforce and support a particular point of view.

Curators select artists whose work thematically falls within the parameters of future exhibitions through the use of slide registries (see page 117). In many instances curators have their own personal registries, which are developed, in part, through artist initiative: artists send letters and presentation packages to introduce these curators to their work.

A young artist who was having a one-person exhibition at a suburban library couldn't understand why a museum would possibly be interested in her work. But I convinced her to include curators in the mailing to announce the show. She sent a cover letter, a color postcard featuring a piece of her work, and a press release to curators nationwide and was utterly amazed that the mailing elicited a response from curators at the Hirshhorn Museum and the Guggenheim Museum. Both curators requested a set of slides to keep for their files.

Resources for obtaining the names of curators are listed in the appendix sections "General Arts References" and "Mailing Lists."

COLLEGES AND UNIVERSITIES

Colleges and universities are often receptive to sponsoring exhibitions and performances, and their interest is not necessarily limited to alumni, although approaching a college or university of which you are an alumnus or alumna is a good beginning.

The first step is to send college and university gallery directors a presentation package and cover letter, or a proposal. This process is described in the section "Develop and Circulate a Proposal" in this chapter (see page 137).

Exhibiting at colleges and universities can also offer other rewards. Sometimes, as a result of an exhibition, artwork is purchased for the school's collection, and artists are commissioned to do projects for particular campus sites. In some cases, exhibiting artists are invited to present a lecture about their work, for which they receive a fee and travel expenses. On the other hand, many college and university

galleries have small operating budgets and expect artists to pay all exhibition-related expenses.

The names and locations of some college and university galleries throughout the United States are listed in the *Art in America Annual Guide to Galleries, Museums, Artists*. In addition, the ArtNetwork rents a mailing list of approximately 1,800 college galleries. These and other resources can be found in "Exhibition and Performance Places and Spaces" in the appendix.

THE CORPORATE ART MARKET

The corporate art market offers artists many sales and exhibition opportunities. Although some corporations buy art primarily for the purpose of investment, the majority buy art to attain a prestigious image, or even for the far nobler reason of improving employee morale. Although some of the motives behind corporate collecting are basically self-serving, the corporate market has become a viable arena for many artists to sell and exhibit work.

Generally, corporations steer away from work that is political, overtly sexual, religious, or negatively confrontational. Otherwise, the field is open.

The term *corporate market* encompasses a wide range of institutions, ranging from financial corporations and law offices to hospitals and restaurants.

There are several ways to reach the corporate market: through art consultants and art advisors, through galleries that work with corporations, through architects and interior designers, through real estate developers, and by directly contacting corporations, usually through staff curators and facilities managers. *The International Directory of Corporate Art Collections* lists hundreds of corporate art collections throughout the United States and abroad. Each listing contains the names of the people responsible for assembling the collection, such as in-house curators, art consultants, or advisors. It also describes each collection and its review procedures and policies. The directory is available as a spiral-bound printout and on diskettes for PC users from the International Art Alliance, Inc.

The book *Corporate Art Consulting* by Susan Abbott provides a thorough overview of the corporate market. Although it was written

primarily for art consultants, gallery dealers, architects, and interior designers, artists will glean ideas and advice on how to approach corporations. For additional information about the above-mentioned resources, see the appendix section "Corporate Art Market."

Art Consultants and Art Advisors

Art consultants are agents who sell work to corporations and individuals. If work is sold or commissioned through the efforts of an art consultant, the artist must pay a commission.

Anyone can become an art consultant. Like gallery dealers, art consultants are unregulated. The occupation of art consultant is often confused with *art advisor*, and often these job titles are used erroneously and interchangeably. Some art advisors are members of the Association of Professional Art Advisors, a national organization that has stringent regulations regarding business practices and professional qualifications. It defines an art advisor as one who is

> qualified to provide professional guidance to collectors on the selection, placement, installation, and maintenance of art. The professional art advisor has an understanding of art history, art administration, the art market, educational concepts, contemporary business practices, public relations, and communications.

Orlando art advisor Brenda Bradick Harris of Administrative Arts, Inc., points out that

> our culture has created a modern-day monster called "consulting" which often is used by those who may have good intentions, but who are not fully qualified or trained to advise or consult. Many of these individuals are unaware of the meaning or responsibilities associated with being an art consultant or advisor. These professional designations are often inappropriately used by gallery or artist sales representatives to indicate expertise and imply that the information is provided in the client's best interest. In reality, it is the product with the greatest profit potential, not artistic quality, that may be promoted.[17]

Art advisors do not receive commissions from artists on work sold or for projects commissioned. They are *paid by their clients* (individuals,

organizations, and businesses) to provide information, advice, and related services *without any conflict of interest*. This means that, unlike many art consultants, art advisors do not maintain permanent inventories of art, so they are not "pushing" only the work of artists they have on hand. Also, art advisors accept work on consignment only for the purpose of presentation or approval.

Expect to be asked to pay art consultants between 40 and 50 percent on work that has already been created. Some consultants charge less but they are very much in the minority. Commissions can be negotiated, and since I have the benefit of having many clients who are represented by the *same* consultant, I know firsthand that some artists pay the same consultant less of a commission because they negotiated. A logical argument for paying an art consultant less of a commission than what a gallery receives is that theoretically a gallery provides artists with gallery services. And I say "theoretically," because as pointed out in chapter 7, "Dealing with Dealers and Psyching Them Out," the quality and amount of services galleries offer artists have drastically diminished.

Under no circumstances should you pay more than 25 percent of the artist's fee for commissioned projects obtained through an art consultant, a gallery dealer, or any form of an agent. In other words, do not pay a commission on the overhead expenses of the project. Additional advice and discussion about commissions and fees are included in chapters 4 and 7, "Pricing Your Work: How Much Is It Worth?" and "Dealing with Dealers and Psyching Them Out."

Art consultant Françoise Yohalem gives excellent advice to artists who are being considered for a commissioned project:

> Never make a model, never make a proposal, unless you are paid for it. This is very important. Artists are too often willing to do a lot of work for nothing on the hopes that maybe something good will come out of it—and that is wrong. It gives the wrong impression to the client. It says that the artist is not professional, that the artist is pathetic and wants the job so badly that [he or she] is willing to do anything. I think the client respects the artist more if the artist says I expect to be paid.[18]

If an art consultant or art advisor requests work on consignment, do not let any work leave your studio *before* an artist/agent contract is

signed. If a commissioned project has been arranged by an intermediary, you should use an artist/agent contract *in addition to* the commission contract between yourself and the client. The appendix section "Law: Contracts and Business Forms" lists publications that discuss contracts, such as *The Artists' Survival Manual*, which provides an artist/agent agreement, and *Business and Legal Forms for Fine Artists*, *Business and Legal Forms for Crafts*, and *Legal Guide for the Visual Artist*, which include a contract for commissioned work. For further information on contracts, refer to pages 177–183.

When approaching an art consultant or art advisor, submit a basic presentation package (see chapter 3). The names and addresses of art consultants and art advisors are listed in various publications, including *The International Directory of Corporate Art Collections*; the *Art in America Annual Guide to Galleries, Museums, Artists*; and the *Art Marketing Sourcebook*. In addition, I sell a list of approximately 650 art consultants and art advisors that is available as a printout version and on disk. For information about these and other resources, see the appendix section "Corporate Art Market."

Corporate Curators

Generally, corporate curators have the same professional qualifications as museum curators and function in a similar capacity as art advisors, but they are on the staffs of corporations and receive salaries for their services instead of fees. In addition, professional practices of corporate curators are governed by the National Association for Corporate Art Management.

Corporate curators should receive a basic presentation package (see chapter 3). The names and addresses of corporate curators are listed in *The International Directory of Corporate Art Collections* (see the appendix section "Corporate Art Market").

Architects and Interior Designers

Many architectural and interior design firms commission artwork or purchase work in behalf of their clients. Some firms delegate a project manager or project designer to select work and/or maintain an artists' slide registry. In some instances a slide registry is organized by a staff librarian.

Architects and interior designers should receive a basic presentation package (see chapter 3).

The names and addresses of architects and interior designers can be obtained in several ways. For example, *The Dodge Report* is a quarterly publication that provides information on every construction project nationwide, including the name of the design firm in charge and whether a budget has been allocated for the purchase or commissioning of artwork. Individual state reports are also available.

A less expensive alternative is a publication published by the American Institute of Architects called *ProFile*. It profiles architecture and interior design firms nationwide. A ProFile database is available on-line.

In addition, you can obtain the names and addresses of architects and interior designers in your area by contacting local chapters of the American Institute of Architects (AIA) and the American Society of Interior Designers (ASID), or through the national headquarters of the AIA and ASID.

For additional information regarding *The Dodge Report*, *ProFile*, the American Institute of Architects, and the American Society of Interior Designers, see the appendix sections "Corporate Art Market" and "Interior Design and Architecture."

You can develop a more personalized list of firms by studying architectural, landscape, and interior design publications to look for designers whose work is aesthetically compatible with your own. The names and addresses of these publications in the United States, Canada, and abroad are listed in the appendix section "Interior Design and Architecture."

Another way of reaching architects and interior designers is to advertise in *The Architect's Sourcebook* and *The Designer's Sourcebook*, which are published by THE GUILD. Each edition contains color photographs of artwork; and the name, address, phone number, and biography of each participating artist. THE GUILD sourcebooks are distributed *free of charge* to those who attend the national conferences of the American Society of Interior Designers and the American Institute of Architects. In addition, the sourcebooks are distributed free of charge to art consultants.

The results of a survey conducted by THE GUILD on commissioning provided interesting findings that challenged some popular misconceptions about why artists are selected for projects.[19] These misconceptions include the belief that artists must be well known, or they must have had prior experience in executing a similar project, or that local artists or artists who submit low-cost project budgets have a better chance of being selected.

A copy of the survey was sent to 161 design professionals who actively use THE GUILD to commission art. Fifty-nine people responded to the survey, including 24 interior designers, 15 architects, 8 art consultants, 3 developers, and 2 art brokers.

Addressing the question "What were the most important factors in selecting the artist?" 43 percent of the respondents said that it was the quality of an artist's portfolio; 16 percent stated that it was the artist's track record with similar projects; 13 percent of the respondents stated it was on the strength of the project proposal; 11 percent stated that it was the personal chemistry with the artist; 10 percent stated that it was an artist's prominence; 4 percent stated that it was an artist's unique style; 2 percent that it was the low cost of proposal; and 1 percent of the respondents said that it was an artist's location.

Not all artists' sourcebooks are as reputable as THE GUILD or used as frequently by art consultants, architects, and interior designers. In the article "Buying Ad Space in Artists' Sourcebooks," published in *Getting the Word Out: The Artist's Guide to Self Promotion*, Carolyn Blakeslee points out that

> there are a slew of sourcebooks on the market now. There are encyclopedias, directories, catalogs, surveys—of contemporary art, New York art, living artists, erotic art, West Coast artists, Florida artists, and so on. Some of the sourcebooks are of questionable quality and value, and a few are downright awful, even some which have been around for a while and are well known.[20]

The article offers good advice to help you determine whether it is worth the effort to advertise in a sourcebook. For example, artists should know what kind of paper the ad will be printed on, at what line-screen ruling the plates will be reproduced, how large the book will be, how many copies of the book will be printed, whether the circulation is audited, how often the book is published, and how many copies of the book are distributed free of charge.[21]

In addition to THE GUILD's sourcebooks, Blakeslee, the publisher of *Art Calendar*, recommends the artists' sourcebook *New American Paintings* published by the Open Studio Press. Artists are selected through a juried procedure. There are no publication fees.

Information about *New American Paintings* and THE GUILD's sourcebooks is listed in the appendix section "Artists' Sourcebooks." Infor-

mation about *Getting the Word Out: The Artist's Guide to Self-Promotion* is listed in the appendix section "Career Management, Business, and Marketing."

Publicizing and Generating
Corporate Sales and Commissions

If your work is purchased or commissioned by a corporation, use public-relations tools such as press releases (see page 82) and photographs (see page 55) to generate publicity and new contacts. *Past accomplishments should always be used as a springboard to solicit new clients and projects.*

Issue a press release to announce a corporate commission or sale. Press releases should be sent to collectors, clients, potential collectors and clients, and people in the art world with whom you are in contact, or people in the art world whom you have always wanted to contact.

Send a press release and photograph to *Public Art Review*, a biennual publication that contains the column "Recently Completed Projects." Each announcement contains the artist's name, the title of the artwork, a project description, the year the work was completed, medium, and the name of the sponsor. If a commission or sale involved the *services of an art consultant or art advisor*, send a press release and photograph to *Art Business News*, a monthly publication that announces recent corporate acquisitions and commissions. The address of *Public Art Review* is listed in the appendix section "Public Art," and the address of *Art Business News* is listed in the appendix section "Corporate Art Market."

A press release issued by an artist announcing the acquisition of three photographs by a Canadian bank led to a feature article in a major New York newspaper. A press release issued by an accounting firm, in behalf of a sculptor, announcing the completion of a commissioned piece was sent to various trade publications read by accountants. An article in one such publication announcing the commission led to a commission for the sculptor from another accounting firm.

THE HEALTH-CARE INDUSTRY

Within the health-care field, many opportunities exist for artists to exhibit and sell work, and create special projects. In the article "Getting

Better: Art and Healing," published in *Sculpture* magazine, the author Anne Barclay Morgan pointed out:

> As our concern with healing the earth has received widespread attention, there is also a renewed interest in healing ourselves. With health care reform now at the foreground of national debate, health services, alternative medicine and other forms of healing are receiving broader public scrutiny. Directed toward health care facilities, such as hospitals and hospices, the burgeoning field of art and healing is creating venues and modes of interaction for artists, health care givers and patients.[22]

The Society for the Arts in Healthcare is a national membership organization that is dedicated to the incorporation of the arts as an appropriate and integral component of health care. Toward this goal, the society is engaged in programs that serve many purposes: to demonstrate the valuable roles the arts can play to enhance the healing process; to advocate the integration of the arts into the planning and operation of health-care facilities; to assist in the professional development and management of arts programming for health-care populations; to provide resources and education to health-care and arts professionals; and to encourage and support research and investigation into the beneficial effects of the arts in health care.

The society's membership includes physicians, nurses, arts administrators, medical students, architects, designers, and artists of all disciplines. It sponsors an annual conference and publishes a membership directory.

The International Arts-Medicine Association (IAMA) is a not-for-profit organization that serves as a forum for interdisciplinary and international communication between arts and healing professionals. Members include clinicians, educators, researchers, and artists who have an interest in the relationship between the arts and health.

The Arts in Medicine (AIM) program at the University of Florida in Gainesville sponsors an artist-in-residence program that has become a model for the incorporation of the arts into the mainstream of clinical practice. The program integrates art into the caregiving of patients, and educates staff and students on new approaches in caring. In addition, the organization Arts in Medicine sponsors art installations, per-

formances, workshops, exhibitions, and other programs for the benefit of patients and their families and staff members.

The Web site of the Arts and Healing Network is a comprehensive resource about the healing potential of art. Updated on an ongoing basis, it lists publications, organizations, and related Web site links. It also features the work of many artists. Contact information about the Arts and Healing Network and other above-mentioned resources can be found in the appendix section "Art and Healing."

PUBLIC-ART PROGRAMS

In addition to private and corporate clients, there is a wide range of commission and sales opportunities available to artists through public-art programs sponsored by federal, state, and municipal agencies and independent organizations.

There is also a wealth of information available about public-art programs. For example: the excellent semiannual magazine *Public Art Review* publishes practical articles about public-art programs and provides lists of opportunities in the public-art field. *Going Public: A Field Guide to Developments in Art in Public Places*, published by the Arts Extension Service of the University of Massachusetts, provides an overview of issues, policies, and processes in the administration and preservation of public art, with an appendix of resources. The *Guidebook for Competitions and Commissions*, published by Visual Arts Ontario, provides guidelines on commissioning public art and discusses the roles of the sponsor and the artist. The *Directory of Percent-for-Art and Art in Public Places Programs* is a comprehensive resource that is updated on an ongoing basis. Published by Mailing Lists Labels Packages, the directory lists public-art programs sponsored by city, county, state, and federal agencies, including transit and redevelopment agencies, private and not-for-profit organizations, colleges and universities, and sculpture gardens and parks. The directory, related mailing labels, and postcards for use in contacting the various programs are available separately or as packages.

The Public Art Network is a new program of Americans for the Arts. It plans to offer professional services and networking opportunities for public-art professionals, visual artists, design professionals, and organizations planning public-art projects and programs.

Web sites of interest related to public art include Art Public, a subscription service with information about events, opportunities, public artworks, and artists, mainly in Europe, although it also includes some programs in the United States and in other countries. It includes a searchable database of more than six thousand artists, publications, and public artworks. Public Art Online, hosted by the British organization Public Art Southwest, is a comprehensive resource that includes advice, opportunities, and dialogues about public art. And Public Art on the Internet includes various sources of information about the field of public art, including essays, articles, projects, links to other related sites, and an e-mail group that posts opportunities for artists.

Contact information about the organizations, publications, and Web sites mentioned in this section, along with other resources, can be found in the appendix section "Public Art."

Federal Public-Art Programs

Through the General Services Administration (GSA)'s Percent for Art Program and Art in Architecture Program, the federal government commissions artists to produce works of art for various government projects. Artists are commissioned to produce works of art that are incorporated into the architectural design of new federal buildings. In addition, artwork is commissioned for buildings undergoing repair or renovation, as well as for federal buildings in which artworks were originally planned but never acquired.

Commissioned work includes (but is not limited to) sculpture, tapestries, earthworks, architecturally scaled crafts, photographs, and murals.

One half of one percent of a building's estimated construction cost is reserved for commissioned work. Artists are nominated cooperatively by the GSA, the National Endowment for the Arts (NEA), and the project architect.

The architect is asked to submit an art-in-architecture proposal that specifies the nature and location of the artwork, taking into consideration the building's overall design concept.

The NEA appoints a panel of art professionals who meet at the project site along with the architect and representatives of the GSA and NEA. They review the visual materials (which are submitted through the GSA's slide registry) and nominate three to five artists for

each proposed artwork. The NEA forwards the nominations to the administrators of the GSA, who make the final decision.

Municipal, State, and Independent Public-Arts Programs

The precedent of allocating a certain percentage of the cost of new or renovated public buildings for art, as described in the GSA's Percent for Art Program and Art in Architecture Program, has also been legislated by many cities, counties, and states throughout the United States. Canada, England, France, and Australia have similar programs.

The National Endowment for the Arts provides grants to nonprofit organizations so that they can commission artists to create art for public spaces. The Public Art Fund, Inc., sponsors installations in public spaces throughout New York City. The Social and Public Art Resource Center in Venice, California, is a multicultural arts center that produces, exhibits, distributes, and preserves public artwork; it also sponsors murals and workshops.

The names and addresses of organizations and resources cited in this section are listed in the appendix section "Public Art."

Public-Art Programs for Transportation Systems

Other public-art projects have been initiated in conjunction with public transportation providers and airport administrators. For example, in New York City, the Metropolitan Transportation Authority Arts for Transit program commissions artwork for its family of agencies: MTA New York City Transit, MTA Metro-North Commuter Railroad, MTA Long Island Rail Road, and MTA Bridges and Tunnels. Arts for Transit places permanent art throughout its network through its Percent for Art program. It installs photographic work through its Lightbox Project, and brings music to subway stations through its Music Under New York initiative. Other art-in-transportation programs are sponsored by the Phoenix Sky Harbor International Airport and the Tucson Airport Authority in Arizona; the Los Angeles Metropolitan Transportation Authority, the Board of Port Commissioners in San Diego, the Santa Cruz Metropolitan Transit District, and the Cultural Council of Santa Cruz in California; Art at the Stations, and the Department of Aviation, Denver International Airport Program in Denver, Colorado; the Metropolitan Atlanta Rapid Transportation Authority in Georgia; the Bi-State Development Agency in St. Louis, Missouri; the Atlantic City

International Airport in New Jersey; the Port Authority of New York and New Jersey; the Philadelphia International Airport in Pennsylvania; the Nashville International Airport in Tennessee; the Department of Aviation, City of Austin, in Texas; and the Seattle-Tacoma International Airport and the Sound Transit Regional Transit Authority in Seattle, Washington.

\mathcal{M}AKING NATIONAL CONNECTIONS

A recent edition of the *Art in America Annual Guide to Galleries, Museums, Artists* lists 5,127 galleries, alternative spaces, museums, university galleries, private dealers, corporate art consultants, and print dealers throughout the United States, from Anniston, Alabama, to Rock Springs, Wyoming.

The *Annual* lists 617 commercial and not-for-profit galleries in Manhattan, 82 in San Francisco, 135 in Chicago, 55 in Los Angeles, 37 in Boston, 41 in Atlanta, and 36 in Dallas. Although many consider New York to be the art capital of the world (and also make the erroneous assumption that New York artists are more talented than artists elsewhere), the main reason New York is deserving of its title is the large number of exhibition opportunities that are packed into the small island of Manhattan. However, thousands of exhibition and sales opportunities are available throughout the United States and outside of the United States, resources that are consistently overlooked and neglected by the majority of artists.

As discussed in chapter 1, the main reason these resources are overlooked is that many naive artists believe that their market is limited to their area of residence; or that some sort of universal censorship is imposed, illogically concluding that there is no market *anywhere* for their work if they are unable to find a receptive audience in their hometown or city.

In addition, many artists fail to make national contacts because they ponder trivial details and dwell on the logistics of transporting work to other cities and working with out-of-town dealers.

It is important to keep in mind that regardless of the varied philosophical or altruistic reasons dealers give to explain their involvement with art, the bottom line is *money*. If someone believes *money can be*

made from your work, geographic considerations become inconsequential.

The *Art in America Annual* can be a helpful tool in locating out-of-town exhibition resources. On a state-by-state, city-by-city basis, it lists the names, addresses, phone numbers, e-mail addresses, and Web sites of gallery dealers, alternative spaces, university galleries, and museums. In most cases it provides a short description of the type of art and/or medium of interest, and the names of artists represented or exhibited.

Use the *Annual* to compile a list of galleries nationwide that are interested in your discipline or disciplines (for example, works on paper, sculpture, photography, painting, decorative arts). Although some of the descriptions that are provided in the *Annual* are vague or very general, an increasing number of galleries have Web sites that feature the work of artists they represent. Previewing these sites can quickly ascertain whether your work is appropriate for a particular gallery. If you are using a brochure (see page 58) or other forms of printed matter (see page 63) to contact a gallery, the cost-effectiveness of these presentations eliminates the need to spend a lot of time researching each gallery. On the other hand, if you are using a costly slide package with a self-addressed envelope, researching appropriate galleries is very important.

Publications that are more regional in scope offer more detailed information about exhibition resources. For example, *New York Contemporary Art Galleries: The Complete Annual Guide* lists galleries and alternative spaces in New York City. It describes each gallery's area or areas of interest, the selection process, philosophy, price range, and whether artists are required to contribute exhibition expenses or pay exhibition fees. *The Artists' Gallery Guide for Chicago and Surrounding Areas* lists exhibition opportunities in the Chicago region; and *Organizing Artists Directory of the National Association of Artists' Organizations* lists hundreds of organizations in the visual, performing, and literary arts, many of which sponsor exhibitions. The names and addresses of the publishers of these resource guides are listed in the appendix section "Exhibition and Performance Places and Spaces."

When an out-of-town gallery expresses interest in representing your work, the most effective way to determine if the gallery is appropriate is to visit it in person. (For guidelines on helping you determine

whether a gallery is right for you, see page 166, and for advice before making travel plans, see page 170.)

You can also make national contacts by writing to out-of-town museums, alternative spaces, public-art programs, art consultants, and university galleries and museums.

Developing markets beyond your home city offers many rewards. You should also consider extending your horizons beyond the United States.

\mathcal{M}AKING INTERNATIONAL CONNECTIONS

If you are interested in exhibiting and selling work abroad or participating in international arts programs, there are several resources that are available:

[A-N] Magazine for Artists is a monthly British publication with a comprehensive listing of exhibitions, residencies, competitions, and other opportunities for artists primarily in the United Kingdom. Its publisher, AN Publications, sponsors an excellent Web site that contains hundreds of resources on exhibitions, organizations, and professional contacts in the United Kingdom and in other countries.

Many other Web sites are devoted to the international arts' community. For example, Art Beyond Borders was initiated by a group of artists who use the Web to exchange ideas and information and organize exhibitions in members' respective countries; World Wide Arts Resources and Artscape2000 provide links to various galleries abroad; and World Arts: A Guide to International Exchange, sponsored by the International Partnership Office of the National Endowment for the Arts, is a comprehensive guide to international arts exchange programs.

As a result of contacting many of the resources provided by AN Publications, the work of artist Elizabeth Bram of Long Island, New York, was exhibited in five galleries in England and Scotland during a two-year period. Keeping detailed notes about her transatlantic adventures, she composed a journal under the title "Zero Gravity: Diary of a Travelling Artist." She wrote: "Why spend your life feeling rejected by the New York art scene when there are millions of other people on the planet who might enjoy your art work?"[23] The journal was cited earlier in this book when Bram described her experience with a vanity gallery in New York (see page 113).

The artist realized how fortunate she was to have cultivated professional contacts outside of the United States, contacts who did not look to New York for validation of her talents.

If you are intrigued with the idea of exhibiting and selling work abroad, but don't know how to make the contacts or get started, a variety of resources are available. Unfortunately, no single comprehensive reference book lists and describes international galleries, museums, private dealers, corporate consultants, and alternative spaces in detail, but several useful references are available.

The International Directory of Corporate Art Collections, published by the International Art Alliance, Inc., contains information on hundreds of corporate art collections, including the collections of Japanese and European corporations.

Arts International of the Institute of International Education in New York City offers several publications, including *Across the Street Around the World: A Handbook for Cultural Exchange*, a handbook for those starting out in the field of cultural exchange, and *Money for International Exchange in the Arts*, which includes information on grants, fellowships, and awards for travel and work abroad; support and technical assistance for touring and international exchange; international artists' residencies; and programs that support artists' professional development. In addition, Arts International distributes *More Bread and Circuses: Who Does What for the Arts in Europe*, which contains descriptions of special programs and funding opportunities available from the European Commission, the Council of Europe, UNESCO, and European foundations and corporations.

The London-based organization Visiting Arts publishes several directories that list cultural agencies, art venues, and resources in specific countries, including the publications *Visiting Arts Asia-Pacific Arts Directory, Visiting Arts Directory of Opportunities for Foreign Visual Artists to Work and Stay in the UK, Visiting Arts Hungary Arts Directory, Visiting Arts Israel Arts Directory, Visiting Arts Norway Arts Directory, Visiting Arts Palestine Arts Directory, Visiting Arts Quebec Arts Directory*, and *Visiting Arts Southern Africa Arts Directory*.

Artists Communities, compiled by the Alliance of Artists Communities, features a special section on artists' communities, art agencies, and key contacts that support international artist exchanges.

Artworld Europe is a bimonthly newsletter about art and gallery-related news in Europe.

In addition, there are many organizations that provide opportunities for artists to work, study, and/or exhibit abroad. For example, Arts International sponsors exchange and fellowship programs for artists; and the German Academic Exchange Office (DAAD) (Deutscher Akademicher Austauschdiens) sponsors an Artists in Berlin program.

By scanning periodicals that review and/or advertise international galleries you can get an idea of the type of work certain galleries exhibit. International periodicals can be found in bookstores and libraries that have extensive art sections. The names of various foreign art periodicals are listed in *Ulrich's International Periodical Directory*.

After compiling a list of museums and galleries, send each contact person a presentation package (see chapter 3), and include a cover letter stating that you are planning a trip to that person's city and would like to arrange an appointment if the person finds your work of interest. If you receive positive responses, make the trip a reality!

The same guidelines for selecting and working with domestic galleries are applicable to galleries in foreign cities (see page 166). The contacts cited in this section and additional resources for making international connections, including funding organizations, artist-in-residence programs, and studio-exchange programs, are listed in the appendix section "International Connections."

CREATING YOUR OWN EXHIBITION OPPORTUNITIES

Even though your presentation packages are circulating in registries, museums, commercial galleries, alternative spaces, and so forth, don't sit around waiting to be asked to exhibit and don't depend on someone to suggest a context in which to exhibit your work. Create your own context and exhibition opportunities.

Theme Shows

Curate your own exhibitions or performances, based on themes that put your work into a context. Theme shows can feature your work exclusively or include the work of other artists. At their best, theme shows increase and enhance art-viewing consciousness, demand the participation of many of our senses, and help the public as well as the art community understand and learn more about what an artist is communicating and the motivating influences revealed in the work.

For example, the group exhibition *Empty Dress: Clothing as Surrogate in Recent Art* featured the work of thirty contemporary artists. It focused "on the use of clothing abstracted from the body as a means of exploring issues of psychological, cultural and sexual identity."[24] The group exhibition *A, E, Eye, O, U, and Sometimes Why* contained two-dimensional pieces that used "a variety of media to express the concerns and reactions to different social, informational, and psychological situations, through the combined use of words and images."[25] The theme show *Top Secret: Inquiries into the Biomirror*[26] featured the work of artist Todd Siler and consisted of a "32-foot, 3-dimensional sketch of a Cerebreactor, drawings and detailed studies which introduce Siler's theories on brain and mind, science and art."[27]

Another asset of theme shows is that it is far more likely you will obtain funding for a theme show with *broad educational value* than for a show called *Recent Paintings*.

DEVELOP AND CIRCULATE A PROPOSAL

A proposal should describe your idea, purpose, intentions, and audience. It should tell why the theme is important, how you plan to develop it, and who will be involved. Supporting materials should include information about the people involved (résumé, slides, etc.) and indicate your space or site requirements. Depending on the intended recipient of the proposal, it could also include a budget and ideas on how the exhibition will be funded.

The proposal should be circulated to museums, colleges, galleries, alternative spaces, cultural organizations, and funding organizations. It could very well be that you will need only one of these groups to complete the project. On the other hand, you might need all of these groups, but for such different reasons as sponsorship, endorsement, administration, facilities, funding, and contributions.

ExhibitsUSA, a national division of the Mid-America Arts Alliance, is a not-for-profit organization that organizes traveling exhibitions. Although it does not accept proposals directly from artists represented in an exhibition, it considers proposals submitted by independent curators, museums or museum affiliates, and community cultural organizations.

Once a proposal is accepted, it is listed in an annual catalog that is circulated to museums, colleges and universities, and cultural centers throughout the United States. Each exhibition that is described in the

catalog includes such information as the exhibition fee and what expenses the fee covers, shipping arrangements, availability dates, and the type of security required.

Curators and participating artists in the ExhibitsUSA program receive a fee. The address of ExhibitsUSA is listed in the appendix section "Exhibition and Performance Places and Spaces."

A book published by the Smithsonian Institution Traveling Exhibition Service (SITES) called *Good Show! A Practical Guide for Temporary Exhibitions* is an excellent resource for artists interested in curating exhibitions and is also helpful for proposal writing, as it covers the complete range of factors that need to be taken into consideration (e.g., advance planning, preparation, fabrication, illumination, and installation). The book also includes a good bibliography for each of the subjects it covers. For further information see "Exhibition and Performance Planning" in the appendix.

ARTIST FEES

Often artists let the excitement of an exhibition opportunity interfere with clear thinking, and overlook various exhibition costs. The most neglected item in budget planning is an artist's *time*—for example, the time spent conceptualizing an exhibition, researching and contacting galleries and museums, and preparing and sending proposals and/or presentation tools. Then there is the time spent preparing, installing, and dismantling the exhibition. The list could go on and on.

Although some alternative and nonprofit galleries pay artists a fee to help offset exhibition expenses, this practice has not been widely adopted, nor is it widely recognized by artists that they have the right to request a fee, particularly a *realistic* fee.

Canada is far ahead of the United States in acknowledging the need for realistic artist exhibition fees. For example, the Canadian arts service organization Canadian Artists' Representation Ontario (CARO) recommends minimum exhibition fees that artists should charge when exhibiting in public or nonprofit museums and galleries. Recommendations take into account a wide variety of exhibiting situations, including single, two-person, three-person, four-person, and group shows; regional, interregional, national, and international touring and nontouring shows; and juried and nonjuried shows. CARO's recommended fees are published in the document *CARFAC Recommended Minimum Exhibition Fee Schedule*, which is posted on the CARFAC Web

site (see the appendix section "Exhibition and Performance Planning").

Open-Studio Events

You can generate exhibition and sales opportunities by opening your studio and/or home to the public. However, a successful open-studio event requires careful planning: You must develop an imaginative guest list with many *new* names and have a clear idea of what you want to achieve. Is your main goal exposure, sales, or a combination of both?

Following are guidelines for open-studio planning:

DATES. An open studio should be held on a *minimum* of two (not necessarily consecutive) days, preferably including at least one weekend day and one weekday evening.

INVITATIONS AND MAILING LIST. The invitation should include a visual image of your work (see page 93). Invitations should be sent to collectors, potential collectors, contacts within the art world, family, and friends. But most important, *invitations should also be sent to new people.* One way to do this is by telling friends and associates *who admire your work* and are *not* necessarily part of the art world that you want to increase your contacts for the purpose(s) of sales and/or exposure. Ask if they would be willing to write a personal note on the invitation, inviting their friends and associates to attend. If ten people send ten invitations in your behalf, one hundred new contacts will be generated. Another way of generating new faces is to send invitations to members of the business community in your area. Mailing lists can be obtained from local chambers of commerce or mailing list companies. Of interest to New York artists is *The Book of Lists Database* compiled by the publication *Crain's New York Business.* It contains hundreds of New York–based companies and identifies decision makers by occupation. It is available as a printout or it can be downloaded from the company's Web site (see "Mailing Lists" in the appendix).

USE AN ASSISTANT. All too often, open studios resemble gallery openings, with guests self-consciously glued to the walls. Uncomfortable environments are not conducive to generating sales or exhibiting work; people want to leave as soon as possible. It is important to create a warm and energizing atmosphere. Guests should be introduced to one

another. But if you are serving beverages, answering the door, asking people to sign a guest book, and taking care of other activities, you will not have time to meet people in an effective way, introduce guests, talk about your work, or answer questions. Hire a person or ask a friend to help out with all of the various tasks associated with an open studio so that you are free to spend time with people.

PROVIDE PRINTED MATERIALS. Prepare multiple copies of printed materials (as many copies as the number of guests expected), including a résumé (see page 43) or biography (see page 50), an artist statement (see page 51), press clippings (if applicable), and a price list (see page 73). These materials should be placed in a central location.

New York artist Donna Marxer uses the opportunity of holding an open studio by exhibiting each new body of work that she has created at various art colonies. In one year she had as many as ten open studios. "I do exhibit [in] other places, but the Open Studio is now a keystone in my career. I now have a solid base of collectors who eagerly attend my art parties."[28]

\mathcal{M}USEUM STORES AND PRODUCT DEVELOPMENT

Museum shops offer a viable venue for the sale of certain types of one-of-a-kind objects and multiples, including ceramics, sculpture, photography, prints, woodworking, fiber arts, graphic products, and jewelry. There are literally thousands of museums shops throughout the United States and abroad.

Museum buyers decide which objects and multiples will be sold through their respective museum shops. Large museums usually have several buyers, some of whom are responsible for product selection, and others for product development.

Kathy Borrus, formerly a merchandise manager at the Smithsonian Museum Shops, recommends that "before you send information to a museum shop or call the buyer, understand the museum's mission. Learn as much as you can about the museum and the shop's products and price points. Remember that education and museum relatedness drive a buyer's selection."[29] Borrus also suggests that you "call the museum shop's buying office to find out if they want to see slides,

photographs or samples of your work. Be prepared to wait for a response. Buyers are inundated with calls and unsolicited samples."[30]

Museum buyers are also interested in working with artists on product development. Borrus points out that "product development is more time consuming [than] selling your basic line. . . . The process is often lengthy. Several prototypes and numerous stages of approval are the norm before an item is ready for sale."[31]

A list of museum shops can be obtained from the American Association of Museums, which rents various museum-related mailing lists. The Museum Store Association also sells a list of museum shops nationwide and in other parts of the world. However, the list is only available to Museum Store Association members. Affiliate memberships are offered to artists who are already selling work to museum shops at a wholesale price. The addresses of both of these organizations are listed in the appendix section "Mailing Lists."

Selling from Your Studio

Most artists find the experience of selling work directly to the public gratifying on several levels. The intimacy of a studio and direct contact with an artist can create a positive environment, and for many people direct contact with an artist is a chief factor in buying art.

But people buy art for many different reasons. Increasing studio sales requires an understanding of basic sales skills particular to selling art, and an understanding of individual buying styles. In her book *How to Sell Art: A Guide for Galleries, Art Dealers, Consultants, and Agents* (see the appendix section "Career Management, Business, and Marketing"), Nina Pratt, a former art market advisor, offers the following advice:

> Learn your own buying style, because it influences your selling style. . . . There are as many different buying styles as there are people. But there are a few main categories that most people fall into . . . [for example,] impulsive versus calculating buyers. . . . There are also people who hate to be told anything . . . as opposed to the ones who want a full biography of the artist; the ones who have to tell you their life stories before they are ready to buy; the apparently timid, docile client with a will of steel; [and] the bargain hunters [who] will ask for a discount at the drop of a hat.

Learning how to distinguish each type comes with time and practice. Until your instincts develop, rely on . . . skillful questions to find out which sort of person you are dealing with.[32]

The questions Nina Pratt recommends include: Does this person buy art? What kind of art? In what price range? Is your work appropriate for this person? Does this person have the authority to buy, or will a spouse have the final say?[33] Pratt points out, however, that "most visitors . . . would be turned off if you boldly grilled them on these subjects. So you must learn to probe delicately but precisely for the information that you need."[34]

Marketing Art on the Internet

In the book *The Arts and the Internet*, the author V. A. Shiva writes about a visual artist who used the Internet as a marketing tool: "Within six months, 15,000 visitors came to view her artwork at her Web site. . . . 'More people have seen my art in the past six months than in the past six years.' She could never had gotten such exposure in the traditional venues of galleries and shows," adds Shiva.[35]

The possibilities for exposure on the Internet are mind-boggling. Web sites offer artists opportunities to have their work seen by gallery dealers, art consultants, collectors, curators, public-art agencies, architects and interior designers, and so forth. But the information that artists want to know about most was not cited in Shiva's anecdote: what are the tangible accomplishments related to art sales or career development that result from thousands of people viewing artwork on Web sites?

When Web sites were first developed for the purpose of establishing on-line galleries, it was hailed as the most promising vehicle for direct sale of artwork between an artist and a collector. However, as time passed, Web site sponsors have become more realistic in defining the Internet's effectiveness as a marketing tool.

Since the mid-1990s I have observed and participated in art-marketing projects on the Internet, tracking the direct and indirect results of on-line exposure as it relates to an artist's career development and sale of artwork. I know artists who have sold work as a result of having their work featured on for-profit on-line galleries (see

below), auction sites, and Web sites sponsored by traditional galleries. I also know artists who have received invitations for gallery represen- tation as a result of having their work shown on not-for-profit on-line galleries (see page 145). And I know artists who have sold work as re- sult of having their own Web sites (see page 146).

In recent years various articles have appeared in newspapers and magazines about the influence of the Internet on the art market, from the perspective of individual artists, traditional galleries, auction houses, and the buying public. The New York Foundation for the Arts con- ducted a survey[36] in 1995 to determine how artists use computer-based technology in their creative (rather than administrative/secretarial) work; however, a study on the effectiveness of artists using the Inter- net for the purpose of marketing and sales or on the sales results of for-profit and not-for-profit on-line galleries has yet to be undertaken. But it is clear that the Internet can offer all artists *support services* for traditional venues of marketing work, and it offers some artists sales benefits. The question of whether technological developments will eventually replace traditional art-marketing venues will be answered in the future, but, at present, the Internet can be used as an effective adjunct to traditional art-marketing efforts. This section offers advice and information about using the Internet to sell and/or exhibit art- work and to make your vision better known.

FOR-PROFIT ON-LINE GALLERIES

When on-line galleries were first developed, they were hailed as the most promising vehicle for the direct sale of artwork between an artist and a collector. Many artists indulged in the fantasy that collectors would view artwork on the Internet and place an order sight unseen. And indeed it has happened. But it is not happening to all artists who use on-line galleries.

Basically, there are two types of for-profit on-line galleries: those that receive a commission on the sale of artwork and those that charge annual or monthly fees.

Commission-based galleries are either juried or nonjuried. Although some of the fee-based galleries vow that their sites are juried, since their main goal is to register as many artists as possible to collect hun- dreds of monthly or annual fees, with the exception of eliminating

artwork that is perceived as pornographic, it is likely that their aesthetic standards are very broad.

My clients have sold work through commission-based on-line galleries, in particular Guild.com, NextMonet.com, and PaintingsDirect.com. The sponsors of these Web sites spend a significant amount of time and money reaching out to consumers with good public relations and advertising campaigns. A correlation between successful sales records and effective publicity, press, and advertising campaigns is very clear. Unfortunately, other commission-based on-line galleries, as well as artists, naively believe that just *being* on the Internet is enough!

A big drawback of participating in fee-based on-line galleries is that the sponsors are compensated with artists' fees, regardless of whether sales are made or not made. As with vanity galleries (see page 111), fee-based on-line galleries do not have an incentive to spend time and money marketing on behalf of participating artists.

Sales commissions charged by commission-based on-line galleries vary, from as little as 20 percent to as much as 60 percent. It would be ill-advised to work with an on-line gallery that charges more than 50 percent, just as it would be to work with any other type of gallery that charges more than 50 percent.

The on-line gallery Passion4Art charges a sales commission of 20 percent and offers artists special services, including the tools and instructions to create their own Web pages free of charge.

Be careful about working with an on-line gallery that requires exclusive representation on *all* Internet-exhibited artwork. Some on-line galleries might consent to having your work exhibited on not-for-profit Web sites if commerce is not involved, but would require exclusivity for all Internet sales. An on-line gallery might also perceive a conflict of interest if you are represented by a traditional gallery that features your work on its Web site.

Although you might agree to give an on-line gallery an exclusive arrangement for a *limited* number of works that are being featured on the gallery's Web site, and for a *limited* amount of time, having all of your work tied up with one on-line gallery means that you are putting all of your eggs in one basket and receiving little in return. This type of broad-based exclusive arrangement rarely makes sense, regardless of whether you are working with an on-line gallery or a traditional gallery.

You should be free to work with as many on-line galleries and tra-
ditional galleries as you desire. In selecting on-line galleries, *make
choices that are in your best interest.* You might be willing to agree to a
limited type of exclusive arrangement if the sponsor is consistently
engaged in advertising and promotion campaigns or provides special
services, such as those offered on the Passion4Art site. Unfortunately,
some of the for-profit on-line galleries were modeled after the greedy
philosophy of traditional galleries, offering artists a minimum of ser-
vices while charging high sales commissions.

The names of on-line galleries referred to in this section and others
are listed in the appendix section "On-Line Galleries."

NOT-FOR-PROFIT ON-LINE GALLERIES

Many state arts commissions have initiated on-line galleries for artist-
constituents, encouraging potential collectors to contact artists di-
rectly. For example, the Artists Register Online sponsored by the
Western States Arts Federation (WESTAF) is a juried site that show-
cases the work of artists living in Colorado, Arizona, and New Mexico.
Maryland Art Place, in conjunction with the Maryland State Arts
Council, sponsors an on-line gallery that features the work of some of
the fifteen hundred artists in the Maryland region who participate in
the Maryland Art Place artists' slide registry. The Showcase Gallery is
an on-line gallery featuring artists selected from the Visual Arts Slide
Registry of the New Jersey State Council on the Arts. The Ohio Online
Visual Artist Registry features the work of artists in Ohio and from
other parts of the United States. It is administered by the Ohio Arts
Council and sponsored by the Ohio Percent for Art Program and by
the Humanities, Fine Arts and Recreation Division of the Columbus
Metropolitan Library.

Not-for-profit art service organizations also sponsor on-line gal-
leries that are available to members for a fee or free. For example, the
American Print Alliance, a consortium of printmakers councils, spon-
sors an on-line gallery. The International Sculpture Center sponsors
an on-line gallery featuring the works of sculptors throughout the
world. The Chicago Artists Coalition is an artist-run service organiza-
tion that offers members access to an on-line gallery. The names of

not-for-profit on-line galleries are listed in the appendix section "On-Line Galleries."

\mathcal{M}ARKETING YOUR OWN WEB SITE

Pointers for designing a Web site are included in chapter 3, "Presentation Tools and Packages" (see page 63). But before plunging into the time and expense of designing your own Web site or having one designed, embark on the project with realistic expectations. Be clear about how you plan to use the site. For example, will it be directed at the general public for the purpose of selling art on-line? Will it be directed at curators, gallery dealers, art consultants, or other members of the art world for the purpose of soliciting interest in your work? Will it be directed at members of the art world who have expressed interest in your work, but need to be updated? Or will it be used as a gallery to share your work and ideas with other artists and members of the art world—without any expectations?

Having a good understanding of how you intend to use your site will dictate how the site should be organized and designed. For example, it will help you determine whether it will be necessary to become involved with e-commerce and the use of merchant credit cards. A well-thought-out design can greatly enhance marketing effectiveness.

Thousands of artists worldwide have already created their own Web sites, and thousands of artists are also experiencing the challenge of how to get people to visit their sites. Advice, suggestions, and guidelines for getting visitors to your site, along with other marketing tips, are now being provided by artists who for several years have been actively engaged in increasing traffic on their sites and have been persistent in their Internet marketing efforts.

The sculptor Marques Vickers, who sells his work on more than thirty international auction sites, offers a lot of useful advice and information on a wide range of topics in his e-publication *Selling Art on the Internet*. Subjects include the use of search engines, indices, and on-line auction houses. He also covers reciprocal links, "hitometers," paying for visitors through "pay for click" services, and guerrilla marketing, which he describes as "the two pronged process of writing your own rules in selling, and maximizing every exposure opportunity."[37]

V. A. Shiva's book, *The Arts and the Internet: A Guide to the Revolution*, explores avenues for selling, exhibiting, promoting, and creating artwork in cyberspace. The chapter "Setting Up Shop" discusses customer orders on-line and the use of merchant credit cards. Other chapters deal with "cyberpublicity," "netiquette," using newsgroups, and the use of guest books.

Artist Chris Maher publishes a free e-mail newsletter, *Selling Your Art Online*. In addition, Maher offers generous and free advice on his Web site by the same name on a wide range of topics such as "Using Information to Sell Your Art," "How Visible Is Your Gallery on the WWW?" "Computer Speak for Artists," and "Off Line Promotions for Your Web Site."

In the book *Self-Promotion Online: Marketing Your Creative Services Using Web Sites, E-mail and Digital Portfolios*, the author, Ilise Benun, an art-marketing consultant to self-employed individuals in creative fields, offers a lot of advice and information on networking techniques.

Information about the above-mentioned resources can be found in the appendix sections "Career Management, Business, and Marketing" and "Web Site Design."

Using Your Web Site to Supplement Traditional Marketing Tools

When the Internet was first introduced and a few pioneering artists had their own Web sites, requests to gallery dealers, curators, and art consultants to preview a site would be honored. But over the years requests to preview Web sites have grown considerably, and recipients of "look at me" e-mails are overwhelmed.

Unless you have already established a relationship with a gallery dealer, curator, or art consultant, a better way to announce your Web site is to use snail mail. Send a postcard (see page 63) or a brochure (see page 58) that includes an example or examples of your artwork. Postcards and brochures *should be accompanied by a personalized cover letter* that announces the Web site and provides background information about yourself and your work (see page 53). If your mailing is not *accompanied* by a cover letter, there is a good chance that the card or brochure will be construed as an exhibition announcement that requires no follow-up. Into the waste basket it will go!

Your Web site address should be incorporated into brochures (see

page 58) and résumés (see page 43). Reference to Web sites can be incorporated into cover letters (see page 53). For example: "If you find my work of interest, I would be pleased to provide additional information. Please note that additional images of my work can be viewed on the Internet," and so forth.

Marketing your Web site should not be limited to members of the art world. Marketing efforts should also include potential collectors who live in your region. An outreach to a regional business community could produce studio visits as well as increase attendance of open-studio events (see page 139).

Announce your Web site to members of your regional business community with cards (see page 63) or brochures (see page 58) and a cover letter (see pages 53). Mailing lists can be obtained from local chambers of commerce or mailing-list companies. Of interest to New York artists is *The Book of Lists Database* compiled by the publication *Crain's New York Business* (see "Mailing Lists" in the appendix).

Dealing with Dealers
and Psyching Them Out

Although this chapter is primarily about gallery dealers, much of the information and advice and most of the perspectives and views are also applicable to people in other arts-related occupations, including art consultants, curators, critics, administrators, collectors, and artists. Some of my impressions and characterizations might seem severe, but it is not my intention to throw all of the blame for the ills and injustices in the art world on dealers, curators, and the like. *Artists must also accept responsibility for the way things are*, mainly because most artists, overtly, covertly, or inadvertently, participate (or try to participate) in the dog-eat-dog system. Few are trying to change it.

If I had my way, I would replace commercial galleries with a system in which artists exhibited work in their studios and sold it directly to the public. But such a system could work only if artists acquired enough self-confidence not to need gallery validations, and if the public, likewise, had the self-confidence necessary to buy work without gallery validation. Since there is a very remote chance that these events will occur in my lifetime, the next best thing for changing the system is to regulate the business practices of galleries nationwide, including policies affecting commissions, discounts, insurance, payments to artists, and the use of contracts. For the time being, since the gallery system is still very much intact and is virtually unregulated, the following opinions, advice, and observations are aimed at helping artists acquire more business savvy, more control over their careers, and more control in their relationships with those who are currently running the show.

\mathcal{L}IES, ILLUSIONS, AND BAD ADVICE

Artists are constantly bombarded with erroneous, irresponsible, and unethical advice about the art world and art galleries. While some advice is exchanged through word of mouth, much of it is disseminated through articles in trade publications. Some of these articles are written by well-meaning but naive individuals who are connected to the art world in some capacity; others are written by less-than-well-intentioned art-world figures whose motives are self-serving. For example, in an article from *Art in America*, a dealer assures readers that "a minority of dealers are strictly concerned with commercial success."[1] However, he then condones the greedy practice of awarding dealers a commission on *all* studio sales:

> An artist may on occasion sell a work directly from his studio to a friend or to a collector he has known before his gallery affiliation. It is the artist's ethical obligation to report such transactions to his dealer and to remit a reduced commission, commonly 20 percent, to compensate the dealer for a work he cannot offer under the usual terms of their agreement.[2]

Another dealer advises *ARTnews* readers that the fastest track into the art world is to work for a famous artist.[3] A political scientist *cum* art collector encourages beginners to exhibit only in "small" places when he writes in *American Artist*, "Begin building your career at smaller local or regional galleries of good repute. It is too bruising to try the larger galleries in major art centers."[4] An arts administrator encourages artists to retreat if they are rejected by galleries, advising, "If your first search is unsuccessful, wait a year or two and try again."[5] And a career consultant to artists states that the reason it is important to dress presentably is "so that you give the impression that you're making money somehow, presumably through your artwork."[6]

Artists also give each other peculiar and bad advice. For example, in a book profiling contemporary artists, an artist discusses how she uses sex to get ahead: "I've been propositioned a lot: 'I'll give you a show if you sleep with me.' It happens often. Would I do it for a show? Now I would, but when I was younger I wouldn't. I wouldn't because I was a jerk."[7] And another artist tells beginners that "one of

the necessary qualities of being an artist . . . is to not expect an awful lot, to be somewhat dense about any thoughts of what you will get out of being an artist."[8]

If you believe everything you read you would conclude that, in order to find a gallery and succeed in the art world, you must sleep with dealers, and dress as though you have a lot of money. You should work for a famous artist, and when beginning your career, you should have low expectations and exhibit in small, local galleries. You should avoid large cities at all costs. And if you are rejected from galleries, you should retreat and wait a year or two before trying again!

Although in composite form these recommendations sound very silly, many artists, unfortunately, believe the advice to be true.

DEALERS: THEIR BACKGROUNDS AND PERSONALITIES

To compile information for the book *New York Contemporary Art Galleries: The Complete Annual Guide*, editor Renée Phillips prepared a questionnaire that was sent to galleries and exhibition spaces in all five boroughs of New York City.

The questionnaire addressed specific areas of interest to artists, such as how the gallery selected artists, the gallery's philosophy, and the type of work exhibited. The questionnaire also asked dealers to provide information on their "backgrounds." Although the book contains over five hundred listings, from a sample of *379 commercial* galleries in Manhattan, 207 of the galleries did not provide "background" information. Since the majority of dealers omitted this information, it is not possible to formulate a typical profile sketch about the backgrounds of dealers in Manhattan. However, one conclusion that can be drawn from Phillips's study is that most dealers in Manhattan are unwilling to share biographical information!

Of the dealers that provided the information, fifty described their background as gallery dealer or as having had gallery experience. Another four dealers provided an even vaguer response of having been "involved in fine art." Thirty-two dealers were artists; fourteen dealers were involved in banking, finance, and business or sales unrelated to art; twelve dealers had studied art history or were art historians; eleven dealers were art collectors; and five dealers were interior designers. Four dealers each were attorneys and art advisors or art consultants.

Four dealers had worked in museums, and another four had been involved in the field of music. Three dealers each were curators and art publishers. Three were previously affiliated with nonprofit organizations. Two dealers each had been in fashion, real estate, advertising, magazine or book publishing, and filmmaking. Two dealers had been involved in teaching and education. In addition, there was an architect, a restaurant owner, a television executive, a theater producer, a philosophy major, an artist manager, a book printer, a journalist, a gemologist/press attaché, and an art-display producer.

Allowing for a handful of elderly dealers who most likely exempted themselves from answering the question because they had been dealers for most of their working lives, one can speculate that the reason dealers were unwilling to share details of their backgrounds is that their backgrounds have nothing to do with visual art. They fear that such a discovery will diminish their power and credibility, and even worse, it will cause them to lose the mystique that envelops their occupation: the mystique of possessing a "golden eye," which gives them the right to determine "good" art and "good" artists.

Although a background in fine arts does not ensure that a dealer will be effective in art sales and capable of running a gallery, for many dealers who do not have such a background fear of exposure of what they *perceive* to be their "dirty little secret" has become a major factor in the molding of their personalities.

Relating to people who possess a fear-based psyche, whether an artist or a dealer, is very difficult, and the difficulties are manifested in several ways. For example, *arrogant* and *temperamental* are adjectives frequently used to describe both artists and dealers. Was it the arrogance of an artist that forced a dealer to retaliate with the same weapon? Or was it a temperamental dealer who elicited the same response from an artist? Is it a chicken-and-egg situation or a matter of simultaneous combustion?

Arrogance is a self-defense tactic to disguise insecurities. Some artists and dealers suffer from the same basic insecurities about their past, present, and future. The fear that causes a dealer to conceal biographical information originates in the very same place as the fear that makes it painful for an artist to compile a résumé because he or she lacks an academic background in the fine arts. The fear that causes a dealer to cut gallery expenditures in all of the wrong places is the same fear that causes an artist to be miserly about investing financially

in his or her career. The fear of a dealer that he or she will never attain art-world recognition is comparable to the fear of an artist who experiences a panic attack when a fortieth, fiftieth, or sixtieth birthday begins to approach.

Many dealers are frustrated artists who did not have the tenacity, perseverance, and fortitude to stick it out. Consequently, they are jealous of anyone who did. The wrath of some dealers pours forth when they spot weak work or weak personalities. A weak artist reminds them of themselves, and the memories bring little pleasure. Other dealers behave like bulls that see red: they believe all artists are threatening. They do not differentiate.

Because many dealers are unable to produce provocative work, and *showing* provocative work does not gratify their frustrated egos, they compensate by cultivating provocative personalities. Some dealers are so skilled in verbal delivery that they lead others to believe they know what they are talking about. These dealers begin to believe that their reputations give them the right to make outrageous, irresponsible demands and give outrageous, irresponsible advice. These dealers also believe that reputation alone exempts them from the requirements of morality or integrity, let alone courtesy.

A painter once came to me for advice about his dealer, with whom he had worked for several years. The dealer gave him single shows on a regular basis, and the artist sold well at all of them. However, the dealer, one of the better known in New York, had been badgering the artist for months to stop doing freelance work for a national magazine. The dealer contended that if the artist continued to work for the magazine he would not be taken seriously as a fine artist. The artist began to question the dealer's judgment only when it infringed on his financial stability. Until then, he let the dealer's opinions influence and control his life.

In response to his problem, I simply stated that it was none of a dealer's business how an artist made money; the artist looked at me as if this were the biggest revelation of the century!

Another client was told by a dealer who had just finished rejecting him to be careful about showing his work to other artists because they might steal his ideas. The artist didn't know what to do with the backhanded compliment. On the one hand, the work wasn't good enough for the dealer. On the other hand, the ideas were good enough to be stolen. Up until that point the artist had not been paranoid about

other artists stealing his ideas, but the dealer successfully instilled a fear: beware of the community of artists!

Dealers take great delight in giving artists advice on how their work can be *improved*. The lecture begins with a critique of the artist's work that quickly transforms into an art history class. And artists listen. They listen in agony, but they listen.

It Takes Two to Tango

Many artists have an "attitude" about dealers and anyone else in the art world who is perceived as an authority figure. In the years that I have worked with artists, I have had to remind clients on several occasions that I am not the enemy!

I am reminded of an artist who called me to make an appointment to discuss her career. She called back a few days later to cancel, saying her slides weren't ready, then quickly changed her mind about the excuse she had offered and lashed into a tirade that ended with: "And who in the hell are you to judge my work? I don't want to be put in a position to be judged."

It took me a while to regain composure, but when I did, I told her that, in my capacity as a career coach to artists, I did not judge work, and even if I did, I hadn't called her, *she had called me* and set up the situation!

Once, at a cocktail party where artists were in the majority, a painter used the opportunity to verbally abuse a dealer he had just met for the first time. At the top of his lungs he held the dealer personally responsible for the hard time he was having selling his work, and he tried, unsuccessfully, to goad his colleagues into joining his tirade. The scene served no other purpose than to add some excitement to what, up to that point, had been a very dull party. The dealer left in a huff, followed by the artist, who was angry that he had received no support or encouragement from his peers.

On another occasion, a meeting I had with a client and his dealer centered on the artist's career. As long as this was the case, the artist was enthusiastic and amiable. However, when we finished with the subject at hand and drifted on to other topics, the artist began yawning, squirming in his chair, and nervously rapping on the table. When he saw that neither the dealer nor I intended to respond to his body language, he started ranting that he was bored with our conversation. With one conciliatory sentence the dealer placated the artist so easily

and skillfully that I realized how familiar and experienced he was with this kind of behavior.

Artists have been known to engage in the shady practice of secretly selling artwork to a dealer's client at a highly discounted rate. Although it does not happen often, it does happen, and once a dealer experiences a broken trust, he or she begins to suspect *all* artists of participating in such schemes.

I recently learned of an artist who had been asked by his dealer to crate and pack a painting that had been sold through the gallery. The artist did not know the name or address of the collector, but in the packing crate the artist left a note saying that if the collector wanted to buy the painting at a substantial discount, he should return the work to the gallery and contact the artist directly. The proposal appealed to the collector, and he informed the dealer that he had changed his mind about buying the painting. When the collector returned the painting to the gallery in the packing crate, he inadvertently included the artist's letter. When the dealer unpacked the crate and found the letter he received quite a shock. And so ended the artist's relationship with the gallery.

Dealers can also be cruel or even sadistic, heaping abuse on artists while the artists masochistically allow it. The following episode illustrates the point loud and clear.

A painter took slides to a dealer. While he was viewing her work, he lit up a cigar. After examining the slides he said that he wasn't interested—her work was "too feminine." He then proceeded to give the artist a lecture on the history of art, all the while dropping cigar ashes on her slides.

The artist watched in excruciating pain, but didn't say a word. When the dealer finished the lecture, the artist collected her slides and left the gallery. But she was so devastated by the symbolism of the ashes on her work that she put herself to bed for three days.

Regardless of whether the dropping of ashes was sadistic or inadvertent carelessness, the question remains, Why didn't the artist say something? For example, "Excuse me, but you are dropping ashes on my slides!"

One wonders: if the dealer had been pressing his foot on her toe, would she have allowed him to continue? When the dealer said that her work was "too feminine," she should have immediately left the gallery (with a curt "Thank you for your time") or stayed to challenge

his idiotic statement. As Mark I. Rosen, author of *Thank You for Being Such a Pain*, points out:

> The decision to tough it out or take a hike is one of our most difficult choices. There is no wrong choice, because we learn from both. Either choice may help us to become a better person or offer us experiences that will help the next time we find ourselves in a similar situation.[9]

Just as artists tend to forget that, to a great extent, a dealer's livelihood depends on an artist's work, dealers also forget, and they need to be reminded. Reminding them won't necessarily mean that they are going to like your work any more, but it can give you some satisfaction and put things in perspective, something that the art world desperately needs.

Dealers as Businesspeople

Finding gallery representation is a task that requires patience. In New York, for example, many artists are strung along by galleries for as long as ten years. After several rounds of annual studio visits and more rounds of appointment changes or no-shows, a commitment is finally made—an actual exhibition date is scheduled. But the exaltation of gallery status can quickly dissipate when one discovers exactly what being a gallery artist entails.

Nina Pratt, who for many years served as a New York–based art-market advisor to gallery dealers and art consultants, observes:

> If those considering opening a gallery or entering a related profession were presented with a checklist of qualities and skills necessary for a successful career, the majority of people would have second thoughts about entering the field![10]

Pratt is knowledgeable about the inner workings of gallery operations, and she sheds light on why so many dealers sink or barely keep their galleries afloat, and live up to neither their own nor artists' expectations. If many of the reasons she addresses sound very familiar, it is because they are the very same reasons that prevent artists from achieving their goals, with or without gallery representation.

Pratt believes the root of the problem is that many dealers believe the myth that art and business do not mix. "Dealers are terrified of being viewed as used-car salesmen. They go to great lengths to disassociate themselves from the 'business' aspects of art."[11] She also points out that many people who open galleries naively assume that an arts-related profession will automatically make them successful. Parallels can be drawn between these dealers and the artists who believe that talent is the only skill necessary to guarantee a constant stream of dealers, curators, and collectors knocking at the door.

Pratt also points out that since a dealer's selling style usually matches his or her personal buying style, he or she frequently hires a staff with a similar selling style. This lack of flexibility can severely cripple sales. "Collectors come with a variety of backgrounds, tastes, and buying power," Pratt says. "They also come with a variety of ways they behave as consumers. A gallery must be able to adapt to the range and differences in consumer habits."[12]

During personal encounters with the public, dealers tend to go to extremes by either not talking at all or taking too much. The cool, nonverbal approach can be perceived as intimidating; overly talkative dealers might not hear what the client is saying. "Important data can be gleaned from listening, including aesthetic learnings, price range, style of buying, and sincerity of interest," Pratt observes.[13]

Citing greed as one of the most self-defeating business practices, and noting dealers' unwillingness to split commissions with other dealers and art consultants (also see page 178), Pratt adds that "dealers should be willing to pass up commissions in order to show clients that they can get them what they want. This can most definitely strengthen a working relationship with collectors, stimulate trust, and encourage future sales. A cooperative spirit between dealers, and between dealers and art consultants, is at an all-time low."[14]

Pratt also faults dealers for their approach to advertising, which is discussed in chapter 5 (see page 95).

"The Attitude"

The former New York dealer André Emmerich once said that "good dealers don't sell art; they allow people to acquire it."[15] Such a statement sets the tone for the way art is often marketed, an attitude conveyed not only in a gallery's selling style, but by its staff.

For many collectors and potential collectors, the Internet has

become a welcome retreat from the abusiveness they have experienced in the art world. As journalist Missy Sullivan points out, "On the Web you don't get that in-your-face snootiness that turns off so many would-be buyers at elite galleries."[16]

In a *New York Times* article the art critic Grace Glueck described some common grievances voiced by the public about galleries.[17] Complaints spanned a range of issues, including the absence of basic civil courtesies and being patronized or treated rudely when purchasing work in the lower end of a gallery's price spectrum.

Dealers, for their part, complained that the public is not knowledgeable about art; they ask too many questions. Dealers further suggested that members of the public do their homework *before* entering a gallery.

The article painted a disheartening picture of the gallery world, primarily in New York City, but the picture is even more disheartening when one realizes how pervasive "the attitude" really is.

Although most dealers are not perceived as used-car salesmen, they often overreact to their fear of being perceived this way by cultivating snobbish airs. However, a haughty attitude coupled with a lack of business acumen often results in a loss of clients and potential clients, and eventually in the loss of their galleries!

Unethical Business Practices

If a dealer is engaged in unethical business practices or emotional abuse, it is not always apparent until an artist is already involved in a formal relationship with the dealer. Some of the ploys used by abusive dealers include playing "mind games," making outrageous demands on artists, and dispensing bad advice. Often, artists are willing to accept a dealer's tyrannical or manipulative behavior as long as they don't feel that the dealer is cheating them financially.

THE MARTYR SYNDROME

Frequently, dealers see themselves as martyrs who are taking a big risk simply by selling art for a living. But many of the dealers who had made their way into the art world in recent years require artists to share the financial risks of running a gallery—without sharing the profits. Because they see themselves as martyrs, dealers also rationalize that it is fair and just to use an *artist's share* of a sale to offset gallery cash-flow problems. Artists are paid when it is convenient—or in some cases they are never paid!

In the second edition of this book, published in 1988, I wrote:

> In the area of finance, there are certain disreputable dealers who
> are easy to identify, for they blatantly nickel-and-dime artists for
> every expense that is directly or indirectly related to an exhibition.
> Up until the time work is placed in a gallery, an artist is financially
> responsible for the costs of preparing the work for exhibition and
> transporting the work to a gallery. But once the work is in the
> gallery, an artist should not have to pay for any costs other than a
> dealer's commission, and then only if the work is sold!

Tragically, there would be slim pickings if artists limited themselves
only to galleries that pay for all exhibition costs. Data compiled in the
book *Artists Gallery Guide for Chicago and Surrounding Areas*, published
in 2000 by the Chicago Artists Coalition, showed that 34 percent of
the for-profit galleries polled require artists to share all or some ex-
penses, including promotion materials, receptions, and postage.

Although the majority of Chicago galleries still pay for most
exhibition-related expenses, the statistics are indicative of *a trend out-
side of New York City* to make artists more responsible for gallery costs.
In New York City, the practice of requiring artists to split or fully ab-
sorb exhibition expenses is not a trend, it is a *fait accompli*!

GALLERY HANKY-PANKY

Sometimes dealers deduct exhibition expenses and/or client discounts
from an artist's share of a sale without forewarning the artist of this
policy. And sometimes when work is sold artists are paid based on a
price they previously set, when in reality the work sold for a higher
amount. In many instances artists are oblivious of the deception.

One artist suspected something fishy after his numerous requests
to his dealer for copies of sales invoices pertaining to his work went
unheeded. He concocted a brilliant scheme to determine whether his
suspicions were justified. Knowing that his dealer was out of town, he
telephoned the gallery assistant to share a secret: he confided his plans
to give the dealer a collage to commemorate his first year as a gallery
artist. The collage would incorporate copies of sales receipts pertaining
to his work, symbolic of hopes for a continuing prosperous relation-
ship. The artist asked the assistant to cooperate by allowing him to
photocopy the receipts. The assistant eagerly complied.

The receipts showed that the artist's suspicions were indeed justified. In one instance, a painting for which he had been compensated based on a selling price of $5,000, had actually been sold for $10,000! The case was settled out of court, and the artist received all of the monies due.

Although the artist was financially compensated for sticking up for his rights, he suffered an emotional blow when he told other gallery artists that he had been cheated and that he planned to take legal recourse. He was chided by some of the artists for "hanging the gallery's dirty laundry in public"; others preferred to look the other way and pretend nothing had happened.

In New York, price manipulation of artwork in galleries was so endemic that in 1988 the city's Department of Consumer Affairs ruled that the prices of artwork in New York galleries must be "conspicuously displayed" for all visitors. Galleries complied, but not without a big fuss. Critic Hilton Kramer wrote a scathing article in *The New York Times* to protest the ruling. His basic point was that galleries are not retail stores and should not be required to display price tags.[18] However, *Times* readers disagreed, and in the following weeks numerous letters to the editor were published contesting Kramer's point of view. One art collector wrote:

> Art galleries are stores. Their proprietors, the art dealers, are merchants. Their primary purpose is to sell art in order to make a profit. They are not houses of worship. They are not museums. They are not schools. They are not eleemosynary institutions. The dealer is not an altruist dedicated to educate and elevate the public. He is a pragmatic businessman. . . . There is no valid reason why this rule should not apply to galleries so that the collector will get the same information as other consumers.[19]

And an artist wrote:

> Mr. Kramer endorses . . . both the "old boy" approach and the "if you must ask the price . . ." snob approach: salesmanship by intimacy and intimidation, respectively, which is exactly what the New York City Department of Consumer Affairs is trying to end. . . . As consumers, we are assured that the amount on whatever price tag is meant for everyone. How strange it is that

the art gallery racket is the singular exception to this forthright concept, and how stranger that art dealers should be allowed to hide behind that protective screen of esthetics, of all things.[20]

\mathcal{H}OW DEALERS FIND ARTISTS

One of the most annoying and irrational explanations of why the work of more artists is not exhibited in galleries is the cliché that "there are too many artists" or "there are not enough galleries for the number of artists." Such notions reinforce the myth of scarcity that is discussed in chapter 1.

The real reason that the work of more artists is not receiving gallery exposure is that there are too many dealers who are unwilling to take a risk on representing artists who do not have an exhibition track record. There are also too many dealers who know very little about how to sell art or develop an expanding and broad base of collectors, and there are too many dealers who do not know how to tap into new markets and audiences.

On the other hand, many artists without exhibition experience feel trapped by the popular belief that one must have a track record to be considered for gallery representation. Although many galleries are only interested in showing the work of artists with exhibition experience, if an artist has a track record it logically implies that other galleries were willing to exhibit the artist's work without a track record!

The book *New York Contemporary Art Galleries* includes information about the selection process of galleries. Out of 471 galleries in the five boroughs of New York City that show the work of contemporary artists (excluding membership galleries, rental galleries, print publishers, and vanity galleries), 151 galleries stated that they find artists through unsolicited slide packages; 125 galleries provided no information on their selection process; 91 galleries stated that they select artists through a combination of unsolicited slide packages, referrals, publications, and exhibitions; 56 galleries listed other means of selecting artists; 36 galleries stated that their galleries are closed to new artists; and 12 galleries stated that they select artists only through referrals.

It is interesting to compare these findings to a study done in the late 1970s when *Artworkers News* published the first and only comprehensive

survey at that time of New York City galleries that showed contempo-
rary art.[21] The study was based on a questionnaire completed by
ninety-nine galleries. Although the main purpose of the study was to
investigate the extent to which galleries were excluding artists on sex-
ual or racial grounds,[22] it unearthed some insights into the gallery sys-
tem of the 1970s. The study indicated that the main way galleries got
new artists was through artist referrals *and* referrals from other "art-
world figures." The study indicated, however, that artist referrals were
the *primary* source.[23]

Referral Systems

Understanding how referral systems operate can sometimes be hazy
and difficult to decipher. But a clear example of how the artist referral
system works is depicted in the following chain of events. One of my
clients, a painter, approached a well-known New York gallery dealer.
He set up an appointment, showed his slides, and the dealer re-
sponded with the "Come back in two years" routine. Several weeks
later, while the painter was working as a waiter, he noticed that a fa-
mous artist was sitting at one of the tables. He introduced himself to
the celebrity and asked whether the celebrity would come to his stu-
dio to see his work. The painter and celebrity exchanged telephone
numbers, and within the next few weeks the celebrity paid the artist a
visit. The celebrity was impressed with the painter's work, so im-
pressed that he bought a painting and insisted that the painter show
his work to a specific gallery dealer, coincidentally the same dealer
who had rejected him a few weeks before. The celebrity called the
gallery dealer, raved about the artist, and shortly afterward my client
returned to the gallery. This time he was greeted with another routine,
but one more pleasing to his ear: "Where have you been all my life?"

Unfortunately, artists who are willing to refer other artists to galleries
are in the minority, and for reasons that reflect on the emotional need-
iness of many of those who have acquired gallery representation (see
chapter 10, "Rationalization, Paranoia, Competition, and Rejection").

On the other hand, although artist referrals do exist, referrals from
other art-world figures offer more mileage.

For example: Curator tells dealer that critic wrote an excellent re-
view about artist. Dealer checks out artist and invites artist into
gallery. Dealer tells curator that artist is now part of gallery. Curator
tells museum colleagues that artist is part of gallery and has backing of

critic. Curator invites artist to exhibit at museum. Curator asks critic to write introduction to exhibition catalog in which artist is included. Dealer tells clients that artist has been well reviewed and is exhibiting at museums. Clients buy.

There are other variations on the same theme, including curator/dealer/critic conspiracies, which involve each buying the work of an unknown artist for very little money. Press coverage and exhibition exposure begin, and within a short period of time the dealer, curator, and critic have substantially increased their investment.

Throughout the book *The Art Biz: The Covert World of Collectors, Dealers, Auction Houses, Museums and Critics*, Alice Goldfarb Marquis describes the many entangled, self-serving relationships among art-world figures, pointing out that

> the marketplace in stocks and bonds operates under stringent regulations against insider trading and conflicts of interest and insists on considerable openness about buyers, sellers, and prices. Despite occasional lapses, trading is constantly monitored; violators of the rules could end up being frog-marched down the center of Wall Street in handcuffs. By contrast, the art marketplace tolerates—indeed fosters—a sleazy, robber-baron style of capitalism not seen on Wall Street since the Great Depression. . . . If they were dealing in securities rather than one of humankind's noblest endeavors—art—the perpetrators of such egregious conflicts would be in jail.[24]

New York art dealer Richard Lerner acknowledged the importance of the art-world-figure referral system when he discussed his criteria for inviting new artists into his gallery. He described his selection process, which sounds more like a shampoo-judging contest, in this way:

> For the benefit of the people that are already in the gallery, it's imperative, if I add names, I add names that already have some luster . . . I mean peer approval . . . who are recognized curatorially, critically as having importance in the mainstream of American art.[25]

One can ponder at great length over the reasons why a dealer initiates a business relationship with an artist. But there could be as many

reasons as there are dealers, and in the end it is a pointless task. A much more productive use of time and energy should be spent contacting dealers to let them know that you exist.

Artists who want to gain broad exposure and/or derive a healthy part-time or full-time income from gallery sales *must be represented by many dealers.* Relying on one dealer for your livelihood is not practical for many reasons. For example, your dealer might die, go into bankruptcy, or go out of business for other reasons. And unless a dealer understands the importance of expanding his or her client base and, most important, *is willing to engage in an expansion,* the gallery's narrowly focused market will soon become saturated, and sales activity will come to a screeching halt.

INSUFFICIENT TRAINING OF DEALERS

The section "Insufficient Training of Fine Artists" in chapter 1 (see page 5) discusses the problem of art schools not preparing students for real life. The same problem of unpreparedness holds true for dealers, most of whom jump into the field without a clue of how to run a gallery, how to sell art, and how to work with artists in order to achieve a mutually satisfying relationship.

Being an art dealer requires no particular qualifications. *Anyone* can become a dealer, and it seems apparent that *anyone* and *everyone* have become art dealers as witnessed by a general lack of good business and marketing skills, good business standards, and good business attitudes in the dealer's community at large. Also prevalent are a general lack of sensitivity toward artists and a lack of basic knowledge about art.

One of the biggest attractions for becoming an art dealer is that the *immediate* payback is formidable. The *instant* respect, awe, and power gained by dealers are probably unparalleled in any other occupation. On the other hand, obtaining a reputation as a dealer who *actually sells* art is a completely separate matter.

However, positive changes are being made to prepare future art dealers for the gallery world. Degrees in arts administration are now being offered at colleges and universities throughout the United States and abroad, and many of the programs are specifically structured for people who want to become art dealers.

The goals expressed by Columbia College Chicago regarding its graduate program, The Arts, Entertainment and Media Management, are certainly refreshing compared to the reality of how galleries are currently being run:

> Successful arts management is critical to the continued vitality of modern cultural institutions, creative enterprises, and arts organizations. If the public is to benefit, skilled arts managers must facilitate the work of artists. To achieve this end, capable managers combine aesthetic sensibilities and business acumen. Their financial, legal and organizational decisions help make it possible for artists to realize their vision and to share it with the public. In short, talented arts managers are partners in a collaborative process.[26]

Courses offered at Columbia College Chicago include Marketing Principles and Applied Marketing; Decision Making: Visual Arts Management; Arts Entrepreneurship; and Arts, Media, and the Law. Golden Gate University in San Francisco offers an M.A. degree and a certificate in arts administration. Courses include Contemporary Arts Issues; Legal Aspects of Arts Administration; and Marketing Management. The State University of New York at Binghamton offers an M.B.A. degree in arts administration. Courses include Marketing for Managers; Operations Management; Human Resource Management; Resource Management for Investors; and Resource Management for Customers. The School of the Art Institute of Chicago offers an M.A. in arts administration. Courses include Exhibition Implementation; Social Issues in Art and Technology; and International Issues in Arts Administration. The University of Oregon in Eugene offers both M.A. and M.S. degrees in arts management with courses titled Art and Human Values; Art and Gender; Art in Society; and Multimedia for Arts and Administrators.

Additional information about colleges and universities that offer degrees in arts administration can be found in the *Guide to Arts Administration Training and Research* (see appendix section "Employment Opportunities") published by the Association of Arts Administration Educators.

Perhaps in the near future the *majority* of individuals joining the

ranks of art dealers will possess the necessary skills and knowledge that can lead to successful careers and make the gallery experience and the experience of working with art consultants much more pleasurable and professional for artists, the public, and other members of the art world.

Selecting Galleries

The most common advice given to artists about selecting galleries is to start small and avoid big cities. The advice is not based on any great truism or profound knowledge; it is simply the way things have been done. However, there is no guarantee that if you start with a small, obscure gallery you will end up in a large, high-profile gallery, just as there is no certainty that if you start big you will automatically be turned away. Since neither of the formulas is guaranteed to work, *approach all galleries that meet your criteria*. Keep all of your options open and do not let supposedly pragmatic advice narrow the possibilities.

Criteria for Selecting Galleries

Deciding whether the gallery is right means paying attention to big and little details. Obviously, respecting the work of gallery artists is an important consideration, but do not limit your selection to those galleries featuring work that is similar to your own. Although it seems like a logical criterion by which to select a gallery, logic does not often prevail in the art world, and a dealer might respond by saying, "We have someone doing that already!" Select galleries that show artists with whom you *share an affinity*.

The physical properties of a space, including size, ceiling height, and light quality, are another important consideration. Envision your work in the gallery space. Would it be exhibited to its best advantage? Does the gallery have a cluttered or a spacious feeling?

Another important factor to consider is a gallery's price range. A gallery should offer you pricing *breadth*. Even though your work might currently be priced in a lower range, you want to be able to gradually increase your prices. Therefore, you need a gallery that sells work in a flexible price range. Many galleries have a price ceiling based on what they think their constituency will spend on art.

Let Your Fingers Do the Walking,
and Wear a Disguise

The *Art in America Annual Guide to Galleries, Museums, Artists* is a helpful tool for locating galleries throughout the United States. Other publications offer more detailed information on a regional basis, including *Artists Gallery Guide for Chicago and Surrounding Areas* and *New York Contemporary Art Galleries: The Complete Annual Guide*. The names and addresses of the publishers of these resource guides are listed in the appendix section "Exhibition and Performance Places and Spaces."

Use the *Annual* and/or regional publications to compile a list of galleries corresponding to the various descriptions that apply to your work (e.g., works on paper, sculpture, photography, painting, decorative arts). The *Annual* includes the Web site addresses of many galleries making it possible to quickly access information about a specific gallery and the type of work that is exhibited. In addition, the Internet offers good resources for locating hundreds of galleries through such sites as World Wide Arts Resources.com and Gallery Guide.com (again see appendix section "Exhibition and Performance Places and Spaces").

For galleries in your area follow up by visiting each gallery to ascertain whether it is right for you. Consider this to be an "exploratory" visit—not the time to approach a dealer about your work. On the contrary, *disguise yourself as a collector*. You can glean much more valuable information about the gallery if the dealer thinks you are there to buy! By asking the right questions, you can learn quite a lot about the gallery's profile, including its price range, the career level of artists represented, and whether the dealer and/or his sales force is effective.

On the basis of your experiences during personal gallery visits, eliminate from your list the galleries that are no longer of interest and concentrate on approaching those that have made an impression.

For artists interested in exploring galleries in New York, the Art Information Center provides a consultation service that involves screening slides and preparing a list of suggested galleries. The center will see artists by appointment or in certain cases review slides by mail. The address of the Art Information Center is listed in the appendix section "Arts Service Organizations." Guidelines for contacting out-of-town galleries are described in "Making National Connections" (see page 132) and "Making International Connections" (see page 134).

What a Gallery Can Do

A gallery has the *potential* to provide artists with many important amenities that are valuable in the present as well as the future. The optimum services to artists can include selling work through single and group exhibitions and on consignment; generating publicity; establishing new contacts and providing entrée into various network systems; developing and expanding markets in all parts of the world; arranging to have work placed in collections; arranging exhibitions in museums and other galleries; and providing financial security in the form of cash advances and/or retainers.

The minimum gallery services can include selling work on consignment (without an exhibition), providing general gallery experience, and adding résumé credits.

Naively, artists either (1) believe that once they are accepted into a gallery, the optimum services will automatically be provided, or (2) enter a gallery relationship without any expectations, thus missing the amenities that a gallery could provide. Keep in mind that dealers in big galleries do not provide any more or fewer amenities than dealers in small galleries. *It really depends on the dealer.*

There are various reasons why some dealers are more supportive than others. In some instances, it is because a dealer is so busy promoting one particular artist that other gallery artists are treated like second-class citizens. Often it is a case of downright laziness. For example, an artist was told by his dealer that he had been nominated for *Who's Who in American Art*, but the dealer had let the deadline pass for providing the required biographical data. In addition, for more than two months she had been "sitting on" sixty-five written inquiries that had resulted from the artist's work being published in a magazine.

Since there are no guidebooks available that evaluate dealers by strengths or weaknesses, the best way to track down this information is to talk to artists who are with a gallery or artists who have left one.

FEAR OF LEAVING A GALLERY

Artists have many excuses for staying with galleries even though the relationship with a dealer might be unproductive or even painful. Many artists believe that it is better to have a gallery with a poor performance record than no gallery at all.

Feelings of financial and/or emotional dependency on a dealer are prevalent among artists who have a difficult time terminating a relationship with a gallery, regardless of whether it is a well-established gallery or it is much less prestigious. The fear of leaving a gallery can be even more intense if an artist has a relationship *only* with *one* gallery.

Regardless of how lazy, contentious, unfair, or ethically dubious a dealer might be, many artists will stay with the dealer through hell and high water because of an underlying fear of *never again* being able to find another gallery. Irrational as the fear might be, it prevents artists from establishing better relationships with other dealers.

Some artists who have achieved success in the art world want to believe that once you are on top you are entitled to stay on top, as if to expect a cosmic IOU slip that is valid for the rest of their lives. And even though a dealer's interest in an artist has waned to a point where an artist is treated with disdain, the artist will remain with the gallery because of false pride. Some artists who have experienced success early in their careers have a particularly difficult time at a midlife junction, because they contend that they have passed the point where they should have to initiate new contacts; they see it as degrading or they fear that other people will perceive it as degrading. They are either unaware or refuse to acknowledge the fact that maintaining career recognition and success is a maintenance job, sometimes for the rest of your working life. Very few successful artists are given the good fortune of being able to coast.

Don't be afraid to leave a gallery if you find that it is no longer serving your best interests. Give a dealer a chance to respond to your needs or requirements, but if he or she is unresponsive, leave.

PRESENTING YOURSELF AND YOUR WORK

Dealers are so whimsical: I mean, who knows who is going to like what? I just tell people that I know it's a humiliating, horrible process. I don't approve of it at all, the way artists have to trundle around with their wares. I hate being in a gallery when an artist is in there showing slides. It makes me sick to my stomach—I mean, whoever the artist is. But the fact remains, that's how it works and I'm not going to be able to change it

singlehandedly. If artists get upset about it, maybe they will do something about it.[27]

Most artists can probably identify with the circumstances and feelings described here by author and critic Lucy Lippard. But showing your work to a dealer doesn't have to be a painful, gut-wrenching experience. Doing everything possible to put yourself on the offensive will make the process easier. As the artist John Balessari points out, "A friend of mine said that you should call gallery dealers merchants and then the relationship becomes clear."[28]

The first step is to understand that many dealers play games. *Just realizing that games are being played will give you an edge*, making it less likely that the games will be played at your expense. Having an edge can give you the self-confidence and perception necessary to respond with precision, candor, wit, or whatever the circumstances call for. Compare this power with the many times you have walked out of a gallery thinking of all the brilliant retorts you wished you had said while you were there. Keep in mind that one reason why dealers appear to be in control, even when they are hostile, is that they have a lot of experience talking to artists. Dealers have much more contact with artists than artists have with dealers. The more face-to-face encounters you have with dealers, the more quickly you will be able to psych them out, and the more rapidly your tongue will untwist. Practice makes perfect!

How you contact a gallery can also put you on the offensive. You can walk in cold, lukewarm, warm, or hot. Walking in cold means that you are literally coming off the streets without setting up an appointment or bothering to inquire whether the dealer has regular viewing hours. Chances are you will be interrupting one of the numerous tasks and appointments that consume a dealer's day. Walking in cold leaves you vulnerable to many uncertainties, except the fact that you will receive a cold reception.

Walking in lukewarm means that you have set up an appointment in advance and/or have received a positive response to your initial presentation package (see chapter 3), and the dealer has requested a more extensive visual presentation, additional information, or has asked to see the work in person.

But before making travel plans or committing to a consignment and/or exhibition arrangement, certain issues need to be addressed.

For example, you need to know the gallery's sales commission policy. An artist from New Jersey drove one thousand miles to Chicago at the request of a gallery that had expressed interest in her work. Although the artist had double-checked to make sure that this new contact was not a vanity gallery (see page 111), she had failed to ask about the sales commission, only to learn that the gallery charged 75 percent!

You also need to know whether the gallery uses contracts. Negotiating with out-of-town dealers can be as simple as sending a contract (see pages 177–182) that outlines your requirements and, if necessary, being willing to compromise over certain issues. However, it can also be as complicated as persuading a dealer to use a contract!

If you are unfamiliar with a gallery's business reputation, request the names and phone numbers of a few artists who are represented by the gallery. Or if you prefer to contact the artists directly, many of the names of artists represented by a particular gallery are listed in the *Arts in America Annual* and on gallery Web sites. Keep calling until you get a reaction. Dealers complain that they are pestered with phone calls, but phone calls are the only way to circumvent procrastination and vagueness. As long as the package remains unopened, you are losing valuable time; the package could be in the process of review elsewhere. One of the advantages of using a brochure (see page 58) in lieu of slides (see page 55) is that you do not have to wait for it to be returned to contact other people.

Walking in warm means that you have been personally referred by an artist or art-world figure. In other words, someone is allowing you to use his or her name. You still might have a hard time getting an appointment, but be persistent. Persistence is not making one telephone call and giving up.

Walking in hot means that a person who is well respected by a dealer has taken the initiative to personally contact the dealer on your behalf.

Don't Show Your Work to Subordinates

Do not show your work to a gallery subordinate (e.g., receptionist, secretary, gallery assistant, assistant manager) for the purpose of eliciting an opinion regarding whether your work is suitable or appropriate for the gallery. Although there are exceptions, subordinates rarely have any power to influence a dealer's decision, and you should not put them in a position to interpret their boss's tastes. Too many artists

make the mistake of allowing their work to be judged by gallery underlings. Subordinates are capable of giving compliments, but your ego is in sad shape if you need to hang on to the opinion of each and every staff member who happens to be hanging out at the gallery. Always get the final word straight from the horse's mouth—the gallery owner or director.

Additionally, do not let subordinates discourage you from seeing a dealer. There are always a million excuses why an appointment is impossible. For example, "Mr. Smith is much too busy; he's going to Europe." "He's just returned from Europe." "He's preparing an opening." Don't assume that this overprotectiveness of the boss is necessarily maternalistic or paternalistic. On the contrary, it can be one of the many tactics used by people who feel powerless to usurp what they don't have. In some cases, subordinates want to see your work so *they* can reject it. In other cases, subordinates derive pleasure simply from informing an artist that a dealer is unavailable. Of course, not all subordinates are involved in these power games, and there are those who are sincerely interested in seeing your work. But keep in mind that subordinates are not in a position to make the decision as to whether your work will be accepted by the gallery. Their enthusiasm or discouragement is opinion, not gospel.

There are ways to penetrate the protective shields that surround a dealer. Name-dropping can work. Demonstrating a good sense of humor can also be effective. And then there is basic honesty, letting the person know that *you know* that he or she is playing a power game and why. Honesty is an effective tool in disarming someone.

Don't Send a Substitute

Even if a friend, mate, spouse, or relative is trying to be supportive and offers to take your work around to galleries, turn the offer down. Do not send a substitute; it is unprofessional and it weakens your position. A dealer wants to know, and has every right to know, with whom he or she is dealing. Likewise, an artist has the same rights and should have the same concerns. If a dealer delegates the responsibility to see an artist's work to a subordinate, an artist will not feel that he or she is being taken seriously. And if an artist is unwilling to confront a dealer, the dealer could conclude that the artist is not serious about exhibiting at the gallery.

Agents

The use of agents is an accepted practice and has sometimes proved to be effective for marketing and selling art that is *commercially used*. For example, photographers, illustrators, and fashion and graphic designers use agents ("reps") to establish contacts, obtain commissions, and sell their products.

In such cases, the artist pays a commission to a rep, but not to anyone else. For an agent to make a decent living, he or she must represent several artists simultaneously. The nature of the commercial art business makes this feasible. A rep may work with many publishers, whose business requires and needs many artists, with different styles and different areas of expertise. Thus, a rep can handle many artists without anyone being neglected (although I am sure some commercial artists would argue with me on this point).

However, in the field of fine arts the use of agents is complicated. Dealers do not like to split commissions, and usually if an agent is involved it means the dealer will receive less money on a sale. And if a commission is paid to an agent from an artist's share of a sale, ultimately the artist pays more money in commissions than he or she receives for the sale of the work. For example, if a dealer's commission is 50 percent, and an agent's commission is 20 percent of the artist's share, for a painting priced at $5,000 the dealer receives $2,500, the agent receives $500, and the artist receives $2,000!

Separate from the issue of paying double commissions, the most practical reason why a business relationship between agents and fine artists rarely succeeds is the amount of time required to nurture and develop *one* artist's career, let alone several artists' simultaneously. Any artist who is actively and persistently engaged in marketing and career development understands how time-consuming these endeavors are.

Beware of an artist representative who requires fees or a monthly stipend in addition to sales commissions. Although they might try to justify the additional fees or stipends, because they offer other services, such as making telephone calls and writing letters, this is *what they should be doing* to earn a sales commission! Whether or not such services are actually provided can be difficult to determine, and it can take several months or even years and several hundreds of dollars to realize that a lot of time and money were wasted. Keep in mind that if

an agent is being paid a fee or stipend in addition to a sales commission, the enticement to sell your art work is not as strong.

A few years ago, on the East End of Long Island, New York, where I live, an agent suddenly vanished with large amounts of money representing unfulfilled promises to more than fifty artists and the proceeds from art sales that belonged to artists and a collector. Each artist had paid her a $2,000 retainer for the promise of exhibitions, sales, publicity, catalogs, and international contacts.

In hundreds of other regions, artists continue to advance money to agents who make promises they do not keep. Some agents are ineffective because they are inexperienced in sales and do not understand the inner workings of the art world. But there are other agents, such as the one on Long Island, with less than honorable intentions, who take advantage of artists who share a particular mind-set that often leads to their victimization. Contributing factors to this mind-set include neediness, gullibility, and the *illusion* that there are actually people in the art world who can look after your best interests better than you.

In 2000, the California-based publication *studioNOTES: The Journal for Working Artists* interviewed gallery dealers and sent questionnaires to 110 top galleries across the country. "We learned that most dealers don't want to work with agents,"[29] reported editor Benny Shaboy.

> On the questionnaire, we listed about 10 ways that galleries might find new art: slide packages from artists, recommendations from collectors or artists already in the "stable," agents, etc. Each dealer was asked to indicate the approximate percentage of new artists he or she took on through each method. The rating for "agent" was zero. A few dealers wrote in "never," and one wrote in "bad idea. . . ."[30]

The article goes on to say that

> galleries want to work directly with the artists because they want to have a sense of who the artist is. In addition, a dealer who can say "the artist told me that . . ." is more likely to impress a potential collector than the one who says "I've never met the artist." Furthermore, there is a belief that the type of art that agents rep-

resent is usually the "churn-em-out-sell-em-to-hotels" sort rather than the more personal one-of-a kind things that contemporary galleries look for. Finally, dealers don't like to share their commissions with agents.[31]

And in my opinion, the fact that galleries do not like to split commissions is the real bottom line!

Over the last several years in the fine arts a new type of agent has emerged. Known as art consultants (also see page 122), they bypass galleries and sell work *directly* to businesses, corporations, and individuals. For the most part, since galleries are not involved, an artist is not faced with the dilemma of having to pay double commissions totaling more than 50 percent. Even when consultants split commissions with galleries or other consultants, an artist's share of the proceeds of a sale is not larger than 50 percent. Although there are a lot of misconceptions about the type of work art consultants sell, while some consultants specialize in mass-produced prints, many other consultants have a sophisticated and eclectic palate.

When working with art consultants, have realistic expectations. Art consultants do not nurture artists' careers; they sell artwork. You might be one of several hundred artists an art consultant represents, and there is a good chance that he or she won't remember your name unless you are in touch on an ongoing basis.

In addition to art consultants, there are private dealers who are former gallery owners who found that it was more cost-effective to represent artists without high gallery overhead costs, and to use their contacts and networks in a new way. Essentially, an agent who works this way goes directly to the client, and two commissions are not involved. Unlike an art consultant, this type of agent represents a limited number of artists, and is likely to be interested only in artists with proven track records.

Some artists are using managers. Although a manager functions as an agent, he or she works with only one artist, and is paid a salary or fee in lieu of commission.

In chapter 10 (see page 213), I describe an artist's fantasy of finding the perfect agent. It is important to learn to *manage your own career* because the odds are too low that you will find the fantasy agent, or even one who works well with dealers and splits commissions with

them; who takes on emerging artists; who is an effective business-person; and who works with a small number of artists, giving each of them tender loving care and individual attention.

Studio Visits

Believe it or not, dealers dread studio visits as much as artists dread having them visit. Both parties are nervous and uncomfortable. Dealers are uneasy because they do not like to be put on the spot on an artist's turf. They feel more comfortable rejecting an artist or being vague in their own territory. Dealers also feel anxious about the reception they will receive. They fear that an artist will use the studio visit to give the dealer a taste of the same medicine the artist received in the gallery!

Artists are nervous about the judgment that a studio visit implies. They are anxious about being rejected, or they feel hostile, thus validating a dealer's worst fears that the studio visit will be used as an opportunity to "get even."

One dealer told me that she had to prepare herself mentally weeks in advance of a studio visit. "They are always a nightmare. Artists are so arrogant and hostile." I asked her how she coped with such situations. "I am indecisive and unresponsive. This drives them crazy!"

You have the power to set things up so that the studio visit accomplishes something positive. In some instances, you also must take some of the responsibility if the visit turns out to be unsatisfactory. A successful studio visit should not depend on whether the dealer offers you an exhibition. Many of my clients have been able to score excellent referrals through studio visits. Although the dealers didn't believe that the work was right for their galleries, they were impressed enough to contact other dealers or curators on the artists' behalf, or offered to let artists use their names to set up appointments (enabling them to "walk in warm").

When you host a studio visit, be yourself and don't turn your life upside down. A curator who had spent a concentrated month visiting artists' studios observed that artists who lived and worked in the same space often made a conscious effort to create an atmosphere that suggested their lives were devoid of other living entities. Although the curator saw relics and signs that indicated that the premises were inhabited by dogs, cats, babies, children, and other adults, the studios

were conspicuously cleared of all of these other forms of life. She felt very uneasy, as if the artists had a special lifestyle reserved for curators. She sensed that the artists viewed her as subhuman. The strange atmosphere actually diverted her attention away from the art. She couldn't give the artists or their work her undivided concentration.

Even though you might not yet have had a gracious or civilized gallery experience, treat a dealer the way you would want to be treated when you enter his or her domain.

As soon as the studio visit begins, *take control* by defusing tension. Tell the dealer that you understand this is only a preliminary visit and you do not expect a commitment.

Sometimes circumstances are beyond your control. The worst studio visit I ever had involved a well-known art critic who came to look at my work for the purpose of writing an article in a national news magazine. The meeting was going well, but just as he began to select photographs to accompany the article, our meeting was interrupted by an emotionally unstable artist acquaintance who had decided to pay me a visit. Before I had a chance to make introductions, the artist lashed into a series of incoherent insults, *impersonally* directed at anyone who had happened to be in the room.

While the art critic quickly packed up his gear, I tried to make apologies. The critic was unresponsive. He had assumed that the artist's insults were directed at him because he was a critic. He departed and I never heard from him again, although I wrote a letter of apology. I was guilty by association.

At first my anger was directed at the artist, but the more I thought about it, the more I realized that the critic and artist had much in common: they were both devoid of clarity and powers of reason.

I lost the article, but I also lost my awe of the critic. This was an important gain.

Artist-Gallery Agreements

Beware of dealers who won't use contracts. Requesting someone to enter into a formal agreement does not imply that you are distrustful. It merely attests to the fact that being human lends itself to being misunderstood and misinterpreted. Contracts can help compensate for

human frailties. Another important reason for using contracts is that it will save you a lot of time and energy in having to reinvent the wheel each time a situation arises that needs some sort of clarification.

Also beware of contracts prepared by dealers. Just because a contract is *ready*, don't assume that its contents are necessarily in your best interests. This brings to mind a contract recently proposed by a New York gallery to an artist living in the Midwest. The contract tied up the artist for three years, requiring him to pay the dealer a 50 percent commission on work sold through the gallery and a 30 percent commission on all work sold *through other galleries*. The contract did not state whether the 30 percent commission should come from the artist's proceeds of a sale or a third party, but either arrangement would have a devastating impact. It would either paralyze the artist from working with other dealers, or it would leave the artist with only 20 percent of the retail price of artwork sold.

Prior to the artist's establishing a relationship with the New York gallery, his work had been exhibited at museums and prestigious institutions throughout the United States and abroad. He was a National Endowment for the Arts fellowship recipient, and a university professor. But his perception of the importance of having a New York gallery threw his reasoning abilities out of whack, and he signed the contract!

Over the years, most of the dealer-originated contracts that I have screened have not been at all in the best interests of the artists. For the most part they have been narrow in scope and have not taken into account the very realistic scenarios that can develop in an artist/gallery relationship. A contract is a *symbol* that a transaction is being handled in a "professional" manner. What the contract contains is the heart of the matter.

All negotiated points (as well as unnegotiated points) *must* be put into writing. The section "Law: Contracts and Business Forms" in the appendix lists resources for obtaining legal advice and *sample* contracts for various situations that involve artists and dealers. I emphasize *sample* because the contracts should be used as *guidelines*. No two artists or their situations are 100 percent similar, and contracts should reflect these distinctions accordingly.

Gallery Exclusives

Some galleries request exclusive rights to sell an artist's artwork. The exclusive arrangement might be limited to a small geographic region

or it could be as broad as world rights. It could be limited to a specific body or series of work, or encompass all of your artwork. It could be limited to only the work that is created during the duration of an artist/gallery contract.

Think twice about entering into an exclusive relationship. What are the benefits and disadvantages of an exclusive arrangement, as compared to being free to exhibit and sell your work through an unlimited number of venues? Does the agreement provide provisions to receive a *realistic* amount of financial compensation to make it worth your while, such as a monthly stipend as an advance against future sales?

What you want to avoid is being exclusively tied to a gallery that is not working hard on your behalf, such as the following worst-case scenario:

An artist accepted an exclusive arrangement with a New York gallery without consulting an attorney. He signed an eight-show contract, giving the gallery exclusive world rights, for all sales, including those made out of his studio. The contract only specified a total number of exhibitions; it did not include an ending date, and the dealer was free to spread the exhibitions over a period of many years, which she did.

Occasionally she advances the artist money, a mere pittance. Since there is no formal arrangement regarding advances against sales, she has the power to oblige or deny his request for money. Making matters worse, the dealer is lazy and has a very limited knowledge of how to sell art. Her husband is wealthy and she is not under pressure to earn money. She has the personality of a barracuda and alienates everyone who crosses her path. Consequently, she sells very little work.

Consignment and Consignment/Exhibition Agreements

A consignment agreement and a consignment/exhibition agreement are the most common types of contracts between an artist and a dealer. Many artists mistake a consignment *sheet* for a contract. A consignment sheet should be *attached* to a consignment agreement or consignment/exhibition agreement; it provides an inventory of the work in a dealer's possession and states the retail value of each piece. A consignment *agreement* should cover basic issues, including the length of time the contract is in effect, whether a dealer is limited to selling your work within a specific geographic region, where in the

gallery your work will be displayed, the range of sales commissions to be awarded a dealer under *various circumstances*, transportation and packaging responsibilities of the artist and dealer, financial arrangements for rentals and installment sales, artist payment-due schedules, and gallery discount policies.

In addition, a consignment agreement should protect an artist against the assignment or transfer of the contract, and address the very important issues of moral rights, arbitration, copyright, and insurance.

A consignment/exhibition agreement should cover all of the issues just raised, but it should also outline the exhibition-related responsibilities of an artist and dealer. Does the gallery pay for advertising, catalogs, posters, announcements, postage for announcements, press releases, postage for press releases, special installations, photography sessions, opening parties, and private screenings? Or are all or some of these costs split between the artist and gallery—or fully absorbed by the artist?

Artist Sales Contract

An artist sales contract is an agreement between an artist and a collector. Although dealers do not sign this contract, the fact that an artist requires a sales contract as a condition of sale can be a provision in a consignment agreement, consignment/exhibition agreement, or artist/agent contract (see page 123).

Some dealers are vehemently opposed to the use of an artist sales contract because they are naive and are unilaterally opposed to all artist-related contracts. Other dealers are opposed to the contract because it states the price actually paid for the work. If a dealer is involved in hanky-panky, the last thing he or she wants an artist to know is the work's real selling price. Probably the most common reason some dealers are opposed to the use of the contract is they fear that if an artist knows the name and address of a collector, the artist will try to sell more work to the collector without the dealer's involvement. You can placate some dealers by assuring them that you would much rather be in your studio creating work than going behind their backs trying to sell work. Making an effort to address a dealer's fear often resolves the situation.

From an artist's point of view, a sales contract or artist transfer sales agreement (see page 181) is very practical. Not only does it provide you with a record of who owns your work at any given time, but it re-

minds collectors that they cannot alter or reproduce your work without your permission. The contract also states that the artist must be consulted if restoration becomes necessary. And if the work is transferred to a new owner, the sales contract is also transferred.

ARTIST TRANSFER SALES AGREEMENT

An artist transfer sales agreement includes all of the provisions of an artist sales contract, but it goes one step further: it requires the collector to pay the artist a percentage of the increase in the value of a work *each* time it is transferred. The amount of the percentage can vary.

In California, which is the only state that has enacted a resale royalties act, artists are entitled to a *5 percent* royalty on the gross sale price when work is resold in California or by a California resident. This ruling applies to any work created after January 1, 1977, that is sold for more than $1,000 and more than the seller's original price. The California act applies only to paintings, sculpture, and drawings, and the artist must be either a United States citizen or a two-year resident of California at the time of resale.

Some artists are using *7 percent*, which was the amount required in the Resale Royalties Act that was proposed but defeated in New York State. Others are using *15 percent*, an amount suggested in what is known as the Projansky Agreement, drafted several years ago by New York attorney Robert Projansky.

In recent years, the United States Congress commissioned the Registrar of Copyrights at the Library of Congress to conduct a study on the feasibility of enacting national resale royalties legislation and establishing a collection agency or agencies to monitor its enforcement. In an article about the Library of Congress study, La Jolla, California, arts attorney Peter H. Karlen discussed the pros and cons of resale royalties:

> There are practical and theoretical reasons for resale royalties. The typical visual artist is one of the most underpaid individuals in our society. The commissions that artists pay to dealers and other agents are terribly high, and sales of artworks are often at extreme discounts. Why shouldn't a consumer of artwork have to pay a royalty based upon each new "consumption" of the work, in the same way that purchasers of books pay the author (via the publisher) upon each new purchase?

Nonetheless, unless the attitudes of dealers and collectors change so that they fully understand artists' residual rights in their works and the theory behind resale royalties, enacting a national resale royalty law is only likely to create a new expensive bureaucracy. It will be much to do about nothing simply because the costs of collecting resale royalties from recalcitrant dealers and collectors may exceed the royalties.[32]

In the meantime, since there is no bureaucracy monitoring or collecting royalties for visual artists, an artist transfer sales agreement is a document based on trust, not law. Each artist makes his or her own personal decision on whether or not to use this contract.

The appendix section "Law: Contracts and Business Forms" lists publications that provide sample contracts, including *Business and Legal Forms for Fine Artists, Business and Legal Forms for Crafts,* and *Business and Legal Forms for Photographers.* Each of these publications, written by Tad Crawford, includes instructions for preparing sales, consignment, and exhibition contracts, as well as contracts for a variety of other situations. In addition, *The Artist-Gallery Partnership: A Practical Guide to Consigning Art* by Tad Crawford and Susan Mellon presents a model contract between artists and dealers. It also includes a description of consignment acts state by state.

Checking Up on Dealers

Before committing to a consignment and/or exhibition relationship with a dealer, request a contract. If a dealer is unwilling to use a contract, do not get involved. If a dealer provides you with a contract that he or she has prepared, compare it with one of the sample contracts referred to in the appendix section "Law: Contracts and Business Forms." If necessary, amend the dealer's contract to include any important provisions that are missing.

If you have successfully negotiated a contract but are unfamiliar with a gallery's business reputation, talk to other artists represented by the gallery. If you do not know the names and whereabouts of other gallery artists, ask the dealer. *It is about time that artists began requesting references!* It is interesting to note that the very same artists who ask me for client references freeze at the thought of asking an art dealer for artist references! Because I am perceived as a supportive ally, artists feel safe to ask for what they want. But because an art

dealer is perceived as a person who wields power and makes aesthetic judgments, many artists are unnerved about requesting references.

If you are still unable to get a clear picture of a gallery's business reputation, contact a local chapter of the Better Business Bureau. Ask whether complaints have been registered against the gallery. You should inquire about the gallery's reputation from both an artist's and a client's point of view.

Dealing With Dealers: In Summary

Over the years, I have met with thousands of artists, often serving as a coach to help them iron out gallery-related problems. And over the years I have had at least one client in approximately 90 percent of the galleries in New York City that exhibit contemporary work. These experiences have provided me with an unusually broad perspective on what has gone on behind the scenes at many galleries since the late 1970s and what is going on today. I have been privy to intimate information about how artists are treated and mistreated, who is suing whom and why, the names of the dealers who do not pay artists or do not pay on time, and other maladies.

I still cringe when I hear or learn about some of the unintelligent remarks and value judgments made by dealers, or the outrageous rudeness they display. Those rare occasions when an artist praises a dealer for being fair and wise give me hope that perhaps things are changing for the better.

More often, though, I have trouble responding when I am asked to name dealers I respect *both* as businesspeople and as human beings. In New York, which has more than five hundred commercial galleries, the dealers on my list could be counted on one hand!

Although for many reasons I consider the gallery system in New York to be the most decadent, New York is certainly not the only place that attracts art dealers with questionable moral and business ethics. Many artists around the country have trying and cumbersome relationships with dealers.

If artists do not learn to *cultivate their own market* and become less dependent on galleries for sales and exposure, they will find themselves paying commissions in the neighborhood of 75 percent and up, just to support dealers in the style to which they are accustomed! And

it is important to note that some galleries in New York have initiated the policy to charge artists a fee for reviewing unsolicited slide packages.

It is important that artists develop an autonomous posture and make their own career decisions rather than wasting time waiting for something to happen. The chances are remote that you will find the perfect agent or be introduced to galleries through an art-world-figure referral system, and the so-called artist referral system is virtually nonexistent, because most artists are too paranoid and competitive to refer each other.

You *can* find a gallery without being referred and without an agent. But do not rely on representation by *one* gallery to provide the exposure or livelihood you are seeking. Build a network of many galleries located throughout the United States and the world. Building such a network requires time and patience. But it can be done.

The Mysterious World of Grants: Fact and Fiction

He who hesitates watches someone else
get the grant he might have gotten.
—*Jane C. Hartwig, former deputy director,*
Alicia Patterson Foundation

Who gets grants and why? The *real* answers to these questions can be provided by jurors who select grant recipients. All other answers are speculative and have more to do with hearsay than reality. When I asked members of various grants panels about their selection criteria, their answers were simple and direct: they liked the artist's work or they liked the project under consideration and thought that the artist was capable of undertaking the work. When I probed further, the answers were predictably numerous, varied, and subjective, and boiled down to "taste buds."

Artists who are apprehensive and skeptical about applying for grants have many misconceptions about who receives them. Skeptical artists deem themselves ineligible for various reasons, such as being too old or young, lacking sufficient or impressive exhibition or performance credits, or lacking the right academic background. They believe that the kind of work they are doing isn't considered "in" or that they lack the right connections, which implies that juries are rigged!

It is perfectly conceivable and probable that some artists have been denied grants by some foundations because of some or all of the above-mentioned factors. However, on the basis of my own experiences as a grant recipient and juror, as well as the experiences of my clients (the majority of whom would not measure up to the tough stereotype that many artists have of "the perfect grant-winning specimen"), I am convinced that, for the most part, grant selection is a

democratic process—meaning that everyone has a *real* chance. Many artists believe that because they have applied for the same grant year after year without success, it is a waste to continue to apply. Images are conjured up of a jury sitting around a table moaning, "Oh, no, not him again!" Or conversely, there are artists who believe that one must apply for the same grant at least three or four times before it will be awarded: "It's her fourth application, let's give her a break!" But contrary to the notion that jurists remember who applied for a grant each year, most panels have new members each time they convene. Each time you apply you have a fresh chance.

Since grant selection in the arts is based on taste, and like taste buds, the grants world is mysterious, whimsical, and fickle, you should not depend on or view grants as the only means of providing the opportunity to do what you really want. Grants should be looked upon as "cream" to help alleviate financial pressures, provide time and new opportunities to develop your career, and add another entry to your list of endorsements.

Projects and ideas should not be tossed aside if funding agencies or foundations reject your application(s). Remember, the selection criteria are subjective and *ultimately you must be the judge* of whether your work and ideas have merit. A grant is not the deciding factor.

Also remember that juries are composed of human beings, and humans are not always right. In fact, we have quite a track record of not recognizing talent (until someone dies) and of putting some questionably talented people on a pedestal.

The grants world might seem mysterious, but hundreds of artists each year who take time and energy to investigate grant possibilities and complete well-thought-out applications are reaping the benefits.

BIG GRANTS AND LITTLE GRANTS

Grants come in many different shapes, sizes, and forms. There are grants for visual and performing artists with broad-based purposes and specific project grants for well-defined purposes. For example, there are grants for artists who are women, artists who are grandmothers, artists with a particular ethnic or religious background; grants for artists born in certain regions, states, and cities; grants for

artists involved with conceptual art or traditional art; grants
grants for formal study; grants for independent study; gra
prenticeship; and grants for teaching.

From year to year grant agencies and foundations open and fold,
cut budgets, increase budgets, change their funding interests and pri-
orities, emphasize one arts discipline over another or one socio-
economic group over another. It is important to keep abreast of these
changes. A grant that is not applicable to your current situation and
interests could be suitable in the future.

Even when budgets are being cut, don't hesitate to submit grant
applications. A case in point: During a time when federal arts budgets
were being slashed, I received a large matching grant from the Na-
tional Endowment for the Arts. I was not optimistic that I would re-
ceive a grant when I submitted the application. Not only was I
surprised that I received the grant, I was also surprised that I was
awarded every penny that I requested. However, it was pointed out to
me by a person familiar with the inner workings of the NEA that
when government arts funding is cut, people are reluctant to submit
grant applications. Thus, the competition is reduced. In many in-
stances, people have a better chance of receiving a grant when the fi-
nancial climate is restrained.

Although the National Endowment for the Arts no longer has an
extensive grants and fellowship program for visual artists, many state
and regional arts councils award grants and fellowships to visual
artists, as well as to performing artists and writers. In addition, several
private foundations give grants to artists, but because they are less
well known, fewer people apply for them.

Good sources of information on grants that are specifically geared
to artists include *The Art Deadlines List,* a comprehensive and up-to-
date newsletter listing opportunities for artists that includes grants
and residencies. Published monthly, the *List* is available by subscrip-
tion through e-mail. It is also available in a printout format through
the U.S. mail and a short version is accessible without subscription.
ArtDeadline is another monthly Internet e-mail resource that includes
a listing of grants and residencies for artists. *Art Calendar,* which is
published eleven times a year, provides a listing of grants and fellow-
ships available to artists and writers and not-for-profit arts organiza-
tions. It also includes a listing of scholarships, residencies, and artist

colonies. *For Us Newsletter* is a monthly on-line publication about grants for individuals and nonprofit organizations. The site also includes how-to articles on grant research, recommended books, and other information. *The Directory of Financial Aid for Women* identifies 1,200 financial resources for women, including scholarships, fellowships, and grants. It is available by subscription on the Internet. The *Guide to Canadian Art Grants* lists more than 1,000 art-grant programs throughout Canada for Canadian artists in all disciplines. It is also available in software for Windows 95/98. In addition, *Grant Searching Simplified* by Bari Caton was written for visual and performing artists and writers who want to apply for grants, but do not know how to get started. It provides artists with a step-by-step plan for conducting an effective search for grant support. An updated version includes *The Online Supplement,* which offers information about grant searching in the electronic age. *Grant Searching Simplified* is available on-line and in softcover.

One of the newest funding organizations, the Creative Capital Foundation, takes a unique approach to grant giving. This national not-for-profit organization supports artists pursuing innovative approaches to form and content in the performing, visual, literary, media, and emerging art fields. In addition to financial support, the foundation provides grant recipients with advisory services and professional development assistance. In return, artists share a portion of any proceeds generated by their projects with Creative Capital to replenish the grantmaking fund so that other artists will benefit in the future. Additional resources for information on grants are listed in the appendix sections "Art Colonies and Artist-in-Residence Programs" and "Grants and Funding Resources."

Art Colonies and Artist-in-Residence Programs

Acceptance in an art colony, also known as a retreat or artist-in-residence program, is a form of a grant, since the sponsoring organization subsidizes the artists it selects.

Such retreats are scattered throughout the United States and the world. They offer an artist the opportunity to work on a project for a specific amount of time, free from life's daily burdens, responsibilities, and distractions.

Subsidization can be as comprehensive as payment of transporta-

tion expenses, room and board, and a monthly stipend. Or it (
limited to partial payment of room and board, with the artist required
to pay a small fee.

Some colonies, such as the American Academy in Rome and the
Bellagio Study Center in Italy, sponsored by the Rockefeller Founda-
tion, offer luxurious creature comforts. Other colonies offer a summer-
camp ambience and are based on a communal structure.

There are colonies that specialize in one particular arts discipline as
well as those that include visual and performing artists and writers.

Artist-in-residence programs can include teaching opportunities
(described in the next chapter) as well as international exchanges.
Many excellent resources are available that list and describe art
colonies and artist-in-residence programs. For example, *Artists Com-
munities*, compiled by the Alliance of Artists' Communities, provides
information on residence opportunities in the United States for visual
and performing artists and writers. In addition, it includes a special
section that lists artists' communities, art agencies, and key contacts
that support international artist exchanges. In addition, the Web site
Artists Communities provides links to numerous arts colonies and
artist-in-residence programs. *About Creative Time Spaces: An Interna-
tional Sourcebook* by Charlotte Plotsky describes artists' communities,
retreats, residencies, and workspaces throughout the world. *Visiting
Arts Directory of Opportunities for Foreign Visual Artists to Work and Stay in
the UK* describes residencies and work opportunities for international
visual artists in the United Kingdom. *Money for International Exchange
in the Arts*, by Jane Gullong, Noreen Tomassi, and Anna Rubin,
provides information on international artists' residency programs.
Additional resource lists and information about art colonies, artist-
in-residence programs, and exchange programs are in the appendix
sections "Art Colonies and Artist-in-Residence Programs" and "Inter-
national Connections."

Nonprofit and Umbrella Organizations

There are more grants available to nonprofit art organizations than
to individual artists, and the dollar value of the grants available is
substantially higher. For this reason, when I was working as an artist I
turned myself into a nonprofit, tax-exempt organization. The tax-
exempt status also allowed individuals to receive tax breaks on any
contributions and donations they made to my projects.

Although there were many advantages to being a nonprofit, tax-exempt organization, there were also disadvantages. For example, while my organization was in operation, I found myself spending a disproportionate amount of time completing the various forms and reports that were required by federal and state agencies. Another drawback was having to contend with a board of directors, which diminished, to a certain extent, the autonomy that I had enjoyed while working on my own. I also spent a lot of time meeting with board members and sustaining their enthusiasm for fund-raising.

Carefully evaluate your situation before taking steps to form a non-profit organization. For further information about forming a nonprofit organization and working with a board of directors see the appendix section "Law: Forming a Not-for-Profit Organization."

If you personally do not wish to go nonprofit, there is an option available that allows you to bypass the tax-exemption route: use the services of an *umbrella organization*. Umbrella organizations are non-profit, tax-exempt groups that let you apply for a grant under their auspices. If a grant is awarded, the umbrella organization receives the award and in turn pays you.

Umbrella services can vary from a minimum of signing a grant application to bookkeeping; managerial advice; preparation of annual, federal, and state reports; assistance with publicity and promotion; and fund-raising. In return for these services, a percentage of any grant that is awarded to an artist or a group of artists goes to the umbrella organization.

With offices in New York and San Francisco, Circum-Arts is a not-for-profit arts organization that offers umbrella services to visual and performing artists. It also provides an extensive range of administrative, technical, and educational resources that are accessible and affordable to individual artists and emerging companies in the performing arts. This includes assistance with proposal writing and serving as a financial conduit for artists to receive contributions and grants. Contact information about Circum-Arts is provided in the appendix section "Grants and Funding Resources."

Umbrella organizations do not take all artists under their wings. They consider the nature of an artist's project and the impact it will have on the community. Umbrella groups rely on grants to pay their overhead and salaries, and their ability to receive grants depends largely on the success of the projects they sponsor.

The best way to learn about umbrella organizations in your area is to contact your local state arts council.

INCREASING YOUR CHANCES OF BEING FUNDED

Preapplication Research

Before completing a grant application, learn as much as possible about the funding organization. Your homework should include learning about eligibility requirements, funding priorities, the long-term goals of the organization, and the maximum and minimum amount of the grant. Jane C. Hartwig, former deputy director of the Alicia Patterson Foundation, emphasizes the importance of homework: "The fact that you have done your homework, even at the earliest stage, is impressive, and appreciated by the foundation. It will also save you time, money, and possibly grief."[1]

When you receive your application instructions and the background information about the agency or foundation, the kind of language used will give you a strong indication of the types of art and arts projects that are funded. For example, if you are told that the purpose of a grant is "to foster a high standard in the study of form, color, drawing, painting, design, and technique as expressed in modes showing a patent affinity with the classical tradition of Western culture,"[2] it is very clear what the foundation giving the grant is looking for. If your work or project involves anything other than "the classical tradition of Western culture," it is a waste of time to apply to this foundation.

Submitting Visual Materials

Grant applications in visual arts usually require that slides or photographs of the artist's work accompany a written application. Although some funding agencies request to see the actual work once an artist passes a semifinal stage, most organizations make their final selections on the basis of slides or photographs.

Too often artists place great importance on a written application and give too little attention to the photographic material. Both are important for completely different reasons. Here are some guidelines to

follow in submitting visual materials. In addition, review the section "Slides and Photographs" in chapter 3, page 55.

(1) All photographic material should be of *top quality*: clear and crisp, with good lighting and tone.

(2) Submit photographs of your most *recent* work. Most funding agencies do not want to see a retrospective of your last ten years. They want a strong, clear indication of your current interests and directions.

(3) Select photographs or slides that represent the *best* of your recent work. *You decide what is best*. If you are indecisive about what to submit, consult with someone whose taste you respect.

(4) Even if the funding agency does not require photographic materials to be labeled, *label* each and every slide or photograph with your name and the title, medium, date, and dimensions of the work. Also include a directional indication showing the top of the work. This information could decide whether your work is rejected or enters the next stage of judging. Photographs or slides should seduce the judges, but if they are confused and can't "read" what is going on, they will not take the time to look up your application in hopes of clarification.

A final pointer about slide presentations: since most funding agencies actually project slides on a screen, it is very *important* to project your slides on a large screen *before* you submit a grant application. If your slides are being projected for the first time, you might be shocked to discover the results. Recently, I borrowed slides from various artists for a lecture that I was giving at a museum. I selected the slides from slide sheets and then reviewed them with a hand viewer. However, I made the mistake of not projecting the slides on a screen before the presentation. When projected, half of the slides were so dark that I had the entire audience squinting.

Completing Applications

When you first encounter a grant application, it can seem like Egyptian hieroglyphics. Mastering grant applications *is* like learning a new language, and the more experience you have, the easier it becomes.

In addition to carefully following instructions, the best posture to

take when filling out an application is to *put yourself in the shoes of a jurist*. In other words, you want to read applications that are legible and clear and that come quickly to the point. You do not want to have to reread an application in order to understand it clearly. Applications should hold the judge's attention.

I am often called upon to review *unsuccessful* grant applications. These applications tend to have in common one or all of the following mistakes:

(1) They reflect a negative tone, implying that the artist has a chip on his or her shoulder (e.g., "The world owes me a grant").

(2) The description of the grant purpose and/or project talks over the heads of the readers, rambles on with artsy language, and goes off on irrelevant tangents.

(3) Funds are requested for inappropriate or "off-the-wall" purposes, basically insulting the intelligence of the judges.

Recently I was one of eight jury members who met to select a public art project. The proposal I liked best was very imaginative and had a wonderful sense of scale. It would have been relatively easy to install, maintenance free, and able to withstand inclement weather. It was also the least costly of all of the proposals submitted.

However, the project did not win because the artist antagonized the jury! Leaving most of the application questions unanswered, except for a project description, the artist wrote (in barely legible longhand) one arrogant sentence implying that the drawings that accompanied the application would make the sculpture's design and meaning clear to all but the dumbest of viewers.

Although most jurors agreed that this project was the most appealing, they also concurred, based on the attitude expressed in the application, that the artist would probably be difficult to work with during the planning and installation stages. Whether or not that would have been true is open to speculation, but the fact of the matter is that the way in which the artist completed the application prevented her from receiving the commission.

Proposals and Budgets

Some agencies that award grants require a written proposal and a budget.

In the book *Supporting Yourself as an Artist* by Deborah A. Hoover, a former executive director of the Council for the Arts at the Massachusetts Institute of Technology, the author covers the topics of proposal writing and budget preparation in a very clear and thorough manner. The book also includes sample proposals and budgets and provides good information on other related subjects, such as how to interpret letters of rejection.

Hoover urges artists to "be direct; express yourself in writing as you would in speech. Keep your sentences short. Put statements in a positive and persuasive form."[3]

Hoover's book is an excellent resource for advice and information about proposal writing and budget preparation. It is listed in the appendix section "Grants and Funding Resources."

JUDGING PROCEDURES

Most funding agencies use the first round of judging to sort through applications to make sure that artists have complied with all of the instructions, rules, and regulations. Consider this the "negative" stage of judging, as the agency is on the lookout for applicants who do not follow instructions. This hunt has no deeper purpose than to make the judges' work easier by reducing the number of applications to be considered.

Each funding agency has its own procedures for reviewing grant applications. After eliminating the applications that do not qualify, some agencies then review the artists' creative achievements by such steps as looking at slides and videotapes, listening to audiotapes, and reading manuscripts. After the judges have narrowed down the selection of artists for the final stages of judging, they review written applications. Other agencies that require written proposals and budgets review the application and support material simultaneously.

"Say the Secret Word and Win One Hundred Dollars"
Probably as a result of the many tests one is subjected to in school, artists approach a grant application as an aptitude or IQ test. It is felt that ultimately the application is trying to trick you with double meanings. The fact is that there are definitely "wrong" answers, such

as those I have described from the unsuccessful grant applications, but there is no one "right" answer.

For example, many grant applications request information on *educational background* and *salary*. Those artists who believe their formal education is inadequate, in terms of the "right" academic credentials, erroneously believe that they will have virtually no chance of being funded. Artists also worry that if their salaries are above poverty level they will be ineligible for a grant. Although there are grants available that are specifically designed to assist impoverished or low-income artists, if this criterion is not stated in a foundation's application guidelines, one can safely assume that the grant is awarded on the basis of merit or merit combined with moderate financial needs. Such situations might include, for example, artists who are on a tight budget and lack the funds to be able to take a leave of absence from a job or reduce the number of hours of employment to devote time to their artwork.

Another part of the "secret word" syndrome is how much money to ask for. Arriving at a funding-request figure is not like competing in a jelly-bean-counting contest—you don't have to guess down to the exact penny how much you think the foundation will give you.

Some foundations give a set amount of money (e.g., twenty grants of $5,000 each). Other foundations state a maximum amount but say that smaller grants—the amount of which will be left to the discretion of the jury—will also be given. In recent years, the discretion of the jury resulted in awarding one of my clients *almost double* the amount of the grant that she requested!

Letters of Recommendation

When foundations request that an applicant include a letter or letters of recommendation, it means that they are asking for testimony from other people that your work is good and/or that your project has merits and is relevant and important. I often encounter blank expressions when I ask applicants whom they are going to use as a reference. They believe there is not one person available to help. Of course, it is impressive if you are recommended by an art-world superstar. However, if such a person is not part of your network, do not let this become a stumbling block. Jane C. Hartwig puts it this way:

You certainly shouldn't shy away from using someone well known in your field if that person happens to know you and your work and has indicated a willingness to write a letter in your behalf. Just don't think that you haven't a chance if you don't know any luminaries. Happily, it really doesn't matter.[4]

In summary, if you were on a grant panel, what would impress you more? An insipid but well-meaning letter of recommendation from a celebrity or a perceptive and analytical letter from someone you have never heard of?

There is a range of possibilities of obtaining letters of recommendation: for example, the curator or director of a museum or nonprofit gallery, a critic, a member of the academic art community, an art historian, another artist, or the director of a nonprofit arts organization.

Less effective sources of letters of recommendation are from those people in positions that could be interpreted as a conflict of interest. For example, gallery directors and collectors have a vested interest in awards that artists receive. Such recognition can contribute to a rise in the monetary value of artwork and heighten an artist's standing in the art world. Since gallery dealers and collectors can directly and indirectly benefit from an artist's achievements, letters of recommendation pumping up an artist's virtues from either source are much less impressive than those letters written by people in much more objective positions.

Remember, the worst thing that can happen is that the person you ask to write the recommendation will say no. Although this happens, it doesn't happen that often, because almost everyone has been in the position of asking for help.

An Untraditional Grantsmanship Route

The traditional way to apply for grants is to rely on a foundation to announce the availability of a grant and submit an application. However, there is an untraditional route, which I have personally used with very successful results.

Corporate Detective Work

I obtained corporate sponsors for many exhibitions and projects by taking the initiative and contacting companies, regardless of whether

they were in "the grants business." I first located corporations that either provided services or manufactured goods and materials that had some relationship to my project or exhibition. I began my detective work at the library using *Standard & Poor's Rating Guide*, a massive directory that lists American corporations, cross-referenced according to product and/or service.

In one instance, I was planning an exhibition of sculpture in which aluminum would be used extensively. Through *Standard & Poor's* I came up with a list of major aluminum companies, their addresses, and the names of key officers and public- or corporate-relations directors.

I sent a letter to each public- or corporate-relations director, with a copy to each key officer; I indicated on each original letter that company officers were also receiving the letter.

The letter detailed the purpose of the exhibition, told where it was being held, and included a description and a budget. I also included a sentence or two about what the company would receive in turn for its sponsorship, namely, public-relations benefits. *Within six weeks* I landed a sponsor.

Value of Sending Copies

Sending copies of the sponsorship request to key corporate officers is very important. It increases the chances that the letter will really be given careful consideration and it decreases the chances that a sponsorship decision will be blocked by one person. For example, if only the public-relations director receives a letter and that person, for one reason or another, is unmoved, the request dies a quick death. By submitting the request to many officers, you increase the chances that you will find an ally with clout!

ℽES, YOU CAN FIGHT CITY HALL

For four consecutive years I applied for a grant from a state arts council for three different projects. Each year I was rejected. After the fourth rejection, I launched my own investigation and learned that one staff member was blocking my application, but for reasons that were so petty I could attribute them only to a "personality conflict." Venting my frustration, I wrote to the director of the arts council, detailing the four-year history of grant applications, documenting all the

hours spent on applications, answering questions, meetings, appoint-
ments, interviews, letters of recommendation, and more letters of rec-
ommendation. But most important, I reiterated the merits of the
project that I wanted funded. I also named the staff member who had
been giving me such a hard time and sent a copy of my diatribe to that
person. About three weeks later I received a letter from the arts coun-
cil stating that it had reversed its decision—the project would be
funded.

9

Generating Income:
Alternatives to Driving a Cab

Being able to support yourself as an artist, and maintain a high-quality life through finances generated from your work, can and does happen all the time. But rarely does it happen overnight, and realistically, until your career gets rolling, it is necessary to earn a living through other means. This chapter covers the assets and drawbacks of conventional jobs, and it discusses some job opportunities and ways of generating income within the fine-arts field. It also provides ideas for minimizing business expenses and saving money.

ASSETS AND DRAWBACKS
OF CONVENTIONAL JOBS

To solve the problem of supporting yourself as an artist you must take into account your financial and emotional needs and your physical capabilities. Whether the options suggested in this chapter are appealing or you prefer traditional forms of employment that offer more financial security depends on your personality, temperament, and energy level. What works for one artist doesn't necessarily work for another. But the *common goal* is to generate income that simultaneously allows you to maintain a good standard of creature comforts, a good state of mind and health, energy for your own projects, and energy to develop your career. Each of these criteria is equally important.

However, in the name of art and the "myth of the artist," compromises and sacrifices are constantly made. Contrary to the teachings of the myth, you are entitled to what you want, and there are ways to get it.

Before jumping into employment, assess carefully and *honestly* what you are looking for and why. Does the job provide a *real means to an end*, or is the job likely to annihilate your end? For example, two of my clients took jobs with arts service organizations. Both jobs provided the artists with sufficient income as well as opportunities to meet people related to their profession and expand contacts and networks. One job involved low-pressure, routine duties. Although the artist was not mentally stimulated, she had energy to sculpt and develop her career because her responsibilities were minimal. The other job was full of responsibilities. It was demanding and stimulating. Although the artist found the work fulfilling, at the end of the day she was drained and did not have the energy for her artwork.

If you want to work within the arts, there are some good resources available. *Artjobonline*, sponsored by the Western States Art Federation (WESTAF), is a biweekly, on-line newsletter that lists employment opportunities in the visual and performing arts, literature, education, and arts administration. There are many Web sites that focus on arts-related employment, including ArtCareer Network, Art & Design Career Employment, Artist Resources, Artsjobs, eLance, and Telecommuting Jobs. The College Art Association's newsletter *CAA Careers* lists arts-related jobs, primarily in colleges, universities, and museums. *ArtSearch*, published by the Theatre Communications Group, is a national employment bulletin for the performing arts. It includes art and art-related positions in education, production, and management. *The New England Conservatory Job Bulletin* is a monthly publication that lists approximately 150 jobs in teaching, arts administration, and performance worldwide. *Careers in Museums: A Variety of Vocations*, published by the American Association of Museums, explains the world of museum work and professional opportunities, and *Museum Jobs from A–Z: What They Are: How to Prepare, and Where to Find Them* by G. W. Bates, describes more than sixty museum positions. It includes information about eligibility requirements, where to find jobs, and various employment opportunities. Information about the above-mentioned resources can be found in the appendix section "Employment Opportunities."

\mathcal{U}SING YOUR TALENTS
TO GENERATE INCOME

Teaching: A Boon or a Trojan Horse?

Teaching is attractive to artists for several reasons: it offers financial security as well as the fringe benefits of health insurance, life insurance, sick leave, vacation pay, and long vacations. In addition, it is a highly respected occupation.

Because of these attractions, the competition to teach is horrendous—so horrendous that, unless one is a superstar, getting a job usually necessitates returning to school for more degrees. On the other hand, even if your qualifications are superlative, there is no job guarantee. There are more qualified artists than teaching positions available in colleges and universities and within school systems.

The scarcity of jobs is not the only drawback. When you are an artist and a teacher, you wear two hats. If teaching consisted only of lecturing, critiquing, and advising students, it would be relatively simple. However, teaching means a lot more. It means extracurricular involvement with faculty politics and yielding to the special demands and priorities of academia. Theoretically, these roles should be compatible and supportive, but often they are not.

Artists who teach *and* want to develop their careers must contend simultaneously with the occupational hazards of both professions. The situation is particularly complex because many of the demands and priorities of the art world and academic world are in conflict. Often, artists involved in the academic world face peer pressure based on how much they know about the past rather than what they are doing in the present. Sometimes artists are forced to change their methods of teaching and/or style of work to conform to current academic trends and ideology. Getting tenure often becomes the most important goal in life. Academia also puts demands on teachers to publish articles, essays, and books about art history and art criticism. An artist may have little time for his or her personal work.

On the other hand, some teaching opportunities are available that allow artists autonomy and flexibility. These opportunities exist both within and outside academic compounds. Some of these opportunities are described on the following pages.

Apprenticeships

Serving as an apprentice to another artist is a viable means of earning a living for a certain period of time. But keep in mind that contrary to the myth, working for a *famous* artist is not a prerequisite to achieving success in the art world. However, serving as an apprentice to an experienced artist can be helpful to less-experienced artists. It can provide an opportunity to learn more about the business of art and see firsthand what being an artist is all about.

An apprenticeship experience can be particularly advantageous if the apprenticeship is with an artist who is surefooted and emotionally secure. Insecure artists might not be generous in sharing career information or their contacts. Insecure people also tend to have difficult personalities. Before accepting an apprenticeship position, ask your potential employer for the names and phone numbers of previous apprentices. You have every right to request references.

Whether you are seeking an apprenticeship position or are seeking an apprentice, additional information about apprenticeships is listed in the appendix section "Apprenticeships and Internships" (pages 225–226) and on page 42 of chapter 2.

Internships

Many not-for-profit organizations, for-profit companies, museums, galleries, and art consultants offer internships to artists. These entry-level positions can lead to interesting job opportunities to supplement your fine-art income or lead to transitional positions until you are a self-supporting artist. Some of the publications that offer information about internships and internship sponsors include *Gardner's Guide to Internships in New Media: Computer Graphics, Animation and Multimedia*, which profiles hundreds of companies in the visual-effects industry that offer internships; *Internships in State Government; New Internships*; and *The National Directory of Art Internships*. The publication *Internship Opportunities at the Smithsonian Institution* is available in print format and on-line. For additional information about internships, see the appendix sections "Apprenticeships and Internships" and "Employment Opportunities" and page 42 of chapter 2.

Artist-in-Residence Programs

There are various forms of artist-in-residence programs. Some have the fundamental purpose of providing artists with opportunities to

live in an environment in which they may work unimpe
daily worries (see page 188). Other artist-in-residence pi
artists to teach on a temporary, part-time, or full-time basis in schoo
systems and communities throughout the United States. For example,
the Studio in a School Program places professional artists in public
schools in New York City. An artist can participate in several ways: by
establishing a studio in a specific school building; by performing
hands-on visual-arts workshops at various locations; or by serving as a
mentor to teachers, helping to create lesson plans for art projects, con-
ducting art lessons, and using art in the classroom.

There are numerous artist-in-schools and artist-in-education programs
throughout the United States, and many of the sponsors have com-
piled directories that list artists available for residencies. For example,
The Directory of Performing Artists and Master Teaching Artists, sponsored
by the Connecticut Commission on the Arts, lists Connecticut-based
artists who specialize in public performances, classroom residencies,
and curriculum development. The directory is also available on-line.
Visual Arts Residencies: Sponsor Organizations, published by the Mid At-
lantic Arts Foundation, describes organizations that sponsor visual
artists' residencies in the mid-Atlantic region. In addition, the Web site
SchoolShows is a national directory of performers who present assem-
blies, workshops, and residencies in schools.

For information about artist-in-schools and artist-in-education pro-
grams, contact local, state, and regional arts councils and agencies. In-
formation about organizations and resources on artist-in-residency
programs can be found in the appendix sections "Art Colonies and
Artist-in-Residence Programs" and "Employment Opportunities."

Lectures and Workshops

Lectures, slide presentations, demonstrations, and workshops are ex-
cellent means of generating income. They also offer exposure and
serve as good public-relations vehicles.

Colleges; universities; social-service agencies; civic, cultural, and
educational organizations; and cruise ships often hire artists for "guest
appearances." For example, the On-Call Faculty Program, Inc., arranges
guest appearances for academics and professionals at colleges and uni-
versities. The organization also places its affiliates in short-course or
semester-course teaching programs.

You can base presentations on your own work alone or also discuss the work of other contemporary artists, art history, and art criticism. Subjects and themes of arts-related presentations are unlimited.

The financial rewards of public appearances can be considerable if you repeat your performance several times. For example, when I receive an out-of-town invitation to conduct career workshops for artists, I use the opportunity to create more opportunities by contacting other educational or cultural institutions in the same region. What starts out as a one-shot engagement ends up as a lecture tour. This generates more revenue and exposure, and since the institutions involved split my travel expenses (apart from the fees I am paid), they all save money.

SETTING UP ARTIST-IN-RESIDENCE POSITIONS, LECTURES, AND WORKSHOPS

The best way to approach an organization or institution about sponsoring an artist-in-residence position, public appearance, or workshop is to provide a concrete proposal that describes the purpose of your idea or program, why it is relevant, and what the audience will gain. If you are applying for an artist-in-residence position, include a proposal, even if the application does not require one. A proposal for a lecture workshop should not be limited to a title. It should elaborate on the contents of your presentation, including the purpose, relevance, and benefit to the audience.

The value of preparing a proposal in advance is that you avoid having to rely on the institution or organization to figure out a way to use your talents. This could take months.

The other value of preparing a proposal is that it can be used to generate residencies, public appearances, and workshops independent of organizations and institutions that sponsor such programs. In other words, you can initiate contacts yourself.

Send proposals to schools, colleges, universities, social-service agencies, and educational and cultural organizations. Corporations are also receptive to sponsoring lectures and workshops, and many organize educational and cultural programs specifically for their employees.

How to Make Money Performing in Schools: The Definitive Guide to Developing, Marketing, and Presenting School Assembly Programs by David Heflick provides information on creating a show that utilizes your talents and

meets the educational needs of the school. It also gives tips on organizing a succesful tour. Advice and information about organizing and publicizing public appearances can be found in the book *How to Develop & Promote Successful Seminars & Workshops: The Definitive Guide to Creating and Marketing Seminars, Workshops, Classes, and Conferences* by Howard L. Shenson (see the appendix section "Employment Opportunities").

Generating Income through the Printed Image

Mail art, book art, rubber-stamp art, photocopy art, postcard art, and digital art are art forms created by artists exploring new communication tools and resources of mass communication and the electronic age. Not only do some of these art forms respond to the aesthetic sensibilities of mass communication, they are mass communication and are mass-produced. Thus, they are art forms with nonexclusive price tags and have the potential to broaden the art-buying market.

A market and marketing vehicles for these art forms have developed over the last twenty-five years. This can be attributed to the efforts of Printed Matter, which was founded in New York City in 1976. This retail store and gallery also offers a mail-order service. It exhibits and sells a vast range of artists' books and other types of artist-created printed materials. Although Printed Matter is considered the largest distributor of artists' books worldwide, artists' books are also sold through retail stores, galleries, and distribution outlets throughout the United States. Their names and addresses are listed in the excellent publication *The Book Arts Directory*. The *Directory* also includes information for papermakers, calligraphers, paper decorators, printmakers, book designers, fine printers and publishers, traditional bookbinders, and makers of artist books.

The addresses of Printed Matter, *The Book Arts Directory*, and other artists' book resources are listed in the appendix section "Artists' Books."

PRINTMAKING

Creating lithographs, etchings, woodblock prints, serigraphs, and giclées offers artists opportunities to generate income and exposure. Painter Toby Judith Klayman, the author of *The Artists' Survival Manual*, writes:

> The idea of "multiples"—of having many prints of the same image—fascinated me. I liked the possibility of having my work

in many places: whereas a one-of-a-kind work can only be in one place at any one time, a print can be in several places simultaneously. It's possible to be selling a print in your studio and have twenty galleries around the country selling them at the same time as well. . . . Since multiples also tend to be priced lower than one-of-a-kind works, more people can not only see your work, but *buy* it as well. There's a "democracy" of pricing possible with prints that appeals to me.[1]

There is a large demand for works on paper, and sales do not necessarily depend on working with art dealers. You can be your own publisher and do your own marketing or go through a print publisher and/or print distributor. The names of print publishers and distributors can be found in the publications *Smith's Printworld Directory* and *Art Marketing Sourcebook*. These publications as well as other resources on printmaking and marketing prints are listed in the appendix section "Prints and Printmaking."

*L*ICENSING ART

Although not all artwork is appropriate for licensing, many artists license the right to use their visual images on various products in return for financial compensation. Products include textiles, towels, sheets, duvet covers, wearing apparel, greetings and note cards, napkins, gift bags, wall coverings, giftwrap and other paper goods, household accessories, posters, wallpaper, and many other types of products.

Compensation for awarding a license is usually in the form of a royalty based on the retail or wholesale price of the product. Some licensing agreements require the licensee to pay an artist a nonrefundable advance against royalties.

Many artists use licensing agents to find potential clients. "An agent's reputation and credentials should be scrutinized carefully,"[2] warns Caryn R. Leland, attorney and author of the very helpful book *Licensing Art and Design: A Professional's Guide to Licensing and Royalty Agreements.*

This can be done rather simply. Ask the prospective agent for references and for the names of some past and present clients; then

speak to them. Find out about the agent's reputation; ask about his or her success rate with negotiating lucrative or high-profile licenses. Do not be shy or hesitant in asking about the agent's fee or negative points or problems that may have arisen during the course of prior representations.[3]

Leland's book discusses the role of a licensing agent. It includes a sample contract for working with a licensing agent, guidelines for comparative average royalties for various products, a checklist for negotiating licensing agreements, model licensing agreements, and useful background information regarding the ins and outs of licensing art. It also includes a section on "Licensing in the Age of Cyberspace."

The names of licensing agents can be found in the *Art Marketing Sourcebook* and the *Licensing Letter Sourcebook*. In addition, the International Licensing Industry Merchandiser's Association, with offices in New York, London, and Munich, offers members access to many services, including an on-line licensing database, and a 1,600-page *Worldwide Licensing Resource Directory*. The association also sponsors an annual International Licensing Exposition and Conference. Additional information about licensing resources can be found in the appendix section "Law: Licensing Art."

Other Ways of Generating Income from Fine-Art Skills

Using talents and skills acquired in the fine arts, some artists generate income by working in applied-arts fields, such as graphic design, fashion illustration, book and book cover design, scenic design, and fabric design.

One very imaginative way of generating income using fine-art skills was achieved by the East Hampton, New York, artist Eleanor Allen Leaver. Leaver has established a network of real estate companies that commission her to create pen-and-ink drawings of homes that have been purchased and sold by their clients. Once a sales transaction has been completed, the artist's drawing is presented as a gift to the real estate agent's clients. It is interesting to note that the artist began this particular freelance business in 1996 when she was seventy-six years old.

I have sold numerous prints through my studio, just on the basis of distributing a press release. In one instance I was involved with a silk-screen series consisting of five prints based on one theme. Press releases

announcing the series and availability details were sent to arts-related publications and museum shops. Except for the prints that I retained for myself, the entire series sold. Marketing involved neither paid advertising nor a middleperson.

There are many potential markets for artists' work. If you limit yourself to one-of-a-kind objects, your market is one-of-a-kind buyers, those who consider exclusivity and scarcity important and are willing and able to pay for it. However, there are many others who appreciate and want to buy art and are not concerned with these issues.

USING YOUR "OTHER" CAREER TO GENERATE INCOME

Wearing two hats can be used to an artist's advantage if one utilizes and transfers the resources and contacts of a second career into the fine arts. Such was the opportunity created by Molly Heron, a New York artist, who parlayed a series of timely events and a freelance position into a one-person exhibition located in prime space on the ground floor of a choice midtown Manhattan office building.

Heron was hired as a freelance book designer at HarperCollins, which, coincidentally, was the publisher of *The Writing Life* by Annie Dillard, a book that she had recently read, savored, and reread.

Six months after she obtained the freelance position, Heron attended an exhibition at the HarperCollins Gallery, located in an open and attractive bilevel space. Impressed with the physical attributes of the gallery and its opportune location, she made inquiries regarding how the space could be acquired for an exhibition. She learned through the gallery curator that all exhibitions in the space *had to be related to a HarperCollins book.*

Eureka! Before the lightbulbs in Heron's head had a chance to dim, she developed an exhibition proposal. Within four weeks she submitted the proposal and a set of slides to the HarperCollins curator, and soon afterward she received an invitation to install a solo exhibition in the gallery later in the year.

Heron's proposal was based on the inspiration she had received from *The Writing Life.* The book had infused her with a new energy force, and she felt compelled to interpret Dillard's metaphors and observations visually. In the proposal she wrote:

> Annie Dillard's *The Writing Life* describes the elusive process of creation in a way that is a strong invitation to try to feel the edge and see if it's possible to have the sun hit you. With her metaphors conjuring up strong visual images, this book inspires me to take color to hand and dance around the mystery with marks on paper. To wonder, to wonder if the dance will take me to the dawn. Will it take me to the abyss?[4]

Heron selected twenty of Dillard's phrases to interpret. Using the medium of collage, she incorporated candy wrappers, paper cups, handmade paper, paper doilies, lace, and other fabrics in combination with a variety of paint, crayons, pencils, and ink. "Combining these materials and building the picture in layers reflected the creative process of making a whole piece out of parts while working in stages," said Heron.[5]

> A phrase like, "The life of the spirit requires less and less"[6] is so provocative that I made several pieces based on Ms. Dillard's insight. At times it was a completely new and mysterious idea and then it would remind me of something that I have known all my life.
>
> Perhaps the most central of Dillard's metaphors are about climbing. Working in the dark, going to the dangerous edge, searching for the opening into the mystery, finding the moment when everything is in place and you are overwhelmed by clarity. I found myself responding with central images of portals as passageways to that mystery and circles as symbols of continuity and connection. The circle allows you to go out into the bright light and also to return. Then you begin the journey again.[7]

Entitled *Impressions on Annie Dillard's* The Writing Life: *Works on Paper by Molly Heron*, the exhibition was organized with the discerning eye and grace of a major museum event. Each collage was displayed with the respective Dillard text that had been the source of Heron's inspiration, and the title of each collage was found within the accompanying prose.

Exhibition visitors were given a nine-page package of information, including a press release, artist's statement, excerpts from the Dillard book, and Molly Heron's and Annie Dillard's biographies.

Molly Heron sold five pieces of work while the exhibition was installed. And as soon as the show closed, she handled the ending as a new beginning and wasted no time in taking the next step. She revised the original proposal and, along with a one-page cover letter, a set of slides, and promotion materials from her HarperCollins show, she began making contacts.

Her new initiatives resulted in exhibition invitations from a university museum, a nonprofit gallery, and a commercial gallery. She also received requests to present lectures and workshops.

In addition, a curator of a branch gallery of the Whitney Museum of American Art informed Heron that, due to the branch museum's policy of only sponsoring group shows, she was unable to offer her a solo exhibition, but that she was so impressed with Heron's work, she had contacted another cultural institution on the artist's behalf.

In part, Molly Heron's adventures and her success can be attributed to the cosmic phenomenon of being at the right place at the right time. But most of the credit belongs to the artist, who through very earthly pursuits took the initiative to utilize in her fine-arts career the resources and contacts of the publishing world.

Rationalization, Paranoia, Competition, and Rejection

RATIONALIZATION

If you want to avoid fulfilling your potential as an artist, it is easy to find an excuse. When excuses linger unresolved too long they become rationalizations. Webster defines the word *rationalize* as "to attribute [one's actions] to rational and creditable motives without analysis of true and especially unconscious motives," and "to provide plausible but untrue reasons for conduct."

Rationalization in one form or another is common to the human species, and sometimes it can be used constructively. However, when rationalization is used to evade fulfilling one's potential, it is being used to disguise a lack of self-confidence and/or fear of rejection.

The most common kinds of rationalizations practiced by artists are rationalizations to *avoid the work process* and rationalizations to *avoid getting work out of the studio and into the public domain*, the marketplace.

Avoiding Work

"I'll get going once I find a work space" and "I'll get going when I have the right working environment" are some of the rationalizations I hear most often from artists who want to postpone or avoid knuckling down. Artists who engage in this form of rationalization do little or nothing, financially or motivationally, in order to attain their goal of finding a suitable work space.

There are many variations on the theme: One artist tells me he can't begin work until he can afford stationery embossed with his

studio address. He believes that no one will take him seriously until he has a business letterhead. Another artist, who has spent the last four years traveling, tells me she needs more life experience in order to paint. Another artist tells me that he is waiting for technology to invent the right material that he needs for sculpture. Chances are that when the letterhead, life experience, and new technology are attained, the artists will quickly find another excuse to avoid confronting their work. As psychotherapist and artist Bruce M. Holly puts it:

> For some of us, the risk of choosing and failing in life and in art is a loss of self-esteem which outweighs the potential satisfaction of success so completely that we are locked into immobility by fear. It is this that causes creative death far more frequently than heart disease. There is a quiet courage demanded of all of us with each breath we take. In art, this courage is manifested each time we choose to move toward a new creation.[1]

For the artist who chronically finds an excuse to avoid work, the consequences of rationalization are not limited to getting nothing accomplished. Guilt sets in because you are not doing what you think you want to be doing and because you are practicing self-deceit. Animosities and tensions develop internally and toward others, whom you blame for your circumstances. Jealousy and contempt rear their miserable heads, directed toward any artists (and nonartists as well) who have managed to put their lives together in such a way that they are accomplishing, or are really trying to accomplish, their goals.

With so much negativity festering, no wonder work is impossible. The distance between what you want to achieve and what you are actually achieving grows wider. And if you try to work you find each product of self-expression tainted and influenced by your anger and hostility. Creativity is used to vent frustration and addresses nothing else.

Avoiding Public Exposure

Some artists have no problem working but begin the rationalization process when it comes time for their work to leave the studio and enter the marketplace. To insure yourself against experiencing any form of rejection, you begin to rationalize: your work isn't ready, you don't have enough work to show, you don't fit into the latest trend, you're

working for your own pleasure and do not want to derive money from art, and no one will understand your work anyway—it's too deep!

Gail McMeekin, author of *The Twelve Secrets of Highly Creative Women* and a career coach and psychotherapist, points out that "putting yourself out there and sharing your work qualifies as an act of courage and tests your fortitude."[2] Unfortunately, many artists do not see the relationship between fortitude, courage, and career development. Other artists limit their courage and fortitude to the art-making process

The Search for the Perfect Agent

One of the more popular rationalizations is the *perpetual search for the perfect agent*. Once this person is found, he or she will take your work to the marketplace. This person, you tell yourself, will shield you from criticism and rejection; schlepp your slides from gallery to museum; bargain, negotiate, and establish your market value; arrange exhibitions; write letters; attend cocktail parties; and make important connections. In addition, the agent will have excellent press contacts and your work will be regularly featured in leading publications, with critics fighting among themselves for the opportunity to review your shows. And of course, this agent will fill out grant applications on your behalf and will be very successful in convincing foundations to subsidize your career. And when cash flow is a problem, the agent will tide you over with generous advances. When your ego needs stroking, the agent will always be on call. All you have to do is stay in your ivory tower and work.

I estimate that the majority of artists who contact me for assistance have the notion in the backs of their minds that I will fulfill this fantasy and provide the buffer zone they are seeking. Apart from my belief that within the visual-arts field this fairy godperson is practically nonexistent, I strongly believe that artists are their own best representatives.

Meanwhile, the search for the perfect agent, the supposed saint of all saints, continues while the artist's work accumulates in the studio, to be seen only by four walls.

Rationalization can become a style of life—an art unto itself. Artists who use rationalization as a style of living tend to associate with other artists who are skilled at the same game, supporting and reinforcing each other, pontificating in unison that "life is hell," and that it's everyone else's fault. It's less lonely going nowhere fast in a group than by yourself.

ᛈARANOIA

Rationalization has a twin: paranoia. Webster defines *paranoia* as a "tendency on the part of an individual or group toward excessive or irrational suspiciousness and distrustfulness of others."

Sometimes the twins are inseparable and it is difficult to know where rationalization ends and paranoia begins. Sometimes rationalization is the aggressor and paranoia takes over, and other times paranoia prevails on its own. But the twins always meet again at the same junction, called *insecurity*.

For example, a painter tells me she dislikes showing her work to dealers because when she invites them to her studio she believes that her invitation is interpreted as a sexual proposition. I asked whether she had encountered this kind of experience. "No," she replied, "but I know what they are all thinking." Consequently, dealers are not invited for studio visits. Thus, she eliminates any possibility of being rejected or hearing that her work isn't good enough. Another artist, who was part of a group that I was assisting with public relations for an upcoming exhibition, told me that he did not want press coverage in certain newspapers and on television out of fear that the "wrong kind of people" would come to the show. I could never figure out who the "wrong kind of people" might be—street gangs, muggers? Nor could the artist shed light on the subject when I asked for an explanation. But in his mind there was a special group of people who were not meant to view or buy art.

The belief that there *is* a special group of people who are not meant to view or buy art is common among artists. It translates into the "creating art for friends" syndrome, a principle that, on the surface, sounds very virtuous, but all too often means that anyone who likes your work is worth knowing, and anyone who doesn't isn't. It is a tidy black-and-white package: a handpicked audience that you create for the purpose of lessening the possibility that you will be rejected and increasing your sense of security and self-esteem.

I don't mean to understate or underrate the importance of support and compliments, but there are many dangers in being paranoid about new audiences. In addition to propagating elitist notions about art, it also creates incestuous attitudes and incestuous results. To continually create only what you know will please your peanut gallery impedes

your creative growth and limits your creativity. The fear of new audiences also applies to artists who are afraid to leave their galleries or expand into new local, regional, national, and international territories.

One area where paranoia runs rampant is within the so-called community of artists. Artists are often fearful of ideas being stolen, competition, and losing the status quo. By this reasoning every artist is a potential enemy.

An artist who served as an apprentice for two years to a well-known sculptor was preparing a grant application and needed three letters of recommendation. He felt comfortable asking his former employer for a letter because on numerous occasions the sculptor had praised his talents. Yet the sculptor turned him down, saying that on principle he does not give artists letters of recommendation.

Reading between the lines, it is likely that the younger artist posed a threat to the sculptor's status. The sculptor felt that there was no more room at the top, and just to ensure that no one else would inch his or her way up, he thwarted every opportunity that might give someone else upward mobility.

A painter who had recently moved to New York and was eager to begin making gallery contacts told me that she had a good friend who was with an established New York gallery where she would like to exhibit. I suggested that she ask her friend for a personal introduction. "I already did," she glumly replied. "But she said that *she* would be heartbroken if the dealer didn't like my work."

In this example, the artist tried to disguise her own insecurities with a protective gesture. She would not allow herself to be put in a position where her "taste" would be questioned, and/or she saw her friend as a potential threat to her status in the gallery—a realistic enough threat to warrant cutting her friend out of a network.

I once asked a sculptor who was sharing a studio with other artists whether her colleagues were supportive and helped each other with contacts. "Oh, no," she replied, "just the opposite. Whenever one of the artists has a dealer or curator over for a studio visit, the day before the appointment she asks us to cover up our work with sheets." Then she added, "I don't blame her. If I were in her position I would do the same."

In this example there is little room to read between the lines. It is a blatant example of paranoid behavior. Oddly enough, her studio mates complied with the outrageous request because they deeply identified with and understood the artist's fear.

Paranoia also manifests itself in the hoarding and concealment of information. I have seen artists smother in their bosoms any tidbit of information or leads that they believed would be a *weapon in the hands of other artists*. A dancer told me that she holds back information from colleagues about scheduled auditions. A sculptor complained that his best friend entered a competition whose theme was very relevant to his own work; when he learned of the opportunity only after the deadline closed, his friend nonchalantly said, "Oh, I thought I mentioned it to you." A photographer suspiciously asked me how many other photographers I had advised to approach a certain gallery.

OVERREACTING TO COMPETITION

Some of the examples cited above might sound familiar—so familiar and ordinary that you most likely never thought to consider them examples of rationalization and paranoid behavior. This is part of the problem. In the art world, illogical and unsubstantiated fears and scapegoating have become the norm.

One of the basic reasons why rationalization and paranoia are condoned in the art world is overreaction to competition. Everyone tells us how competitive the art world is, how competitive being an artist is. We hear it from critics, curators, dealers, educators, our parents, and other artists. We enter contests and juried shows; vie for the interest of dealers, collectors, patrons, and critics; fight for grants, teaching jobs, and commissions. We write manifestos to be more profound than others.

Competition is an occupational hazard in every profession; it is not exclusive to the art world. But all too often in the art world we have let rivalry assume the predominant role in how we relate to one another. Although for some artists the mere thought of being judged is so overwhelming that they won't even allow themselves to compete, others plunge into the match but let a dog-eat-dog mentality pilot their trip. These are artists who backstab, hoard information, and exercise selective memories.

Some artists try to deal with competition by establishing elitist values, adamantly contending that only a select few were meant to understand their work. Trying to win the interest of a select audience makes competition seem less threatening. Other artists have con-

cocted a myth that dealers, curators, and collectors are incapable of simultaneous appreciation of or interest in more than a few artists. Such artists cultivate a brutal "It's me or you" attitude.

The main reason competition has become so fierce is that many artists really believe only a limited number of artists *can* achieve success. Although it might be true that only a limited number of artists do achieve success, the *potential number* of artists who can succeed *is not limited*. Achieving success has nothing to do with "beating out the competition" through deception, lies, manipulation, and viciousness. Artists who succeed have beaten out the competition through exercising powers of perseverance and discipline, and by cultivating good marketing skills.

Until competition in the art world is recognized for what it really is, rationalization and paranoia will continue to be used by many artists as tools of the trade. They are odious, unproductive, and self-defeating props that are dangerous to your health, career, and the present and future of the art world.

There is no need to expound on why it is unhealthy to live a life predicated on fear, lies, and excuses and what it can do to us physically and mentally. Some artists are at least consistent, allowing self-destruction and self-deceit to govern all facets of their existence. But other artists have a double standard: honesty, intellect, courage, discipline, and integrity are their ruling principles, except when it comes to their art and careers!

Those who let rationalization and paranoia rule their careers in order to avoid rejection, assuage insecurity, and fend off competition must face the fact that their careers can come to a screeching halt, limp along in agonizing frustration, or be limited in every possible sense. Their work suffers (reflecting lies, excuses, and fears) and their network of friends and contacts degenerates to the lowest common denominator, as they stop at nothing to eliminate what is perceived as a possible threat.

Dealing with Rejection

An artist described her experience with rejection in this way: "I, like most young artists, romanticized the idea of 'being an artist' and in so doing anticipated a degree of rejection, but had I known the degree of

rejection that would be in store . . . I might have chosen to become a doctor instead. Frankly, I don't get it."[3]

There are many reasons why an artist's work is rejected. Artists are constantly turned down from galleries, museums, alternative spaces, juried shows, and teaching jobs. A bad review is a form of rejection; so is not being reviewed.

Some artists are rejected for reasons for which they are *ultimately responsible*, and for these artists rejection can be an asset. It might be the only indication an artist has that his or her career is being mismanaged.

Artists who are responsible for rejection include those who make no effort to improve their chances by taking the initiative or creating career opportunities. Examples of such artists have been described throughout this book: those who haphazardly enter the marketplace, those who prepare poor presentations, and those who can't abandon "the myth of the artist."

Some artists rely on moods to enter the marketplace. A burst of energy tells them it is time to make contacts and take action, and for a week or two, or perhaps a month, they are sincerely dedicated to showing their work around. But the goal is instant gratification, and if expectations are not rewarded, they retreat. Depending on the artist, it can take months—sometimes years—for anything constructive to happen.

Artists who are controlled by moods further encourage self-defeat by drawing the conclusion that rejection is an absolute: once they are rejected, a museum's or gallery's doors are always closed. Consequently, these artists will not return with a new body of work.

But there are many instances in which artists are not responsible for rejection. These instances are caused by subjective forces, including "taste buds," trends, norms, and other people's priorities. These forces can be illogical and arbitrary, and are, by nature, unfair.

I once had a grant application rejected. The grant's panel had confused me with another artist whose name was similar. That artist had previously received a grant from the same foundation, but had misused the funds. It was only by accident, and many months later, that I learned what had happened.

This was luxurious rejection: I could not take it personally or hold myself responsible, and I was able to learn the *real* reason. It is rare, though, that artists know the real reasons why they are rejected. Con-

sequently, they think they are untalented and that their ideas are without merit.

The side effects of rejection are more horrendous than the actual rejection. For this reason, once you have ascertained that you are no longer responsible for the situation, it is important to build up an immunity against being affected by rejection.

Artist Billy Curmano described his immunity system in *Artworkers News*: "One day, while reflecting on . . . accumulated rejections, I composed an equally impersonal rejection rejection and have begun systematically sending it to everyone in my file. . . . Striking back immediately becomes a ritual to look forward to."[4] Here is the letter Mr. Curmano composed:

> Hello:
>
> IT HAS COME TO OUR ATTENTION that you sent a letter of rejection concerning BILLY CURMANO (hereinafter the "Artist") or his work dated _____ to the Artist.
>
> BE IT KNOWN TO ALL, that the said MR. CURMANO no longer accepts rejection in any form.
>
> KNOW YE THAT, this document, as of the day and year first written, shall serve as an official rejection rejection.
>
> IN WITNESS WHEREOF, Artist and Counsel have set their hands and seals as of the date above first written.[5]

Mr. Curmano provided space for his signature as well as his counsel's and ended his rejection rejection notice with: "We are sorry for the use of a form letter, but the volume of rejections received makes a personal response impossible."[6]

One starting point for developing an immunity to rejection is to look at rejection in terms of its counterpart—acceptance, or what is commonly referred to as *success*. Rejection and success are analogous for various reasons. What artists define as rejection and success are usually borrowed from other people's opinions, values, and priorities. Artists who measure success and rejection in terms of what society thinks have the most difficult time coping with both phenomena.

Both success and rejection are capable of producing an identity crisis. Some artists who attain success find themselves stripped of goals, direction, and a sense of purpose. The same holds true for artists who are rejected.

Stagnation is a by-product of success and rejection. Artists who are rejected can be diverted and blocked in their creativity. Artists who attain success can lose momentum and vision.

It *is* possible for artists to be unscathed by rejection or success, and continue with new goals, directions, and explorations, irrespective of other people's aesthetic judgments.

The sooner you lose an obsession with rejection, the sooner your real potential develops, and the better equipped you will be to handle success.

If you accept the premise that the reasons for rejection are not truths or axioms, analyze rejection under a microscope. Reduce it to its lowest common denominator. Who is rejecting you? What does the person or entity mean relative to your existence? Is this entity blocking your energy, self-confidence, and achievements? Are you so vulnerably perched that other people's opinions can topple you?

When you can have a good laugh over the significance you had once placed on the answers to these questions, you will be able to respond to rejection the same way you respond to any other form of junk mail.

Building Immunities to Rejection

Keep in mind that generally it takes fifty slide packages of the same body of work to generate one positive response (see page 57). A number less than fifty does not even begin to approach an effective market penetration level that justifies any sense of defeat or rejection.

Each time you receive a letter of rejection, initiate a new contact, send out another presentation package, or pick up the phone. Replace feelings of rejection with a sense of anticipation. This process increases the odds of acceptance and keeps your psyche in good shape.

Stop putting all of your eggs in one basket. Submitting one grant application a year or submitting work to one gallery every six months is only a gesture; strong, affirmative results do not come from gestures. Create opportunities for things to happen. Think big and broad. Make inroads in many directions. *What you want are lots of baskets filled with lots of eggs.*

Appendix of Resources

The following listing includes contact information for the organizations, agencies, publications, Web sites and other resources cited in this book and other resources of interest. This listing is a beginning and by no means covers all of the career information available to artists. But it is a good starting point from which to develop a library of materials and contacts to launch (or relaunch) and sustain your career.

A new feature of this listing is the inclusion of Web site addresses or e-mail addresses for each resource entry, when applicable. A table of contents of the appendix of resources is located on pages v–vi at the beginning of the book.

An adjunct to the appendix of resources is a new Web site that I have created, the Artist Help Network (www.artisthelpnetwork.com), a free information service devoted to resources that will help *artists take control of their careers*. The Web site contains most of the contacts listed in the fifth edition's appendix of resources. Readers can use the Web site to receive updated contact information and listings of new resources that have come to my attention. The Artist Help Network is a work in progress with new information added on an ongoing basis.

ACCOUNTING AND BOOKKEEPING
Publications

The Art of Deduction: Income Tax for Performing, Visual and Literary Artists. California Lawyers for the Arts, Fort Mason Center, Building C, Room 255, San Francisco, CA 94123, 1999. Web site: www.calawyersforthearts.org

The Artist in Business: Basic Business Practices by Craig Dreesen. Arts Extension Service, Division of Continuing Education, University of Massachusetts, P.O. Box 31650, Amherst, MA 01003, revised 1996. Includes information on record keeping and taxes. Web site: www.umass.edu/aes

Artists' Bookkeeping Book. Chicago Artists' Coalition, 11 East Hubbard Street, 7th Floor, Chicago, IL 60611, revised annually. Explains legal tax deductions for artists and record keeping procedures. Also includes ten pages of sample journals illustrating effective record keeping. Web site: www.caconline.org

Artists' Taxes Hands-on Guide. An Alternative to Hobby Taxes by Jo Hanson. Vortex Press, 201 Buchanan Street, San Francisco, CA 94102, 1987. Includes comprehensive information on how to prepare and manage a tax audit; tips for avoiding an audit; and a discussion of an artist's right to deduct art expenses.

Business Entities for Artists Fact Sheet by Mark Quail. Available from Artists' Legal Advice Services and Canadian Artists' Representation Ontario (CARO), 401 Richmond Street West, Suite 443, Toronto, Ontario M5V 3A8, 1991. Summarizes information on sole proprietorships and corporations, including tax perspectives, registration procedures, and legal liability. Web site: www.caro.ca

The Business of Art, edited by Lee Caplin. Englewood Cliffs, N.J.: Prentice-Hall Direct, revised 2000. See "Understanding Everyday Finances" by Robert T. Higashi. Web site: www.phdirect.com

Do-It-Yourself Quick Fix Tax Kit by Barbara A. Sloan. AKAS II, P.O. Box 123, Hot Springs, AR 71902-0123, updated on a yearly basis. Presented in two parts: "The General Tax Guide" enumerates the various types of taxes affecting artists who sell their artwork; "Schedule C Kit" is for visual artists who are sole proprietors of their art business. Web site: www.akasii.com

Fear of Filing: A Beginner's Guide to Tax Preparation and Record Keeping for Artists, Performers, Writers and Freelance Professionals by Theodore W. Striggles and Barbara Sieck Taylor. Volunteer Lawyers for the Arts, 1 East 53rd Street, New York, NY 10022-4201, revised 1985. Web site: www.vlany.org

General Tax Guide for Visual Artists by Barbara A. Sloan. AKAS II, P.O. Box 123, Hot Springs, AR 71902-0123, 1995 version with 2001 update. Provides an overview of taxes on income, sales, property, gifts, estates, and employment. Contains a short supplement to reflect recent changes in tax laws that directly affect visual artists. Web site: www.akasii.com

Legal Guide for the Visual Artist by Tad Crawford. New York: Allworth Press, revised 1999. See four chapters on taxes. Web site: www.allworth.com

National Directory of Volunteer Accounting Programs. Accountants for the Public Interest, 1625 Eye Street, NW, Washington, DC 20006. Provides information on who to contact for free accounting services.

The Paper Chase: Non Profit Filings, Forms & Record Keeping by Peter Wolk and Peter Lewit. Washington, D.C.: Washington Area Lawyers for the Arts and the Cultural Alliance of Greater Washington, 1992. Available from Washington Area Lawyers for the Arts, 815 15th Street, NW, Washington DC 20005. Includes definitions of IRS, state, and local rules; filing tax and payroll forms; and record keeping requirements. Web site: www.thewala.org

Recordkeeping Kit by Barbara A. Sloan. AKAS II, P.O. Box 123, Hot Springs, AR 71902-0123, revised 1999. Includes bookkeeping basics for artists' business and personal records, with suggested alternatives to formal bookkeeping and accounting, and completed sample record-keeping forms. Web site: www.akasii.com

Schedule C Tax Kits for Artists by Barbara A. Sloan. AKAS II, P.O. Box 123, Hot Springs, AR 71902-0123, 2001. Includes line-by-line instructions and examples for artists to complete Schedule C and Schedule SE for filing with the IRS. Provides tips on how to lower income taxes and avoid unwanted tax problems. Web site: www.akasii.com

The Tax Workbook for Artists and Others by Susan Harvey Dawson. ArtBusiness, Inc., 223 North St. Asaph Street, Alexandria, VA 22314. Revised annually.

Taxation of the Visual and Performing Artist: An Insight into Federal Income Tax. Texas Accountants and Lawyers for the Arts, 1540 Sul Ross, Houston, TX 77006, revised annually. A step-by-step guide to assist artists in completing income tax returns. Answers frequently asked questions and provides examples of completed returns. Web site: www.talarts.org

Software

QuickBooks. Recommended software program for accounting and bookkeeping. Available in software section of computer stores. Web site: www.quickbooks.com

Web Sites

Artist Help Network (www.artisthelpnetwork.com). Founded by Caroll Michels, this site is devoted to all aspects of career development, including contact information for organizations, periodicals, publications, software, audiovisual aids, Web sites, and service providers. See heading "Money" and subheadings "Accounting," "Art Accountants Organizations," and "Accountants."

Organizations by State

CALIFORNIA

Business Volunteers for the Arts, c/o San Francisco Chamber of Commerce, 465 California Street, San Francisco, CA 94104.

Business Volunteers for the Arts/East Bay, 1404 Franklin Street, Suite 713, Oakland, CA 94612.

CONNECTICUT

Business Volunteers for the Arts, c/o Arts Council of Greater New Haven, 70 Audubon Street, New Haven, CT 06510.

DISTRICT OF COLUMBIA

Business Volunteers for the Arts, Cultural Alliance of Greater DC, 1436 U Street, NW, Suite 103, Washington, DC 20009. Web site: www.cultural-alliance.org

FLORIDA

ArtServe, 1350 East Sunrise Boulevard, Suite 100, Fort Lauderdale, FL 33304.

Business Volunteers for the Arts/Miami, Museum Tower, 150 West Flagler Street, Suite 2500, Miami, FL 33130.

GEORGIA

Business Volunteers for the Arts, P.O. Box 1740, Atlanta, GA 30301.

Georgia Volunteer Accountants for the Arts, One CNN Center, 1395 South Tower, Atlanta, GA 30303.

ILLINOIS

Business Volunteers for the Arts, 800 South Wells Street, Chicago, IL 60607.

MISSOURI

St. Louis Volunteer Lawyers and Accountants for the Arts, 3540 Washington, 2nd Floor, St. Louis, MO 63103. Serves artists in Missouri and Southwest Illinois. Web site: www.vlaa.org

OHIO

Volunteer Lawyers and Accountants for the Arts, 113 St. Clair Avenue, NE, Cleveland, OH 44114-1253.

PENNSYLVANIA

Community Accountants, University City Science Center, 3508 Market Street, #135, Philadelphia, PA 19104. Offers free services to qualified artists.

TEXAS

Arts and Business Connection, 3325 West Seventh Street, Fort Worth, TX 76107. E-mail: artsbusiness@star.telegram.com

Business Volunteers for the Arts of Fort Worth and Tarrant County, 1 Tandy Center, Suite 150, Fort Worth, TX 76102.

Texas Accountants and Lawyers for the Arts, P.O. Box 2019, Cedar Hill, TX 75106. Web site: www.talarts.org

Texas Accountants and Lawyers for the Arts, 1540 Sul Ross, Houston, TX 77006. Web site: www.talarts.org

WASHINGTON

Business Volunteers for the Arts, 1301 Fifth Avenue, #2400, Seattle, WA 98101. Web site: www.bvaseattle.org

APPRENTICESHIPS AND INTERNSHIPS
Publications

Gardner's Guide to Internships at Multimedia and Animation Studios by Garth Gardner. Annandale, Va.: Garth Gardner Inc., 2001. Profiles hundreds of computer graphics, animation, and multimedia companies in the United States and Canada that offer internships. Web site: www.gogardner.com

Gardner's Guide to Internships in New Media: Computer Graphics, Animation and Multimedia by Garth Gardner and Bonney Ford. Annandale, Va.: Garth Gardner Inc., 2000. Profiles hundreds of companies in the visual-effects industry that offer internships. Web site: www.gogardner.com

Internship Opportunities at the Smithsonian Institution, edited by Bruce C. Craig and Stacey Burkhardt. Center for Museum Studies, MRC 427, Smithsonian Institution, Washington, DC 20560, revised 1997–98. Lists internship positions at the Smithsonian Institution. Also available on-line. Web site: www.si/edu/cms

Internships and Job Opportunities in New York City and Washington, D.C. The Graduate Group, P.O. Box 370351, West Hartford, CT 06117-0351, revised annually. Web site: www.graduategroup.com

Internships in Federal Government. The Graduate Group, P.O. Box 370351, West Hartford, CT 06117-0351, revised annually. Web site: www.graduategroup.com

Internships in State Government. The Graduate Group, P.O. Box 370351, West Hartford, CT 06117-0351, revised annually. Web site: www.graduategroup.com

Internships Leading to Careers. The Graduate Group, P.O. Box 370351, West Hartford, CT 06117-0351, revised annually. Web site: www.graduategroup.com

National Directory of Art Internships, edited by Warren Christensen and Diane Robinson. The National Network for Artist Placement, 935 West Avenue, Suite 37, Los Angeles, CA 90065, updated regularly. Lists hundreds of internship opportunities in the arts. Web site: www.artistplacement.com

New Internships. The Graduate Group, P.O. Box 370351, West Hartford, CT 06117-0351, revised annually. Web site: www.graduategroup.com

Web Sites

Artist Help Network (www.artisthelpnetwork.com). Founded by Caroll Michels, this site is devoted to all aspects of career development, including contact information for organizations, periodicals, publications, software, audiovisual aids,

Web sites, and service providers. See heading "Money" and subheading "Apprenticeships and Internships."

Artist Resource (www.artistresource.org/jobs.htm). Lists internships in the fields of art and design.

Artjobonline (www.artjob.org). Lists internships in visual and performing arts, literature, education, and arts administration. A service of the Western States Arts Federation (WESTAF).

Internship Opportunities at the Smithsonian Institution (www.si.edu/cms). Lists internship positions at the Smithsonian Institution.

Organizations

The National Network for Artist Placement, 935 West Avenue, Suite 37, Los Angeles, CA 90065. Web site: www.artistplacement.com

New York Arts Program, Great Lakes Colleges Association Program in New York, 305 West 29th Street, New York, NY 10001. Provides students with the opportunity to serve as apprentices to established professional artists or arts institutions in New York City for one semester. Administered by Ohio Wesleyan University. Web site: www.newyorkartsprogram.org

Percent for Art Program Internships, New York City Department of Cultural Affairs, 330 West 42nd Street, 14th Floor, New York, NY 10036. Web site: www.ci.nyc.ny.us/html/dcla/html/internshipopp.html

Also see "Employment Opportunities."

ART COLONIES AND
ARTIST-IN-RESIDENCE PROGRAMS
Publications

About Creative Time Spaces: An International Sourcebook by Charlotte Plotsky. P.O. Box 30854, Palm Beach Gardens, FL 33420, revised 1996. Lists and describes artists' communities, retreats, residences, and work spaces throughout the world.

Art Calendar. P.O. Box 2675, Salisbury, MD 21802. Includes listings of residency opportunities for artists. Published eleven times a year. Web site: www.artcalendar.com

Art Opportunities Monthly. P.O. Box 502, Benicia, CA 94510-0502. A listing of opportunities for artists, including residencies. Published eleven times a year. Available via e-mail or postal mail. Web site: studionotes.com

Artist Residencies for Health Care Members. Queensland Artworkers Alliance, Level 1, 381 Brunswick Street, Fortitude Valley 4006, Queensland, Australia. A guide for health care institutions interested in developing and implementing artist residency programs. Web site: www.artworkers.asn.au

Artist Residencies in Schools. Queensland Artworkers Alliance, Level 1, 381 Brunswick Street, Fortitude Valley 4006, Queensland, Australia. A guide to developing and implementing visual artists' residency programs. Web site: www.artworkers. asn.au

Artists and Writers Colonies: Retreats, Residencies and Respites for the Creative Mind by Gail Bowler. Portland, Ore.: Blue Heron Publishing, Inc., 1995. Describes nearly two hundred residencies, retreats, and fellowships. Indexed by state and disciplines. Includes information on eligibility requirements, application deadlines, and services. Web site: www.teleport.com/~bhp/a_authors/a_Bowler.html

Artists' Colonies & Retreats, Chicago Artists' Coalition, 11 East Hubbard Street, 7th Floor, Chicago, IL 60611, regularly revised. Web site: www.caconline.org

Artists Communities, edited by Tricia Snell. New York: Allworth Press, revised 2000. A complete guide to residence opportunities in the United States for visual and performing artists and writers. Includes information on facilities, admission deadlines, eligibility requirements, and the selection process. Web site: www. allworth.com

An Artist's Resource Book by Jennifer Parker. Go Far Press, 4030 Martin Luther King Way, Oakland, CA 94609. Includes a listing of residency programs and facilities for visual artists. E-mail: gofarpress@earthlink.net

Arts Education Directory of Artists. Idaho Commission on the Arts, P.O. Box 83720, Boise, ID 83720. Revised regularly. A listing of artists who participate in Idaho's artist-in-residence, Educational Innovations, and Folk Arts in the Schools programs. Web site: www2.state.id.us/arts

Directory of Performing Artists and Master Teaching Artists. Connecticut Commission on the Arts, 755 Main Street, One Financial Plaza, Hartford, CT 06103. Lists Connecticut-based artists who specialize in public performances, classroom residencies, and curriculum development. Revised regularly. Also available on-line. Web site: www.ctarts.org/directry.htm

The Fine Artist's Guide to Marketing and Self-Promotion by Julius Vitali. New York: Allworth Press, 1996. Provides background information about teaching-residency opportunities in the arts. See the chapter "Artists-in-Education." Web site: www.allworth.com

Money for International Exchange in the Arts by Jane Gullong, Noreen Tomassi, and Anna Rubin. American Council for the Arts in cooperation with Arts International, revised 2000. Available from Arts International, Institute of International Education, 809 United Nations Plaza, New York, NY 10017. Includes information on international artists' residency programs. Web site: www. artsinternational.org

Open Space: UK Opportunities for Visual Artists from Overseas, edited by Kristin Danielsen. Visiting Arts, 11 Portland Place, London W1N 4EJ, England, 1999. A directory of opportunities for international visual artists in the United Kingdom, including residencies. Web site: www.britcoun.org/visitingarts

Visual Arts Residencies: Sponsor Organizations. Mid Atlantic Arts Foundation, 22 Light Street, Suite 300, Baltimore, MD 21202, revised 1996. Describes organizations that sponsor visual artists' residencies in the mid-Atlantic region. Lists the name, address, phone number, and contact person for each sponsoring organization. Web site: www.charm.net/~midarts

Web Sites

Alliance of Artists' Communities (www.artistcommunities.org). Provides links to numerous art colonies and artist-in-residence programs.

Artist Help Network (www.artisthelpnetwork.com). Founded by Caroll Michels, this site is devoted to all aspects of career development, including contact information for organizations, periodicals, publications, software, audiovisual aids, Web sites, and service providers. See heading "Money" and subheadings "Art Colonies and Artist-in-Residence Programs," "International Connections," and "Grants and Funding."

Directory of Artists in Schools 1999–2002 (www.artsineddirectory.org). An on-line listing of artists who participate in arts-in-education programs and use the New York State Learning Standards for the Arts. Sponsored by the Board of Co-operative Educational Services.

Directory of Performing Artists and Master Teaching Artists (www.ctarts.org/Directry.htm). Lists Connecticut-based artists who specialize in public performances, classroom residencies, and curriculum development. Revised regularly. Sponsored by the Connecticut Commission on the Arts.

SchoolShows.com (www.schoolshows.com). A national directory of performers who present assemblies, workshops, and residencies in schools.

Organizations

Alliance of Artists' Communities, 2325 East Burnside Street, Suite 201, Portland, OR 97214. A national service organization that supports artists' communities and residency programs. Web site: www.artistcommunities.org

Florida Division of Cultural Affairs, The Capitol, Tallahassee, FL 32399-0250. Places professional artists in Florida schools. Also sponsors a visiting-artist residency program that places artists in community colleges. Web site: www.dos.state.fl.us/dca/

Hospital Audiences, Inc., 548 Broadway, 3rd Floor, New York, NY 10012-3950. Brings visual and performing art programs to New Yorkers who are confined to hospitals and health care facilities, shelters, etc. Web site: www.hospitalaudiences.org

New York Foundation for the Arts, Artists in Residence Program, 155 Avenue of the Americas, 14th Floor, New York, NY 10013. Awards matching grants to organizations and schools to support artists' residences. Web site: www.nyfa.org

Northern Artists into Schools, School of Cultural Studies, Sheffield Hallem University, Psalter Lane Campus, Sheffield, South Yorkshire S11 8UZ, England. Maintains a register of artists in all disciplines who are interested in working with young people in the north of England. Web site: www.shu.ac.uk/nais

Studio in a School, 410 West 59th Street, New York, NY 10019. Places professional visual artists in New York City's public schools. Web site: www.studioinaschool.org

Young Audiences, Inc., 115 East 92nd Street, New York, NY 10128-1688. National organization that offers opportunities for artists in all disciplines to work in school systems throughout the United States. Web site: www.youngaudiences.org

VSA arts (formerly Very Special Arts), 1300 Connecticut Avenue, NW, Suite 700, Washington, DC 20036. Sponsors an artist-in-residence program that helps veterans build independence and self-confidence by using artistic outlets to enhance the rehabilitation process. Web site: www.vsarts.org

Also see "Art and Healing," "Grants and Funding Resources," and "International Connections."

ART AND HEALING
Publications

Artist Residencies for Health Care Members. Queensland Artworkers Alliance, Level 1, 381 Brunswick Street, Fortitude Valley 4006, Queensland, Australia. A healthcare guide for institutions that are developing and implementing artist residency programs. Web site: www.artworkers.asn.au

The Arts in Health Care: A Palette of Possibilities, edited by Charles Kaye and Tony Blee. Jessica Kingsley Publishers, c/o Taylor & Francis, Inc., 325 Chestnut Street, Philadelphia, PA 19106, 1996. Chronicles the expanding use of the arts in the United Kingdom's National Health Service and at selected medical centers in the United States. Discusses the therapeutic value of using the arts in health and health care. Web site: www.jkp.com

Web Sites

Art as a Healing Force (www.artashealing.org). Provides links to hospitals that are involved in art and healing programs.

Artist Help Network (www.artisthelpnetwork.com). Founded by Caroll Michels, this site is devoted to all aspects of career development, including contact information for organizations, periodicals, publications, software, audiovisual aids, Web sites, and service providers. See heading "Career" and subheading "Career Challenges and the Psyche" and heading "Other Resources" and subheading "Art and Healing."

The Arts and Healing Network (www.artheals.org). A site devoted to information on arts and healing, including recommended books, conferences, and opportunities for artists. Also features the work of more than two hundred visual artists.

Organizations

Aesthetics, Inc., 2900 Fourth Avenue, Suite 100, San Diego, CA 92103. Incorporates art into heath care, validating the relationship between the community

and the hospital. Health-care designers, art directors, and artists collaborate on projects, including the design of healing centers and the design of interior and architectural elements. Web site: www.aesthetics.net

The Arts and Healing Network, Box 612, San Francisco, CA 94118. Sponsors a Web site devoted to information on arts and healing, including recommended books, conferences, and opportunities for artists. Web site: www.artheals.org

Arts in Medicine, Shands Hospital, P.O. Box 100317, University of Florida, Gainesville, FL 32610-0317. Combines standard medical practices with innovative healing methods that include a program involving artists and patients and their families. Web site: www.shands.org/aim

Children's National Medical Center, 111 Michigan Avenue, NW, Washington, DC 20010-2970. Sponsors the New Horizons program that hosts exhibitions, performances, and an artists', writers', and musicians' residency program. E-mail: tmobley@cnmc.org

Connecticut Hospice Program, Arts Department, 61 Burban Drive, Branford, CT 06405. Sponsors several artist-in-residence programs.

Duke University Medical Center, Cultural Services Department, P.O. Box 3071, Durham, NC 27710. Sponsors professional arts programming in health care for the benefit of medical and support staff, patients, and their families, including art in patients' rooms and display cases, and a touchable art gallery in the Eye Center. Web site: http://dukehealth.org/patients_visitors/getting_around.asp

The Foundation for Hospital Art, 120 Stonemist Court, Roswell, GA 30076. Provides original artwork to hospitals and nursing homes for the purpose of supplementing the healing work of hospital staffs. Web site: www.hospitalart.com

Gifts of Art, NI-5B01, NIB, 300 North Ingalls, Ann Arbor, MI 48109-0470. A program of the University of Michigan hospitals. Open to Michigan artists. Sponsors exhibitions in nine hospital galleries. Artwork should enrich the lives of the patients, their families, and staff.

Hospital Audiences, Inc., 548 Broadway, 3rd Floor, New York, NY 10012-3950. Brings visual and performing art programs to New Yorkers who are confined to hospitals and health care facilities, shelters, etc. Web site: www.hospitalaudiences.org

International Arts-Medicine Association (IAMA), 714 Old Lancaster Road, Bryn Mawr, PA 19010. A nonprofit organization that serves as a forum for interdisciplinary, international communication between arts and healing professionals. Members include clinicians, educators, researchers, and artists who have an interest in the relationships between the arts and health. Web site: www.members.aol.com/iamaorg

Smith Farm Center for the Healing Arts, 1229 15th Street, NW, Washington, DC 20005. Coordinates creative art projects with cancer patient groups and retreats, and health professional development programs. Web site: www.smithfarm.com

Society for the Arts in Healthcare, 1229 15th Street, NW, Washington DC 20005. A national membership organization dedicated to promoting the incorporation of the arts as an integral component of health care. Conducts conferences and

publishes a semiannual newsletter and membership directory. Web site: www.societyartshealthcare.org

ARTISTS' BOOKS
Publications

Art on Paper: The International Magazine of Prints, Drawings and Photography. Fanning Publishing Company, 39 East 78th Street, New York, NY 10021. Covers information on artists' books. Published bimonthly. Web site: www.artonpaper.com

The Book Arts Classified. Page Two, Inc., P.O. Box 77167, Washington, DC 20013-7167, 1996. Lists opportunities and information of interest to book artists. Published bimonthly. Web site: www.bookarts.com

The Book Arts Directory. Page Two, Inc., P.O. Box 77167, Washington, DC 20013-7167. Published annually. An excellent resource for artists working in the book arts field. Also includes information for papermakers, calligraphers, paper decorators, printmakers, book designers, fine printers, publishers, traditional bookbinders, and artist bookmakers. Lists dealers, galleries, guilds, museums, organizations, libraries, schools, and suppliers related to book arts. Web site: www.bookarts.com

Hand Papermaking. Hand Papermaking, Inc., P.O. Box 77027, Washington, DC 20013-7027. Repository of information on the art and craft of hand papermaking. Irregularly published. Web site: www.handpapermaking.org

Hand Papermaking Newsletter. Hand Papermaking, Inc., P.O. Box 77027, Washington, DC 20013-7027. Includes information and listings for national and international exhibitions, lectures, workshops and other events. Published quarterly. Web site: www.handpapermaking.org

Journal of Artists' Books. 324 Yale Avenue, New Haven, CT 06515. Provides a forum for critical debate about artists' books. Published twice a year.

Umbrella. Umbrella Associates, P.O. Box 3640, Santa Monica, CA 90408. Digest of current trends in artists' books, artists' publications, and mail art. Published three to four times a year. Web site: www.colophon.com/umbrella

Web Sites

Artist Help Network (www.artisthelpnetwork.com). Founded by Caroll Michels, this site is devoted to all aspects of career development, including contact information for organizations, periodicals, publications, software, audiovisual aids, Web sites, and service providers. See heading "Other Resources" and subheading "Artists' Books."

Zybooks. Contemporary Artists Books Online (www.zyarts.com/zybooks). A Web site devoted to the promotion of artists' books.

Organizations

Arnolfini Bookshop, Narrow Quay, Bristol BS1 4QA, England. Publishes and distributes artists' multiples and bookworks. Offers an on-line catalog and mail-ordering service. Web site: www.arnolfini.demon.co.uk/bookshop

Art Metropole, 788 King Street West, 2nd Floor, Toronto, Ontario M5V 1N6, Canada. An artist-run center that operates a shop that specializes in artists' products, including bookworks. Web site: www.artmetropole.org

Artists Bookworks Houston, 915 Richmond Avenue, Houston, TX 77006. Devoted to new and traditional art forms of the book. Offers workshops and sponsors an exhibition space.

Artworks Bookworks, 2525 Michigan Avenue, #T2, Santa Monica, CA 90404. Sells artists' books.

Califia Books, 20 Hawthorne Street, San Francisco, CA 94105. Sells offset artists' books. Web site: www.califiabooks.com

Carnegie Mellon University, Fine Arts and Special Collections Department, Hunt Library, 4909 Frew Street, Pittsburgh, PA 15213. Collects and exhibits artists' books of individual international artists and established artist book distributors and publishers. Web site: www.library.cmu.edu/bySubject/Art/artistsbooks.html

Center for Book & Paper Arts, Columbia College, 1104 South Wabash, 2nd Floor, Chicago, IL 60605. Sponsors exhibitions and workshops. Offers a master's program in book and paper arts. Web site: www.colum.edu/centers/bpa/

Center for Book Arts, 28 West 27th Street, 3rd Floor, New York, NY 10001. Nonprofit educational and exhibition facility. Offers classes and production facilities for artists' books. Web site: www.centerforbookarts.org

Dieu Donné Papermill, 433 Broome Street, New York, NY 10013. A nonprofit hand-papermaking studio. Sponsors exhibitions, workshops, residencies, and other programs. Web site: www.papermaking.org

871 Fine Arts, 49 Geary Street, Suite 513, San Francisco, CA 94108. Features exhibitions of artists' books.

Granary Books, 307 Seventh Avenue, Suite 1401, New York, NY 10001. Publisher of artists' books. Web site: www.granarybooks.com

Hand Papermaking, Inc., P.O. Box 77027, Washington, DC 20013-7027. A nonprofit organization dedicated to advancing traditional and contemporary ideas in the art of hand papermaking. Sponsors a slide registry and publishes *Hand Papermaking* and a newsletter. Web site: www.handpapermaking.org

Joshua Heller Rare Books, P.O. Box 39114, Washington, DC 20016-9114. Sells artists' books. E-mail: hellerbkdc@aol.com

Lake Galleries, 624 Richmond Street West, Toronto, Ontario M5V 1Y9, Canada. Exhibits artists' books.

Minnesota Center for Book Arts, 1011 Washington Avenue South, Minneapolis, MN 55415. Offers studio space and workshops and classes in papermaking, bookbinding, and letterpress. Web site: www.mnbookarts.org

The Museum of Modern Art Library, 11 West 53rd Street, New York, NY 10019-5489. Maintains an extensive collection of artists' books. Web site: www.moma.org

Nexus Press, 535 Means Street, Atlanta, GA 30818. Publishes artists' books. Web site: www.nexusart.org

Printed Matter, 535 West 22nd Street, New York, NY 10011. Largest nonprofit distributor and retailer of artists' books. Also sponsors exhibitions. Web site: www.printedmatter.org

Visual Studies Workshop, Book Service, 31 Prince Street, Rochester, NY 14607. Publishes artists' books and offers residencies and internships related to book arts. Web site: www.vsw.org

White Columns, 320 West 13th Street, New York, NY 10014. An alternative exhibition space that publishes artists' books. Web site: www.whitecolumns.org

Also see "Prints and Printmaking."

ARTISTS' HOUSING AND STUDIO/PERFORMANCE SPACE
Publications

About Creative Time Spaces: An International Sourcebook by Charlotte Plotsky. P.O. Box 30854, Palm Beach Gardens, FL 33420, revised 1996. Includes descriptions of work spaces for artists available throughout the world.

Artists' Housing Manual: A Guide to Living in New York City. Volunteer Lawyers for the Arts, 1 East 53rd Street, 6th Floor, New York, NY 10022-4201, 1987. Helps unravel legal mysteries governing housing and work space in New York City, including tenants' and landlords' rights and responsibilities, loft laws, and more. Web site: www.vlany.org

Conversion Frontiers: Military Bases and Other Opportunities for the Arts. ArtHouse, Fort Mason Center, Building C, Room 255, San Francisco, CA 94123, 1996. A nuts-and-bolts resource guide that provides information about converting military bases for peacetime use by artists and arts organizations. Outlines the steps in the conversion process and provides a framework for groups to evaluate whether they are equipped to purchase space on former base property. Web site: www.arthouseca.org

Creating Space: A Real Estate Development Guide for Artists by Cheryl Kartes. New York: American Council for the Arts in conjunction with Artspace Projects, Inc., and the Bay Area Partnership, 1993. Available from Americans for the Arts, 1000 Vermont Avenue, NW, 12th Floor, Washington, DC 20005. A comprehensive guide that shows artists how they can develop their own spaces for living and working. Includes techniques for assessing a studio/housing project, identifying resources, and organizing tenants. Also provides information on financing strategies, legal structures, design issues, and management. Web site: www.artsusa.org

Doing Homework: Educating Yourself as a Warehouse Tenant, designed and compiled by Catherine Orfald. Toronto: Canadian Artists Representation Ontario (CARO)

and Toronto Artscape, Inc., 1996. Available from Canadian Artists' Representation Ontario, 401 Richmond Street West, Suite 443, Toronto, Ontario M5V 3A8, Canada. A resource book designed to provide artists with information on their rights and obligations in accessing warehouse space. Web site: www.caro.ca

Live/Work: Form and Function by Jennifer Spangler. ArtHouse, Fort Mason Center, Building C, Room 255, San Francisco, CA 94123, revised 1990. Web site: www. arthouseca.org

Live-Work Forum Handbook. ArtHouse, Fort Mason Center, Building C, Room 255, San Francisco, CA 94123, 1999. Based on a workshop sponsored by ArtHouse and the Coalition for Jobs, Arts, and Housing, and Pro Arts. Addresses affordable housing crisis facing Bay Area artists. Web site: www. arthouseca.org

The 100 Best Small Art Towns in America: Where to Discover Creative Communities, Fresh Air, and Affordable Housing by John Villani. John Muir Publications, P.O. Box 613, Santa Fe, NM 87504, revised 1996. An annotated list of communities that are particularly artist-friendly.

Will It Make Theatre: Find, Renovate, and Finance the Non-Traditional Performance Space by Eldon Elder. New York: American Council for the Arts in cooperation with A.R.T./NY, 1993. Available from Americans for the Arts, 1000 Vermont Avenue, NW, 12th Floor, Washington, DC 20005. Discusses how to create a performance facility in a building designed for another purpose. Also covers upgrading space, determining priorities for renovations, understanding building and fire codes, and sharing space with other organizations. Web site: www.artsusa.org

Web Sites

Artist Help Network (www.artisthelpnetwork.com). Founded by Caroll Michels, this site is devoted to all aspects of career development, including contact information for organizations, periodicals, publications, software, audiovisual aids, Web sites, and service providers. See heading "Creature Comforts" and subheadings "Health Hazards in Your Workspace," "Housing & Studio Space," and "Studio Insurance."

Live/Work Institute (www.live-work.com). A nonprofit organization that advocates and assists in the development of live/work housing and communities. Web site provides information about live/work planning and building codes and examples of live/work projects.

Organizations

Art Space Clearinghouse, 3540 Washington Street, St. Louis, MO 63103. Supports and facilitates the development of affordable work and living spaces for artists. Web site: www.vlaa.org/artspace.htm

ArtHouse, Fort Mason Center, Building C, Room 255, San Francisco, CA 94123. Nonprofit organization created to serve as a clearinghouse for information about artists' studio and live/work space and cultural facilities. Provides a hot-

line listing of available space on a twenty-four-hour basis. Web site: www. arthouseca.org

Artist Relocation Program, City Hall, P.O. Box 2267, Paducah, KY 42002-2267. Provides economic and business incentives to artists who wish to relocate to Paducah, Kentucky. E-mail: mbarone@cipaducah.ky.us

Artscape, 60 Atlantic Avenue, Suite 111, Toronto, Ontario M6K 1X9, Canada. A nonprofit organization that devises practical solutions for securing and maintaining artist live/work space in Toronto. Web site: www.torontoartscape.on.ca

Artspace, 329 West Pierpont Avenue, Suite 200, Salt Lake City, UT 84101. A nonprofit arts organization that creates affordable housing and workspaces. Web site: www. artspaceutah.org

Artspace Projects, Inc., 528 Hennepin Avenue South, Suite 404, Minneapolis, MN 55403. Assists artists in finding or developing affordable studio and performance space in vacant and underutilized buildings. Web site: www.artspaceprojects.org

Contemporary Art Center Studio Program, 22-25 Jackson Avenue, Long Island City, NY 11101. An international studio program, sponsored by P.S. 1, the Institute for Contemporary Art, that provides visual artists with free, nonliving studio space for one year at the P.S. 1 Museum in Long Island City and the Clocktower Gallery in Manhattan. Web site: www.ps1.org/cut/studio.html

Elizabeth Foundation for the Arts Studio Center, P.O. Box 2670, New York, NY 10108. Provides 120 reasonably priced work spaces for visual artists in Manhattan. E-mail: studio@efa1.org

Fort Point Arts Community, Inc., 300 Summer Street, Boston, MA 02210. An advocacy organization that helps Boston area artists obtain studio space.

Graphic Artists Guild Mortgage and Real Estate Program, 90 John Street, Suite 403, New York, NY 10038-3202. A special program that offers Graphic Artists Guild members, their parents, and families special help for first-time home buyers, including savings on real estate commissions paid to participating real estate agents, low-cost down payments, competitive mortgage rates, and other benefits. Web site: www.unionprivilege.org

Marie Walsh Sharpe Art Foundation, 711 North Tejon Street, #B, Colorado Springs, CO 80903. Provides free studio space in New York City to visual artists. Artists living throughout the United States are eligible to apply for work spaces.

New York Coalition for Artist's Housing, Brooklyn Arts Council, 195 Cadman Plaza West, Brooklyn, NY 11201. A coalition of artists who work together to purchase and renovate loft buildings in New York City, providing safe, secure, legal, and affordable artist-owned live/work space. Web site: www.brooklynartscouncil. org/baca/nycah

ARTISTS' SOURCEBOOKS
Publications

The Architect's Sourcebook. THE GUILD, 228 State Street, Madison, WI 53703. A re-
source directory that contains the names, addresses, phone numbers, and pho-
tographs of the work of American fine and craft artists, as well as biographical
information. Distributed free of charge to attendees of the American Society of
Interior Designers' and American Institute of Architects' national conferences.
Also distributed free of charge to art consultants. Published annually. Web site:
www.guild.com

The Designer's Sourcebook. THE GUILD, 228 State Street, Madison, WI 53703-2955. A
resource directory that contains the names, addresses, phone numbers, and
photographs of the work of American fine and craft artists, as well as biograph-
ical information. Distributed free of charge to attendees of the American Society
of Interior Designers' and American Institute of Architects' national confer-
ences. Also distributed free of charge to art consultants. Published annually.
Web site: www.guild.com

New American Paintings. The Open Studio Press, 66 Central Street, Suite 18, Welles-
ley, MA 02482. A series of artists' sourcebooks published several times a year.
Artists are selected by a juried procedure. No publication fees are charged. Web
site: www.newamericanpaintings.com

Web Sites

Artist Help Network (www.artisthelpnetwork.com). Founded by Caroll Michels,
this site is devoted to all aspects of career development, including contact infor-
mation for organizations, periodicals, publications, software, audiovisual aids,
Web sites, and service providers. See heading "Exhibitions, Commissions, Sales"
and subheading "Artist Sourcebooks."

ARTISTS WITH DISABILITIES
Publications

Directory of Deaf Artists. Deaf Artists of America, 302 North Goodman Street, Suite
205, Rochester, NY 14607-1149. Phone and fax 716-244-3690.

Disability Arts in London magazine. The London Disability Arts Forum, Diorama Arts
Centre, 34 Osnaburgh Street, London NW1 3ND, England. A magazine devoted
to disability and the arts. Published bimonthly. Web site: www.dail.dircon.co.uk

Kaleidoscope: International Magazine of Literature, Fine Arts, and Disability. United Dis-
ability Services, 701 South Main Street, Akron, OH 44311. Published twice a
year. Voice mail: 330-762-9755. TTY: 330-379-3349.

Resources for Illinois Artists Overcoming Disabilities by William Harroff. Chicago Artists'
Coalition, 11 East Hubbard Street, 7th Floor, Chicago, IL 60611, regularly up-
dated. Web site: www.caconline.org

Audiotapes

Crafts Report. Jewish Guild for the Blind, Cassette Library, 15 West 65th Street, New York, NY 10023. A newsletter in cassette form. Published monthly. Web site: www.jgb.org

Web Sites

Artist Help Network (www.artisthelpnetwork.com). Founded by Caroll Michels, this site is devoted to all aspects of career development, including contact information for organizations, periodicals, publications, software, audiovisual aids, Web sites, and service providers. See heading "Other Resources" and subheading "Artists with Disabilities."

National Arts and Disability Center (http://nadc.ucla.edu). 300 UCLA Plaza, Suite 3310, Los Angeles, CA 90095-6967. An on-line gallery that features the work of artists with disabilities.

VSA arts Online Gallery (www.vsarts.org). VSA arts, 1300 Connecticut Avenue, NW, Suite 700, Washington, DC 20036. Features the work of artists with disabilities who are members of the VSA arts Artist Registry.

Organizations

Coalition for Disabled Musicians, Inc., P.O. Box 1002M, Bay Shore, New York 11706-0533. Volunteer, self-help organization for individuals with disabilities that provides assistance in the pursuit of musical aspirations. Web site: www.disabled-musicians.org

Deaf Artists of America, 302 North Goodman Street, Suite 205, Rochester, NY 14607-1149. Not-for-profit arts service organization for deaf artists. TTY: 716-244-3460. Fax: 716-244-3690.

Disabled Artists' Network, P.O. Box 20781, New York, NY 10025. Support group for disabled professional visual artists. Publishes a newsletter.

Enabled Artists United, P.O. Box 178, Dobbins, CA 95935. Provides referral services to artists with disabilities and assists in networking. Maintains a roster of member artists. E-mail: inkwell@oro.net

The London Disability Arts Forum, Diorama Arts Centre, 34 Osnaburgh Street, London NW1 3ND, England. Strengthens and develops the image of disability in arts and culture. Publishes *Disability Arts in London* and sponsors events and programs. Web site: dail.dircon.co.uk

Mouth and Foot Painting Artists, 9 Inverness Place, London W2 3JG, England. Sponsors a gallery featuring exhibitions of artists who paint with their mouth or foot. Also sponsors a Web site with a selection of greeting cards, calendars, and other items designed by mouth and foot artists. Web site: www.amfpa.com

Mouth and Foot Painting Artists, Inc. (formerly Association of Handicapped Artists, Inc.), 5150 Broadway, Depew, NY 14043. Also has an office in Atlanta: 2070

Peachtree Industrial Court, Atlanta, GA 30341. An information clearinghouse for mouth and foot artists. Conducts workshops and organizes exhibitions. Web site: www.thegrid.net/sconi/Association.htm

National Arts and Disability Center, UCLA University Affiliation Program, 300 UCLA Medical Plaza, Room 3330, Los Angeles, CA 90095-6967. A resource, information, and training center that provides information on the arts and disabilities. Voice: 310-794-1141. Web site: http://nadc.ucla.edu

National Endowment for the Arts, Office for AccessAbility, 1100 Pennsylvania Avenue, NW, Washington, DC 20506. An advocate-technical assistance arm of the NEA for people with disabilities, as well as for older adults, veterans, and people living in institutions. Web site: www.arts.endow.gov/partner/Accessibility/ AccessMap.html

National Exhibits by Blind Artists, Associated Services, 919 Walnut Street, Philadelphia, PA 19107.

National Federation for the Blind, 1800 Johnson Street, Baltimore, MD 21230. Sponsors an artists' organization. Voice: 410-659-9314. Web site: www.nfb.org

National Institute of Art and Disabilities, 551 23rd Street, Richmond, CA 94804. Provides studios to artists with developmental disabilities. Sponsors a gallery. Web site: www.niadart.org

New York Foundation for the Arts, 155 Avenue of the Americas, 14th Floor, New York, NY 10013. Sponsors grants and fellowship programs for the disabled community and provides technology and audience exchange programs for disabled artists. Web site: www.nyfa.org

VSA arts (formerly Very Special Arts), 1300 Connecticut Avenue, NW, Suite 700, Washington, DC 20036. Sponsors several programs including an on-line gallery and the Yamagata International Visual Arts Institute, which offers opportunities for artists with disabilities to enhance their professional careers by working with fellow artists. Web site: vsarts.org

ARTS SERVICE ORGANIZATIONS
Publications

Asian American Arts Resource Directory. Asian American Arts Alliance, Inc., 74 Varick Street, New York, NY 10013, revised 1999. Lists more than two hundred Asian-American arts organizations and artists' tours nationwide. Web site: www. aaartsalliance.org

Directory of Minority Arts Organizations, edited by Carol Ann Huston. Office of Civil Rights, National Endowment for the Arts, 1100 Pennsylvania Avenue, NW, Washington, DC 20506. Regularly updated. Lists art centers, galleries, performing groups, presenting groups, and local and national arts service organizations with leadership and constituencies that are predominately Asian-American,

African-American, Hispanic, Native American, or multiracial. Web site: www.arts.endow.gov/learn/civil.html

Directory of the Arts. Canadian Conference of the Arts, 104-130 Albert Street, Ottawa, Ontario K1P 5G4, Canada, revised 2000. A complete listing of Canadian cultural departments and agencies, national arts associations, arts councils, and cultural agencies. Web site: www.ffa.ucalgary.ca/cca

Manitoba Visual Artists Index. CARFAC Manitoba, 221-100 Arthur Street, Winnipeg, Manitoba R3B 1H3, Canada, 1992. Includes a list of art service organizations in Manitoba. Web site: www.umanitoba.ca/schools/art/gallery/hpgs/carfac

The National Resource Guide for the Placement of Artists, edited by Cheryl Slean. The National Network for Artist Placement, 935 West Avenue, Suite 37, Los Angeles, CA 90065. Revised regularly. An annotated guide to arts organizations that provide support to artists. Web site: www.artistplacement.com

Organizing Artists: A Document and Directory of the National Association of Artists' Organizations. National Association of Artists' Organizations, 1718 M Street, NW, PMB #239, Washington, DC 20036, revised 1998. Describes alternative spaces and art service organizations. Each entry includes a description of programs, disciplines, exhibition and/or performance spaces, proposal procedures, and the name of a contact person. Web site: www.naao.org

Web Sites

Artist Help Network (www.artisthelpnetwork.com). Founded by Caroll Michels, this site is devoted to all aspects of career development, including contact information for organizations, periodicals, publications, software, audiovisual aids, Web sites, and service providers. See heading "Other Resources" and subheadings "National Art Service Organizations," "Regional Art Service Organizations," and "Art Service Organizations Abroad."

Arts and Healing Network (www.artheals.org). An international resource and exchange for those interested in the healing potential of art. Features a list of various events, books, and organizations and a registry of visual artists.

Directory of Hispanic Arts Organizations (www.latinoarts.org/directory.htm). An on-line directory of Hispanic organizations involved with dance, literature, media, music, theater, and visual arts.

National Endowment for the Arts (www.arts.endow.gov). Describes all of the various programs sponsored by the National Endowment for the Arts and includes program guidelines.

National Organizations

American Association of Museums, 1575 Eye Street, NW, Suite 400, Washington, DC 20005. Membership organization open to professional and volunteer museum staff, independent curators, and consultants. Provides members with health insurance. Web site: www.aam-us.org

The American Ceramic Society, P.O. Box 6136, Westerville, OH 43086-6136. Dedicated to the advancement of ceramics. Sponsors publications, a ceramic-information center, and more. Web site: www.ceramics.org

American Craft Council, 72 Spring Street, 6th Floor, New York, NY 10012. National organization that sponsors exhibitions, seminars, workshops, an international exchange, and communications programs. Publishes *American Craft*. Web site: www.craftcouncil.org

American Print Alliance, 302 Larkspur Turn, Peachtree City, GA 30269-2210. A nonprofit consortium of printmakers' councils. Publishes the journal *Contemporary Impressions*. Web site: www.printalliance.org

American Sculptors & Casters Association (ASCA), 8 Ecclestone, Irvine, CA 92604. Sponsors seminars, workshops, and a Web site to promote members' work. Seeks to encourage ethics and excellence in the field of cast art.

American Society of Portrait Artists, 2781 Zelda Road, Montgomery, AL 36106. Publishes a quarterly journal and a monthly newsletter. Members are eligible to use a toll-free information line regarding questions related to marketing, technical support, contracts, and pricing. Web site: www.asopa.com

Americans for the Arts, 1000 Vermont Avenue, NW, 12th Floor, Washington, DC 20005, and 1 East 53rd Street, New York, NY 10022. National organization for groups and individuals dedicated to advancing the arts and culture in communities throughout the United States. Sponsors a publications program and distributes career-related books for visual and performing artists. Web site: www.artsusa.org

Aperture Foundation, 20 East 23rd Street, New York, NY 10010. A nonprofit organization devoted to photography and related visual arts. Sponsors exhibitions, publications, research, and the Paul Strand Archive. Web site: www.aperture.org

Art & Science Collaborations, Inc., P.O. Box 358, Staten Island, NY 10301-3225. An organization formed to raise public awareness about artists and scientists who use science and technology to explore new forms of creative expression and to increase communication and collaboration between these fields. Web site: www.asci.org

Arts and Healing Network, Box 612, San Francisco, CA 94118. Sponsors a Web site that serves as an international resource and exchange for those interested in the healing potential of art, including environmentalists, social activists, artists, health care practitioners, and those challenged by illness. The site features a list of various events and resources and a registry of visual artists. Web site: www.artheals.org

Arts Extension Service, Division of Continuing Education, University of Massachusetts, P.O. Box 31650, Amherst, MA 01300. Serves as a catalyst for better management of the arts in communities through continuing education for artists and arts organizations. Sponsors programs in arts management, business development, fund-raising, advocacy leadership, and marketing. Publishes and distributes books, guides, and pamphlets. Web site: www.umass.edu/aes

Asian American Arts Alliance, Inc., 74 Varick Street, Suite 302, New York, NY

10013. Sponsors exhibitions, publications, and programs for Asian-American artists. Web site: www.aaartsalliance.org

Association of Hispanic Arts, Inc., 250 West 26th Street, 4th Floor, New York, NY 10001-6737. Offers a variety of services geared toward professional Hispanic artists and arts organizations. Web site: www.latinoarts.org

Association of Independent Video and Filmmakers, Inc., 304 Hudson Street, 6th Floor, New York, NY 10013. Provides creative and professional opportunities for independent videomakers and filmmakers. Web site: www.aivf.org

ATLATL, P.O. Box 34090, Phoenix, AZ 85067-4090. A national nonprofit organization dedicated to the preservation, promotion, growth, and development of contemporary and traditional Native American arts. Sponsors a Native American resource and distribution clearinghouse. Offers employment referrals and publishes *Native Arts Update.* Web site: www.atlatl.org

Coast to Coast National Women Artists of Color, P.O. Box 110548, Cambria Heights, NY 11411-0548. National membership organization dedicated to supporting women artists of color. Maintains a slide registry, mailing lists, and a database of information. Publishes a newsletter. E-mail: hramsaran@aol.com

En Foco, Inc., 32 East Kingsbridge Road, Bronx, NY 10468. National organization devoted to photographers of color. Sponsors traveling exhibitions, a slide registry, and publishes the newsletter *Critical Mass* and photographic journal *Nueva Luz.* Web site: www.enfoco.org

Friends of Fiber Art International, P.O. Box 468, Western Springs, IL 60558. Sponsors annual programs and a fiber-art registry and publishes a quarterly newsletter.

Graphic Artists Guild, 90 John Street, Suite 403, New York, NY 10038-3202. National membership organization with local chapters throughout the United States. Advances the rights and interests of graphic artists through legislative reform and organizes networking activities, including job-referral services. Publishes the newsletter *Guild News.* Web site: www.gag.org

Guerrilla Girls, 532 LaGuardia Place, #237, New York, NY 10012. A group of women artists, writers, performers, filmmakers, and arts professionals dedicated to fighting sexual discrimination. Web site: www.guerrillagirls.com

Hand Papermaking, Inc., P.O. Box 77027, Washington, DC 20013-7027. A nonprofit organization dedicated to advancing traditional and contemporary ideas in the art of hand papermaking. Sponsors a slide registry and publishes *Hand Papermaking* and *Hand Papermaking Newsletter.* Web site: www. handpapermaking.org

Handweavers Guild of America, Inc., Two Executive Concourse, Suite 201, 3327 Duluth Highway, Duluth, GA 30096-3301. Provides forums for the education of hand weavers, hand spinners, basket makers, and fiber artists in related disciplines. Web site: www.weavespindye.org

International Association of Fine Art Digital Printmakers, 570 Higuera Street, Suite 120, San Luis Obispo, CA 93401. A membership organization that supports the development of the fine-art digital printmaking industry and the development

of standards, definitions, and practices to promote the orderly integration of digital technology into the fine-art industry. Web site: www.iafadp.org

International Sculpture Center, 14 Fairgrounds Road, Suite B, Hamilton, NJ 08619-3447. Nonprofit service organization for professional sculptors. Sponsors a computerized data bank of members' works and organizes international and national exhibitions. Publishes *Sculpture*. Web site: www.sculpture.org

Intuit: The Center for Intuitive and Outsider Art, 756 North Milwaukee Avenue, Chicago, IL 60622. Established to recognize the work of artists who demonstrate little influence from the mainstream art world and who are motivated by a unique personal vision. Sponsors exhibitions, lectures, and public programs. Publishes *In 'Tuit*, a quarterly newsletter. Web site: http://outsider.art.org

Lesbians in the Visual Arts, 870 Market Street, Suite 618, San Francisco, CA 94102. An international organization that advocates visible lesbian inclusion in the art world. Sponsors a slide registry and publishes *Pentimenta Art Journal*. Web site: www.lesbianarts.org

Museum Reference Center, Smithsonian Institution Libraries, Office of Museum Studies, Arts and Industries Building, Room 2235, 900 Jefferson Drive, SW, Washington, DC 20560-0427. Provides technical assistance, workshops, conferences, and information on museums and visual arts. Sponsors an internship program and publishes booklists and guides. Web site: www. sil.si.edu/branches/mrc-hp.htm

National Association of Artists' Organizations (NAAO), 1718 M Street, NW, PMB #239, Washington, DC 20036. A membership organization composed of organizations and individuals. Programs and services are designed to address common concerns, including cultural pluralism, community-based work, organizational stability, working conditions, isolation, and lack of visibility. Web site: www.naao.org

National Endowment for the Arts, 1100 Pennsylvania Avenue, NW, Washington, DC 20506. A federal agency that aims to support America's cultural heritage and nurture and support the arts. Sponsors grants and various programs. Web site: www.arts.endow.gov

National Sculpture Society, 237 Park Avenue, New York, NY 10169. Publishes *Sculpture Review* and a bimonthly newsletter. Also provides members with information on grants, awards, and competitions. Web site: www.nationalsculpture.org

National Women's Caucus for Art, P.O. Box 1498, New York, NY 10013. National organization with regional chapters throughout the United States. Represents the professional and economic concerns of women artists, art historians, educators, writers, and museum professionals. Sponsors conferences and exhibitions and publishes a newsletter. Web site: www.nationalwca.com

National Wood Carvers Association, P.O. Box 43218, Cincinnati, OH 45243. Web site: www.chipchats.org

Open Studio: The Arts Online, The Benton Foundation, 1800 K Street, NW, 2nd Floor, Washington DC 20006. A national initiative that funds organizations to train the arts community to use the Internet for gathering resources, sharing in-

formation, and building new audiences. Provides free access and training to artists and nonprofit arts organizations. Web site: www.openstudio.org

Photographic Resource Center, 602 Commonwealth Avenue, Boston, MA 02215. A membership organization that provides a range of programs and services for photographers, journalists, critics, curators, students, and other individuals and organizations interested in photography. Web site: www.bu.edu/prc

Society for Photographic Education, P.O. Box 2811, Daytona Beach, FL 32120-2811. Nonprofit membership organization that provides a forum for the discussion of photography and related media as a means of creative expression and cultural insight. Sponsors publications, services, and interdisciplinary programs. Web site: www.spenational.org.

Society for the Arts in Healthcare, 3867 Tennyson Street, Denver, CO 80212-2107. A national membership organization that is dedicated to the incorporation of the arts as an appropriate and integral component of health care. Members include physicians, nurses, medical students, arts administrators, architects, designers, and artists in all disciplines. Publishes a newsletter and membership directory and sponsors an annual conference. Web site: www. societyartshealthcare.org

The Studio Potter, P.O. Box 70, Goffstown, NH 03045. A nonprofit organization dedicated to the service of the international community of ceramic artists. Web site: www.studiopotter.org

Surface Design Association, P.O. Box 360, Sebastopol, CA 95473-0360. A national membership organization for artists involved in surface design, textiles, weavings, quilts, and other forms of fiber art. Publishes *Surface Design*. Web site: www.surfacedesign.org

UrbanGlass, 647 Fulton Street, Brooklyn, NY 11217-1112. Dedicated to promoting the use of glass as a medium for creative endeavors in art, craft, and design. Web site: www.urbanglass.com

Regional Organizations

Albany/Schenectady League of Arts, 161 Washington Avenue, Albany, NY 12210. Serves artists in the New York State capitol region. Sponsors workshops and seminars, publishes a newsletter, and offers members health insurance. Web site: www.artsleague.org

Alliance for the Arts, 330 West 42nd Street, #1701, New York, NY 10036. A not-for-profit research center that gathers, analyzes, and publishes information about the arts in New York City. Sponsors the Estate Project for Artists with AIDS, the New York City Arts Online, and the New York Citywide Cultural Database project. Web site: www.allianceforarts.org

Allied Arts of Seattle, P.O. Box 2584, Bellingham, WA 98227. Serves as a referral and information center for artists and arts organizations. Web site: www.alliedarts-seattle.org

Art in General, 79 Walker Street, New York, NY 10013-3523. A nonprofit membership organization. Sponsors publications, exhibitions, and workshops. Web site: www.artingeneral.org

Art Information Center, 55 Mercer Street, New York, NY 10013. Provides information to artists interested in exhibiting in New York.

Artists Alliance of California, P.O. Box 2424, Nevada City, CA 95959. A membership organization that publishes a newsletter and a directory of vendors who give members discounts. Offers a health care plan to California artists. Web site: www.cdiart.com/artists-alliance

The Artists Foundation, 516 East Second Street, #49, Boston, MA 02127. A statewide nonprofit organization devoted to enhancing the careers of individual artists and the position of artists in society. Sponsors exhibitions and performances and provides other services. Web site: www.artistsfoundation.org

Artists Trust, 1402 Third Avenue, Suite 404, Seattle, WA 98101. Provides information services and grants to artists. Web site: www.artisttrust.org

Arts & Cultural Council for Greater Rochester, 277 North Goodman Street, Rochester, NY 14607. A coalition of arts organizations, artists, businesses, and county government. Provides support services to individual artists, including promotion, consultation, management workshops, volunteer legal assistance, group health insurance, and a slide registry. Web site: www.artsrochester.org

Arts Midwest, 2908 Hennepin Avenue, Suite 200, Minneapolis, MN 55408-1954. Regional arts organization serving Illinois, Indiana, Iowa, Michigan, Minnesota, North Dakota, Ohio, South Dakota, and Wisconsin. Provides services, publications, workshops, exhibitions, and grants. Web site: www.artsmidwest.org

ArtServe, Inc., 1350 East Sunrise Boulevard, Fort Lauderdale, FL 33304. An arts service organization assisting Florida artists and cultural not-for-profit organizations through ArtServe Business Services/Broward, Business Volunteers for the Arts, and Volunteer Lawyers for the Arts/Florida.

Artswatch, 2337 Frankfurt Avenue, Louisville, KY 40206. Sponsors exhibitions, performances, workshops, educational programs, and residencies.

Association of Teaching Artists, P.O. Box 106, Gilbertsville, NY 13777. Champions the professional status of teaching artists in New York State by providing professional development opportunities. Represents the field in educational policy discussions and forms regional networks among artists, arts organizations, and institutions. Web site: www.teachingartists.com

Boston Visual Artists Union, P.O. Box 399, Newtonville, MA 02160. Service organization that supports artists' work through exhibitions, a slide registry, a resource center, a newsletter, and special programs.

The Business Center for the Arts, 965 Longwood Avenue, Bronx, NY 10459. Sponsors workshops and provides information on proposal writing, business plans, grant writing, and other career-related topics. Web site: www. bcadc.org

Center for Contemporary Art, 410 Terry Avenue North, Seattle, WA 98109. Sponsors exhibitions, performances, publications, educational programs, and residencies. Web site: www.cocaseattle.org

The Center for Contemporary Arts of Santa Fe, 291 East Barcelona Road, Santa Fe, NM 87501. Sponsors exhibitions, performances, workshops, residencies, publications, educational programs, studio programs, and other services.

The Center for Photography at Woodstock, 59 Tinker Street, Woodstock, NY 12498. Sponsors exhibitions, fellowships, lecture/workshops, and publications for photographers, video artists, and filmmakers. Web site: www.cpw.org

Center for Women and Their Work, 1710 Lavaca Street, Austin, TX 78701. Sponsors exhibitions, performances, workshops, educational programs, and publications. Web site: www.womenandtheirwork.org

Central Coast Chapter Artists Equity, P.O. Box HG, Pacific Grove, CA 93950. A resource network for artists devoted to protecting artists' rights and improving the economic conditions of visual artists. Web site: www.artists-equity.org

Chicago Artists Coalition, 11 East Hubbard Street, 7th Floor, Chicago, IL 60611. An artist-run service organization for visual artists that offers members a slide registry, lectures, job referral services, and workshops. Publishes *ChicagoArtists' News* and other resources. Web site: www.caconline.org

Chicano Humanities and Arts Council, Inc., P.O. Box 2512, Denver, CO 80204. Provides technical assistance on grant proposals and promotion and offers workshops on the business of art and on marketing techniques. Web site: www.chacweb.org

Consortium for Pacific Arts and Cultures, 1508 Makaloa Street, Suite 930, Honolulu, HI 96814-3220. Helps state arts agencies in the Pacific Basin develop multistate and international programs. Sponsors workshops, residencies, and educational programs. Web site: www.pixi.com/~cpac

Contemporary Arts Center, P.O. Box 30498, New Orleans, LA 70190. Sponsors exhibitions, performances, publications, workshops, educational programs, and grants and provides other services. Web site: www.cacno.org

Craft Alliance of New York State, 501 West Fayette Street, Room 132, Syracuse, NY 13204. Provides programs and services to assist the professional development of craftspeople and foster a greater appreciation of New York State crafts. E-mail: nyscrafts@aol.com

Cultural Alliance of Greater Washington, 1436 U Street, NW, Suite 103, Washington DC 20009-3997. Membership organization that sponsors workshops and seminars. Publishes *Arts Washington*. Web site: www.cultural-alliance.org

Cultural Development Group, 2263 SW 37th Avenue, Penthouse One, Miami, FL 33145. Offers a variety of low-cost and no-cost services to artists in South Florida, including printing and graphic design, grant writing, consultations, videography, and more. Also has a fund to assist artists through bartering arrangements, advances, and delayed payment plans. Web site: www.cdgfl.org

The Delaware Center for the Contemporary Arts, 200 South Madison Street, Wilmington, DE 19801. Sponsors exhibitions, publications, workshops, educational programs, residencies, and studio space. Web site: www.thedcca.org

Delta Axis, P.O. Box 11527, Memphis, TN 38111. Sponsors exhibitions, lectures, and other programs. Web site: www.deltaaxis.com

Detroit Artists Market, 4719 Woodward Avenue, Detroit, MI 48201. Promotes and assists Detroit metropolitan-area artists and Michigan artists. Sponsors exhibitions, publications, and educational programs. Web site: www.comnet.org/detroitartistsmarket

DiverseWorks Artspace, Inc., 1117 East Freeway, Houston, TX 77002-1108. Sponsors exhibitions, performances, publications, and workshops. Web site: www.diverseworks.org

Georgia Artists Registry, Atlanta College of Art, 1280 Peachtree Street NE, Atlanta, GA 30309. Serves as a referral service and maintains an artists slide collection. Also publishes a biannual newsletter *Artists' Proof.* Phone: 404-733-5025.

The Graphic Artists Guild, Boston Chapter, 14 Eaton Square, Suite 8, Boston, MA 02492. Web site: www.boston.gag.org

Houston Center for Photography, 1441 West Alabama, Houston, TX 77006. Sponsors exhibitions and educational programs and publishes a newsletter. Web site: www.hcponline.org

Individual Artists of Oklahoma, P.O. Box 60824, Oklahoma City, OK 73146. Sponsors exhibitions, performances, publications, and workshops. Web site: www.iaogallery.org

Maryland Art Place, 218 West Saratoga Street, Baltimore, MD 21201. Sponsors exhibitions, performances, publications, workshops, educational programs, and residencies. Web site: www.mdartplace.org

Massachusetts Cultural Council, 10 St. James Avenue, 3rd Floor, Boston, MA 02116-3803. Sponsors programs and residencies, and awards grants for a wide range of arts-related programs. Web site: www.massculturalcouncil.org

Media Alliance, 450 West 33rd Street, New York, NY 10001. A nonprofit membership organization dedicated to advancing independent media in New York State by expanding resources, support, and audiences. Includes the disciplines of video, film, audio, radio, and computer art. Publishes a newsletter and other publications, sponsors advocacy campaigns, and offers mailing lists. Web site: www.mediaalliance.org

Mid Atlantic Arts Foundation, 11 Light Street, Suite 300, Baltimore, MD 21202. Serves artists and arts organizations in Delaware, the District of Columbia, Maryland, New Jersey, New York, Pennsylvania, Virginia, and West Virginia. Sponsors performances, fellowships, and residencies and provides other services. Web site: www.charm.net/~midarts

Mid-America Arts Alliance, 912 Baltimore Avenue, Suite 700, Kansas City, MO 64105. Provides recognition and opportunities for artists and arts institutions in Arkansas, Kansas, Missouri, Nebraska, Oklahoma, and Texas. Sponsors exhibitions, performances, workshops, residencies, grants, and other services. Web site: www.maa.org

National Conference on Artists, Michigan Chapter, 216 Fisher Building, 3011 West Grand Boulevard, Detroit, MI 48202-3096. The oldest national organization for

African-American artists in the United States. Devoted to the preservation, promotion, and development of the work of African-American artists through its various services, publications, and programs. Web site: www.ncamich.org

New England Foundation for the Arts, 330 Congress Street, 6th Floor, Boston, MA 02210-1216. Serves artists and arts organizations in Connecticut, Maine, Massachusetts, New Hampshire, Rhode Island, and Vermont. Sponsors exhibitions, performances, workshops, residencies, and publications and provides other services. Web site: www.nefa.org

New York Artists Equity Association, Inc., 498 Broome Street, New York, NY 10013. A resource network and support group. Sponsors programs that are designed to meet a broad range of artists' human, social, and work-related needs. Web site: www.anny.org

New York Foundation for the Arts, 155 Avenue of the Americas, 14th Floor, New York, NY 10013-1507. Supports the development of individual professional artists, their projects, and their organizations. Publishes *FYI*, a quarterly publication. Provides grants and services and sponsors the Visual Artist Information Hotline, a toll-free information and referral service for visual artists nationwide. Phone: 800-232-2789. Web site: www.nyfa.org

Nexus Contemporary Art Center, 535 Means Street, NW, Atlanta, GA 30318. Sponsors exhibitions, performances, publications, workshops, residencies, educational programs, grants, and studios and provides other services. Web site: www.nexusart.org

Northwest Print Council, 922 SW Main Street, Portland, OR 97205. Open to printmakers in the Pacific Northwest, including Canada. Web site: www.art2u.com/NWPC

Ohio Arts and Crafts Guild, P.O. Box 3080, Lexington, OH 44904. A not-for-profit service and informational organization representing practicing artists and craftspeople at all levels of achievement. Sponsors seminars, a merchant bank card program, publications, and business and liability insurance. Web site: www. cg-tinsmith. com/oacg

Oklahoma Visual Arts Coalition, P.O. Box 54416, Oklahoma City, OK 73154-1416. Sponsors publications, workshops, a slide registry, and educational programs, and awards grants to Oklahoma artists.

Organization of Independent Artists, 19 Hudson Street, Suite 402, New York, NY 10013. Provides artists with exhibition opportunities throughout New York City. Sponsors artist-curated shows, maintains a slide registry for members, and publishes *OIA Newsletter*. Offers members a group health insurance plan.

Painted Bride Art Center, 230 Vine Street, Philadelphia, PA 19106. Sponsors exhibitions, performances, publications, and workshops. Web site: www.paintedbride.org

Pro Arts, 461 Ninth Street, Oakland, CA 94607. Nonprofit membership organization serving artists of all disciplines in the Bay Area. Offers technical assistance, consultations, service library, seminars, workshops, artist-in-residence programs, and exhibitions. Web site: www.proartsgallery.org

Real Art Ways (RAW), 56 Arbor Street, Hartford, CT 06106. Sponsors exhibitions, performances, publications, educational programs, residencies, and grants and provides other services. Web site: www.realartways.org

Resources and Counseling for the Arts, 308 Prince Street, Suite 270, Saint Paul, MN 55101-1437. Provides business-related information, advice, and technical assistance to artists in Minnesota and surrounding states through workshops, consultations, publications, and other support services. Web site: www.rc4arts.org

1708 Gallery, P.O. Box 12520, Richmond, VA 23241-0520. Sponsors exhibitions, performances, publications, and workshops. Web site: http://freenet.vcu.edu/arts/g1708

Southern Arts Federation, 1401 Peachtree Street, Suite 460, Atlanta, GA 30309-7603. Serves artists and arts organizations in Alabama, Florida, Georgia, Kentucky, Louisiana, Mississippi, North Carolina, South Carolina, and Tennessee. Web site: www.southarts.org

Southern Exposure, 401 Alabama Street, San Francisco, CA 94110. An artist-run organization. Sponsors exhibitions, panels, symposia, and educational programs. Web site: www.soex.org

Texas Fine Arts Association, The Jones Center for Contemporary Art, 700 Congress Avenue, Austin, TX 78701. Membership organization for Texas artists. Sponsors national art exhibitions and provides information and referrals. Offers Texas members a group health insurance plan. Publishes the newsletter *ARTSNews*. Web site: www.tfaa.org

Urban Institute for Contemporary Arts, 41 Sheldon Boulevard, SE, Grand Rapids, MI 49503. Sponsors exhibitions, performances, publications, workshops, educational programs, and residencies. Web site: www.uica.org

Visual Aid, 731 Market Street, Suite 600, San Francisco, CA 94103. Assists artists who have life-threatening illnesses. Provides services, including art material vouchers, a free materials art bank, and more. Serves nine counties in the Bay Area. Web site: www.visualaid.org

Visual Studies Workshop, 21 Prince Street, Rochester, NY 14607. Provides services, including educational and publishing programs, exhibitions, residencies, and grants for artists working in photography, artists' books, video, and independent film. Web site: www.vsw.org

Washington DC Chapter Artists Equity, c/o Susan Brown, P.O. Box 23369, Washington DC 20026-3369. A resource network for artists devoted to protecting artists' rights and improving the economic conditions of visual artists. Web site: www.artists-equity.org

Washington Project for the Arts (WPA), 500 17th Street, NW, Washington, DC 20006-4804. Sponsors exhibitions, performances, publications, and residencies. Web site: www.wpaconline.org

Western States Arts Federation (WESTAF), 1543 Champa Street, Suite 220, Denver, CO 80202. Serves artists and arts organizations in Alaska, Arizona, California, Colorado, Hawaii, Idaho, Montana, Nevada, New Mexico, Oregon, Utah,

Washington, and Wyoming. Sponsors exhibitions, performances, and publications and provides other services. Web site: www.westaf.org

Wisconsin Painters and Sculptors, Inc., 1112 Smith Street, Green Bay, WI 54302. Sponsors exhibitions, performances, publications, workshops, and educational programs. Publishes *Art in Wisconsin*. Web site: www.artinwisconsin. com

Women's Art Registry of Minnesota (WARM), 2402 University Avenue West, St. Paul, MN 55114-1701. Membership organization serving women visual artists in Minnesota. Maintains a slide registry and administers a mentor program that matches emerging women artists with more established women artists for a period of one year.

Arts Service Organizations Abroad

Canadian Artist's Representation Ontario (CARO), 401 Richmond Street West, Suite 442, Toronto, Ontario M5V 3A8, Canada. An association of professional artists in Ontario working to improve the financial and professional status of artists. Web site: www.caro.ca

Canadian Crafts Federation (formerly Canadian Crafts Council), 345 Lakeshore Road, West Oakville, Ontario L6K 1G3, Canada. Provides information and services to artists.

CARFAC-BC, P.O. Box 2359, Vancouver, British Columbia V6B 3W5, Canada. A regional branch of a national advocacy organization for Canadian artists. Web site: www.islandnet.com/poets/carfacbc/carfac.htm

CARFAC Manitoba, 523-100 Arthur Street, Winnipeg, Manitoba R3B 1H3, Canada. An advocacy organization that provides career-related services and publications for artists. Web site: www.umanitoba.ca/schools/art/gallery/hpgs/carfac/

CARFAC National, 401 Richmond Street, Suite 442, Toronto, Ontario M5V 3A8, Canada. A national advocacy organization for Canadian artists. Web site: www. carfac.ca

CARFAC Ontario, 401 Richmond Street West, Suite 440, Toronto, Ontario M5V 3A8, Canada. A regional branch of an advocacy organization for Canadian artists. Web site: www.caro.ca

CARFAC Saskatchewan (Regina), 210-1808 Smith Street, Regina, Saskatchewan S4P 2N4, Canada. Provides legal and financial advisory services. Sponsors professional development workshops and publishes a monthly newsletter. Web site: www.carfac.sk.ca

CARFAC Saskatchewan (Saskatoon), 302-220 Third Avenue South, Saskatoon, Saskatchewan S7K 1M1, Canada. Provides many services, including a legal and financial advisory service. Also sponsors professional development workshops and publishes a monthly newsletter. Web site: www.carfac.sk.ca

The Crafts Council, 44a Pentonville Road, London N1 9BY, England. Promotes contemporary crafts in Great Britain. Sponsors exhibitions and provides business advice to craft artists. Publishes *Crafts* and *Maker's News*. Web site: www. craftscouncil.org.uk

Design and Artists Copyright Society, Parchment House, 13 Northburgh Street, London EC1V 0JV, England. Represents visual artists and protects members' copyright interests. Web site: www.dacs.co.uk

Ontario Crafts Council, Designers Walk, 170 Bedford Road, Toronto, Ontario M5R 2K9, Canada. Maintains the Craft Resource Center to assist craft artists and promote an awareness of craft and of craft artists. Publishes *The Newsletter* and *Ontario Craft*. Sponsors a slide registry and publishes marketing and business guides. Web site: www.craft.on.ca

Visual Arts Newfoundland and Labrador (VANL), Devon House, 59 Duckworth Street, St. John's A1C 1E6, Newfoundland. A regional branch of CARFAC, a national advocacy organization for Canadian artists. E-mail: vanl@thezone.net

Visual Arts Ontario, 1153A Queen Street West, Toronto, Ontario M6J 1J4, Canada. Provides a wide range of programs and services that address the changing professional development needs of the visual-arts community. Web site: www.vao.org

World Crafts Council (WCC), International Secretariat, 7A Tzavella Street, Ionnina GR453 33, Greece. Promotes strengthening the status of crafts as a vital part of culture, economic life, and fellowship among craftspeople of the world. Web site: www.wccwis.gr

Also see "Artists with Disabilities" and "International Connections."

ARTWORK CARE AND MAINTENANCE
Publications

Caring for Your Art by Jill Snyder. New York: Allworth Press, revised 1996. Covers the best methods to store, handle, mount, frame, display, document and inventory, photograph, pack, transport, insure, and secure art. Also discusses proper environmental controls to enhance longevity of work. Web site: www.allworth.com

Conservation Concerns: A Guide for Collectors and Curators, edited by Konstanze Bachmann. Washington, D.C.: Smithsonian Institution Press, 1992. Available from the American Association of Museums, 1575 Eye Street, NW, Suite 400, Washington, DC 20005. Focuses on proper art storage techniques for environmental control. Web site: www.aam-us.org

Curatorial Care of Works of Art on Paper by Anne F. Clapp. New York: The Lyons Press, revised 1991. Includes advice on conservation techniques and describes the effect of light, acid, and temperature on works on paper. Web site: www.lyonspress.com

Guide to Maintenance of Outdoor Sculpture by Virginia Naude and Glenn Wharton. American Institute of Conservation, 1717 K Street, NW, Suite 200, Washington, DC 20006, 1991. Describes how to care for and maintain outdoor sculpture. Web site: http://aic.stanford.edu

Permanence and Care of Color Photographs: Traditional and Digital Color Prints, Color Negatives, Slides and Motion Pictures by Henry Wilhelm and Carol Brower. Grinnell, Iowa: Preservation Publishing, 1993. Available from Light Impressions, P.O. Box 22708, Rochester, NY 14692-2708. Web site: www.lightimpressionsdirect.com

Videotapes

Basic Art Handling, Gallery Association of New York State, P.O. Box 345, Hamilton, NY 13346, 1988. Demonstrates the best methods for handling artworks in all disciplines. Web site: www.dreamscape.com/ganys

Web Sites

Artist Help Network (www.artisthelpnetwork.com). Founded by Caroll Michels, this site is devoted to all aspects of career development, including contact information for organizations, periodicals, publications, software, audiovisual aids, Web sites, and service providers. See heading "Other Resources" and subheading "Artwork Care and Maintenance."

Also see "Exhibition and Performance Planning."

BARTERING
Publications

TradeArt: A Cooperative Arts Information Exchange. P.O. Box 1112, Upper Marlboro, MD 20773-1112. A bimonthly publication of TradeArt, Inc., a nonprofit organization that assists artists with bartering products and services for artwork. Features the work of artists interested in bartering. Web site: www.tradeart.org

Web Sites

Artist Help Network (www.artisthelpnetwork.com). Founded by Caroll Michels, this site is devoted to all aspects of career development, including contact information for organizations, periodicals, publications, software, audiovisual aids, Web sites, and service providers. See heading "Money" and subheading "Bartering Organizations."

Barter.Net (www.bigyellow.com). Provides a listing of bartering networks. Search "Barter and Trade Exchanges" and "Barter Service."

Krislyn's Favorite Business Barter Sites (sites.krislyn.com/barter.htm). Bartering posting services on the Internet. Provides links to numerous business barter sites.

Organizations

TradeArt, Inc., P.O. Box 1112, Upper Marlboro, MD 20773-1112. A nonprofit membership organization that promotes public acceptance of art in lieu of cash for products and other professional services. Sponsors The Art Exchange, a bartering program for members. Web site: www.tradeart.org

CAREER MANAGEMENT, BUSINESS, AND MARKETING
Publications

Annotated Bibliography for the Professional Visual Artist by Sarah Yates. Canadian Artists' Representation Ontario (CARO), 401 Richmond Street West, Suite 443, Toronto, Ontario M5V 3A8, Canada, 1989. Lists and describes books available on various career-related topics for visual artists. Web site: www.caro.ca

Art and Reality: The New Standard Reference Guide and Business Plan for Actively Developing Your Career as an Artist by Robert J. Abbott. Santa Ana, Calif.: Seven Locks Press, 1997. A guide through the process of executing a fast-track career plan. Web site: www.pma-online.org

Art Business News. 1 Park Avenue, 2nd Floor, New York, NY 10016-5802. Published monthly. Web site: www.artbusinessnews.com

Art Calendar. P.O. Box 2675, Salisbury, MD 21802. Contains career-related articles and provides listings of opportunities for artists. Published eleven times a year. Web site: www.artcalendar.com

The Art Deadlines List. Resources, P.O. Box 381067, Harvard Square Station, Cambridge, MA 02238-1067. A comprehensive digest of competitions, grants, fellowships, jobs, internships, and other career-related opportunities for visual and performing artists, and writers. Subscription required. Available through U.S. mail and on-line. Published monthly. A short version of the list is available for free on-line. Web site: www.artdeadlineslist.com

Art Marketing 101: A Handbook for the Fine Artist by Constance Smith. ArtNetwork, P.O. Box 1360, Nevada City, CA 95959, 1997. Covers various aspects of career development, including publicity, contacting galleries, and preparing a marketing plan. Web site: www.artmarketing.com

Art Marketing Sourcebook. ArtNetwork, P.O. Box 1360, Nevada City, CA 95959, regularly revised. Contains the names of various art marketing–related organizations and companies, including greeting card reps and publishers, licensing companies, calendar publishers, museum gift store buyers, and poster and print publishers. Web site: www.artmarketing.com

The Art of Self Promotion. Creative Marketing Management, P.O. Box 23, Hoboken, NJ 07030. Published quarterly. Web site: www.artofselfpromotion.com

The Art of Selling Art by Zella Jackson. New York: The Consultant Press, revised 1998. Contains tips on how to sell art and build collectors. Web site: www. consultantpress.com

Art Opportunities Monthly. P.O. Box 502, Benicia, CA 94510-0502. An extended listing of the selected opportunities section of the publication *studioNOTES.* Includes competitions, grants, exhibitions, public art commissions, and residencies. Listings are screened to include those opportunities that are free to entrants or offer good rewards in relation to the fees and increase the exposure of those accepted or are prestigious or special in some way. Also includes an "editor's choice" checkmark for opportunities deemed a particularly good fit.

Available by e-mail or U.S. postal mail. Published eleven times a year. Web site: www.studionotes.com

Artist. Caxton House, 63-65 High Street, Tenterden TN30 6BD, England. Features articles on artists' materials and provides practical technical advice and ideas. Published monthly. Web site: theartistmagazine.co.uk

The Artist in Business: Basic Business Practices by Craig Dreesen. Arts Extension Service, Division of Continuing Education, University of Massachusetts, P.O. Box 31650, Amherst, MA 01003, revised 1996. Includes information on record keeping, legal issues, grants, commissions, and competitions. Web site: www.umass.edu/aes

The Artist's and Graphic Designer's Market, edited by Mary Cox. Cincinnati: Writer's Digest Books, revised annually. Web site: www.writersdigest.com

Artists and Illustrators. The Fitzpatrick Building, 188-194 York Way, London N7 9QR, England. Contains practical information and advice. Published monthly.

The Artist's Guide to New Markets: Opportunities to Show and Sell Art Beyond Galleries by Peggy Hadden. New York: Allworth Press, 1998. Provides advice on selling art to markets and clients that many artists would never consider approaching. Web site: www.allworth.com

The Artist's Resource Handbook by Daniel Grant. New York: Allworth Press, revised 1997. Guide to career assistance for artists on a wide range of topics. Web site: www.allworth.com

The Artist's Survival Manual: A Complete Guide to Marketing Your Work by Toby Judith Klayman with Cobbett Steinberg. Originally published by Charles Scribner's Sons, the book is now being published by Toby Judith Klayman and Joseph Branchcomb, revised in 1996. Full of sensible, good-natured practical advice. Web site: www.goldwarp.com/klayman. Also available from California Lawyers for the Arts, attention Book Ordering, Fort Mason Center, C-255, San Francisco, CA 94123. Web site: www.calawyersforthearts.org

Artists' Yellow Pages. Chicago Artists' Coalition, 11 East Hubbard Street, 7th Floor, Chicago, IL 60611, 1998. A listing of materials, services, and supplies for visual artists. Web site: www.caconline.org

ARTnewsletter: The International Biweekly Report on the Art Market. ARTnews, 48 West 38th Street, New York, NY 10018. Web site: www.artnewsonline.com/news.htm

Arts Management Bibliography and Publishers, compiled by Dyan Wiley and edited by Sarah Elliott. Arts Extension Service, Division of Continuing Education, University of Massachusetts, P.O. Box 31650, Amherst, MA 01003, 1995. Topics include artist self-management and career development. Web site: www.umass.edu/aes

ArtSource Quarterly. ArtNetwork, P.O. Box 1360, Nevada City, CA 95959. A newsletter that contains marketing tips for artists. Published quarterly. Web site: www.artmarketing.com

ArtWorld Hotline. ArtNetwork, P.O. Box 1360, Nevada City, CA 95959. A newsletter that contains marketing tips and opportunities. Includes information on galleries, art consultants, art publishers, residencies, and percent for art programs. Published monthly. Web site: www.artmarketing.com

Breaking through the Clutter: Business Solutions for Women, Artists and Entrepreneurs by Judith Luther Wilder. The National Network for Artist Placement, 935 West Avenue, Los Angeles, CA 90065, 1999. Covers writing successful grant proposals, grant resources for individual artists, technical assistance providers, and Internet resources. Web site: www.artistplacement.com

Business Entities for Artists Fact Sheet by Mark Quail. Artists' Legal Advice Services and Canadian Artists' Representation Ontario (CARO), 1991. Available from Canadian Artists' Representation Ontario (CARO), 401 Richmond Street West, Suite 443, Toronto, Ontario, M5V 3A8, Canada. Summarizes information on sole proprietorships and corporations, with information on tax perspectives, registration, and legal liability. Web site: www.caro.ca

Business Information Folder. Ontario Crafts Council, Designers Walk, 170 Bedford Road, Toronto, Ontario M5R 2K9, Canada. Revised annually. A compilation of business information sheets for craft artists, including a bibliography, grant information, business registration and incorporation, marketing, and copyright. Web site: www.craft.on.ca

The Business of Art, edited by Lee Caplin. Englewood Cliffs, N.J.: Prentice-Hall Direct, revised 2000. Web site: www.phdirect.com

The Business of Being an Artist by Daniel Grant. New York: Allworth Press, revised 2000. Covers a range of career-related topics. Web site: www.allworth.com

Career Opportunities in Art: A Comprehensive Guide to the Exciting Careers Open to You in Art by Susan H. Haubenstock and David Joselit. Provides information on eighty-three specific jobs for people with art experience, art education, or ambition to work in the arts. New York: Facts on File Publications, 1995. Web site: www.facts.com

Careers in Arts by Gerald F. Brommer and Joseph A. Gatto. The National Network for Artist Placement, 935 West Avenue, Suite 37, Los Angeles, CA 90065, 1999. Web site: www.artistplacement.com

Ceramic Review. 21 Carnaby Street, London W1V 1PH, England. Includes information on equipment, materials, and techniques. Published bimonthly. Web site: www.ceramicreview.com

The Craft Directory. Ontario Crafts Council, Designers Walk, 170 Bedford Road, Toronto, Ontario M5R 2K9, Canada. An annual listing of craft artists, their chosen media, and studio location. More than 500,000 directories are distributed free of charge to tourist centers, libraries, studios, and other locations throughout Ontario. Web site: www.craft.on.ca

Craft Equipment Exchange Newsletter. P.O. Box 358, Sebastopol, CA 95473. A national newsletter for selling used equipment, overstocked or unused supplies, and display materials. Published six times a year. E-mail:siri@sonic.net

Craft News. The Craft Center, 1001 Connecticut Avenue, Suite 525, Washington, DC 20036. Features updates on market trends and trade regulations, sources of assistance, successful artisan projects, and crafts-related publications and events. Published quarterly. Web site: www.craftscenter.org

Crafting as a Business by Wendy Rosen. The Rosen Group, 3000 Chestnut Avenue, Suite 304, Baltimore, MD 21211, 1994. Includes information on contacting galleries, pricing, networking, and more. Lists more than four hundred galleries with contact information. Web site: www.rosengrp.com

The Crafts Report: The Business Journal for the Crafts Industry. P.O. Box 1992, Wilmington, DE 19899. Contains articles, departments, and columns about the business of art for craft artists. Published monthly. Web site: www.craftsreport.com

Craftsman Magazine. P.O. Box 5, Driffield YO25 8JD, England. Monthly magazine with business advice and practical information. Web site: www.craftsman-magazine.co.uk

Creating a Life Worth Living by Carol Lloyd. New York: Harper Perennial, 1997. A practical course in career design for artists, innovators, and others aspiring to a creative life. Web site: www.harpercollins.com

Do-It-Yourself Art Market Survival Kit by Barbara A. Sloan. AKAS II, P.O. Box 123, Hot Springs National Park, AR 71902-0123, 2000. Includes information on legal issues, taxes, the Internet, computers, art markets, exhibitions, and more. Web site: www.akasii.com

The Fine Artist's Career Guide by Daniel Grant. New York: Allworth Press, 1998. Contains practical advice, discussions, interviews, and success stories gleaned from a wide range of professional artists. Web site: www.allworth.com

The Fine Artist's Guide to Marketing and Self-Promotion by Julius Vitali. New York: Allworth Press, 1996. Covers various topics related to marketing and publicity. Includes chapters on other career-related issues. Web site: www.allworth.com

Getting the Word Out: An Artist's Guide to Self Promotion, edited by Carolyn Blakeslee, Drew Steis, and Barb Dougherty. Art Calendar, P. O Box 2675, Salisbury, MD 21802, 1995. Contains selected articles compiled from the monthly publication *Art Calendar* on a wide variety of career-related topics. Web site: www. artcalendar.com

Hand Papermaking Newsletter. P.O. Box 77027, Washington, DC 20013-7027. Lists information and opportunities of interest to hand papermaking artists, including exhibits, competitions, conferences, and workshops. Published four times a year. Web site: www.bookarts.com/handpapermaking

How to Get Happily Published: A Complete and Candid Guide by Judith Appelbaum. New York: HarperCollins, revised 1998. A step-by-step guide with good advice on a range of subjects, from submitting proposals to editors and agents to taking control of publicity campaigns. Builds a case for self-publishing versus vanity publishing, and how to go about doing it. Web site: www.harpercollins.com

How to Get Started Selling Your Art by Carole Katchen. Cincinnati: North Light Books, 1996. Explores various sales venues for selling artwork. Web site: www. artistsnetwork.com/nlbooks

How to Start and Succeed as an Artist by Daniel Grant. New York: Allworth Press, 1997. A guide for devoted amateurs and beginning professionals, covering the practical matters of being an artist. Web site: www.allworth.com

Information Factsheets. Visual Artist Information Hotline, New York Foundation for the Arts, 155 Avenue of the Americas, 14th Floor, New York, NY 10013-1507. Updated on a regular basis. Detailed information on thirty-three career-related topics. Also available on-line. Web site: www.nyfa.org.vaih/vaih_factsheet.htm

Information for Artists: A Practical Guide for Visual Arts, edited by Sarah Yates. Canadian Artists' Representation Ontario (CARO), 401 Richmond Street West, Suite 443, Toronto, Ontario M5V 3A8, Canada, revised 1990. Outlines a variety of alternative venues for exhibitions and sale of work and provides information on basic business practices. Web site: www.caro.ca

Informational Memo. Florida Department of State, Division of Cultural Affairs, The Capitol, Tallahassee, FL 32399-0250. Focuses on opportunities for Florida artists and resources for artists nationwide. Also available on-line. Published quarterly. Web site: www.dos.state.fl.us/dca

Maker's News. Crafts Council, 44a Pentonville Road, London N1 9BY, England. A business newsletter for crafts artists. Published quarterly. Web site: www.craftscouncil.org.uk

Making a Living as an Artist. Art Calendar, P.O. Box 2675, Salisbury, MD 21802, 1995. Contains selected articles compiled from the monthly publication *Art Calendar* on a wide variety of career-related topics. Web site: www.artcalendar.com

Making Marketing Manageable: A Painless & Practical Guide to Self-Promotion by Elise Benun. Available from Creative Marketing, P.O. Box 23, Hoboken, NJ 07030, 1995. Web site: www.artofselfpromotion.com

Marketing to the Affluent by Thomas J. Stanley. New York: McGraw-Hill, revised 1997. Provides information on the buying and patronage habits of the wealthy, and marketing tips. Web site: www.mcgraw-hill.com

The National Resource Guide for the Placement of Artists, edited by Cheryl Slean. The National Network for Artist Placement, 935 West Avenue, Suite 37, Los Angeles, CA 90065. Revised regularly. An annotated guide to organizations and publications of interest to artists. Covers legal assistance, contract information, publications, job banks, funding, and arts organizations that provide support to artists. Web site: www.artistplacement.com

Opportunities in Arts and Crafts Careers by Elizabeth B. Gardner. Lincolnwood, Ill.: Contemporary Publishing Group, VGM Career Horizons, 1998. Provides tips for obtaining the best education in the field of arts and crafts. Profiles artists and craftspeople.

The Photographer's Guide to Marketing and Self-Promotion by Maria Piscopo. New York: Allworth Press, revised 2001. Discusses publicity, networking, researching prospective clients, and developing a personal marketing strategy. Web site: www.allworth.com

Photographer's Market. Cincinnati: Writer's Digest Books, revised annually. Provides more than two thousand contacts for selling photographs, finding marketing resources, finding buyers, and more. Web site: www.writersdigest.com

Photography Your Way: A Career Guide to Satisfaction and Success by Chuck DeLaney. New York: Allworth Press, 1999. Outlines career avenues and options and includes grant information, business strategies, and discussions on business and legal and ethical issues. Web site: www.allworth.com

Plugging In: A Resource Guide for Media Artists. Media Alliance, WNET/Thirteen, 450 West 33rd Street, New York, NY 10001, revised 2001. Includes information on media service groups in New York State, equipment access, funding, national festivals, and distributors. Web site: www.mediaalliance.org

Poor Dancer's Almanac: Managing Life and Work in the Performing Arts, edited by David R. White, Lise Friedman, and Tia Tibbits Levenson. The National Network for Artist Placement, 935 West Avenue, Suite 37, Los Angeles, CA 90065, revised regularly. Web site: www.artistplacement.com

The Practical Handbook for the Emerging Artist by Margaret R. Lazzari. Fort Worth, Tex.: Harcourt Brace and Company, 1996. Designed to help visual art students make the transition from art school to their own art practice. Web site: www. hbcollege.com

Publishing Your Art As Cards, Posters & Calendars by Harold Davis. New York: The Consultant Press, revised 1996. A guide to creating, designing, and marketing cards, posters, and calendars. Web site: www.consultantpress.com

Self-Management Workbook for Visual Artists. Canadian Artists' Representation Ontario (CARO), 401 Richmond Street West, Suite 443, Toronto, Ontario M5V 3A8, Canada, 1993. Contains various CARO publications including *CARO Fact Sheets, Copyright for Visual Artists, Artist/Dealer Checklist, Artist/Exhibition Contract, Preparing for Your Tax Return,* and *Guidelines for Professional Standards in the Organization of Juried Exhibitions.* Web site: www.caro.ca

Self-Promotion Online: Marketing Your Creative Services Using Web Sites, Email and Digital Portfolios by Ilise Benun. Cincinnati: North Light Books, 2000. Offers practical and easy-to-implement promotional strategies for using the Internet to promote creative services. Includes case studies of designers, illustrators, and writers who used on-line marketing tools to make connections and maintain high visibility. Web site: www.artistsnetwork.com/nlbooks

Selling Art on the Internet by Marques Vickers. Marques Vickers, 331 Howard Avenue, Vallejo, CA 94589, 2000. An e-publication that addresses topics related to art marketing on the Internet, including Web site design, generating traffic, cultivating media exposure, virtual and portfolio galleries, auction sites, and self-publishing artwork. Available in several formats. Web site: www.marquesv.com

Selling Art with a Higher Mind or No More Art Sharks by Barbara G. Scott. Santa Monica, CA: Inchor, 1990. A spiritual approach to the selling of art.

Selling Your Crafts by Susan Joy Sager. New York: Allworth Press, 1998. Provides tips and tactics for promoting and marketing crafts, and the necessary forms to start a business. Web site: www.allworth.com

State Factsheets. Visual Artist Information Hotline, New York Foundation for the Arts, 155 Avenue of the Americas, 14th Floor, New York, NY 10013-1507.

Updated on a regular basis. Detailed information on career-related resources, organizations, and programs in each of the fifty states, the District of Columbia, Puerto Rico, the Virgin Islands, the Mariana Islands, and American Samoa. Also available on-line. Web site: www.nyfa.org/vaih/vaih_state.htm

studioNOTES: The Journal for Working Artists, P.O. Box 502, Benicia, CA 94510-0502. An artist-to-artist journal that reports on what artists are doing and thinking, and provides an information and idea exchange. Also includes interviews with artists, dealers, and others in the art world about practical issues. Published five times a year. Web site: www.studionotes.org

Success Now! For Artists newsletter. Manhattan Arts International, 200 East 72nd Street, Suite 26-L, New York, NY 10021. Bimonthly. Includes career advice and opportunities for artists. Web site: www.manhattanarts.com

Success Now! The Artrepreneur Newsletter for Artists by Renée Phillips. New York: Manhattan Arts International, five issues per year. Essays on various career-related topics for artists. Web site: www.manhattanarts.com

Successful Fine Art Marketing by Marcia Layton. New York: The Consultant Press, 1993. A guide for artists and gallery personnel. Web site: www.consultantpress.com

Supporting Yourself as an Artist: A Practical Guide by Deborah A. Hoover. New York: Oxford University Press, revised 1989. Provides advice on how to deal with common problems confronting artists. Emphasis is on obtaining funding and proposal writing. Web site: www.oup-usa.com

Taking the Leap: Building a Career as a Visual Artist by Cay Lang. San Francisco: Chronicle Books, 1998. Covers a comprehensive range of career-related topics. Web site: www.chronbooks.com

Ten Steps to Marketing by Sue Viders. Marketing Solutions, 9739 Tall Grass Circle, Littleton, CO 80124-3108, revised 1998. Includes advice on market research, networking, pricing, distribution, promotion, visuals, presentation, and follow-up. Web site: www.sueviders.com

Women Environmental Artists Directory, produced by Jo Hanson and Susan Leibovitz Steinman. Available from Jo Hanson, 201 Buchanan Street, San Francisco, CA 94102, revised 1999. Listings in the directory are open to all women arts professionals concerned with environmental issues and environmentally conscious methods and materials. Includes a broad range of media and work. The database is also available on-line. Web site: http://wead.dreamfish-creative.com

Audiovisual Materials and Software

Art Charts by Sue Viders, Marketing Solutions, 9739 Tall Grass Circle, Littleton, CO 80124-3108, 1992. Ten charts with seventy-seven promotional ideas for marketing artwork. Web site: www.sueviders.com

Creating a Successful Career in Photography by Dan Fear. ArtSupport, 300 Queen Anne Avenue North, #425, Seattle, WA 98109. Includes artist business forms, computer templates, and advice on using the forms. Also provides art resources

for a successful career in the visual arts. Published on diskette. Web site: www.
art-support.com

Six Steps to Success, narrated by Sue Viders and Steve Doherty. Marketing Solutions,
9739 Tall Grass Circle, Littleton, CO 80124-3108, 1995. One-hour audiotape about
marketing art. Accompanied by a printed outline. Web site: www.sueviders.com

Web Sites

About the Arts (www.aboutthearts.com). An offshoot of the Boston television
show *About the Arts.* Features the work of guest artists, career resources, and up-
coming events and exhibitions in the Boston area.

AN Web (www.anweb.co.uk). Turner Building, 7-15 Pink Lane, 1st Floor, Newcas-
tle upon Tyne NE1 5DW, England. A valuable resource of information for artists
interested in establishing contacts in the United Kingdom and in Europe. Con-
tains on-line career guides, resources on a variety of arts-related subjects, and
career advice. Hundreds of contacts are provided.

The Art Deadlines List (www.artdeadlineslist.com). A comprehensive digest of com-
petitions, grants, fellowships, jobs, internships, and other career-related oppor-
tunities for visual and performing artists, and writers. A subscription is required.
Published monthly. A short version is available without a subscription.

Art Marketing Workshop (www.artmarketingworkshops.com). An on-line art mar-
keting school produced by art marketing consultants Sue Viders and Geofrey
Gorman. Each class is designed around a four-week schedule with different top-
ics e-mailed to students.

ArtDeadline (www.artdeadline.com). Lists juried shows, art festivals, grants, in-
ternships, scholarships, residencies, fellowships, and writing competitions.

Artist Help Network (www.artisthelpnetwork.com). Founded by Caroll Michels,
this site is devoted to all aspects of career development, including contact infor-
mation for organizations, periodicals, publications, software, audiovisual aids,
Web sites, and service providers. See heading "Career" and subheadings "Gen-
eral Career Information," "Art Marketing Consultants," and "Career Coaches.

Artists' Exchange (www.artistexchange.about.com). Links to various arts-related
services, vendors, and professionals.

Artist's Resource Letter (www.smfa.edu). A biweekly on-line publication devoted to
job openings, exhibition opportunities, competitions, grants, residencies, and
more. Sponsored by the School of the Museum of Fine Arts in Boston.

Arts Business Exchange (www.artsbusiness.com). Contains news, career informa-
tion, opportunities for artists, and an on-line newsletter, *Art Biz Bits.*

ArtsMarketing Online (www.artsmarketing.org). A service of the National Arts
Marketing Project of the Arts and Business Council, Inc. Disseminates arts mar-
keting information and resources, including an in-depth bibliography, extensive
links to other pertinent marketing sites, and marketing articles that are benefi-
cial to individual artists and arts administrators.

ArtSupport (www.art-support.com). 300 Queen Anne Avenue North, #425, Seattle, WA 98109. Offers career advice to photographers and various support materials. Provides links to recommended photography galleries, museums, and other sites of interest.

ArtsWire (www.artswire.org). One of the first arts-related Web sites, initiated by the New York Foundation for the Arts. Includes a database with numerous career-related topics for artists.

The Digital Directory: Art & Technology Resources in New York State (www.nyfa.org/vaih/vaih_dig_directory.htm). A sourcebook of low-cost tele-communications, computer, and new media resources for artists and arts organizations within New York State. Sponsored by the Visual Artist Information Hotline of the New York Foundation for the Arts.

Hotline Directory (www.nyfa.org/vaih/vaih_directory.htm). A comprehensive, al-phabetical directory of organizations, publications, and programs listed on the Visual Artist Information Hotline's Factsheets, covering a wide range of career-related topics. A new version of the directory is posted on the Web site each month. Sponsored by the New York Foundation for the Arts.

Information Factsheets (www.nyfa.org/vaih/vaih_factsheet.htm). Provides detailed information on thirty-three career-related topics. Sponsored by the Visual Artist Information Hotline of the New York Foundation for the Arts.

Informational Memo (www.dos.state.fl.us/dca). Sponsored by the Florida Depart-ment of State, Division of Cultural Affairs. Focuses on opportunities for Florida artists and resources for artists nationwide.

The Informed Artist (www.spl.org/finearts/informed.html). Sponsored by the Seattle Public Library. Provides links to various career topics for visual and per-forming artists, including resources for employment, grants, awards, and schol-arships, and opportunities for exhibitions, auditions, and competitions.

Interweave (www.interweave.com). A site devoted to fiber arts. Lists publica-tions and information on spinning, weaving, needlework, knitting, beading, and more.

PhotoAIM (www.photoaim.com). A weekly on-line newsletter with marketing tips and news about stock photography.

Professional Practices in the Arts (http://website.education.wisc.edu/allison). Pro-duced by Sophia Allison and Dan LaValley. Offers artists advice and information on a variety of career-related topics.

Rhizome (www.rhizome.org). A Web site devoted to artists who are using technology.

Sculptor.Org (www.sculptor.org). Produced by Richard Collins. Packed full of on-line and off-line resources for sculptors, including support services, technical in-formation, sculpture as a business, and much more.

Selling Your Art Online (www.1x.com/advisor). Edited by Chris Maher. A free e-mail newsletter that covers topics of interest to artists about selling work on the In-ternet. Subjects include setting up your gallery, making sales, security issues, and new opportunities. A Web site includes an archive of past articles, resource links, and a extensive listing of on-line galleries and artists' Web sites.

State Factsheets (www.nyfa.org/vaih/vaih_state.htm). Provides information on career-related resources, organizations, and programs in each of the fifty states, the District of Columbia, Puerto Rico, the Virgin Islands, the Mariana Islands, and American Samoa. A program of the New York Foundation for the Arts in conjunction with the Visual Artist Information Hotline.

Women Environmental Artists Directory (http://wead.dreamfish-creative.com). Database of women arts professionals concerned with environmental issues.

Organizations

ArtStudio Network, 484 West 43rd Street, #21H, New York, NY 10036. Created as a networking tool to support and encourage connection and community for visual artists living in New York City. Artists present their artwork to peers at their respective studios. E-mail: filanart2@aol.com

The Business Center for the Arts, 965 Longwood Avenue, Bronx, NY 10459. Sponsors workshops and provides information on proposal writing, business plans, grant writing, and other career-related topics. Web site: www.bcadc.org

Career Transition for Dancers, 1727 Broadway, 2nd Floor, New York, NY 10019-5284. A national career counseling organization for professional dancers. Also has an office in Los Angeles: 5757 Wilshire Boulevard, Suite 902, Los Angeles, CA 90036-3635. There is also a toll-free hotline, 800-581-2833. Web site: www.danceonline.com/feat/career.html

Circum-Arts, 151 West 30th Street, Suite 200, New York, New York 10001. A not-for-profit membership organization that provides numerous support services to individual artists and arts organizations, including marketing and development. There is also an office in San Francisco: 2940 16th Street, Suite 110, San Francisco, CA 94103. Web site: www.circum.org

Caroll Michels, career coach and artist's advocate, 19 Springwood Lane, East Hampton, NY 11937-1169. Author of *How to Survive and Prosper as an Artist.* Assists artists throughout the United States and abroad with career development through phone and in-person consultations. Also publishes mailing lists. Web site: www.carollmichels.com

The National Network for Artist Placement, 935 West Avenue, Suite 37, Los Angeles, CA 90065. Devoted to bringing career counseling, and employment and survival-skills services to visual and performing artists. Web site: www.artistplacement.com

Resources and Counseling for the Arts, 308 Prince Street, St. Paul, MN 55101-1437. Provides career management information to independent artists and small to mid-sized cultural organizations. Offers consultations, training, and information. Web site: www.rc4arts.org

Taking the Leap, 1506 62nd Street, Emeryville, CA 94608. A professional practices school for artists and writers. Web site: www.taking-the-leap.com

Visual Artist Information Hotline, New York Foundation for the Arts, 155 Avenue of the Americas, 14th Floor, New York, NY 10013-1507, 800-232-2789. A toll-free information service for visual artists. Provides visual artists nationwide with

information on various career-related topics, including grants, art law, health insurance, emergency funding, health and safety issues, and more. The hotline staff is available between 1 P.M. and 5 P.M. Monday through Friday. Information may also be requested through e-mail: hotline@nyfa.org. Information, resources, and directories are also available on-line. Web site: www.nyfa.org/vaih

Visual Arts Ontario,1153A Queen Street West, Toronto, Ontario M6J 1J4, Canada. A not-for-profit organization that offers personal career consultations via e-mail, fax, or phone. Web site: www.vao.org

Also see "Creative Challenges, Career Blocks, and the Psyche," "International Connections," "Organizing Paperwork," "Periodicals," "Presentation Tools," and "Press Relations and Publicity."

COMPETITIONS AND JURIED EXHIBITIONS
Publications

Art Calendar. P.O. Box 2675, Salisbury, MD 21802. Includes a comprehensive listing of juried exhibitions and competitions. Published eleven times a year. Web site: www.artcalendar.com

The Art Deadlines List. Resources, P.O. Box 381067, Harvard Square Station, Cambridge, MA 02238-1067. A comprehensive monthly digest of opportunities for visual and performing artists and writers, including competitions and juried shows. Subscription required. Available through U.S. mail and e-mail. Published monthly. Web site: www.artdeadlineslist.com

Art Opportunities Monthly. P.O. Box 502, Benicia, CA 94510-0502. A listing of opportunities for artists, including juried shows. Listings are screened to include those opportunities that are free to entrants or offer good rewards in relation to the fees, and increase the exposure of those accepted or are prestigious or special in some way. Also includes an "editor's choice" checkmark for opportunities deemed particularly a good fit. Published eleven times a year. Available via e-mail or postal mail. Web site: www.studionotes.org

The Business of Being an Artist by Daniel Grant. New York: Allworth Press, revised 1996. See book's index entry "Jurying Art Shows." Web site: www.allworth.com

Competitions and Financial Opportunities for Artists. Queensland Artworkers Alliance, Level 1, 381 Brunswick Street, Fortitude Valley 4006, Queensland, Australia. A listing of awards, competitions, scholarships, grants, fellowships, foundations, and professional development opportunities. Web site: www.artworkers.asn.au

Guidebook for Competitions and Commissions. Visual Arts Ontario, 1153A Queen Street West, Toronto, Ontario M6J 1J4, Canada, 1991. A step-by-step guide to the process of commissioning art. Includes options, sample call-to-enter and competition briefs, budget analysis, procedures for sponsors and artists, a technical manual, and practical advice. Web site: www.vao.org

Guidelines for Professional Standards in the Organization of Juried Exhibitions. CARO/CARFAC, revised 1988. Available from Canadian Artists' Representation

Ontario, 401 Richmond Street West, Suite 443, Toronto, Ontario M5V 3A8, Canada. Web site: www.caro.ca

Hot Buttons: Jurors on Jurying by Donna Marxer and Drew Steis. Salisbury, Md.: Art Calendar, 1998. Thirteen jurors speak their minds on the jurying process and how artists can increase their chances of acceptance into prestigious shows. Web site: www.artcalendar.com

Juried Art Exhibitions: Ethical Guidelines and Practical Applications. Chicago Artists' Coalition, 11 East Hubbard Street, 7th Floor, Chicago, IL 60611, revised 1997. Discusses ethical standards to be used by individuals or groups who are organizing a juried exhibition. Also provides a step-by-step guide on how to organize juried shows. Web site: www.caconline.org

Recommended Guidelines for Juried Exhibitions. National Artists Equity Association, P.O. Box 28068, Central Station, Washington, DC 20038, 1991. Web site: www.artists_equity.org

Web Sites

The Art Deadlines List (www.artdeadlineslist.com). A comprehensive digest of opportunities for visual and performing artists, including competitions and juried shows. Subscription required. Available through e-mail and U.S. mail. Published monthly. A short version is available without a subscription.

ArtDeadline (www.artdeadline.com). Lists juried shows, art festivals, grants, internships, scholarships, residencies, fellowships, and writing competitions.

Artist Help Network (www.artisthelpnetwork.com). Founded by Caroll Michels, this site is devoted to all aspects of career development, including contact information for organizations, periodicals, publications, software, audiovisual aids, Web sites, and service providers. See heading "Exhibitions, Commissions, Sales" and subheadings "Competitions and Juried Shows," "Exhibition Places & Spaces," "Exhibition Planning," and "Public Art."

Suggested Guidelines for Art Competitions and Contests (www.gag.org/ resources/ compet_rules.html). Graphic Artists Guild, 90 John Street, Suite 403, New York, NY 10038-3202.

Also see "Public Art."

CORPORATE ART MARKET
Publications

The Architect's Sourcebook. THE GUILD, 931 East Main Street, #106, Madison, WI 53703-2955. A resource directory that contains the names, addresses, telephone numbers, and photographs of the work of American fine and craft artists, as well as biographical information. Distributed free of charge to attendees of the American Society of Interior Designers' and American Institute of Architects' national conferences. Also distributed free of charge to art consultants. Published annually. Web site: www.guild.com

Art Business News. 1 Park Avenue, New York, NY 10016-5802. Lists the names of corporations that have purchased art and commissioned art projects. Each listing also includes the name of the artist, a short project description, and, if applicable, the name of the art consultant or advisor involved. Published monthly. Web site: www.artbusinessnews.com

Art Consultants List, compiled by Caroll Michels. Available from Caroll Michels, 19 Springwood Lane, East Hampton, NY 11937-1169, updated several times a year. An annotated list of art consultants and art advisors who sell work to corporate markets. Includes names, addresses, telephone and fax numbers, e-mail addresses, Web sites, and information about art disciplines and markets of interest. Available in three formats. Web site: www.carollmichels.com

Art in America Annual Guide to Galleries, Museums, Artists. Published annually. See "Corporate Consultants" in index.

Art Marketing Sourcebook. ArtNetwork, P.O. Box 1360, Nevada City, CA 95959, updated every two years. Contains the names and addresses of art consultants. Web site: www.artmarketing.com

Art Representatives, Consultants & Dealers. Chicago Artists' Coalition, 11 East Hubbard Street, 7th Floor, Chicago, IL 60611, regularly updated. List of artists' agents, art consultants, and gallery dealers. Web site: www.caconline.org

The Business of Art, edited by Lee Caplin. Englewood Cliffs, N.J.: Prentice-Hall Direct, revised 2000. See "Art Advisory Services: The Age of the Art Advisor" and "Art Collections in Corporations." Web site: www.phdirect.com

Corporate Art Consulting by Susan Abbott. New York: Allworth Press, revised 1999. Although written for those who want to enter or expand the art consulting business, it provides advice and tips for artists interested in corporate sales. Web site: www.allworth.com

The Designer's Sourcebook. THE GUILD, 931 East Main Street, #106, Madison, WI 53703-2955. A resource directory that contains the names, addresses, telephone numbers, and photographs of the work of American fine and craft artists, as well as biographical information. Distributed free of charge to attendees of the American Society of Interior Designers' and the American Institute of Architects' national conferences. Also distributed free of charge to art consultants. Published annually. Web site: www.guild.com

The Dodge Report. McGraw-Hill, 1221 Avenue of the Americas, New York, NY 10020, revised on a regular basis. Computerized printouts of construction projects nationwide, including the name of the design firm in charge and whether a budget has been allocated for the purchase or commissioning of artwork. Individual state reports are also available. Web site: www.fwdodge.com

The International Directory of Corporate Art Collections, edited by S. R. Howarth. International Art Alliance, Inc., P.O. Box 1608, Largo, FL 33779, revised 2000. More than 1,250 entries. Also available on diskettes for PC users. Web site: www. exhibitionsonline.org

ProFile. American Institute of Architects, 1735 New York Avenue, NW, Washington, DC 20006. Revised biennially. Profiles architecture and interior design

firms nationwide. A database is also available on-line. Web site: www.aiaonline.com

Software

Art Consultants List, compiled by Caroll Michels. Available from Caroll Michels, 19 Springwood Lane, East Hampton, NY 11937-1169, updated several times a year. Available on disk for MAC and PC. Names and addresses of art consultants and art advisors. Web site: www.carollmichels.com

International Directory of Corporate Art Collections, edited by S. R. Howarth. International Art Alliance, Inc., P.O. Box 1608, Largo, FL 33779, revised 2000. More than 1,250 entries. Available on diskettes for PC users. Web site: www.exhibitionsonline.org

Web Sites

Artist Help Network (www.artisthelpnetwork.com). Founded by Caroll Michels, this site is devoted to all aspects of career development, including contact information for organizations, periodicals, publications, software, audiovisual aids, Web sites, and service providers. See heading "Exhibitions, Commissions, Sales" and subheading "Corporate Art Market."

ProFile (www.cmdg.com/profile). A database of architecture and interior design firms nationwide. Describes focus and services of each company.

Organizations

American Institute of Architects, 1735 New York Avenue, NW, Washington, DC 20006. Web site: www.aiaonline.com

American Society of Interior Designers, 608 Massachusetts Avenue, NE, Washington, DC 20002-6006. Web site: www.asid.org

International Facility Management Association, 1 East Greenway Plaza, Suite 1100, Houston, TX 77046-0194. A not-for-profit organization dedicated to serving the facility management professionals, many of whom are decision makers for purchasing art for corporate facilities. Web site: www.ifma.org

Also see "Interior Design and Architecture."

CREATIVE CHALLENGES,
CAREER BLOCKS, AND THE PSYCHE
Publications

Affirmations for Artists by Eric Maisel. New York: Putnam Publishing Group, 1996. Deals with issues of introspection, self-examination, and a willingness to take risks. Web site: www.penguinputnam.com

Art and Fear by David Bayles and Ted Orland. Santa Barbara, Calif.: Capra Press, 1994. Explores the way art gets made and the nature of the difficulties that cause so many artists to give up along the way. Web site: www.amazon.com

The Artist Inside: A Spiritual Guide to Cultivating Your Creative Self by Tom Crockett. New York: Bantam Doubleday Dell, 2000. A new approach to tapping into creativity, using the images and artifacts in dreams. Web site: www.randomhouse.com

The Artist's Quest for Inspiration by Peggy Hadden. New York: Allworth Press, 2000. Instructs artists how to work their way out of a creative slump. Offers practical tips about color, form, light, and other technical elements. Web site: www.allworth.com

The Artist's Way: A Spiritual Path to Higher Creativity by Julia Cameron. New York: J. P. Tarcher, 1991. A twelve-week program to recover your creativity from a variety of blocks, including limiting beliefs, fear, self-sabotage, jealousy, guilt, addictions, and other inhibiting forces. Web site: www.penguinputnam.com

The Blank Canvas: Inviting the Muse by Anna Held Audette. Boston: Shambhala Publications, 1993. Includes strategies for getting unstuck. Offers advice to artists who are struggling with creative blocks or personal expression. Web site: www.shambhala.com

The Career Guide for Creative and Unconventional People by Carol Eikleberry and Richard Nelson Bolles. Berkeley, Calif.: Ten Speed Press, 1999. Offers advice and support for creative people who are uncertain about their future and finding a place in the world. Web site: www.tenspeed.com

Career Management for the Creative Person by Lee Silber. New York: Harmony Books, Three Rivers Press, 1999. Covers various aspects of professional life—from freelancing to working as a full-time employee to changing careers midstream. Offers coping strategies and tips and warns the right-brainer of common self-sabotaging behavior, with advice on how to spot it and stop it early. Web site: www.randomhouse.com

Creating a Life Worth Living by Carol Lloyd. New York: HarperPerennial, 1997. Provides a road map toward achieving creative renewal and career success. Weaves together anecdotes, insights, and exercises. Web site: www.harpercollins.com

The Energy of Money: A Spiritual Guide to Financial and Personal Fulfillment by Maria Nemeth. New York: Balantine Publishing Company, revised 2000. Provides spiritual and practical techniques to create a unique program for achieving personal life goals and financial wealth. Web site: www.randomhouse.com

Fearless Creating by Eric Maisel. New York: Putnam Publishing Group, 1995. Includes exercises designed to help you blast through inertia and fear. Web site: www.penguinputnam.com

Leonardo's Ink Bottle: The Artist's Way of Seeing by Roberta Weir. Berkeley: Ten Speed Press/Celestial Arts, 1998. Guides readers through the rediscovery of instinct and intuition, and the quicksilver nature of inspiration in creating art. Web site: www.tenspeedpress.com

A Life in the Arts: Practical Guidance and Inspiration for Creative and Performing Artists (Inner Work Book) by Eric Maisel. New York: Putnam Publishing Group, 1994. Addresses problems encountered by artists, including creative blocks, aloneness, and the concept of talent. Provides self-help strategies for coping. Web site: www.penguinputnam.com

Life, Paint and Passion: Reclaiming the Magic of Spontaneous Expression by Michelle Cassou and Stewart Cubley. New York: J. P. Tarcher, 1996. Explains how to use the creative process as an important tool for self-discovery. Web site: www. penguin putnam.com

Making Room for Making Art: A Thoughtful and Practical Guide to Bringing the Pleasure of Artistic Expression Back into Your Life by Sally Warner. Chicago Review Press, 1994. Offers advice for artists who are becoming discouraged or feel stalled and want to rekindle their passion for making art.

Marry Your Muse: Making a Lasting Commitment to Your Creativity by Jan Phillips. Wheaton, Ill.: Theosophical Publishing House, 1997. A course in creative expression. Web site: www.theosophical.org

The Money Mirror: How Money Reflects Women's Dreams, Fears, and Desires by Annette Lieberman and Vicki Lindner. New York: Allworth Press, 1996. Helps women understand and overcome cultural and personal barriers to intelligent money management. Web site: www.allworth.com

The 9 Steps to Financial Freedom: Practical & Spiritual Steps So You Can Stop Worrying by Suze Orman. New York: Crown Books, revised 2000. Explores the psychological and spiritual power money has in our lives, emphasizing that before we can get control of our finances, we must get control of our attitudes about money. Web site: www.randomhouse.com

Pencil Dancing: New Ways to Free Your Creative Spirit by Mari Messer. San Francisco: Walking Stick Press, 2001. Focuses on developing creative confidence, overcoming blocks, and taming your inner critics.

Pushcart's Complete Rotten Reviews & Rejections, edited by Bill Henderson & André Bernard. Wainscott, N.Y.: Pushcart Press, 1998. A compilation of nasty reviews and ridiculous rejections of great authors and classical books.

A Question of Balance: Artists and Writers on Motherhood by Judith Pierce Rosenberg. Milford, Conn.: Papier-Mache Press, 1995. Interviews with women artists and writers who share how they organize their lives to nurture both their children and their craft. E-mail: info@papiermache.com

The Secret Life of Money: How Money Can Be Food for the Soul by Tad Crawford. New York: Allworth Press, revised 1996. Web site: www.allworth.com

Thank You for Being Such a Pain: Spiritual Guidance for Dealing with Difficult People by Mark I. Rosen. New York: Three Rivers Press, 1998. Provides insights, anecdotes, and guidelines to help overcome the distractions and energy drain of dealing with difficult people. Web site: www.randomhouse.com

Trust the Process: An Artist's Guide to Letting Go by Shaun McNiff. Boston: Shambhala Publishing, 1998. Expands the reader's view of what it means to live in

tune with the labyrinthine ways of the creative spirit. Web site: www.shamhala. com

The 12 Secrets of Highly Creative Women: A Portable Mentor by Gail McMeekin. Berkeley, Calif.: Conari Press, 2000. An empowering book for those ready to confront self-defeating patterns related to creativity. Web site: www.conari.com

Work with Passion: How to Do What You Love for a Living by Nancy Anderson. Novato, Calif.: New World Library, revised 1995. Packed with inspiration for taking chances, making choices, and recognizing opportunities. E-mail: escort@nwlib.com

Web Sites

Artist Help Network (www.artisthelpnetwork.com). Founded by Caroll Michels, this site is devoted to all aspects of career development, including contact information for organizations, periodicals, publications, software, audiovisual aids, Web sites, and service providers. See heading "Career" and subheadings "Creative Challenges, Career Blocks and the Psyche," "Therapists and Healers," and "Career Coaches." Also see heading "Other Resources" and subheading "Art and Healing."

Rejection Collection (www.rejectioncollection.com). Share your rejection stories and letters with the arts community.

EMPLOYMENT OPPORTUNITIES
Publications

ArtSearch. Theatre Communications Group, 355 Lexington Avenue, New York, NY 10017. Published biweekly, this is a national employment-service bulletin for jobs in the performing arts and arts administration. Web site: www.tcg.org/artsearch

Artwork: Opportunities in Arts Administration. Resources and Counseling for the Arts, 308 Prince Street, Suite 270, St. Paul, MN 55101-1437, 1993. Web site: www.rc4arts.org

Aviso. American Association of Museums, 1575 Eye Street, NW, Washington, DC 20005. Lists museum-related positions. Published monthly. Web site: www. aam-us.org

CAA Careers. College Art Association, 275 Seventh Avenue, New York, NY 10001. A newsletter that lists jobs in higher education and museums, including international listings. Published six times a year. Web site: www.collegeart.org

Career Opportunities in Art: A Comprehensive Guide to the Exciting Careers Open to You in Art by Susan H. Haubenstock and David Joselit. New York: Facts on File Publications, 1995. Provides information on eighty-three specific jobs for people with art experience, art education, or ambition to work in the arts. Web site: www. facts.com

Careers by Design: A Headhunter's Secrets for Success and Survival in Graphic Design by Roz Goldfarb. New York: Allworth Press and the American Council for the Arts, revised 1997. Web site: www.allworth.com

Careers for Nonconformists: A Practical Guide to Finding and Developing a Career Outside the Mainstream by Sandra Gurvis. New York: Marlowe & Company, 1999. Covers a multitude of careers in which people can shine and be authentic.

Careers in Museums: A Variety of Vocations. American Association of Museums, 1575 Eye Street, NW, Suite 400, Washington, DC 20005, 1994. Explains the world of museum work and professional opportunities. Web site: www.aam-us.org

Current Jobs in Art. Plymouth Publishing, P.O. Box 40550, Washington, DC 20016. A national listing of employment opportunities for new and early-career art graduates. Published monthly. Web site: www.graduatejobs.com

Directory of Performing Artists and Master Teaching Artists. Connecticut Commission on the Arts, 755 Main Street, One Financial Plaza, Hartford, CT 06103. Lists Connecticut-based artists who specialize in public performances, classroom residencies, and curriculum development. Also available on-line. Revised regularly. Web site: www.ctarts.org/directry.htm

The Fine Artist's Guide to Marketing and Self-Promotion by Julius Vitali. New York: Allworth Press, 1996. Provides background information about teaching-residency opportunities in the arts. See the chapter "Artists-in-Education." Web site: www.allworth.com

Gardner's Guide to Internships at Multimedia and Animation Studios by Garth Gardner. Annandale, Va.: Garth Gardner, Inc., 2001. Profiles hundreds of computer graphics, animation, and multimedia companies in the United States and Canada that offer internships. Web site: www.gogardner.com

Gardner's Guide to Internships in New Media: Computer Graphics, Animation and Multimedia by Garth Gardner and Bonney Ford. Annandale, Va.: Garth Gardner, Inc., 2000. Profiles hundreds of companies in the visual effects industry who offer internships. Web site: www.gogardner.com

Guide to Arts Administration Training and Research, edited by Dan J. Martin. San Francisco: Association of Arts Administration Educators, revised 1999. Available from Americans for the Arts, 1000 Vermont Avenue, NW, 12th Floor, Washington, DC 20005. Describes graduate degree programs in arts management in the United States and abroad. Web site: www.artsusa.org

Guide to Museum Studies and Training in the United States. American Association of Museums, 1575 Eye Street, NW, Suite 400, Washington, DC 20005. Revised annually. Includes the names of more than 150 graduate and undergraduate museums studies programs, including address, phone, e-mail, URL, and contact person. Also provides in-depth descriptions of each program. Web site: www.aam-us.org

Heart & Soul Resumes by Chuck Cochran and Donna Peerce. Palo Alto, Calif.: Davies-Black Publishing, 1998. Advice on how to prepare creative résumés for job searching. Includes twenty real-life résumé makeovers. Web site: www.cpp-db.com

How to Develop & Promote Successful Seminars & Workshops: The Definitive Guide to Creating and Marketing Seminars, Workshops, Classes, and Conferences by Howard L. Shenson. New York: John Wiley and Sons, Inc., 1990. Web site: www.wiley.com

How to Make Money Performing in Schools: The Definitive Guide to Developing, Marketing, and Presenting School Assembly Programs by David Heflick. Orient, Wash.: Silcox Production, 1997. Includes marketing secrets, program ideas, and information on what administrators look for in programs and factors in determining who gets booked. Web site: www.schoolgigs.com/performing_in_schools.htm

Introduction to Museum Work by G. Ellis Burcaw. Walnut Creek, Calif.: AltaMira Press/American Association for State and Local History, revised 1997. Available from the American Association of Museums, 1575 Eye Street, NW, Suite 400, Washington, DC 20005. Discusses central issues of museum work. Web site: www.aam-us.org

Jobs by Design: A Headhunter's Secrets for Success and Survival in Graphic Design by Roz Goldfarb. New York: Allworth Press, revised 1997. Discusses jobs, hiring practices, salaries, portfolios, résumés, networking, headhunters, freelancing, and more. Web site: www.allworth.com

Jobs in Arts and Media Management: What They Are and How to Get One by Stephen Langley and James Abruzzo. New York: American Council for the Arts, revised 1992. Available from Americans for the Arts, 1000 Vermont Avenue, NW, 12th Floor, Washington, DC 20005. Web site: www.artsusa.org

More Than Once in a Blue Moon: Multiple Jobholdings by American Artists by Neil O. Alper and Gregory H. Wassall. Santa Ana, Calif.: Seven Locks Press, 2000. Published in conjunction with the National Endowment for the Arts, Research Division Report #40. Results of the first systematic study about artists and "moonlighting." Web site: www.pma-online.org

Museum Jobs from A–Z: What They Are: How to Prepare, and Where to Find Them by G. W. Bates. Switzerland, Fla.: Batax Museum Publishing, 1994. Available from the American Association of Museums, 1575 Eye Street, NW, Suite 400, Washington, DC 20005. Describes more than sixty museum positions. Includes information about education, training, and experience; also personnel characteristics; and opportunities for employment and promotion. Web site: www.aam-us.org

Museums: A Place to Work–Planning Museum Careers by Jane R. Glaser and Artemis Z. Zenetou. London: Routledge, Inc., 1996. Describes more than thirty museum positions and the skills and education recommended for each one. Web site: www.routeledge.com

The National Resource Guide for the Placement of Artists, edited by Cheryl Slean. The National Network for Artist Placement, 935 West Avenue, Suite 37, Los Angeles, CA 90065. Revised regularly. Lists arts organizations, including national job banks, that provide support to artists. Web site: www.artistplacement.com

The New England Conservatory Job Bulletin. Career Services Center, New England Conservatory, 290 Huntington Avenue, Boston, MA 20115. Monthly publication that lists approximately 150 jobs in teaching, arts administration, and performance worldwide. Web site: www.newenglandconservatory.edu

The Photographer's Assistant by John Kieffer. New York: Allworth Press, revised 2001. Provides information on how to become a photographer's assistant, what skills and personal attributes professionals seek, and how they hire assistants. Also includes technical tips on lighting, camera equipment, and more. Web site: www. allworth.com

Soul Work: Finding the Work You Love, Loving the Work You Have by Deborah P. Bloch and Lee J. Richmond. Palo Alto, Calif.: Davies-Black Publishing, 1998. Web site: www.cpp-db.com

What Color Is Your Parachute? A Practical Manual for Job Hunters and Career Changers by Richard Nelson Bolles. Berkeley, Calif.: Ten Speed Press, revised regularly. Web site: www.tenspeed.com

The Whole Work Catalog: Options for Rewarding Work. The New Careers Center, P.O. Box 339, Boulder, CO 80306, regularly updated. Describes career-related books on a variety of topics, including alternative careers and new work options. Web site: wholework.com

The Work We Were Born to Do: Find the Work You Love, Love the Work You Do by Nick Williams and Robert Holden. London: HarperCollins, 1999. Offers insights to explore the infinite possibilities inherent in every human being. Web site: www. harpercollins.com

Work with Passion: How to Do What You Love for a Living by Nancy Anderson. Novato, Calif.: New World Library, revised 1995. E-mail: escort@nwlib.com

Web Sites

Art & Design Career Employment (http://art.nmu.edu). A Web site sponsored by the Department of Art and Design, Northern Michigan University. Includes large contact lists in the fields of new media, graphics, photography, film, video, teaching, museums, and architecture. Also provides a list of art and design employment agencies, and links to Web sites for art and design employment opportunities outside of the United States.

ArtCareer Network (www.artcareer.net). A site devoted to employment, educational, and additional opportunities in the visual arts.

Artist Help Network (www.artisthelpnetwork.com). Founded by Caroll Michels, this site is devoted to all aspects of career development, including contact information for organizations, periodicals, publications, software, audiovisual aids, Web sites, and service providers. See heading "Money" and subheadings "Apprenticeships and Internships," "Art Colonies & Artist-in-Residence Programs," and "Employment."

Artist Resource (www.artistresource.org/jobs.htm). Lists jobs in the fields of art and design, jobs for writers, and volunteer positions and internships.

Artjobonline (www.artjob.org). Biweekly on-line listing of positions in visual and performing arts, literature, education, and arts administration. Résumés can be posted on site. Sponsored by the Western States Arts Federation.

Artsjobs (www.onelist.com/subscribe.cgi/ARTSJOBS). A site for those with fine-art degrees and others in the arts looking for employment in arts administration, arts education, graphics, photography, music, theater, and other specialty arts-related positions in the art community and in the United States and abroad.

Directory of Performing Artists and Master Teaching Artists (www.ctarts.org/directry.htm). Connecticut Commission on the Arts, 755 Main Street, One Financial Plaza, Hartford, CT 06103. Lists Connecticut-based artists who specialize in public performances, classroom residencies, and curriculum development.

eLance (www.eLance.com). A site for freelancers to list their skills and search for work. Includes graphic design, illustration, and animation.

Museum Employment Resource Center—MERC (www.museum-employment.com). Posts museum and cultural-resource jobs.

Museum Resource Board (www.seeing2020.com/museums/jobs.html). Posts job openings in museums, including administrative and secretarial positions, development and marketing, exhibit design, and management. Curatorial and librarian/archivist openings are also included.

Schoolgigs (www.schoolgigs.com). Provides information and links on opportunities for performing artists in schools.

SchoolShows (www.schoolshows.com). A national directory of performers who present assemblies, workshops, and residencies in schools.

Telecommuting Jobs (www.tjobs.com/new/artists.htm). Lists jobs for artists in the telecommunications field, including graphic designers, user-interface specialists, fontographers, Internet producers, virtual professionals, and Web site designers.

Organizations

Chicago Artists' Coalition, Job Referral Service, 11 East Hubbard Street, 7th Floor, Chicago, IL 60611. A computerized employment service offered free of charge to Chicago Artists' Coalition members. Web site: caconline.org

Hospital Audiences, Inc., 548 Broadway, 3rd Floor, New York, NY 10012-3950. Brings visual- and performing-art programs to New Yorkers who are confined in hospitals, health care facilities, shelters, and other social service agencies. Web site: www.hospitalaudiences.org

National Guild of Community Schools of the Arts, P.O. Box 8018, Englewood, NJ 07631. Membership organization that provides employment referrals to members in visual-arts education. Web site: www.natguild.org

The National Network for Artist Placement, 935 West Avenue, Suite 37, Los Angeles, CA 90065. Nonprofit organization dedicated to bringing career counseling, employment services, and survival skills to visual and performing artists. Web: www.artistplacement.com

The On-Call Faculty Program, Inc., 3655 Darbyshire Drive, Hillard, OH 43026-2534. Arranges guest appearances for academics and professionals at colleges

and universities. Also arranges for affiliates to teach short or semester courses. Web site: www.oncallfaculty.com

Prison Arts Project, William James Association, 303 Potrero, #12B, Santa Cruz, CA 95060. Open to visual and performing artists interested in conducting workshops in California correctional facilities.

Professionals for NonProfits, 515 Madison Avenue, Suite 900, New York, NY 10022. An employment agency that offers part-time and full-time temporary and permanent positions to people interested in working for arts-related organizations. Web site: www.pnp-inc.com

Also see "Apprenticeships and Internships" and "Art Colonies and Artist-in-Residence Programs."

EXHIBITION AND PERFORMANCE PLACES AND SPACES
Publications

American Craft Guide to Craft Galleries and Shops USA. American Craft Council, 72 Spring Street, New York, NY 10012, revised regularly. Web site: www.craftcouncil.org

Annual Craft Shows Book. Ontario Crafts Council, Designers Walk, 170 Bedford Road, Toronto, Ontario M5R 2K9, Canada, 1999. Lists more than three hundred craft shows in the Ontario area with application details and jurying information. Web site: www.craft.on.ca

Art in America Annual Guide to Galleries, Museums, Artists. Art in America, 575 Broadway, New York, NY 10012. Alphabetical listing of American museums, galleries, private dealers, and alternative spaces arranged by state and city. Each entry includes the address, phone number, business hours, names of key staff members, a short description of type of art shown, and artists represented. Published in August.

Art Calendar. P.O. Box 2675, Salisbury, MD 21802. Provides listings of exhibition opportunities. Published eleven times a year. Web site: www.artcalendar.com

The Art Deadlines List. Resources, P.O. Box 381067, Harvard Square Station, Cambridge, MA 02238-1067. A comprehensive monthly digest of competitions, grants, fellowships, jobs, internships, and other career-related opportunities for visual and performing artists and writers. Subscription required. Available through U.S. mail and e-mail. Published monthly. Web site: www.artdeadlineslist.com

Art Marketing Sourcebook. ArtNetwork, P.O. Box 1360, Nevada City, CA 95959, regularly revised. Contains more than two thousand listings of galleries. Web site: www.artmarketing.com

Art Now Gallery Guide. P.O. Box 5541, Clifton, NJ 08809-0401. A national publication with up-to-date information on exhibitions in galleries and museums. Special geographic editions are also available for New York City, Boston/New England, Philadelphia, the Southwest, Chicago/Midwest, the Southeast,

California, Europe, and Latin America. Published eleven times a year. Web site: www.galleryguide.com

Art Opportunities Monthly. P.O. Box 502, Benicia, CA 94510-0502. A listing of opportunities for artists, including exhibitions. Available via e-mail or U.S. mail. Published eleven times a year. Web site: www.studionotes.org

The Artist's and Graphic Designer's Market. Cincinnati: Writer's Digest Books. Revised annually. Describes a selection of galleries throughout the United States. Web site: www.writersdigest.com

Artists' Gallery Guide for Chicago and Surrounding Areas. Chicago Artists' Coalition, 11 East Hubbard Street, 7th Floor, Chicago, IL 60611, revised 2000. A comprehensive and well-organized guide to commercial and alternative galleries, museums, and arts organizations in Chicago. Web site: www.caconline.org

The Artist's Guide to New Markets: Opportunities to Show and Sell Art Beyond Galleries by Peggy Hadden. New York: Allworth Press, 1998. Provides advice on selling art to clients and markets that many artists would never consider approaching. Web site: www.allworth.com

Booking and Tour Management for the Performing Arts by Rena Shagan. New York: Allworth Press, 1996. Provides information on how to book performances, organize tours, and succeed on the road as a performing artist. Web site: www.allworth.com

Crafts in Ontario: Shops & Galleries. Ontario Crafts Council, Designers Walk, 170 Bedford Road, Toronto, Ontario M5R 2K9, Canada. Information on shops and galleries for selling and exhibiting crafts in Ontario. Web site: www.craft.on.ca

Fairs and Festivals, compiled by Clare D. Wood and Jesse Pompei. Arts Extension Service, Division of Continuing Education, University of Massachusetts, P.O. Box 31650, Amherst, MA 01003, published annually. Provides information on locations, dates, and descriptions of more than 1,200 craft events each year in thirty states. Web site: www.umass.edu/aes

free Expression Guide. Department of Cultural Affairs, City of New York, 330 West 42nd Street, 14th Floor, New York, NY 10036. A guide to alternative and free exhibition space in New York City. Web site: www.ci.nyc.ny.us/html/dcla/html/express.html

Getting Exposure: The Artist's Guide to Exhibiting the Work, edited by Carolyn Blakeslee, Drew Steis, and Barb Dougherty. Art Calendar, P.O. Box 2675, Salisbury, MD 21802, 1995. Compiled by the editors of *Art Calendar,* this guide includes information on juried shows, cooperative galleries, commercial galleries, college and university galleries, and more. Web site: www.artcalendar.com

Information for Artists. Canadian Artists' Representation Ontario (CARO), 401 Richmond Street West, Suite 443, Toronto, Ontario M5V 3A8, Canada, revised 1990. Lists a variety of alternative venues for exhibition and sale of work. Web site: www.caro.ca

Little Museums by Lynne Arany and Archie Hobson. New York: Owl Books, Henry Holt and Company, 1998. Describes more than 1,000 little museums throughout the United States, including those that specialize in themes. Web site: www.henryholt.com

Manitoba Visual Artists Index. CARFAC Manitoba, 523-100 Arthur Street, Winnipeg, Manitoba R3B 1H3 Canada, 1992. Includes a list of exhibition spaces in Manitoba. Web site: www.umanitoba.ca/schools/art/gallery/hpgs/carfac

The National Resource Guide for the Placement of Artists, edited by Cheryl Slean. The National Network for Artist Placement, 935 West Avenue, Suite 37, Los Angeles, CA 90065, revised regularly. An annotated guide to arts organizations, including those that provide exhibition and performance space. Web site: www.artistplacement.com

New York Contemporary Art Galleries: The Complete Annual Guide by Renée Phillips, Manhattan Arts International, 200 East 72nd Street, Suite 26L, New York, NY 10021. Lists commercial art galleries and alternative spaces in New York City. Provides names, addresses, phone numbers, and contact persons. Also provides background information, when available, on each gallery, including the selection process, philosophy, and demographic profiles of gallery artists. Revised annually. Web site: www.manhattanarts.com

Organizing Artists: A Document and Directory of the National Association of Artists' Organizations. National Association of Artists' Organizations, 1718 M Street, NW, PMB #239, Washington, DC 20004, revised 1998. Describes alternative spaces and art service organizations. Each entry includes a descriptions of programs, disciplines, exhibition and/or performance spaces, proposal procedures, and the name of the contact person. Also includes a critical examination of the evolution of artists' organizations and the artist-space movement, tracing the history of artist activism in the United States from 1905 to 1990. Web site: www.naao.org

Photographer's Market. Cincinnati: Writer's Digest Books. Revised annually. Web site: www.writersdigest.com

Photography in New York International. Photography in New York, Inc., 64 West 89th Street, New York, NY 10024. A comprehensive guide to photography galleries in New York City. Also includes national and international listings. Published bimonthly. Web site: www.photography-guide.com

Resource Bulletin. Maryland Art Place, 218 West Saratoga Street, Baltimore, MD 21201. A quarterly publication that lists hundreds of exhibition opportunities. Web site: www.mdartplace.org

University Galleries. Chicago Artists' Coalition, 11 East Hubbard Street, 7th Floor, Chicago, IL 60611. A list of university galleries in the Chicago area. Web site: www.caconline.org

Web Sites

The Art Deadlines Lists (www.artdeadlineslist.com). A monthly list of career-related information for artists, including exhibition opportunities. Subscription required. Available through the U.S. mail and on-line. A short version of the list is available on-line without a subscription.

Art Museum Network (www.amn.org). Connected to 33,000 museums worldwide.

ArtDeadline (www.artdeadline.com). A monthly digest of career-related information, including exhibition opportunities, residencies, fellowships, and writing competitions.

Artist Help Network (www.artisthelpnetwork.com). Founded by Caroll Michels, this site is devoted to all aspects of career development, including contact information for organizations, periodicals, publications, software, audiovisual aids, Web sites, and service providers. See heading "Exhibitions, Commissions, Sales" and subheadings "Art Shippers," "Competitions and Juried Shows," "Exhibition Places & Spaces," "Exhibition Planning," and "On-line Galleries."

Exhibit. Basic Guide to Gallery and Exhibition Spaces in Minnesota (www.rc4arts. org). Sponsored by the Minnesota State Arts Board and Resources and Counseling for the Arts.

Musée (www.musee-online.org). Provides links to museum shops.

Museum Shop (www.museumshop.com). Provides links to various museum shops in the United States and abroad that sell one-of-a-kind objects and multiples. Links include art, science, historical, maritime, and children's museums.

Museum Stuff (www.museumstuff.com). Provides links to various museum shops, including those that specialize in art and design, history, science, children, natural history, Native Americans, African-Americans, zoos and animals, automotive, aviation, maritime, military, local history, and sports.

Space. A Basic Guide to Performance and Rehearsal Spaces in Minnesota (www.rc4arts.org). Sponsored by Resources and Counseling for the Arts.

World Wide Art Resources (www.wwar.com). Provides links to galleries in the United States and abroad.

Organizations

Art in Embassies Program, U.S. Department of State, Room B-258, Washington, DC 20520-0258. Loans artwork to American embassies thorought the world for up to three years. Accepts applications from individual artists. Web site: www. state.gov/www/about_state/e-art

Art Information Center, 55 Mercer Street, New York, NY 10013. A not-for-profit organization that provides information and advice to artists interested in exhibiting in New York City.

Council for Creative Projects, Inc., 17 Main Street, Lee, MA 01238. A not-for-profit organization that organizes traveling exhibitions featuring art rarely shown, underrecognized art, and well-known art interpreted in new ways. Web site: www.ccpexhibits.org

ExhibitsUSA, Mid-America Arts Alliance, 912 Baltimore Avenue, Suite 700, Kansas City, MO 64105. Organizes exhibits that travel to small and mid-sized museums, university galleries, and community art centers throughout the United States. Also provides various exhibition-related services. Web site: www. maaa.org

Museum Store Association, 4100 East Mississippi Avenue, Suite 800, Denver, CO 80246. Provides members with a mailing list of museums shops nationwide, as well as in other parts of the world. Affiliate memberships are available to artists

who are already selling work to a museum shop at wholesale prices. Web site: www.museumdistrict.com

Also see "International Connections" and "On-Line Galleries."

EXHIBITION AND PERFORMANCE PLANNING
Publications

The Art of Displaying Art by Lawrence B. Smith. New York: The Consultant Press, 1998. Provides advice and tips on displaying art, including oils, graphics, drawings, and photographs. Web site: www.consultantpress.com

The Art of Showing Art by James K. Reeve. Council Oak Books, 1350 East 15th Street, Tulsa, OK 74120, revised 1992. Includes guidelines for protecting and displaying paintings, sculpture, and photographs; and information on display concepts, storage, records, and appraisals. Web site: www.counciloakbooks. com/cob/index.html

CARFAC Recommended Minimum Exhibition Fee Schedule. 401 Richmond Street West, Suite 442, Toronto, Ontario M5V 3A8, Canada. Revised annually. A bilingual official exhibition fee schedule outlining the amounts of money that visual artists receive in Canada when exhibiting in a nonprofit space. Web site: www.carfac.ca

Good Show! A Practical Guide for Temporary Exhibitions by Lothar P. Witteborg. Smithsonian Institution Traveling Exhibition Service, Washington, D.C., revised 1991. Available from the American Association of Museums, 1575 Eye Street, NW, Washington, DC 20005. A how-to manual for developing temporary exhibitions. Web site: www.aam-us.org

On Your Own: Alternative Exhibition Strategies. Visual Arts Ontario, 1153A Queen Street West, Toronto, Ontario M6J 1J4, Canada, 1995. A step-by-step analysis of how to mount your own exhibition. Includes sample budgets, time lines, sample press releases, and other information. Web site: www.vao.org

Presenting Performances by Thomas Wolf. New York: American Council for the Arts in cooperation with the Association of Performing Arts Presenters, revised 1991. Available from Americans for the Arts, 1000 Vermont Avenue, NW, 12th Floor, Washington, DC 20005. Covers the topics of acquiring space, handling promotion, dealing with unions, and dependable technical assistance. Web site: www.artsusa.org

Way to Go: Crating Artwork for Travel by Stephen A. Horne. Gallery Association of New York, Box 345, Hamilton, NY 13346-0345, 1985. Provides information on how to crate two- and three-dimensional work. Web site: www.dreamscape.com/ganys

Web Sites

Artist Help Network (www.artisthelpnetwork.com). Founded by Caroll Michels, this site is devoted to all aspects of career development, including contact information for organizations, periodicals, publications, software, audiovisual aids, Web

sites, and service providers. See heading "Exhibitions, Commissions, Sales" and subheadings "Exhibition & Performance Planning," and "Art Shippers." Also see heading "Other Resources" and subheading "Artwork Care and Maintenance."

Craters and Freighters (www.cratersandfreighters.com). An on-line service that provides quotes for shipping artwork. Also provides the names of art transport companies on a state-by-state basis.

Also see "Artwork Care and Maintenance."

GALLERY RELATIONS
Publications

The Art Biz: The Covert World of Collectors, Dealers, Auction Houses, Museums, and Critics by Alice Goldfarb Marquis. Chicago: Contemporary Books, 1991. Reveals the hype, hypocrisy, greed, manipulation, and secrecy that takes place in the contemporary art world. Web site: www.contbooks.com

The Artists' Survival Manual: A Complete Guide to Marketing Your Work by Toby Judith Klayman with Cobbett Steinberg. Originally published by Charles Scribner's Sons, the book is now being published by Toby Judith Klayman and Joseph Branchcomb, revised in 1996. See "Preparing to Negotiate with Dealers" and "Questions to Ask Your Gallery." Web site: www.goldwarp.com/klayman. Also available from California Lawyers for the Arts, attention Book Ordering, Fort Mason Center, C-255, San Francisco, CA 94123. Web site: www. calawyersforthearts.org

Taking the Leap: Building a Career as a Visual Artist by Cay Lang. San Francisco: Chronicle Books, 1998. See "When Things Begin to Happen." Web site: www.chronbooks.com

Web Sites

Artist Help Network (www.artisthelpnetwork.com). Founded by Caroll Michels, this site is devoted to all aspects of career development, including contact information for organizations, periodicals, publications, software, audiovisual aids, Web sites, and service providers. See heading "Exhibitions, Commissions, Sales" and subheading "Gallery Relations." Also see heading "Legal" and subheading "Law: Contracts."

Also see "Law: Contracts and Business Forms."

GENERAL ARTS REFERENCES
Publications

American Art Directory. New Providence, N.J.: R. R. Bowker. Published biennially. A directory of arts organizations, art schools, museums, periodicals, scholarships, and fellowships. Web site: www.reedref.com

Art Information and the Internet: How to Find It, How to Use It by Lois Swan. Phoenix, Ariz.: The Oryx Press, 1998. Divided into three sections: basic information formats, types of Web sites, and using and supplementing Web information. Two appendixes contain extensive listings of individual artists, group exhibitions, professional associations, and journals with Internet links. Web site: www.oryxpress.com

International Directory of the Arts. New Providence, N.J.: K. G. Saur. Revised biennially. Two-volume guide to museums, universities, associations, dealers, galleries, publishers, and others involved in the arts in Europe, the United States, Canada, South America, Asia, and Australia. Web site: www.saur.de

Little Museums by Lynne Arany and Archie Hobson. New York: Owl Books, Henry Holt and Company, 1998. Describes more than 1,000 little museums throughout the United States devoted to a variety of themes. Web site: www.henryholt.com

Museums of the World. New Providence, N.J.: K. G. Saur. Revised regularly. Provides information about more than 24,000 museums throughout the world. Organized by country and city. Web site: www.saur.de

Official Museum Directory. Skokie, Ill.: National Register Publishing, in cooperation with the American Association of Museums. Revised regularly. Profiles more than 7,300 museums and institutions. Web site: www.reedref.com

Web Sites

Absolutearts (www.absolutearts.com). A daily news update featuring articles about the arts, including international, national, and regional coverage.

Art in Context (www.artincontext.com). A nonprofit resource for fine-art research. Provides a free venue for patrons and scholars to locate and discover information about fine art. Open to artists, museums, galleries, and dealers. There are no on-line fees, but if artwork is selected, a processing fee is charged.

Artist Help Network (www.artisthelpnetwork.com). Founded by Caroll Michels, this site is devoted to all aspects of career development, including contact information for organizations, periodicals, publications, software, audiovisual aids, Web sites, and service providers. See heading "Other Resources" and subheading "General Arts References."

Arts Journal (www.artsjournal.com). A daily digest of arts and cultural journalism from around the world.

Artsource (www.ilpi.com/artsource/welcome.html). A site devoted to fine-art and architectural resources, including publications, art journals, and organizations.

Wet Canvas (www.wetcanvas.com). Contains an on-line arts resource directory with links to more than 200,000 arts sites, including genre sites, directories and portals, magazines and e-zines, art periods and movements, and specific art discipline sites.

World Wide Arts Resources (www.wwar.com). Links to art resources throughout the world.

GRANTS AND FUNDING RESOURCES
Publications

The Art Deadlines List. Resources, P.O. Box 381067, Cambridge, MA 02238. A comprehensive and up-to-date list of opportunities for visual and performing artists and writers, including grants and residencies. Also available on-line. Subscription required. A short version of the list is available on-line without subscription. Web site: www.artdeadlineslist.com

Art Opportunities Monthly. P.O. Box 502, Benicia, CA 94510-0502. A listing of opportunities for artists, including grants. Published eleven times a year. Available via e-mail or postal mail. Web site: www.studionotes.org

An Artist's Resource Book by Jennifer Parker. Go Far Press, 4030 Martin Luther King Way, Oakland, CA 94609, revised 1997. Describes more than three hundred national and international grants, awards, fellowships, residency programs, and facilities for visual artists. E-mail: gofarpress@earthlink.net

Breaking Through the Clutter: Business Solutions for Women, Artists and Entrepreneurs by Judith Luther Wilder. The National Network for Artist Placement, 935 West Avenue, Los Angeles, CA 90065, 1999. Includes information on writing successful grant proposals and on grant resources for individual artists. Web site: www. artistplacement.com

Competitions and Financial Opportunities for Artists. Queensland Artworkers Alliance, Level 1, 381 Brunswick Street, Fortitude Valley 4006, Queensland, Australia. A listing of awards, scholarships, grants, fellowships, and foundations. Web site: www.artworkers.asn.au

Directory of Financial Aids for Women by Gail Schlachter. San Carlos, Calif.: Reference Service Press. Updated regularly. Identifies 1,200 scholarships, fellowships, grants, awards, loans, and internships, designed primarily or exclusively for women. Web site: www.rspfunding.com

Directory of Grants in the Humanities. Phoeniz, Ariz.: The Oryx Press. Revised regularly. More than 3,600 listings of funding sources in the arts and humanities. Web site: www.oryxpress.com

The Fine Artist's Guide to Marketing and Self-Promotion by Julius Vitali. New York: Allworth Press, 1996. Includes information on how to find corporate support, grants, and other funding. Web site: www.allworth.com

The Foundation Center's Guide to Grantseeking on the Web. The Foundation Center, 79 Fifth Avenue, New York, NY 10003, revised 2000. Discusses how to maximize the use of the Web for funding research. Web site: www.fdncenter.org

Foundation Grants to Individuals. The Foundation Center, 79 Fifth Avenue, New York, NY 10003. Revised regularly. Contains more than 3,800 entries. Lists scholarships, educational loans, fellowships, residencies, internships, awards, and prizes available to individuals from private foundations. Also includes information on how to approach foundations. Web site: www.fdncenter.org

Funding for Artists. Chicago Artists' Coalition, 11 East Hubbard Street, 7th Floor,

Chicago, IL 60611, Revised regularly. Part of a series of artists' Self-Help Guides. Web site: www.cac.org

Getting Funded: A Complete Guide to Proposal Writing by Mary Stewart Hall. Continuing Education Press, School of Extended Studies, Portland State University, P.O. Box 1394, Portland, OR 97207. Revised regularly. Web site: www.extended.pdx.edu/press/index.htm

Getting the Word Out: An Artist's Guide to Self Promotion, edited by Carolyn Blakeslee, Drew Steis, and Barb Dougherty. Upper Fairmount, Md.: Art Calendar Publishing, Inc., 1995. See "Competing for Grants Effectively." Web site: www.artcalendar.com

Grant Searching Simplified by Bari Caton. Creative Resources, P.O. Box 850, West Jefferson, NC 28694, revised 2001. Provides artists with an easy-to-learn, step-by-step plan for conducting an effective search for grant support. Includes "The Online Supplement," which offers a wealth of information about grant searching in the electronic age. Also available on-line. Web site: artgrants.com

Grants and Awards Available to American Writers. PEN American Center, 568 Broadway, New York, NY 10012, revised 2000. Lists American and international grant programs for writers. Includes deadlines, guidelines, and summaries of application procedures. Web site: www.pen.org/grants.html

Grants for Arts, Culture and the Humanities. The Foundation Center, 79 Fifth Avenue, New York, NY 10003, 2000. Regularly revised. Lists grants to arts and cultural organizations and in the media and visual and performing arts. Web site: www.fdncenter.org

Guide to Canadian Arts Grants. Canada Grants Service, 100-2 Bloor Street West, Toronto, Ontario M4W 3E2, Canada. Regularly revised. Lists 1,000 art-granting programs and awards throughout Canada for artists in all disciplines. Also available in software for Windows 95/98. Web site: www.interlog.com/~cgs

"How To" Grants Manual: Successful Grantseeking Techniques for Obtaining Public and Private Grants by David G. Bauer. Phoenix, Ariz.: Oryx Press, revised 1999. Addresses the methods, new techniques, and procedures that create proactive grant-seeking efforts. Web site: www.infogreenwood.com

Money for Film and Video Artists: A Comprehensive Resource Guide, researched by Douglas Oxenhorn. New York: American Council for the Arts, revised 1993. Available from Americans for the Arts, 1000 Vermont Avenue, NW, 12th Floor, Washington, DC 20005. Provides information on fellowships, grants, awards, low-cost facilities, emergency assistance programs, and technical assistance and support services. Web site: artsusa.org

Money for Visual Artists, researched by Douglas Oxenhorn. New York: Allworth Press and the American Council for the Arts, revised 1993. Available from Americans for the Arts, 1000 Vermont Avenue, NW, 12th Floor, Washington, DC 20005. Includes grants, fellowships, awards, artist colonies, emergency and technical assistance, and support services. Web site: artsusa.org

The National Guide to Funding in Arts and Culture, edited by Gina-Marie Cantarella. The Foundation Center, 79 Fifth Avenue, New York, NY 10003, 2000. Regularly

revised. Lists thousands of grants for arts and cultural programs from independent, corporate, and community foundations. Web site: www.fdncenter.org

The National Resource Guide for the Placement of Artists, edited by Cheryl Slean. The National Network for Artist Placement, 935 West Avenue, Suite 37, Los Angeles, CA 90065. Revised regularly. Lists arts organizations, including those that provide funding to artists. Web site: www.artistplacement.com

Shaking the Money Tree: How to Get Grants and Donations for Film and Video by Morrie Warshawski. Studio City, Calif.: Michael Wiese Productions, 1994. Available from Morrie Warshawski, 1408 W. Washington Street, Ann Arbor, MI 48103. Web site: www.warshawski.com

Standard & Poor's Rating Guide. New York: Standard & Poor's Corporation. Revised annually.

Supporting Yourself as an Artist by Deborah A. Hoover. New York: Oxford University Press, revised 1989. Web site: www.oup-usa.org

Software

Guide to Canadian Arts Grants, Canada Grants Service, 100-2 Bloor Street West, Toronto, Ontario M4W 3EL, Canada. Regularly revised. Lists one thousand granting programs and awards throughout Canada for artists in all disciplines. Available for Windows 95/98. Web site: www.interlog.com/~cgs

Web Sites

The Art Deadlines List (www.artdeadlineslist.com). A comprehensive and up-to-date list of opportunities for visual and performing artists and writers, including grants and residencies. Published monthly via e-mail. Subscription required. Also available as a printout through the U.S. mail. A short version is available free on-line.

ArtDeadline (www.artdeadline.com). A monthly digest of career-related information, including grants and artist-in-residence programs. Available by subscription.

Artist Help Network (www.artisthelpnetwork.com). Founded by Caroll Michels, this site is devoted to all aspects of career development, including contact information for organizations, periodicals, publications, software, audiovisual aids, Web sites, and service providers. See heading "Money" and subheadings "Art Colonies and Artist-in-Residence Programs," "Grants and Funding," and "Grant-writers."

The Canada Council on the Arts (www.canadacouncil.ca). The Web site includes a listing of grants for Canadian artists and application information.

Cultural Funding. Federal Opportunities (www.arts.gov/federal.html). Sponsored by the National Endowment for the Arts. Includes government-sponsored funding programs for artists and organizations.

For Us Grants newsletter (www.grantlady.com). A monthly on-line newsletter about grants for individuals and not-for-profit organizations. The site also in-

cludes how-to articles on grant research, recommended books, and information about phone consultations pertaining to grants and grant applications.

Grant Searching Simplified (www.artgrants.com) by Bari Caton. The new edition is available on-line and in print. Provides artists with an easy-to-learn, step-by-step plan for conducting an effective search for grant support. Includes *The Online Supplement*, which offers a wealth of information about grant searching in the electronic age.

Grants. Basic Guide to Grants for Minnesota Artists (http://rc4arts.org). A list of grants for Minnesota artists prepared by the Minnesota State Arts Board and Resources and Counseling for the Arts.

Institute for Museum and Library Services Newsletter (www.imls.gov). A monthly electronic newsletter that includes information about new grants and highlights best practices and successful grant proposals.

National Endowment for the Arts (www.arts.endow.gov/Guide). An on-line version of the National Endowment for the Arts' program guidelines. Also includes the answers to frequently asked questions about the NEA.

Organizations

The Business Center for the Arts, 965 Longwood Avenue, Bronx, New York 10459. Provides information on proposal and grant writing. Web site: www.bcadc.org

The Canada Council for the Arts, P.O. Box 1047, Ottawa, Ontario K1P 5V8, Canada. Offers grants to individual Canadian artists and arts organizations. Web site: www.canadacouncil.ca

Circum-Arts, 151 West 30th Street, Suite 200, New York, NY 10001. A not-for-profit membership organization with offices in New York and San Francisco that provides numerous support services to individual artists and arts organizations, including grant research, proposal writing, and as an umbrella for grant applications. San Francisco Office: 2940 16th Street, Suite 110, San Francisco, CA 94103. Web site: www.circum.org

Creative Capital Foundation, 65 Bleecker Street, 7th Floor, New York, NY 10012. A national not-for-profit organization that supports artists pursuing innovative approaches to form and content in the performing, visual, literary, and media arts and in emerging art fields. In addition to financial support, the foundation provides grant recipients with advisory services and professional development assistance. Web site: www.creative-capital.org

The Foundation Center, 79 Fifth Avenue, New York, NY 10003. A national service organization that provides information on foundation funding. Services include disseminating information on foundations and publishing reference books on foundations and foundation grants. Web site: www.fdncenter.org

The Foundation Center, 1422 Euclid Avenue, Suite 811, Cleveland, OH 44115-2001. Web site: www.fdncenter.org/cleveland

The Foundation Center, 312 Sutter Street, San Francisco, CA 94108. Web site: www.fdncenter.org/sanfrancisco

The Foundation Center, 50 Hurt Plaza, #150, Atlanta, GA 30303-2914. Web site: www.fdncenter.org/atlanta

The Foundation Center, 1627 K Street, NW, 3rd Floor, Washington, DC 20016-1708. Web site: www.fdncenter.org/washington

The Fund for Women Artists, P.O. Box 60637, Florence, MA 01062. Offers umbrella services to women artists who need a short-term affiliation with a nonprofit organization to raise funds. Also provides free or low-cost grant writing and other management services. Focus is on artists whose work features nontraditional images of women and those who are working in theater, film, or video. www.womenarts.org

National Endowment for the Arts, The Nancy Hanks Center, 1100 Pennsylvania Avenue, NW, Washington, DC 20256. Awards a limited number of grants to visual artists, including National Heritage Fellowships for master folk and traditional artists. Also awards fellowships in literature and jazz. Web site: www. arts.endow.gov

Also see "Art Colonies and Artist-in-Residence Programs."

HEALTH HAZARDS
Publications

ACTS FACTS. 181 Thompson Street, #23, New York, NY 10012. A monthly newsletter that focuses on health hazards for artists, published by the organization Arts, Crafts, and Theater Safety. Web site: www.caseweb.com/acts

Artist Beware by Michael McCann. New York: The Lyons Press, revised 2001. A comprehensive overview on preventing and correcting health hazards of art and craft materials. Analyzes materials and the harm they can create. Web site: www.lyonspress.com

The Artist's Complete Health and Safety Guide by Monona Rossol. New York: Allworth Press, revised 1994. A guide to using potentially toxic materials safely and ethically. Designed to help artists and teachers comply with applicable health and safety laws, including the American and Canadian right-to-know laws and the U.S. Art Materials Labeling Act. Web site: www.allworth.com

The Artist's Resource Handbook by Daniel Grant. New York: Allworth Press, 1996. See chapter "Health and Safety in the Arts." Web site: www.allworth.com

Data Sheets. Arts, Crafts, and Theater Safety (ACTS), 181 Thompson Street, #23, New York, NY 10012-2586. Offers numerous data sheets on various health and safety topics for artists, including "Ventilation for Art Buildings," "Solvents," "Quilting Safety," "Linseed Oil: A Fire Hazard," "Identifying Pigments," and much more. Web site: www.caseweb.com/acts

Health Hazards for Photographers by Siegfried and Wolfgang Rempel. New York: The Lyons Press, 1992. A reference guide to the safe use of all chemicals used in black-and-white and color photography. Web site: www.lyonspress.com

Health Hazards Manual for Artists by Michael McCann. New York: The Lyons Press, revised 1994. Details harmful effects caused by art materials and outlines procedures that can make working with these materials safer. Web site: www.lyonspress.com

Keeping Clay Work Safe & Legal. Published by the National Council of Education on the Ceramic Arts, revised 1996. Available from Arts, Crafts, and Theater Safety (ACTS), 181 Thompson Street, #23, New York, NY 10012-2586. Discusses health hazards to avoid when working with clay. Web site: www.caseweb.com/acts

Overexposure: Health Hazards in Photography by Susan D. Shaw and Monona Rossol. New York: Allworth Press, revised 1991. Web site: www.allworth.com

Studio Safety Checklist by P. Durr, CARFAC-National, 401 Richmond Street West, Suite 442, Toronto, Ontario M5V 3A8, Canada, 1985. Contains information notes, safety rules, an extensive list of resources, and a checklist on health hazards. Web site: www.caro.ca

Videos

First Steps, produced by Artsafe at the University of Melbourne, Australia. Available from Arts, Crafts, and Theater Safety (ACTS), 181 Thompson Street, #23, New York, NY 10012-2586. An introduction to art hazards, this video was designed for high-school and freshman-college students. Web site: www.caseweb.com/acts

Web Sites

Artist Help Network (www.artisthelpnetwork.com). Founded by Caroll Michels, this site is devoted to all aspects of career development, including contact information for organizations, periodicals, publications, software, audiovisual aids, Web sites, and service providers. See heading "Creature Comforts" and subheading "Health Hazards in Your Workspace."

The Artists Foundation (www.artistsfoundation.org/html/afa/healthcoverage/genhealthcare.html). Provides information on occupational health hazards, with warnings surrounding printmaking, ceramics, painting, sculpture, theater safety, photography, and jewelry metalworking.

Health Hazards in the Arts: Information for Artists, Craftspeople and Photographers (wally.rit.edu/pubs/guides/healthhaz.html). Sponsored by the Rochester Institute of Technology.

Health and Safety in the Arts and Crafts (www.ianr.unl.edu/pubs/consumered/nf126.htm). Sponsored by the Nebraska Cooperative Extension.

Organizations

Arts and Crafts Materials Institute, Inc., 100 Boylston Street, Suite 1050, Boston, MA 02116. Certifies 90 percent of all art materials sold in the United States. Provides information on hazardous art products and publishes a newsletter.

Arts, Crafts, and Theater Safety (ACTS), 181 Thompson Street, #23, New York, NY 10012-2586. A not-for-profit organization that provides health and safety services to the arts on a national and international basis. Provides copies of educational and technical materials and refers callers to doctors, health services, and other resources. Publishes the newsletter *ACTS FACTS* and various data sheets. Web site: www.caseweb.com/acts

HEALTH INSURANCE AND MEDICAL PLANS
Publications

Health Insurance: A Guide for Artists, Consultants, Entrepreneurs, and Other Self-Employed by Leonore Janecek. New York: Allworth Press and the American Council for the Arts, 1993. Available from the Americans for the Arts, 1000 Vermont Avenue, NW, 12th Floor, Washington, DC 20005, 1993. Explains how to select and use insurance plans; discusses insurance options, including short-term health, dental, disability, and life insurance. Web site: www.artsusa.org

Web Sites

Artist Help Network (www.artisthelpnetwork.com). Founded by Caroll Michels, this site is devoted to all aspects of career development, including contact information for organizations, periodicals, publications, software, audiovisual aids, Web sites, and service providers. See heading "Creature Comforts" and subheading "Health Insurance."

Artists and Health Insurance (www.artistexchange.about.com). A discussion about health insurance for artists.

The Artists Foundation (www.artistsfoundation.org/html/afa/healthcoverage/genhealthcare.html). Provides a wealth of information on health-care options for artists in Massachusetts.

Health Insurance Resources for Artists (www.massculturalcouncil.org/grants/for_artists/aghealth.html). Lists health insurance options for artists, including organizations and agencies.

Insurance Resources for Craftspeople (www.craftsreport.com/resources/insurance.htm). Lists guilds and arts associations that provide insurance for artists, and other related information.

Organizations

Albany/Schenectady League of Arts, 161 Washington Avenue, Albany, NY 12210. Serves artists in the New York State capitol region. Offers members health insurance. Web site: www.artsleague.org

American Association of Museums, 1575 Eye Street, NW, Suite 400, Washington, DC 20005. Provides members with reduced rates on health insurance. Web site: www.aam-us.org

American Institute of Graphic Arts, 164 Fifth Avenue, New York, NY 10010. Offers members group health insurance. Web site: www.aiga.org

The American Print Alliance, 302 Larkspur Turn, Peachtree City, GA 30269. Not-for-profit alliance of artists' organizations involved in printmaking. Offers members health insurance. Web Site: www.printalliance.org

Artists' Health Insurance Resource Center, The Actors' Fund, 729 Seventh Avenue, 10th Floor, New York, NY 10019. Provides the arts community information necessary to make informed choices about individual and small-business group health insurance options in all fifty states. Sponsors a toll-free telephone number. Phone: 800-798-8447. Web site: www.actorsfund.org/ahirc

Artists Talk On Art, 60 Madison Avenue, New York, NY 10010. Offers health insurance to members. Web site: www.artiststalkonart.org

Arts & Cultural Council for Greater Rochester, 277 North Goodman Street, Rochester, NY 14607. Offers group health insurance to artist-members who reside in the New York counties of Monroe, Livingston, Yates, Ontario, Seneca, and Wayne. Web site: www.artsrochester.org.

Association of Independent Video and Filmmakers, 304 Hudson Street, 6th Floor, New York, NY 10013. Offers members health insurance. Web site: www.aivf.org

Boston Visual Artists Union, P.O. Box 399, Newtonville, MA 02160. Offers health insurance to members.

Chicago Artists' Coalition, 11 East Hubbard Street, 7th Floor, Chicago, IL 60611. Membership organization that offers group medical insurance to artists living in Arizona, Iowa, Illinois, Indiana, Minnesota, Missouri, and Wisconsin. Web site: www.caconline.org

Circum-Arts, 151 West 30th Street, Suite 200, New York, NY 10001. A not-for-profit membership organization that provides numerous support services to individual artists and arts organizations, including group health insurance. San Francisco office: 2940 16th Street, Suite 110, San Francisco, CA 94103 Web site: www.circum.org

College Art Association of America, 275 Seventh Avenue, New York, NY 10001. Offers members group health insurance and life insurance. Web site: www.collegeart.org

Craft Alliance of New York State, 501 West Fayette Street, Room 132, Syracuse, NY 13204. Offers health insurance, dental insurance, and eyeglass insurance to members. E-mail: nyscrafts@aol.com

Cultural Alliance of Greater Washington, 1436 U Street, NW, Suite 103, Washington, DC 20009. Offers members health and dental insurance. Web site: www.cultural-alliance.org

Deaf Artists of America, Inc., 302 North Goodman Street, Suite 205, Rochester, NY 14607-1149. Offers members a health insurance plan. Fax: 716-244-3690. TTY: 716-244-3460.

Graphic Artists Guild, 90 John Street, Suite 403, New York, NY 10038-3202. Offers members health insurance and dental insurance. Web site: www.gag.org

Lenore Janecek & Associates, Ltd., 980 North Michigan Avenue, Suite 1400, Chicago, IL 60611. Offers health insurance to visual and performing artists and writers in Illinois, Wisconsin, Michigan, and Connecticut. Specialized insurance services include health, life, dental, disability, and retirement programs. E-mail: ljanecek@aol.com

National Association for the Self-Employed, P.O. Box 612067, DFW Airport, TX 75261-2067. Offers major medical, PPO, and HMO policies to members. Membership is open to all self-employed persons. Web site: www.nase.org

National Sculpture Society, 237 Park Avenue, New York, NY 10169. Offers major medical, dental, and disability insurance to members. Web site: www. nationalsculpture.org

National Women's Caucus for Art, P.O. Box 1498, Canal Street Station, New York, NY 10013. Membership organization open to women and men who are artists and others involved in the visual-arts field. Offers health, life, and disability insurance to members. Web site: www.nationalwca.com

New York Artists Equity Association, Inc., 498 Broome Street, New York, NY 10013. Offers members group health insurance and dental plans. Available to artists in New York, Pennsylvania, and Florida. Web site: www.anny.org

Organization of Independent Artists, 19 Hudson Street, Suite 402, New York, NY 10013. Offers members a group health insurance plan.

PEN American Center, 568 Broadway, New York, NY 10012-3225. Offers medical insurance at group rates to members. Web site: www.pen.org

RBA Insurance Strategies, 800-722-0160. Provides information on the various health insurance plans available for New York artists.

Texas Fine Arts Association, The Jones Center for Contemporary Art, 700 Congress Avenue, Austin, TX 78701. Membership organization for Texas artists. Offers members a group health insurance plan. Web site: www.tfaa.org

Working Today, P.O. Box 1031, Cooper Station, New York, NY 10276-1031. A national not-for-profit membership organization that promotes the interests of America's independent workforce, including freelancers and the self-employed. Offers members access to health insurance, and discounts on dental insurance and alternative care. Web site: www.workingtoday.org

INTERIOR DESIGN AND ARCHITECTURE
Publications

The Architect's Sourcebook. THE GUILD, 931 East Main Street, #106, Madison, WI 53703-2955. A resource directory that contains the names, addresses, telephone numbers, and photographs of the work of American fine and craft artists, as well as biographical information. Distributed free of charge to attendees of the American Society of Interior Designers' and the American Institute of Architects' national conferences. Also distributed free of charge to art consultants. Published annually. Web site: www.guild.com

Architectural Digest. 6300 Wilshire Boulevard, Suite 1100, Los Angeles, CA 90048-5204. Published monthly. Web site: www.archdigest.com

Architectural Record. 2 Penn Plaza, New York, NY 10121-0101. Published monthly. Web site: www.architecturalrecord.com

Architecture. 770 Broadway, New York, NY 10003-9522. Published monthly. Web site: www.architecturemag.com

Better Homes and Gardens. 1716 Locust Street, Des Moines, IA 50309-3023. Published monthly. Web site: www.bhg.com

Blacklines. 2011 Newkirk Avenue, #7D, Brooklyn, NY 11226-7423. Published quarterly. Written for architects, interior designers, and artists, with focus on the achievements of black design professionals. Web site: www.blacklines.net

Canadian Architect. Southam Business Information, 1450 Don Mills Road, Toronto, Ontario M3B 2X7, Canada. Published monthly. Web site: www.cdnarchitect.com

Contract Design. 1 Penn Plaza, 11th Floor, New York, NY 10119-1198. Published monthly. Web site: www.contractdesign.com

Decor. 330 North Fourth Street, St. Louis, MO 63102-2729. Published monthly. Web site: www.decormagazine.com

The Designer's Sourcebook. THE GUILD, 931 East Main Street, #106, Madison, WI 53703-2955. A resource directory that contains the names, addresses, telephone numbers, and photographs of the work of American fine and craft artists, as well as biographical information. Distributed free of charge to attendees of the American Society of Interior Designers' and American Institute of Architects' national conferences. Also distributed free of charge to art consultants. Published annually. Web site: www.guild.com

Elle Decor. 1633 Broadway, New York, NY 10019-6708. Published eight times a year. Web site: www.elle.com/elle/decor

Harvard Design Magazine. 48 Quincy Street, Cambridge, MA 02138. Published three times a year. Web site: www.gsd.harvard.edu/hdm

Homestyle. 375 Lexington Avenue, New York, NY 10017-5514. Published monthly. Web site: www.americanhomestyle.com

House and Garden. 4 Times Square, New York, NY 10036-6562. Published monthly.

House Beautiful. 1700 Broadway, 29th Floor, New York, New York 10019-5905. Published monthly. Web site: www.housebeautiful.com

Interior Design. 345 Hudson Street, 4th Floor, New York, NY 10014-4587. Published monthly. Web site: www.interiordesignmag.com

Interiors. 770 Broadway, New York, NY 10003-9522. Published monthly.

Interiors and Sources. 666 Dundee Road, Suite 807, Northbrook, IL 60062. Published monthly. Web site: www.isdesignet.com

Landscape Architecture. 636 Eye Street, NW, Washington, DC 20001-3736. Published monthly. Web site: www.asla.org

Metropolis. 61 West 23rd Street, New York, NY 10010. Published ten times a year. Web site: www.metropolismag.com

Metropolitan Home. 1633 Broadway, New York, NY 10019-6714. Published bimonthly.

Southern Accents. 2100 Lakeshore Drive, Birmingham, AL 35209-6721. Published six times a year. Web site: www.southernaccents.com

Web Sites

Artist Help Network (www.artisthelpnetwork.com). Founded by Caroll Michels, this site is devoted to all aspects of career development, including contact information for organizations, periodicals, publications, software, audiovisual aids, Web sites, and service providers. See heading "Other Resources" and subheading "Design and Architecture Publications."

Organizations

American Institute of Architects, 1735 New York Avenue, NW, Washington, DC 20006. Web site: www.aiaonline.com

American Society of Interior Designers, 608 Massachusetts Avenue, NE, Washington, DC 20002-6006. Web site: www.asid.org

Also see "Corporate Art Market."

INTERNATIONAL CONNECTIONS
Publications

Across the Street Around the World: A Handbook for Cultural Exchange by Jennifer Williams. London: British American Arts Association, 1996. Available from Arts International, Institute of International Education, 809 United Nations Plaza, New York, NY 10017-3580. A handbook for those starting out in the field of cultural exchange. Chapters include information on planning, fund-raising, and international contacts. Web site: www.artsinternational.org

[A-N] Magazine for Artists. AN Publications, Turner Building, 7-15 Pink Lane, 1st Floor, Newcastle upon Tyne NE1 5DW, England. Comprehensive listings of awards, commissions, exhibitions, residencies, competitions, and other opportunities for artists in the United Kingdom. Also includes articles and reviews. Published monthly. Web site: www.anweb.co.uk

Art & Auction International Directory. Art & Auction, ArtPress International, 11 East 36th Street, 9th Floor, New York, NY 10016. Published annually. Includes the names, addresses, and phone numbers of art galleries in Europe, Canada, and the United States. Web site: www.artandauction.com

Art Bulletin: Journal of the Representative Body for Professional Artists in Ireland. Artists Association of Ireland, 43/44 Temple Bar, Dublin 2, Ireland. Includes news, reviews, and opportunities for artists. Published bimonthly. Web site: www.artistsireland.com

Art Diary: The World's Art Directory. Milan, Italy: Giancarlo Politi Editore. Published annually. Available c/o Flash Art, 799 Broadway, New York, NY 10003. Separate

editions are available for Europe, South America, the United States, and Japan. Lists artists, galleries, museums, critics, organizations, agencies, and magazines. Web site: www.artdiarynet.com

The Art Newspaper. 27-29 Vauxhall Grove, London SW8 1SY, England. Published eleven times a year. Web site: www.theartnewspaper.com

Artists Communities by the Alliance of Artists' Communities; edited by Tricia Snell. New York: Allworth Press, revised 2000. A complete guide to residence opportunities in the United States for visual and performing artists and writers. Features a special section that lists artists' communities, art agencies, and key contacts that support international artist exchanges. Web site: www.allworth.com

Artworker. Queensland Artworkers Alliance, Level 1, 381 Brunswick Street, Fortitude Valley 4006, Queensland, Australia. A quarterly newsletter for artists with information on exhibition opportunities. Web site: www.artworkers.asn.au

Artworld Europe. The Humanities Exchange, P.O. Box 1608, Largo, FL 33779, and c/o S. R. Howarth, Editor, *L'Echange Culturel,* BP 152, 68003 Colmar Cedex, France. A bimonthly newsletter about art- and gallery-related news in Europe. Web site: www.artworldeurope.org

Brisbane Galleries for Artists. Queensland Artworkers Alliance, Level 1, 381 Brunswick Street, Fortitude Valley 4006, Queensland, Australia. A guide to galleries in Brisbane, Australia. Web site: www.artworkers.asn.au

Export Development of Artisanal Products by Caroline Ramsey Merriam and Malcolm Benjamin. Washington, D.C.: The Crafts Center and the International Trade Center, United Nations Conference on Trade and Development/World Trade Organization, 1998. The Crafts Center, 1001 Connecticut Avenue, Suite 525, Washington, DC 20036. A study that reviews the various steps and approaches for marketing handcrafts in international markets. Web site: www.craftscenter.org

Financial Aid for Research and Creative Activities Abroad by Gail A. Schachter and R. David Weber. San Carlos, Calif.: Reference Service Press. Updated regularly. Web site: www.rspfunding.com

Financial Aid for Study and Training Abroad by Gail A. Schachter and R. David Weber. San Carlos, Calif.: Reference Service Press. Updated regularly. Web site: www.rspfunding.com

Guide to Funding for International and Foreign Programs. The Foundation Center, 79 Fifth Avenue, New York, NY 10003, 1996. Designed to help those seeking grants from U.S. corporations and foundations for international and foreign projects. Contains information on more than 622 grant makers. Web site: www.fdncenter.org

International Directory of the Arts. New Providence, N.J.: K. G. Saur. Revised biennially. Two-volume guide to museums, universities, associations, dealers, galleries, publishers, and others involved in the arts in Europe, the United States, Canada, South America, Asia, and Australia. Web site: www.saur.de

International Volunteer Opportunities in the Crafts Sector. The Crafts Center, 1001 Connecticut Avenue, Suite 525, Washington, DC 20036. A directory of international volunteer organizations that have experience with and/or an interest in working with artisan groups. Web site: www.craftscenter.org

London Art and Artists Guide by Heather Waddell. London Art and Artists Guide, 27 Holland Park Avenue, London W11 3RW, England, revised 2000. Provides details of contemporary galleries, including the types of work shown and contact information, studio information, press contacts, and more. Web site: www.hwlondonartandartistsguide.com

Money for International Exchange in the Arts by Jane Gullong, Noreen Tomassi, and Anna Rubin. New York: American Council for the Arts, published in cooperation with Arts International, revised 2000. Available from Arts International, Institute of International Education, 809 United Nations Plaza, New York, NY 10017-3850. Includes information on grants, fellowships, and awards for travel and work abroad; support and technical assistance for touring and international exchange; international artists' residencies; and programs that support artists' professional development. Web site: www.artsinternational.org

More Bread and Circuses: Who Does What for the Arts in Europe. London: Informal European Theater Meeting and the Arts Council of England, 1994. Available from Arts International, Institute of International Education, 809 United Nations Plaza, New York, NY 10017. Describes special programs and funding opportunities available from the European Commission, the Council of Europe, UNESCO, and European foundations and corporations. Web site: www.artsinternational.org

Museums of the World. New Providence, N.J.: K. G. Saur. Revised regularly. Provides information about more than 24,000 museums throughout the world. Organized by country and city. Web site: www.saur.de

Open Space: UK Opportunities for Visual Artists from Overseas, edited by Kristin Danielsen. Visiting Arts, 11 Portland Place, London W1N 4EJ, England, 1999. A directory of opportunities for international visual artists in the United Kingdom. Web site: www.britcoun.org/visitingarts

Performing Arts Yearbook for Europe, edited by Rod Fisher and Martin Huber. London: Arts Publishing International Limited, revised 1994. Available from Americans for the Arts, 1000 Vermont Avenue, NW, 12th Floor, Washington, DC 20005. Lists more than 14,000 organizations in fifty countries, including ministries of culture, funding agencies, national organizations, networks, resource centers, arts centers, promoters, agents, festivals, and publications. Web site: www.artsusa.org

Ulrich's International Periodical Directory. New Providence, N.J.: R. R. Bowker. Revised annually. Includes the names, addresses, and descriptions of periodicals published throughout the world. Web site: www.bowker.com

Visiting Arts Asia-Pacific Arts Directory by Tom Doling. London: Visiting Arts, revised 2000. Available from Visiting Arts, 11 Portland Place, London W1N 4EJ, England. A three-volume guide to the arts in the Asia-Pacific region. Includes general background information, and lists cultural agencies, arts venues, and resource centers. Web site: www.britcoun.org/visitingarts

Visiting Arts Hungary Arts Directory. London: Visiting Arts, 1999. Available from Cornerhouse Publications, 70 Oxford Street, Manchester M1 5NH, England. Includes contacts across the cultural sectors, programs, technical and policy

information, an overview of the country's arts scene, funding contacts, and practical guidelines on cultural exchange. Web site: www.cornerhouse.org

Visiting Arts Israel Arts Directory. London: Visiting Arts, 1999. Available from Cornerhouse Publications, 70 Oxford Street, Manchester M1 5NH, England. Includes contacts across the cultural sectors, programs, technical and policy information, an overview of the country's arts scene, funding contacts, and practical guidelines on cultural exchange. Web site: www.cornershouse.org

Visiting Arts Norway Arts Directory. London: Visiting Arts, 1999. Available from Cornerhouse Publications, 70 Oxford Street, Manchester M1 5NH, England. Includes contacts across the cultural sectors, programs, technical and policy information, an overview of the country's arts scene, funding contacts, and practical guidelines on cultural exchange. Web site: www.cornerhouse.org

Visiting Arts Palestine Arts Directory. London: Visiting Arts, 2000. Available from Cornerhouse Publications, 70 Oxford Street, Manchester M1 5NH, England. Includes contacts across the cultural sectors, programs, technical and policy information, an overview of the country's arts scene, funding contacts, and practical guidelines on cultural exchange. Web site: www.cornerhouse.org

Visiting Arts Quebec Arts Directory. London: Visiting Arts, 2000. Available from Cornerhouse Publications, 70 Oxford Street, Manchester M1 5NH, England. Includes contacts across the cultural sectors, programs, technical and policy information, an overview of the country's arts scene, funding contacts, and practical guidelines on cultural exchange. Web site: www.cornerhouse.org

Visiting Arts Southern Africa Arts Directory. London: Visiting Arts, 1999. Available from Cornerhouse Publications, 70 Oxford Street, Manchester M1 5NH, England. Eleven separate guides to the sub-Saharan region of Africa, including Angola, Botswana, Lesotho, Malawi, Mozambique, Namibia, South Africa, Swaziland, Tanzania, Zambia, and Zimbabwe. Each directory includes contacts across the cultural sectors, programs, technical and policy information, an overview of the country's arts scene, funding contacts, and practical guidelines on cultural exchange. Web site: www.cornerhouse.org

Zero Gravity: Diary of a Travelling Artist by Elizabeth Bram. Available from Elizabeth Bram, 4 Prospect Street, Baldwin, NY 11510, 1995. A detailed account of the adventures and impressions of an American artist who took the initiative to explore exhibition opportunities abroad and in the United States and in Canada.

Web Sites

AN Web (www.anweb.co.uk). Turner Building, 7-15 Pink Lane, 1st Floor, Newcastle upon Tyne NE1 5DW, England. A valuable resource of information for artists interested in establishing contacts in the United Kingdom and in Europe. Contains on-line career guides, resources on a variety of arts-related subjects, and career advice.

Art & Design Career Employment (http://art.nmu.edu). Sponsored by the Department of Art and Design, Northern Michigan University. Provides a list of Web sites for art and design employment opportunities outside of the United States.

Art Beyond Borders (www.artbeyondborders.org). An international project of artists who use the Web to exchange ideas and information and to organize exhibitions in members' respective countries. Open to artists worldwide.

The Art Brief (www.exhibitionsonline.org). The Humanities Exchange, P.O. Box 1608, Largo, FL 33779, and c/o S. R. Howarth, Editor, *L'Echange Culturel*, BP 152, 68003 Colmar Cedex, France. A weekly e-mail on the latest news about exhibitions, museums, and art fairs in Europe and North America.

Artist Help Network (www.artisthelpnetwork.com). Founded by Caroll Michels, this site is devoted to all aspects of career development, including contact information for organizations, periodicals, publications, software, audiovisual aids, Web sites, and service providers. See heading "Exhibitions, Commissions, Sales" and subheadings "Art Colonies and Artist-in-Residence Programs," "Art Shippers," and "International Connections."

Artist's Careers (www.artistscareers.co.uk). Covers advice and information about working as an artist in the United Kingdom.

Artscape2000 (www.artscape2000.com). Provides links to various galleries throughout Europe. In most cases, visuals, as well as gallery addresses, are provided.

German Galleries (www.germangalleries.com). A site that features German galleries.

World Arts: A Guide to International Exchange (www.arts.endow.gov). Sponsored by the International Partnership Office of the National Endowment for the Arts. A comprehensive guide to international arts exchange programs.

World Wide Arts Resources (www.wwar.com). Links to international galleries and resources.

Organizations

American Academy in Rome, 7 East 60th Street, New York, NY 10021. An American study and advanced research center in the fine arts and humanities. Sponsors the Rome Prize Fellowship and other residency programs. Web site: www.aarome.org

American Council on Germany, 14 East 60th Street, Suite 606, New York, NY 10022. Awards professional fellowships annually to promising young Germans and Americans in a variety of fields, including the arts. E-mail: info@acqusa.org

The American Scandinavian Foundation, 58 Park Avenue, New York, NY 10016. Awards fellowships and grants to professionals and scholars, including those in the creative and performing arts, born in the United States or Scandinavian countries. Web site: www.amscan.org

ArtNetwork, P.O. Box 1360, Nevada City, CA 95959-1360. Sells a mailing list of foreign galleries. Web site: www.artmarketing.com

Arts Exchange, Massachusetts Cultural Council, 10 St. James Avenue, 3rd Floor, Boston, MA 02116-3803. Funds international tours, exhibitions, and residencies. Web site: www.massculturalcouncil.org

Arts International, Institute of International Education, 809 United Nations Plaza, New York, NY 10017-3580. Promotes and supports global connections and interchange in the visual and performing arts and develops programs and projects to educate and inform audiences and the public about the richness and diversity of cultural productions worldwide. Web site: www.artsinternational.org

ArtsLink, CEC International Partners, 12 West 31st Street, New York, NY 10001-4415. Supports exchanges with the newly independent states of Central and Eastern Europe, the former Soviet Union, and the Baltic countries. U.S. artists work with their counterparts abroad. Web site: www.cecip.org

Bellagio Study Center, Rockefeller Foundation, 420 Fifth Avenue, New York, NY 10018-2702 Artist-in-residence program in Como, Italy. Web site: www.rockfound.org

German Academic Exchange Service (DAAD), Artists in Berlin Program, 950 Third Avenue, 19th Floor, New York, NY 10022. Selects young sculptors, painters, writers, composers, and filmmakers to spend twelve months in Berlin as artists-in-residence. Web site: www.daad.de

The Humanities Exhchange, P.O. Box 1608, Largo, FL 33779. A nonprofit organization and clearinghouse for information on international exhibition exchange and touring exhibitions. Publishes directories, guides, and newsletters. Web site: www.exhibitionsonline.org

Res Artis: The International Association of Residential Art Centres and Networks, Kunstlerhaus Bethanien, Mariannenplatz 2, 10997 Berlin, Germany. Web site: www.resartis.org

U.S./Japan Creative Artists' Program, Japan/U.S. Friendship Commission, 1120 Vermont Avenue, NW, Suite 925, Washington, DC 20005. Provides six-month residencies in Japan for individual artists in all disciplines. Artists work on individual projects, which may include the creation of new work or other pursuits related to their artistic goals. Web site: www.jusfc.gov

Visiting Arts, 11 Portland Place, London W1N 4EJ, England. Promotes and facilitates the inward flow of international arts into England, Scotland, Wales, and Northern Ireland in the context of contributions the arts can make to cultural relations and awareness and to fostering mutually beneficial international arts contacts and activities at national, regional, local, and institutional levels. Web site: www.britcoun.org/visitingarts

Also see "General Arts References."

LAW: CONTRACTS AND BUSINESS FORMS
Publications

The Artist-Gallery Partnership: A Practical Guide to Consigning Art by Tad Crawford and Susan Mellon. New York: Allworth Press, revised 1998. Presents a model contract between artists and dealers for arranging a consignment relationship. Web site: www.allworth.com

Artist-Public Gallery Exhibition Contract. CARFAC-National, 401 Richmond Street West, Suite 442, Toronto, Ontario M5V 3A8, Canada, 1977. Four-page sample contract for use between visual artists and local, regional, national, and international galleries. Web site: www.carfac.ca

The Artist's Survival Manual: A Complete Guide to Marketing Your Work by Toby Judith Klayman with Cobbett Steinberg. Originally published by Charles Scribner's Sons, the book is now being published by Toby Judith Klayman and Joseph Branchcomb, revised in 1996. Web site: www.goldwarp.com/klayman. Also available from California Lawyers for the Arts, attention Book Ordering, Fort Mason Center, C-255, San Francisco, CA 94123. Web site: www.calawyersforthearts.org

Business and Legal Forms for Crafts by Tad Crawford. New York: Allworth Press, 1998. Contains twenty-three ready-to-use forms with detailed instructions and negotiation checklists. Includes forms for sales, commissions, limited editions, exhibition loans, gallery agreements, consignments, licensing contracts, and permission forms. A CD-ROM with electronic versions of each form is also provided. Web site: www.allworth.com

Business and Legal Forms for Fine Artists by Tad Crawford. New York: Allworth Press, revised 1999. Contains seventeen ready-to-use contracts and forms with detailed instructions for a variety of situations, including artist-gallery agreements; licensing agreements; and contracts for sales, commissions, and limited editions. A CD-ROM with electronic versions of each form is also provided. Web site: www.allworth.com

Business and Legal Forms for Illustrators by Tad Crawford. New York: Allworth Press, revised 1998. Updated to include electronic rights. It also includes twenty-one forms accompanied by instructions, advice, and negotiation checklists. Forms include licensing of electronic rights; contracts for the sale of artwork; and agreements with agents, collaborators, book publishers, galleries, and licensing. A CD-ROM with electronic versions of each form is also provided. Web site: www.allworth.com

Business and Legal Forms for Photographers by Tad Crawford. New York: Allworth Press, revised 1997. Includes negotiation tactics and twenty-six forms, including electronic rights and sample contracts and instructions for a variety of situations. A CD-ROM with electronic versions of each form is also provided. Web site: www.allworth.com

Contracts. Chicago Artists' Coalition, 11 East Hubbard Street, 7th Floor, Chicago, IL 60611. Part of a series of self-help guides. Web site: www.caconline.org

Exhibition Right: Interior Contract and Description. CARFAC and Canadian Artists Representation Ontario, 1988. Available from CARFAC-National, 401 Richmond Street West, Suite 443, Toronto, Ontario M5V 3A8, Canada. A short description of exhibition rights with a sample bill of sale. Web site: www.carfac.ca

Illinois Fine Art Consignment Act & Sample Contract. Chicago Artists' Coalition, 11 East Hubbard Street, 7th Floor, Chicago, IL 60611. In 1985 Illinois passed a Fine Art Consignment Act in response to a number of art galleries that filed for bankruptcy, leaving artists without a means to retrieve their artwork. This publication contains the act in its entirety, an explanation of the law, and a sample contract for artists to use in dealing with anyone holding work on consignment. Web site: www.caconline.org

Minimum Artist-Dealer Agreement. National Artist Equity Association, P.O. Box 28068, Washington, DC 20038. Sample contract available to National Artist Equity members that contains very basic terms of an artist–gallery dealer relationship.

Model Agreements for Visual Artists: A Guide to Contracts in the Visual Arts by Paul Sanderson. Canadian Artists' Representation Ontario (CARO), 401 Richmond Street West, Suite 443, Toronto, Ontario M5V 3A8, Canada, 1982. An introduction to Canadian art law and professional business practices. Includes twenty-three model contracts and checklists, each accompanied by a commentary clarifying particular provisions. Web site: www.caro.ca

Public Commissions Contract for Artists. CARFAC-National, 401 Richmond Street West, Suite 442, Toronto, Ontario M5V 3A8, Canada. Three-page sample contract for visual artists involved in public commissions with federal, provincial, or municipal governments in Canada. Web site: www.carfac.ca

The Rights of Authors, Artists, and Other Creative People. Carbondale, Ill.: Southern Illinois University Press in cooperation with the American Civil Liberties Union, revised 1992. Available from Volunteer Lawyers for the Arts, 1 East 53rd Street, New York, NY 10022-4201. Explains how authors and visual artists can protect themselves and their work under the present law. Discusses contracts between writers and artists and their agents, collaborators, publishers, and galleries. Web site: www.vlany.org

Web Sites

AN Web (www.anweb.co.uk). Provides information about contracts and legal arrangements in the United Kingdom in the visual arts. See topic "Protection."

Artist Help Network (www.artisthelpnetwork.com). Founded by Caroll Michels, this site is devoted to all aspects of career development, including contact information for organizations, periodicals, publications, software, audiovisual aids, Web sites, and service providers. See heading "Legal" and subheadings "Art Law Resources" and "Contracts & Forms."

Contract Monitor (www.gag.org). Graphic Artists Guild, 90 John Street, Suite 403, New York, NY 10038-3202. A bimonthly e-mail newsletter available to Guild members that analyzes and demystifies contracts.

LAW: COPYRIGHTS, PATENTS, AND TRADEMARKS
Publications

Canadian Copyright Law by Lesley Ellen Harris. Toronto: McGraw-Hill Ryerson Limited, 1992. Written for visual and performing artists and writers. Includes information on current copyright laws in Canada. Web site: www.mcgrawhill.ca

Copyright. Chicago Artists' Coalition, 11 East Hubbard Street, 7th Floor, Chicago, IL 60611. Part of a series of self-help guides. Web site: www.caconline.org

Copyright Collective Fact Sheet, Ottawa. CARFAC Copyright Collective, Inc., 1993. Available from Canadian Artists' Representation Ontario (CARO), 401 Richmond Street West, Suite 443, Toronto, Ontario M5V 3A8, Canada. A bilingual brochure that contains basic copyright information and an outline of activities and benefits of the CARFAC Copyright Collective, Inc. Web site: www.carfac.ca

Copyright for Performing, Literary and Visual Artists. Texas Accountants and Lawyers for the Arts, 1540 Sul Ross, Houston, TX 77006. Explains copyright as it applies to musical, literary, and visual works of art. Also includes answers to frequently asked questions. Web site: www.talarts.org

Copyright for Visual and Media Artists by Garry Conway. Canadian Artists' Representation Ontario (CARO), 401 Richmond Street West, Suite 443, Toronto, Ontario M5V 3A8, Canada, 1997. Examines copyright as it applies to the visual and media arts. Includes information on the use of photo images as source material, copyright for commissioned works and collectives, copyright as applied to digitization, and model agreements. Web site: www.caro.ca

The Copyright Guide: A Friendly Guide to Protecting and Profiting from Copyright by Lee Wilson. New York: Allworth Press, revised 2000. Reflects recent changes in U.S. copyright law. Contains information for artists and anyone looking to understand and benefit from copyrights in the Information Age. Web site: www.allworth.com

The Copyright Handbook by Stephen Fishman. Volunteer Lawyers for the Arts, 1 East 53rd Street, 6th Floor, New York, NY 10022-4201. Provides step-by-step instructions and forms to register a copyright. Covers the latest information on copyright on the Internet, electronic publishing, and multimedia rights. Web site: www.vlany.org

Electronic Highway Robbery: An Artist's Guide to Copyrights in the Digital Era by Mary E. Carter. Berkeley, Calif.: Peachpit Press, 1996. A guide to copyright law as it applies to the digital arts market. Web site: www.peachpitpress.com

Moral Rights in Copyright by Mark Burnham. Canadian Artists' Representation Ontario (CARO), 401 Richmond Street West, Suite 443, Toronto, Ontario M5V 3A8, Canada, 1982. Web site: www.caro.ca

The Patent Guide: A Friendly Guide to Protecting and Profiting from Patents by Carl W. Battle. New York: Allworth Press, 1997. A step-by-step guide to apply for a patent. Follows an application through the Patent Office, shows how to select legal representation if needed, and concludes with information on infringement

procedures, foreign-protection options, and licensing and marketing. Web site: www.allworth.com

Retransmission Rights Fact Sheet by Marian Hebb. Canadian Artists' Representation Ontario (CARO), 401 Richmond Street West, Suite 443, Toronto, Ontario M5V 3A8, Canada, 1990. Contains information on retransmission royalties, copyright collectives, copyright ownership, and effects of new copyright legislation. Web site: www.caro.ca

The Trademark Guide: A Friendly Guide for Protecting and Profiting from Trademarks by Lee Wilson. New York: Allworth Press, 1998. An introduction to trademark protection with tips for creating trademarks and pitfalls to watch out for when using or licensing a trademark. Web site: www.allworth.com

Trademarks and the Arts: How Performers, Visual Artists & Other Creators Can Benefit from The Trademark Law by William M. Borchard. New York: Kernochan Center for Law, Media and the Arts, Columbia Law School, revised 2000. Includes instructions on obtaining and retaining trademarks, information on protecting artistic elements as trademarks, and advice on shaping merchandising licensing agreements. E-mail: akaplan@law.columbia.edu

Visual Arts and Crafts Guide to the New Laws for Copyright and Moral Rights by Henry Lydiate. Art Monthly, 26 Charing Cross Road, Suite 17, London WC2H 0DG, England, 1991. Provides an explanation of the new copyright law and provides advice on remedies for copyright infringement. Web site: www.artmonthly.co.uk

VLA Guide to Copyright for the Performing Arts. Volunteer Lawyers for the Arts, 1 East 53rd Street, 6th Floor, New York, NY 10022-4201, revised 1993. Web site: www.vlany.org

VLA Guide to Copyright for Visual Artists. Volunteer Lawyers for the Arts, 1 East 53rd Street, 6th Floor, New York, NY 10022-4201, revised 1989. Web site: www.vlany.org

The Wonderful World of Trademark Law by Bruce Aronson and Carey Roberts. Washington Area Lawyers for the Arts, 815 15th Street, NW, Washington, DC 20005, 1995. A guide to trademark law, including distinctions between different types of trademarks, how to register, how to protect and defend your trademark, and more. Web site: www.thewala.org

Web Sites

Artist Help Network (www.artisthelpnetwork.com). Founded by Caroll Michels, this site is devoted to all aspects of career development, including contact information for organizations, periodicals, publications, software, audiovisual aids, Web sites, and service providers. See heading "Legal" and subheading "Copyrights, Trademarks and Patents."

Copyright Office, Library of Congress (www.loc.gov/copyright). Copyright application forms can be obtained from this Web site.

The Copyright Website (www.benedict.com). Provides practical and relevant copyright information. Encourages discourse and invites solutions to the myriad of copyright tangles that currently permeate the Web.

10 Big Myths About Copyright Explained by Brad Templeton (www.clari.net/brad/copymyths.html). Discusses common misconceptions about intellectual-property law that are often seen on the Internet and various issues related to copyright.

Organizations

Art Monthly Copyright Helpline, Finers Stephens Innocent, 179 Great Portland Street, London W1N 6LS, England. Provides a direct connection to a law firm specializing in all aspects of copyright law. Calls cost £1.50 per minute, which covers all expenses, including the cost of legal advice. Phone: 020.7323.4000. Web site: www.stephensinnocent.com

Artists' Rights Society, 65 Bleecker Street, 9th Floor, New York, NY 10012. Protects the rights and permissions interests of artists within the United States. Monitors the reproduction, publication, merchandising, advertising, or public display of artworks by member artists.

CARfac Copyright Collective, Box 172, Christopher Lake, Saskatchewan S0J 0N0, Canada. Creates opportunities for increased income for visual and media artists. Provides services to artists affiliated with the collective, including negotiating the terms for copyright use and issuing an appropriate license to the user. Web site: www.carfac.ca/collective

Copyright Office, Library of Congress, 101 Independence Avenue, SE, Washington, DC 10559. Copyright application forms can be obtained from this address. Web site: www.loc.gov/copyright

Design and Artists Copyright Society, Parchment House, 13 Northburgh Street, London EC1V OAH, England. Represents visual artists and protects members' copyright interests. Gives advice, checks on infringements, and collects reproduction fees. Also publishes fact sheets on copyright clearance and other matters. Web site: www.dacs.co.uk

United States Patent and Trademark Office, Crystal Park 3, Suite 461, Washington, DC 20231. Web site: www.uspto.gov

LAW: ESTATE PLANNING
Publications

The Business of Art, edited by Lee Caplin. Englewood Cliffs, N.J.: Prentice-Hall Direct, revised 2000. See "Estate and Gift Tax Planning." Web site: www.phdirect.com

Estate Planning for Artists by Ruth J.Waters, Marcee Yeager, and Paul Barulich. Women's Caucus for Art, 1992. Available from Ruth J. Waters, 1870 Ralston Avenue, Belmont, CA 94002. E-mail: rjwaters@sirius.com

Estate Planning for Artists and Collectors by Ann M. Garfinkle and Janet Fries. Washington Area Lawyers for the Arts, 815 15th Street, NW, Washington, DC 20005,

1996. Provides an overview of legal issues in estate planning as it applies to artists and collectors. Web site: thewala.org

Estate Planning for Visual Artists by Liz Wylie. Canadian Artists' Representation Ontario (CARO), 401 Richmond Street West, Suite 443, Toronto, Ontario M5V 3A8, Canada, 1994. Advises artists on how to plan their estates and prepare a will. Web site: www.caro.ca

A Legal Guide for Lesbian and Gay Couples by Hayden Curry, Denis Clifford, and Robin Leonard. Berkeley, Calif.: Nolo Press, 1996. A detailed legal survey of the laws affecting gay and lesbian couples, including estate planning. Web site: www.nolo.com

Legal Guide for the Visual Artist by Tad Crawford. New York: Allworth Press, revised 1999. See chapter "The Artist's Estate." Web site: www.allworth.com

Plan Your Estate by Denis Clifford and Cora Jordan. Berkeley, Calif.: Nolo Press, 1996. Explains the use of wills, trusts, and other planning devices, and suggests ways to minimize estate taxes and maneuver through probate. Sample estate plans are included. Web site: www.nolo.com

A Visual Artists' Guide to Estate Planning. Marie Walsh Sharpe Art Foundation, 711 North Tejon, Suite B, Colorado Springs CO 80903, 1998.

Your Living Trust and Estate Plan: How to Maximize Your Family's Assets and Protect Your Loved Ones by Harvey J. Platt. New York: Allworth Press, revised 1999. A guide to using a living trust to create a flexible estate plan. Covers estate planning for small-business owners and others with special needs. Web site: www. allworth.com

Web Sites

Artist Help Network (www.artisthelpnetwork.com). Founded by Caroll Michels, this site is devoted to all aspects of career development, including contact information for organizations, periodicals, publications, software, audiovisual aids, Web sites, and service providers. See heading "Legal" and subheading "Estate Planning."

Future Safe. A Guide to Planning for the Future of Your Art in All Disciplines (www.artistswithaids.org). Sponsored by the Estate Project for Artists with AIDS, Alliance for the Arts. An on-line guide with information on estate planning.

A Life in Dance: A Guide to Dance Preservation and Estate Planning for Dance Artists (www.artistswithaids.org). Sponsored by the Estate Project for Artists with AIDS, Alliance for the Arts. An on-line guide with information on estate planning for dancers.

Organizations

Art for Healing, Inc., 230 Scott Street, San Francisco, CA 94117. Accepts donations of art for free loans to health-care facilities, including Ronald McDonald House, cancer projects, AIDS hospices, general hospitals, and homes for the aged. E-mail: afhsf@aol.com

Art in Perpetuity, 324 Bowery, New York, NY 10012. Places artwork from artists' estates.

Leslie-Lohman Gay Art Foundation, 127-B Prince Street, New York, NY 10012-3154. Represents the estates of lesbian and gay artists. Web site: www.leslie-lohman.org

New York City Health and Hospitals Corporation, Public Art Program, Attention: Gregory Pierre Mink, 346 Broadway, Room 506, New York, NY 10013. Acquires art for hospitals from artists' estates.

Volunteer Lawyers for the Arts, Artist Legacy Project, 1 East 53rd Street, New York, NY 10022-4201. Provides free and specialized estate planning and related legal services to artists. Web site: www.vlany.org

LAW: FORMING A NOT-FOR-PROFIT ORGANIZATION
Publications

Getting Organized: A Not-for-Profit Manual. New York: Lawyers Alliance of New York, 1994. Available from Volunteer Lawyers for the Arts, 1 East 53rd Street, 6th Floor, New York, NY 10022-4201. A comprehensive handbook on forming a not-for-profit organization. Includes a detailed discussion of New York State not-for-profit law. Web site: www.vlany.org

How to Form a Non-Profit Corporation by Anthony Mancuso. Berkeley, Calif.: Nolo Press, revised 1997. Explains the legal formalities involved in forming and operating a tax-exempt, nonprofit corporation. Web site: www.nolo.com

The Paper Chase: Non Profit Filings, Forms & Record Keeping by Peter Wolk and Peter Lewit. Washington, D.C.: Washington Area Lawyers for the Arts and the Cultural Alliance of Greater Washington, 1992. Available from Washington Area Lawyers for the Arts, 815 15th Street, NW, Washington, DC 20005. Includes definitions of IRS, state, and local rules; filing tax and payroll forms; and record-keeping requirements. Web site: www.thewala.org

This Way Up: Legal and Business Essentials for Nonprofits. Volunteer Lawyers for the Arts, 1 East 53rd Street, 6th Floor, New York, NY 10022-4201, 1988. Summary of the Volunteer Lawyers for the Arts' national conference on not-for-profit arts organizations. Web site: www.vlany.org

To Be or Not to Be: An Artist's Guide to Not-for-Profit Incorporation. Volunteer Lawyers for the Arts, 1 East 53rd Street, 6th Floor, New York, NY 10022-4201, revised 1998. Explains the pros and cons of not-for-profit corporate status, legal responsibilities and requirements, and alternatives to incorporation. Web site: www. vlany.org

LAW: GENERAL RESOURCES
Publications

Answers to Common Legal Questions of Independent Photographers by Charles D. Ossola and Janet Fries. Washington Area Lawyers for the Arts, 815 15th Street, NW, Washington, DC 20005, 1995. A general guide that clarifies basic legal principles

for photographers to enable them to function more effectively in the market-place. Web site: www.thewala.org

Art, Artifact & Architecture Law by Jessica L. Darraby. St. Paul, Minn.: Clark Board-man Callaghan, West Group, 1995. Discusses policies and laws concerning the creation, display, production, distribution, and preservation of visual art. Web site: www.cbclegal.com

Art Law: Rights and Liabilities of Creators and Collectors by Franklin Feldman, Stephen E. Weil, and Susan Duke Biederman. Boston: Little, Brown and Company, 1988. Analyzes hundreds of cases involving art, from art in public places to re-sale royalties and artist-dealer contracts. Web site: www. twbookmark.com

Art Law: The Guide for Collectors, Investors, Dealers and Artists by Ralph E. Lerner and Judith Bresler. Practicing Law Institute, 810 Seventh Avenue, New York, NY 10019, revised 1998.

Art, the Art Community, and the Law. Ontario Crafts Council, Designers Walk, 170 Bedford Road, Toronto, Ontario M5R 2K9, Canada. A legal and business guide for artists, collectors, gallery owners, and curators. Web site: www.craft.on.ca

The Artist in Business: Basic Business Practices by Craig Dreesen. Arts Extension Ser-vice, Division of Continuing Education, University of Massachusetts, P.O. Box 31650, Amherst, MA 01003, revised 1996. Includes information on legal issues. Web site: www.umass.edu/aes

An Artist's Guide to Small Claims Court. Volunteer Lawyers for the Arts, 1 East 53rd Street, 6th Floor, New York, NY 10022-4201, revised 1994. A step-by-step guide for preparing a case in New York City's small-claims court. Web site: www.vlany.org

Business Entities for Artists, fact sheet by Mark Quail. Ontario, Canada: Artists' Legal Advice Services and Canadian Artists' Representation Ontario, 1991. Available from Canadian Artists' Representation Ontario (CARO), 401 Richmond Street West, Suite 443, Toronto, Ontario M5V 3A8, Canada. Summarizes information on sole proprietorships and corporations for Canadian artists, with tax perspec-tives, registration, and legal liability. Web site: www.caro.ca

Journal of Law and the Arts. A joint publication of the Columbia University School of Law and Volunteer Lawyers for the Arts. Available from Volunteer Lawyers for the Arts, 1 East 53rd Street, 6th Floor, New York, NY 10022-4201. Published quarterly. Web site: www.vlany.org

The Law (in Plain English) for Crafts by Leonard Duboff. New York: Allworth Press, revised 1999. Helps crafts artists understand the law and tackle the business and legal issues they face each day. Web site: www.allworth.com

The Law (in Plain English) for Galleries by Leonard D. Duboff. New York: Allworth Press, revised 1999. Covers all legal aspects of gallery business—from trade-marks and copyright to contracts, consignments, taxes, product liability, adver-tising, catalog sales, and customer relations. The author also advises on how to find a good lawyer. Web site: www.allworth.com

The Law (in Plain English) for Photographers by Leonard D. Duboff. New York: All-worth Press, revised 1995. Drawing from examples of real cases, this book

discusses everyday legal and business issues affecting professional photography. Topics include copyright, defamation and libel, censorship and obscenity, business organization and taxes, working and living space, contracts and remedies, agents, estate planning, and digitalization. Web site: www.allworth.com

Legal Guide for the Visual Artist by Tad Crawford. New York: Allworth Press, revised 1999. The new edition provides updated legal information and vital data on new media and electronic rights. Covers copyright and moral rights; sale of art by artist, gallery, or agent; sale of reproduction rights, including assignment confirmations, licensing, and book contracts; taxation, hobby-loss challenges, and the IRS; studios and leases; and estate planning. Model contracts are also included. Web site: www.allworth.com

Legal-Wise: Self-Help Legal Guide for Everyone by Carl W. Battle. New York: Allworth Press, 1991. Covers procedures and forms for solving career-related and noncareer issues, including how to change your name legally and apply for patents, trademarks, and copyright. It also discusses real estate agreements, living wills, bankruptcy, and how to handle an IRS audit. Web site: allworth.com

Visual Artist's Business and Legal Guide, edited by Gregory T. Victoroff. Englewood Cliffs, N.J.: Prentice-Hall, 1995. Offers business and legal information about such matters as sales, promotion, copyrights, licenses, privacy, art destruction, fraud, and fund-raising and grants. Also includes artists' contracts, with comments by lawyers on negotiable clauses. Web site: www.prenhall.com

Volunteer Lawyers for the Arts Most Called List. Volunteer Lawyers for the Arts, 1 East 53rd Street, 6th Floor, New York, NY 10022-4201, 1999. Considered the Yellow Pages of the arts-law community. Lists the most frequently requested telephone numbers and addresses from the Art Law Hotline. Web site: www. vlany.org

Web Sites

Art Law by Ann Avery Andres, Esq. (www.tfaoi.com/articles/andres/aa1.htm). Attorney Ann Avery Andres gives legal advice to artists.

The Artist as Creditor and Debtor: Collections, Small Claims, Court, Bankruptcy and Alternatives to Bankruptcy (www.libertynet.org/pvla/creditordebtor.htm). Edited by Jennifer Irrgang. A series of articles on debt collection, small-claims court, bankruptcy, and alternatives to bankruptcy written by attorneys. Sponsored by Philadelphia Volunteer Lawyers for the Arts.

Artist Help Network (www.artisthelpnetwork.com). Founded by Caroll Michels, this site is devoted to all aspects of career development, including contact information for organizations, periodicals, publications, software, audiovisual aids, Web sites, and service providers. See heading "Legal" and subheading "Art Law Resources.

Nolo.com Self-Help Law Center (www.nolo.com). Includes a legal encyclopedia, a law dictionary, answers to eight hundred common legal questions, and information on relevant books and software.

Starving Artists Law (www.starvingartistslaw.com). A launchpad for artists and writers looking for self-help legal information.

LAW: LEGISLATION AND ARTS ADVOCACY
Publications

Censorship and the Arts: Law Controversy, Debate, Facts by Brenda Cossman. Ontario, Canada: The Ontario Association of Art Galleries, 1995. Available from Canadian Artists' Representation Ontario (CARO), 401 Richmond Street West, Suite 442, Toronto, Ontario M5V 3A8, Canada. An overview of art censorship in Canada. Web site: www.caro.ca

The Cultural Battlefield: Art Censorship & Public Funding, edited by Jennifer A. Peter and Louis M. Crosier. Gilsom, Mass.: Avocus Publishing, 1997. Offers perspectives on the validity of public funding, the meaning of obscenity, and targets of censorship. It also explores why and how the government has tried to stifle artistic expression that challenges the status quo. Web site: www.avocus.com

The National Campaign for Freedom of Expression Handbook to Understanding, Preparing for, and Responding to Challenges to Your Freedom of Artistic Expression. National Campaign for Freedom of Expression, 1429 G Street, NW, Washington, DC 20005, 1998. Provides an overview of legal concepts, tips for organizing and empowering local arts communities, summaries of past incidents, examples of censored work, and a resource directory. Web site: www.ncfe.net

NAAO Bulletin. National Association of Artists' Organizations, 1718 M Street, NW, PMB #239, Washington, DC 20004. Quarterly newsletter that contains articles and reports on issues involving pending legislation, freedom of expression, and other pertinent governmental policies affecting artists and arts organizations. Web site: www.naao.org

Web Sites

Artist Help Network (www.artisthelpnetwork.com). Founded by Caroll Michels, this site is devoted to all aspects of career development, including contact information for organizations, periodicals, publications, software, audiovisual aids, Web sites, and service providers. See heading "Legal" and subheading "Arts Legislation and Advocacy."

Fear No Art (www.fearnoart.com). Devoted exclusively to issues of art censorship. Sponsored by the National Campaign for Freedom of Expression.

Organizations

Americans for the Arts, 1000 Vermont Avenue, NW, 12th Floor, Washington, DC 20005. National organization that provides information on legislative issues and government policies affecting the arts. Also promotes the development of the arts by strengthening the role of local arts agencies. Web site: www.artsusa.org

Canadian Artists' Representation Ontario (CARO), 401 Richmond Street West, Suite 442, Toronto, Ontario M5V 3A8, Canada. An association of professional artists in Ontario working to improve the financial and professional status of artists. Web site: www.caro.ca

CARFAC-BC, P.O. Box 2359, Vancouver, British Columbia V6B 3W5, Canada. A regional branch of a national advocacy organization for Canadian artists. Web site: www.islandnet.com/poets/carfacbc/carfac.htm

CARFAC Manitoba, 523-100 Arthur Street, Winnipeg, Manitoba R3B 1H3, Canada. A regional advocacy organization that provides career-related services and publications for artists. Web site: www.umanitoba.ca/schools/art/gallery/hpgs/carfac/

CARFAC National, 401 Richmond Street West, Suite 442, Toronto, Ontario M5V 3A8, Canada. A national advocacy organization for Canadian artists. Web site: www.carfac.ca

CARFAC Ontario, 401 Richmond Street West, Suite 440, Toronto, Ontario M5V 3A8, Canada. A regional branch of an advocacy organization for Canadian artists. Website: www.caro.ca

CARFAC Saskatchewan (Regina), 210-1808 Smith Street, Regina, Saskatchewan S4P 2N4, Canada. A regional branch of a national advocacy organization for Canadian artists. Web site: www.carfac.sk.ca

CARFAC Saskatchewan (Saskatoon), 302-220 Third Avenue South, Saskatoon, Saskatchewan S7K 1M1, Canada. A regional branch of a national advocacy organization for Canadian artists. Web site: www.carfac.sk.ca

Graphic Artists Guild, 90 John Street, Suite 403, New York, NY 10038-3202. National membership organization with local chapters throughout the United States. Advances the rights and interests of graphic artists through legislative reform. Web site: www.gag.org

National Association of Artists' Organizations, 1718 M Street, NW, PMB #239, Washington, DC 20004. A membership organization comprised of organizations and individual artists. Provides information on legislative issues and governmental policies affecting artists and arts organizations. Web site: www.naao.org

National Campaign for Freedom of Expression, 1429 G Street, NW, Washington, DC 20005. Coalition of artists and other individuals and artists' organizations, working together to protect the First Amendment and freedom of expression. Chapters are located throughout the United States. Web site: www.ncfe.net

Visual Arts Newfoundland and Labrador (VANL), Devon House, 59 Duckworth Street, St. John's A1C 1E6, Newfoundland. A regional branch of CARFAC, a national advocacy organization for Canadian artists. E-mail: vanl@thezone.net

LAW: LICENSING ART
Publications

Art Marketing Sourcebook. ArtNetwork, P.O. Box 1360, Nevada City, CA 95959, regularly revised. Contains the names and addresses of licensing agents. Web site: www.artmarketing.com

Licensing Art and Design by Caryn R. Leland. New York: Allworth Press, revised 1995. A comprehensive and helpful guide to the mechanics of licensing images for use on apparel, ceramics, posters, stationery, and many other products. Web site: allworth.com

The Licensing Letter. EPM Communications, Inc., 160 Mercer Street, 3rd Floor, New York, NY 10012. A guide to licensing contacts, trends, and deals. Published twenty-two times a year. Web site: www.epmcom.com

Licensing Letter Sourcebook. EPM Communications, Inc., 160 Mercer Street, 3rd Floor, New York, NY 10012. Revised annually. Includes the names of licensing agents with contact information and a list of properties they represent. Web site: www.epmcom.com

Web Sites

Artist Help Network (www.artisthelpnetwork.com). Founded by Caroll Michels, this site is devoted to all aspects of career development, including contact information for organizations, periodicals, publications, software, audiovisual aids, Web sites, and service providers. See heading "Legal" and subheadings "Licensing Agents" and "Licensing Art & Design."

Organizations

International Licensing Industry Merchandiser's Association, 350 Fifth Avenue, Suite 2309, New York, NY 10118. Offers members access to many services, including an on-line licensing database, and a 1,600-page worldwide licensing resource directory. Also sponsors an annual International Licensing Exposition and Conference. Web site: www.licensing.org

LAW: ORGANIZATIONS
Publications

The National Resource Guide for the Placement of Artists, edited by Cheryl Slean. The National Network for Artist Placement, 935 West Avenue, Suite 37, Los Angeles, CA 90065, revised regularly. An annotated guide to organizations lending support to artists, including those offering legal advice. Web site: www.artistplacement.com

VLA Listing of New York Attorneys. Volunteer Lawyers for the Arts, 1 East 53rd Street, 6th Floor, New York, NY 10022-4201, regularly updated. Lists the names and addresses of New York area lawyers who are interested in representing artists and arts organizations. Web site: www.vlany.org

VLA National Directory. Volunteer Lawyers for the Arts, 1 East 53rd Street, 6th Floor, New York, NY 10022-4201, regularly updated. Describes Volunteer Lawyers for the Arts programs throughout the United States and Canada. Web site: www.vlany.org

Web Sites

Artist Help Network (www.artisthelpnetwork.com). Founded by Caroll Michels, this site is devoted to all aspects of career development, including contact information for organizations, periodicals, publications, software, audiovisual aids, Web sites, and service providers. See heading "Legal" and subheadings "Art Law Organizations," "Art Law Organizations Abroad," and "Arts Attorneys."

Pro Bono, Pro Arts: Finding a Volunteer Lawyer (www.arts.endow.gov/arforms/ Manage/ VLA.html). An article written by Amy Schwartzman, executive director of Volunteer Lawyers for the Arts.

Organizations

CALIFORNIA

Barristers Committee for the Arts, Beverly Hills Bar Association, 300 South Beverly Drive, #201, Beverly Hills, CA 90212. Serves artists in Los Angeles County. E-mail: mmeadow@ix.netcom.com

California Lawyers for the Arts, 1212 Broadway, Suite 834, Oakland, California 94612. Serves artists in California. Also handles requests from artists outside of the state. Web site: www.calawyersforthearts.org

California Lawyers for the Arts, 926 J Street, Suite 811, Sacramento, CA 95814. Serves artists in California. Also handles requests from artists outside of the state. Web site: www.calawyersforthearts.org

California Lawyers for the Arts, C-255, Fort Mason Center, San Francisco, CA 94123. Serves artists in California. Also handles requests from artists outside of the state. Web site: www.calawyersforthearts.org

California Lawyers for the Arts, 1641 18th Street, Santa Monica, CA 90404. Serves artists in California. Also handles requests from artists outside of the state. Web site: www.calawyersforthearts.org

San Diego Lawyers for the Arts, 1205 Prospect Street, Suite 400, La Jolla, CA 92037. Serves artists in San Diego County.

COLORADO

Colorado Lawyers for the Arts, 200 Grant Street, Suite 303E, Denver, CO 80203. Serves artists in Colorado. E-mail: cola@artstozoo.org

CONNECTICUT

Connecticut Volunteer Lawyers for the Arts, c/o Sorokin, Gross & Hyde, Pullman & Conley, 90 State Street, 13th Floor, Hartford, CT 06103-3702. Serves artists in Connecticut. Web site: www.ctarts.org/vla.htm

DISTRICT OF COLUMBIA

Washington Area Lawyers for the Arts, 815 15th Street, NW, Suite 900, Washington, DC 20005. Serves artists in Washington, D.C.; northern Virginia; Delaware; and parts of Maryland. Web site: www.thewala.org

FLORIDA

Volunteers Lawyers for the Arts/Florida, ArtServe, Inc., 1350 East Sunrise Boulevard, Suite 100, Fort Lauderdale, FL 33304. Serves artists in Florida.

GEORGIA

Atlanta Lawyers for the Arts, 152 Nassau Street, Atlanta, GA 30303. Serves artists in Georgia.
Georgia Volunteer Lawyers for the Arts, 675 Ponce de Leon Avenue, NE, Atlanta, GA 30308-1807. Serves artists in Georgia.

ILLINOIS

Lawyers for the Creative Arts, 213 West Institute Place, Suite 411, Chicago, IL 60610-3125. Serves artists in Illinois.

KANSAS

Mid-America Arts Resources, P.O. Box 363, Lindsborg, KS 67456. Serves artists in Kansas, Nebraska, and Oklahoma.

KENTUCKY

Lexington Arts and Cultural Council, 161 North Mill Street, Lexington, KY 40507. Offers limited legal services to artists in Lexington-Fayette County. Web site: wwwlexarts.org

LOUISIANA

Louisiana Volunteer Lawyers for the Arts, 225 Barrone Street, Suite 1712, New Orleans, LA 70112. Serves artists in Louisiana.

MAINE

Maine Volunteer Lawyers and Accountants for the Arts, 43 Pleasant Street, South Portland, ME 04106. Serves artists in Maine.

MARYLAND

Maryland Lawyers for the Arts, 218 West Saratoga Street, Baltimore, MD 21201. Serves artists in Maryland. E-mail: imani2@msn.com

MASSACHUSETTS

Volunteer Lawyers for the Arts of Massachusetts, City Hall Plaza, Room 716, Boston, MA 02201. Serves artists in Massachusetts. E-mail: vla@world.std.com

MINNESOTA

Art Law Referral Service, Resources and Counseling for the Arts, 308 Prince Street, Suite 270, St. Paul, MN 55101-1437. A joint effort of Resources and Counseling for the Arts and the Art and Entertainment Law Committee of the Minnesota State Bar Association. Serves artists in Minnesota, western Wisconsin, Iowa, North Dakota, and South Dakota. Web site: www.rc4arts.org

MISSOURI

St. Louis Volunteer Lawyers and Accountants for the Arts, 3540 Washington, St. Louis, MO 63103. Serves artists in Missouri and southwestern Illinois. Web site: www.vlaa.org

MONTANA

Montana Volunteer Lawyers for the Arts, P.O. Box 8687, Missoula, MT 59807. Serves artists in western Montana.

NEW HAMPSHIRE

Lawyers for the Arts/New Hampshire, One Granite Place, Concord, NH 03301. Serves artists in New Hampshire. E-mail: Joan_Goshgarian@bcbsnh.com

NEW YORK

Albany/Schenectady League of Arts, Inc., 161 Washington Avenue, Albany, NY 12210. Sponsors a Volunteer Lawyers for the Arts program for member artists in the New York counties of Albany, Columbia, Fulton, Green, Montgomery, Rensselaer, Saratoga, Schenectady, Schoharie, Warren, and Washington. Web site: www.artsleague.org

Arts Council in Buffalo and Erie County, 700 Main Street, Buffalo, NY 14202-1962. Offers limited legal services to artists. Web site: www.artscouncilbuffalo.org

Visual Artists and Galleries Association (VAGA), 350 Fifth Avenue, Suite 6305, New York, NY 10118. Membership organization that reviews cases and helps artists determine whether they need professional legal assistance; in such instances the organization provides attorney referrals. E-mail: rpanza.vaga@erols.com

Volunteer Lawyers for the Arts, 1 East 53rd Street, New York, NY 10022-4201. Operates an Art Law Hotline (212-319-2910) for artists and arts organization that need quick answers to arts-related legal questions. Also sponsors the MediateArt Project that trains participants to think about new ways to approach conflict "to allow them to create and thrive, rather than dispute and wither." Web site: www.vlany.org

NORTH CAROLINA

North Carolina Volunteer Lawyers for the Arts, Inc., P.O. Box 26513, Raleigh, NC 27611-6513. Serves artists in North Carolina.

OHIO

Volunteer Lawyers and Accountants for the Arts, 113 St. Clair Avenue NE, Suite 225, Cleveland, OH 44114-1253.

Toledo Volunteer Lawyers for the Arts, 608 Madison Avenue, Suite 1523, Toledo, OH 43604. Serves artists in northwestern Ohio.

OREGON

Northwest Lawyers and Artists, 520 SW Yamhill Avenue, Portland, OR 97204. Serves artists in Oregon. E-mail: artcop@aol.com

PENNSYLVANIA

Philadelphia Volunteer Lawyers for the Arts, 251 South 18th Street, Philadelphia, PA 19103. Serves artists in Pennsylvania, Delaware, and New Jersey. Web site: www.libertynet.org/pvla

Western Pennsylvania Professionals for the Arts, P.O. Box 19388, Pittsburgh, PA 15213-5388. E-mail: proarts@cmu.edu

RHODE ISLAND

Ocean State Lawyers for the Arts, P.O. Box 19, Saunderstown, RI 02874. Serves artists in Rhode Island and southeastern New England. E-mail: dspatt@ artslaw.org

SOUTH DAKOTA

South Dakota Arts Council, 800 Governors Drive, Pierre, SD 57501-2294. Provides legal-referral services to artists. Web site: www.state.sd.us/deca/sdarts

TENNESSEE

Tennessee Arts Commission, 401 Charlotte Avenue, Nashville, TN 37243-0780. Offers limited legal services to artists. Web site: www.arts.state.tn.us

TEXAS

Texas Accountants and Lawyers for the Arts, 1540 Sul Ross, Houston, TX 77006. Web site: www.talarts.org

Texas Accountants and Lawyers for the Arts, P.O. Box 2019, Cedar Hill, TX 75106. Web site: www.talarts.org

UTAH

Utah Lawyers for the Arts, P.O. Box 652, Salt Lake City, UT 84110-0652. Serves artists in Utah.

WASHINGTON

Artists Legal Clinic, Artist Trust, 1402 Third Avenue, Room 404, Seattle, WA 98122. Volunteer lawyers specializing in arts and entertainment. Offers half-hour private legal advice on contracts, copyright, and general art law. Web site: www.artisttrust.org

Washington Lawyers for the Arts, c/o the Richard Hugo House, 1634 11th Avenue, Seattle, WA 98122. Web site: www.wa-artlaw.org

AUSTRALIA

Arts Law Centre of Australia, The Gunnery, 43-51 Cowper Wharf Road, Woolloomooloo, Sydney NSW 2011, Australia. Provides legal and business advice and referral services for artists and arts organizations. Web site: www.artslaw.com.au

CANADA

Artists Legal Advice Services, Canadian Artists' Representation Ontario (CARO), 401 Richmond Street West, Suite 443, Toronto, Ontario M5V 3A8, Canada. Serves artists in Ontario. Web site: www.caro.ca

CARFAC Copyright Collective, Box 172, Christopher Lake, Saskatchewan S0J 0N0, Canada. Represents artists in the administration and protection of copyrights and exhibition fees. Web site: www.carfac.ca/collective

UNITED KINGDOM

British Photographers' Liaison Committee, Gwen Thomas, 81 Leonard Street, London EC2A 4QS, England. Provides photographers with information and advice on copyright issues. E-mail: aop@dircon.co.uk

British Photographic Industry Copyright Association, Roxburghe House, 272–287 Regent Street, London W1R 7BP, England. Provides photographers with copyright information and legal advice.

Design and Artists Copyright Society, Parchment House, 13 Northburgh Street, London EC1V 0AH, England. Represents visual artists and protects members' copyright interests. Web site: www.dac.co.uk

MAILING LISTS
Publications

The Book of Lists Database. Crain's New York Business. 711 Third Avenue, New York, NY 10017-4036. Updated regularly. Contains hundreds of New York–based companies, identifying decision maker by occupation. For a fee, it can be downloaded off the Web site or purchased as a printout. Web site: www.crainsny.com

Web Sites

Artist Help Network (www.artisthelpnetwork.com). Founded by Caroll Michels, this site is devoted to all aspects of career development, including contact information for organizations, periodicals, publications, software, audiovisual aids, Web sites, and service providers. See heading "Career" and subheadings "Art World Mailing Lists," "Press and Public Relations," and "Public Relations Agencies."

The Book of Lists Database (www.crainsny.com). Contains hundreds of New York-based companies, identifying decision maker by occupation, taken from the publication *Crain's New York Business*. For a fee, it can be downloaded off the Web site or purchased as a printout.

Organizations

American Association of Museums, 1575 Eye Street, NW, Suite 400, Washington, DC 20005. Rents various museum-related mailing lists. Web site: www.aam-us.org

ArtNetwork, P.O. Box 1360, Nevada City, CA 95959. Rents arts-related mailing lists that include the addresses of art publications, corporations that collect art, art critics, architects, galleries, and arts organizations. Web site: www.artmarketing.com

Arts Information Exchange, Mid Atlantic Arts Foundation, 22 Light Street, Suite 300, Baltimore, MD 21202. Sells computerized lists of arts-related organizations in the mid-Atlantic region. Web site: www.charm.net/~midarts

ArtSupport, 300 Queen Anne Avenue North, #425, Seattle, WA 98109. Offers various mailing lists related to photography, including galleries, museums, not-for-profit organizations, and periodicals. Web site:www.art-support.com

Best Mailing Lists, 7505 East Tanque Verde Road, Tucson, AZ 85711. Sells the names and addresses of America's most wealthy people in hundreds of categories, including medical doctors (by speciality) and lawyers. Web site: www.bestmailing.com

Mailing Lists Labels Packages, P.O. Box 1233, Weston, CT 06883-0233. Publishes the Mailing List Labels Packages for percent-for-art and art in public places programs. The package includes a directory of percent-for-art and art in public places programs in the United States, and related mailing labels, postcards, and forms that can be used to make cost-effective and systematic contact with the programs.Web site: http://home.att.net/~mllpackage/package_information.htm

Media Alliance, 450 West 33rd Street, New York, NY 10001. Offers mailing lists related to independent media, including the disciplines of video, film, audio, radio, and computers. Includes independent producers/artists, media arts organizations, multicultural organizations, colleges and universities with media studies, and more., Web site: www.mediaalliance.org

Caroll Michels, career coach and artist advocate. 19 Springwood Lane, East Hampton, New York 11937-1169. Offers various arts-related mailing lists, including the names and addresses of museum and independent curators, art consultants, New York City critics, national and regional arts press and consumer press, and New York City arts and consumer press. Updated on an ongoing basis. Web site: www.carollmichels.com

Museum Store Association, 4100 East Mississippi Avenue, Suite 800, Denver, CO 80246. Provides members with a mailing list of museum shops nationwide and in other parts of the world. Affiliate memberships are available to artists who are already selling work to a museum shop at wholesale prices. Web site: www.museumdistrict.com

MATERIALS FOR THE ARTS PROGRAMS
Publications

The Artist's Resource Handbook by Daniel Grant. New York: Allworth Press, revised 1996. See sections "Materials for the Arts" and "Obtaining In-Kind Contributions." Web site: www.allworth.com

Web Sites

Artist Help Network (www.artisthelpnetwork.com). Founded by Caroll Michels, this site is devoted to all aspects of career development, including contact information for organizations, periodicals, publications, software, audiovisual aids, Web sites, and service providers. See heading "Money" and subheading "Materials for the Arts."

New York Wa$teMatch (www.wastematch.org). A program sponsored by the New York City Department of Sanitation's Bureau of Waste Prevention, Reuse and Recycling. Provides information on the availability of raw materials, such as marble scraps, fabrics, and textiles, mahogany, plastics, and materials that are being discarded. The price of materials is much less expensive than on the open market, and in most cases, users can negotiate prices directly with companies that have materials.

Organizations

East Bay Depot for Creative Reuse, 6713 San Pablo Avenue, Oakland, CA 94608. A not-for-profit organization that collects unwanted materials from manufacturers, businesses, and individuals and makes them available to artists, teachers, and the general public at low prices. Web site: www.ciwmb.gov/reuse/Profiles/EastBay.htm

Materials for the Arts, Black Hawk County Solid Waste Management, 1407 Independence Avenue, Waterloo, IA 50703. Donates goods, supplies, and equipment to individual artists. Web site: www.cedarnet.org/bhcswmc/arts.htm

Materials for the Arts, Bureau of Cultural Affairs, City Hall East, 675 Ponce de Leon Avenue, NE, Atlanta, GA 30308.

Materials for the Arts, Cultural Affairs Department, City of Los Angeles, 3224 Riverside Drive, Los Angeles, CA 90027.

Materials for the Arts, Department of Cultural Affairs, 33-00 Northern Boulevard, Long Island City, NY 11101. Provides individual artists—who work with a registered New York City cultural organization—office equipment and supplies, furnishings, art materials, and other items free of charge. Web site: www.ci.nyc.ny.us/html/dcla/html/mfa.html

Materials for the Arts, Monroe County Solid Waste Management District, 3400 Old State Road 37 South, Bloomington, IN 47401. Web site: www.mcswmd.org/arts.html

ON-LINE GALLERIES
Web Sites

Art Galore (www.b17.com). A fee-based on-line gallery.

Art on the Net (www.art.net). Nonjuried membership in on-line gallery.

Art Original (www.artoriginal.com). A fee-based on-line gallery.

ArtAdvocate (www.artadvocate.com). ArtAdvocate, 16 West 55th Street, #3F, New York, NY 10019. Juried, commission-based on-line gallery for New York artists.

ArtCanyon.com (www.artcanyon.com). Art Canyon, 800 Peachtree Street, Suite 8611, Atlanta, GA 30308. Juried, commission-based on-line gallery.

Artists Register On-line (www.artistsregister.com). Western States Arts Federation (WESTAF), 2543 Champa Street, Suite 220, Denver, CO 80205. Presents the work of Colorado and Arizona artists.

ArtMecca (www.artmecca.com). Art Mecca, 300 Brannan Street, #503, San Francisco, CA 94107. Nonjuried, commission-based on-line gallery.

Artnet (www.artnet.com). Artnet.com, 61 Broadway, 23rd Floor, New York, NY 10006-2701. Nonjuried, fee-based on-line gallery.

ArtOasis (www.artoasis.com). Devoted to promoting the work of Pacific Northwest artists.

ArtQuest (www.artquest.com). Nonjuried, fee-based on-line gallery.

ArtSeek (www.artseek.com). Fee-based on-line gallery.

Artstar (www.artstar.com). A fee-based on-line gallery that also charges a 20 percent commission.

ArtXpo (www.artxpo.com). Fee-based on-line gallery.

Craft Site Directory (www.craftsitedirectory.com). Devoted to crafts, with links to Web sites of craft artists working in various fields.

Eco-Artware (www.eco-artware.com). Specializes in arts and crafts items created from recycled, reused, and natural materials.

ElCoquigifts.com (www.elcoquigifts.com). Features the work of Latino artists.

The Guild (www.guild.com). Juried, commission-based on-line gallery.

IncredibleArt (www.incredibleart.com). A commission-based on-line gallery.

Itheo (www.itheo.com). Nonjuried, commission-based on-line gallery.

National Arts and Disability Center (http://nadc.ucla.edu). An on-line gallery that features the work of artists with disabilities.

Nature Art Network (www.nature-art.net). A not-for-profit on-line gallery devoted to the work of women artists who specialize in work related to nature.

New Mexico CultureNet (www.nmcn.org). Database of artists, arts organizations, and various cultural resources in New Mexico.

NextMonet (www.nextmonet.com). Juried, commission-based on-line gallery.

nowCulture (www.nowculture.com). Juried, commission-based on-line gallery. Focuses on art and literature and gives artists exposure. Charges 10 percent commission if work is sold.

PaintingsDirect (www.paintingsdirect.com). Juried, commission-based on-line gallery.

RisingArtist (www.risingartist.com). Nonjuried, commission-based on-line gallery.

Soarts (www.soarts.com). Fee-based on-line gallery.

Solid Expressions.com (www.solidexpressions.com). Nonjuried, commission-based on-line gallery.

A Stroke of Genius (www.portraitartist.com). Fee-based on-line gallery for portrait painters.

Traditional Fine Arts On-line (www.tfaoi.com). A fee-based on-line gallery.

The Varo Registry (www.varoregistry.com). A membership on-line gallery for women artists.

Visual Arts Network (www.visualartsnetwork.com). Nonjuried membership on-line gallery.

VSA arts On-line Gallery (www: vsarts.org). Features the work of artists with disabilities who are members of the VSA arts Artist Registry.

Wonders of the West (www.wondersofthewest.com). Devoted to artwork and articles about the American West. Fee-based on-line gallery.

World Artist Directory (www.worldartistdirectory.com). Juried on-line gallery.

Additional Web Sites

Artist Help Network (www.artisthelpnetwork.com). Founded by Caroll Michels, this site is devoted to all aspects of career development, including contact information for organizations, periodicals, publications, software, audiovisual aids, Web sites, and service providers. See heading "Exhibitions, Commissions, Sales" and subheading "On-line Galleries."

ORGANIZING PAPERWORK
Publications

Art Office by Constance Smith and Sue Viders. ArtNetwork, P.O. Box 1268, Penn Valley, CA 95946, 1998. Includes more than eighty business forms, charts, sample letters, legal documents, and business plans. Also available on disk for Mac users. Web site: www.artmarketing.com

Business and Legal Forms for Crafts by Tad Crawford. New York: Allworth Press, 1998. Contains twenty-three ready-to-use forms with detailed instructions and negotiation checklists. Includes forms for sales, commissions, limited editions, exhibition loans, gallery agreements, consignments, and licensing contracts, plus permission forms. A CD-ROM with electronic versions of each form is also provided. Web site: www.allworth.com

Business and Legal Forms for Fine Artists by Tad Crawford. New York: Allworth Press, revised 1999. Contains seventeen ready-to-use contracts and forms with detailed information covering a variety of situations, including artist-gallery agreements; licensing agreements; and contracts for sales, commissions, and limited editions. A CD-ROM with electronic versions of each form is also provided. Web site: www.allworth.com

Business and Legal Forms for Illustrators by Tad Crawford. New York: Allworth Press, revised 1998. The revised edition has been updated to include electronic rights. It also includes twenty-one forms accompanied by instructions, advice, and negotiation checklists to guide artists to the best deal. Forms include licenses for electronic rights, contracts for the sale of artwork, and agreements with agents,

collaborators, book publishers, and galleries. A CD-ROM with electronic versions of each form is also provided. Web site: www.allworth.com

Business and Legal Forms for Photographers by Tad Crawford. New York: Allworth Press, revised 1997. Covers negotiation tactics and contains twenty-six forms, including electronic rights licenses, sample contracts, and instructions for a variety of situations. A CD-ROM with electronic versions of each form is also provided. Web site: www.allworth.com

Conquering the Paper Pile-Up: Moving Those Mountains of Paper Out of Your Life by Stephanie Culp. Cincinnati: Writer's Digest Books, 1990. Advice on how to organize, file, and store every piece of paper in your office or home, with tips on how to categorize and create files. Web site: www.writersdigest.com

The Organization Map by Pam McClellan. Cincinnati: Betterway Books, 1993. See chapter "The Office."

Organizing for the Creative Person by Dorothy Lehmkuhl with Dolores Cotter Lamping. New York: Crown Publishing, 1994. Helps right-brain people with conquering clutter, mastering time, and reaching goals. Includes practical solutions in harmony with the way creative people think and act. Web site: www.randomhouse.com

A Question of Balance: Artists and Writers on Motherhood by Judith Pierce Rosenberg. Milford, Conn.: Papier-Mache Press, 1995. Interviews with women artists and writers who share how they organize their lives to nurture both their children and their craft. E-mail: judith@calle.com

Time Management for the Creative Person by Lee T. Silber. New York: Three Rivers Press, 1998. Helps right-brain people on how to focus on more than one thing at a time, including hundreds of time-saving tips, and how to improve memory. Web site: www.randomhouse.com

Software Programs

Art & Craft Organizer, Faben, Inc., P.O. Box 3133, Sarasota, FL 34230. A PC software program that tracks inventory records, business expenses, sales tax, and sales. Also includes a database for establishing a mailing list. Web site: www.fabenbooks.com

Art Office by Constance Smith and Sue Viders, ArtNetwork, P.O. Box 1360, Nevada City, CA 95959, 1998. Disk for Mac users. Business forms, charts, sample letters, legal documents, and business plans. Web site: www.artmarketing.com

Artstacks, 11 West 25th Street, 5th Floor, New York, NY 10010. Offers various software for the arts community, including ArtStacks for Photographers and ArtStacks for Artists. Designed for the Macintosh and Windows. Web site: www.artstacks.com

Creating a Successful Career in Photography by Dan Fear. ArtSupport, 300 Queen Anne Avenue North, #425, Seattle, WA 98109. Includes artist business forms, computer templates, and advice on using the forms. Published on diskette. Web site: www.art-support.com

MangoArts, P.O. Box 547935, Orlando, FL 32854-7935. A software system designed for artists who want to streamline and use technology to manage the business of art. Creates customized mailing lists, slide labels, letters, résumés, contact lists, sales records, and more. Available for PC and Mac. Web site: www.mangoarts.com

WorkingArtist: The Artist's Business Tool for Windows. Software for Artists, 7700 Earling Street NE, Olympia, WA 98506. Helps artists track artwork including multiple editions, view provenance, display images, create slide labels, track patrons and patron activities, create standard and custom price lists, and create consignment forms and invoices. Web site: www.workingartist.com

Web Sites

Artist Help Network (www.artisthelpnetwork.com). Founded by Caroll Michels, this site is devoted to all aspects of career development, including contact information for organizations, periodicals, publications, software, audiovisual aids, Web sites, and service providers. See heading "Career" and subheadings "Getting Organized" and "Artist Assistants." Also see heading "Legal" and subheading "Contracts & Forms."

PENSION PLANS AND SAVINGS
AND LOAN PROGRAMS
Publications

The Feisty Woman's Guide to Money by Rusty Cantor, Ruth J. Waters, and Marcee Yeager. Belmont, Calif.: Womens' Caucus for Art, 1994. The authors ask you to take a good look at your financial life, and forms are provided to assist in this endeavor. Offers ways to ensure security in your future, including retirement. Provides suggestions for getting credit, keeping a good credit record, and applying for mortgages and equity loans. Includes advice on insurance. Available from Ruth J. Waters, 1870 Ralston Avenue, Belmont, CA 94002. E-mail: rjwaters@sirius.com

Web Sites

Artist Help Network (www.artisthelpnetwork.com). Founded by Caroll Michels, this site is devoted to all aspects of career development, including contact information for organizations, periodicals, publications, software, audiovisual aids, Web sites, and service providers. See heading "Creature Comforts" and subheading "Pension Plans, Savings & Loan Programs."

Small Business Administration (http://www.sbaonline.sba.gov). Provides loans and loan guarantees to independently owned and operated profit-making small businesses, including culture-related businesses (teaching studios; performing-arts

schools; retail music or art and crafts shops). Describes the various loan programs and eligibility requirements, and contact information for SBA offices state by state.

Organizations

The Artists Community Federal Credit Union, 155 Avenue of the Americas, 14th Floor, New York, NY 10013-1507. A federally insured credit union for artists and arts organizations. Offers savings accounts, loans, CDs, IRAs, and a money-market fund. Assists artists in establishing a credit rating.

Artists Welfare Fund, New York Artists Equity Association, Inc., 498 Broome Street, New York, NY 10013. Assists visual artists with interest-free loans. Web site: www.anny.org

Chicago Artists' Coalition, 11 East Hubbard Street, 7th Floor, Chicago, IL 60611. Offers members credit-union services, including savings accounts, loans, and IRAs. Web site: www.caconline.org

Craft Emergency Relief Fund, P.O. Box 838, Montpelier, VT 05601-0838. Provides crafts artists with interest-free loans and a flexible payback schedule. Web site: www.craftemergency.org

Dayton Hudson Artists Loan Fund, Resources and Counseling for the Arts, 308 Prince Street, Suite 270, St. Paul, MN 55101. Makes loans of up to $5,000 to Twin Cities–area artists for artistic business development. Web site: www.rc4arts.org

Small Business Administration. Offices throughout the United States. Provides loans and loan guarantees to independently owned and operated profit-making small businesses, including culture-related businesses (teaching studios; performing-arts schools; retail music or arts and crafts shops). Web site: http://www.sbaonline.sba.gov

Working Today, P.O. Box 1031, Cooper Station, New York, NY 10276-1031. A national nonprofit membership organization that promotes the interests of America's independent workforce, including freelancers and the self-employed. Offers members free retirement-planning advice. Web site: www.workingtoday.org

PERIODICALS
Print Publications

Afterimage, Visual Studies Workshop, 31 Prince Street, Rochester, NY 14607. For photographers, independent filmmakers, and video artists. Published monthly except July through September. Web site: www.vsw.org/afterimage

Agenda, Visual Arts Ontario,1153A Queen Street West, Toronto, Ontario M6J 1J4, Canada. Features listings including competitions, funding opportunities, workshops, and a free classified section. Published quarterly, 1991. Web site: www.vao.org

American Art Review, P.O. Box 480500, Kansas City, MO 64148-0500. Published bimonthly. E-mail: amartrev@aol.com

American Artist, 770 Broadway, New York, NY 10003. Published monthly. E-mail: amerart@aol.com

American Ceramics, 9 East 45th Street, 3rd Floor, New York, NY 10017-2425. Published quarterly. E-mail: ceramicsonline@earthlink.net

American Craft, American Craft Council, 72 Spring Street, New York, NY 10012-4090. Articles on all aspects of crafts, and information on grants, marketing, and exhibitions. Published bimonthly. Web site: www.craftcouncil.org

AmericanStyle, 3000 Chestnut Avenue, Suite 304, Baltimore, MD 21211. Focuses on contemporary American crafts with feature articles about artists and their work. Published quarterly. Web site: www.americanstyle.com

[A-N] Magazine for Artists, Turner Building, 7-15 Pink Lane, Newcastle upon Tyne NE1 5DW, England. Monthly guide for visual artists and applied artists with features, news, and information on career opportunities. Web site: anweb.co.uk

Aperture, 20 East 23rd Street, New York, NY 10010. Quarterly journal of contemporary photography. Web site: www.aperture.org

Art and Auction, ArtPress International, 11 East 36th Street, 9th Floor, New York, NY 10016-3318. Published monthly. Web site: www.artandauction.com

Art Bulletin, 43 Temple Bar, Dublin 2, Republic of Ireland. Bimonthly journal of the Artists Association of Ireland. Includes news, reviews, and opportunities for artists. Web site: www.artistsireland.com

Art in America, 575 Broadway, New York, NY 10012-3230. Published monthly.

Art Line, International Art News, 11 Phoenix House, Phoenix Street, Charing Cross Road, London WC2H 8BS, England. Published quarterly. E-mail: art_line@compuserve.com

Art Matters, P.O. Box 1628, Fort Washington, PA 19034. Philadelphia's regional guide to the visual arts. Features the work of area artists, reviews, and previews of exhibitions and lists exhibitions and other visual-arts activities. Published ten times a year. Web site: www.philly-art-world.com

Art Monthly, 26 Charing Cross Road, Suite 17, London WC2H 0DG, England. Lists exhibitions in the United Kingdom and publishes reviews. Web site: www.artmonthly.co.uk

Art Monthly Australia, GPO Box 804, Canberra ACT 2601, Australia. Focuses on contemporary visual art in Australia, including opportunities for artists, news, and reviews. Published ten times a year. Web site: www.anu.edu.au/ITA/AusArts/www/art.monthly/ART.MONTHLY. html

Art New England: A Resource for Visual Artists, 425 Washington Street, Brighton, MA 02135. Focuses on artists and exhibitions in New England. Published ten times a year. Web site: www.artnewengland.com

Art New Zealand, Art Magazine Press Ltd., 10-249 Balmoral, Auckland 4, New Zealand. Published monthly.

The Art Newspaper, 27-29 Vauxhall Grove, London SW8 1SY, England. Covers international art-market news. Eleven issues per year.

Art on Paper: The International Magazine of Prints, Drawings, and Photography, Fanning Publishing Company, 39 East 78th Street, New York, NY 10021-0213. Published

bimonthly. Covers information on artists' books, prints, photographs, and works on paper. Web site: www.artonpaper.com

Art Opportunities Monthly, P.O. Box 502, Benicia, CA 94510-0502. Published eleven times a year. A listing of opportunities for artists, including competitions, grants, exhibitions, public art commissions, and residencies. Web site: www.studionotes.org

Art Papers, P.O. Box 5748, Atlanta, GA 31107-5748 Focuses on artists living in the Southeast. Published bimonthly. Web Site: www.artpapers.org.

Art Review, Hereford House, 23-24 Smithfield Street, London EC1A 9LF, England. A monthly guide to exhibitions. Also includes news and reviews.

Art Times, P.O. Box 730, Mount Marion, NY 12456-0730. Covers visual and performing arts and literature. Published monthly. Web site: www.arttimesjournal.com

Artbyte, 39 East 78th Street, New York, NY 10021-0213. Focuses on the digital art field. Published bimonthly. Web site: www.artbyteonline.com

artfocus, Fleisher Fine Arts, Inc., 15 McMurrich Street, Suite 706, Toronto, Ontario M5R 3M6, Canada. Focuses on contemporary visual arts. Published three times a year. Web site: www.artfocus.com

Artforum International, 350 Seventh Avenue, 19th Floor, New York, NY 10001-5013. Published ten times a year. Web site: www.artforum.com

The Artist's Magazine, 1507 Dana Avenue, Cincinnati, OH 45207. Published monthly. Web site: www.artistsmagazine.com

Artlink Australia, 363 Esplanade, Henley Beach SA, 5022, Australia. Contemporary art in Australia. Published quarterly. E-mail: artlinkmag@webmedia.com.au

ARTnews, 48 West 38th Street, 9th Floor, New York, NY 10018-6238. Published monthly. Web site: artnewsonline.com

Arts Washington, Cultural Alliance of Greater Washington, 1436 U Street, NW, Suite 103, Washington, DC 20009-3997. Published monthly. Web site: www.cultural-alliance.org

Artweek, P.O. Box 26340, San Jose, CA 95119-6340. Regional focus: the Northwest, the Southwest, Alaska, and Hawaii. Includes information on competitions, exhibitions, and festivals for visual and performance artists. Forty-four issues, published weekly, September through May; biweekly, June through August. Web site: www.artweek.com

Asian Art News, 28 Arbuthnot Road, Central Hong Kong. Covers contemporary Asian art and artists. Published bimonthly. Web site: asianartnews.com

Association of Hispanic Arts News, Association of Hispanic Arts, 250 West 26th Street, 4th Floor, New York, NY 10010. Published nine times a year. Web site: www.latinoarts.org

Backflash, 12 23rd Street East, Saskatoon, Saskatchewan S7K 0H5, Canada. Contemporary photography. Published quarterly.

Boston Visual Artists Union News, Boston Visual Artists Union, P.O. Box 399, Newtonville, MA 02160. Focuses on art news, events, and opportunities in the Boston area. Published monthly.

British Journal of Photography, 39 Earlham Street, Covent Garden, London WC2H 9LD, England. Includes photography industry news and exhibition listings. Published weekly. Web site: www.bjphoto.co.uk

C: International Contemporary Art, P.O. Box 5, Station B, Toronto, Ontario M5T 2T2, Canada. Covers Canadian and international contemporary art. Published quarterly. Web site: cmagazine.com

Ceramic Review, Ceramic Review Publishing Ltd., 25 Foubert's Place, London W1F 7QF, England. Includes reviews of ceramic exhibitions and news and events. Also includes information on equipment, materials, and techniques. Published bimonthly. Web site: www.ceramic-review.com

Ceramics: Art and Perception, 35 William Street, Paddington, Sydney NSW 2021, Australia. International ceramics magazine. Published quarterly. Web site: www.ceramicart.com.au

Ceramics Monthly, American Ceramics Society, P.O. Box 6136, Westerville, OH 43086-6136. Published monthly. Web site: www.ceramicsmonthly.org

Chicago Artists' News, Chicago Artists' Coalition, 11 East Hubbard Street, 7th Floor, Chicago, IL 60611. Includes information on local exhibition opportunities and national art issues. Published monthly. Web site: www.caconline.org

Circa, Arthouse, Curved Street, Temple Bar, Dublin 2, Republic of Ireland. Covers Irish and international contemporary visual culture. Published quarterly. Web site: www.recirca.com

Clay Times: The Journal of Ceramics, Trends and Techniques, P.O. Box 365, Waterford, VA 20197. Published bimonthly. Web site: claytimes.com

Coagula Art Journal: The Low Down on High Art, 2100 North Main Street, #A-8, Lincoln Heights, CA 90031. Contains articles and interviews, and insider information on the art world. Six issues per year. Web site: www.coagula.com

Contemporary Visual Arts, The International Foundation for Scientific and Education Cooperation, Tower Bridge, Business Complex, 100 Clements Road, Suite K101, London SE16 4DG, England. News, features, and reviews. Published quarterly. Web site: gbhap.com/contemporary_visual_arts

Crafts, Crafts Council, 44a Pentonville Road, Islington, London N1 9BY, England. Focuses on decorative and applied arts, including news, reviews, and features. Published bimonthly. Web site: www.craftscouncil.org.uk

Crafts News, The Crafts Center, 1001 Connecticut Avenue, NW, Suite 525, Washington, DC 20036. Features updates on market trends and trade regulations, sources of assistance, successful artisan projects, and crafts-related publications and events. Published quarterly. Web site: www.craftscenter.org

The Crafts Report: The Business Journal for the Crafts Industry, P.O. Box 1992, Wilmington, DE 19899. Published monthly. Web site: www.craftsreport.com

Critical Angles: The Newsletter of the Center for Arts Criticism, Center for Arts Criticism, 2822 Lyndale Avenue South, Minneapolis, MN 55408. Published quarterly.

Critical Mass, En Foco, 32 East Kingsbridge Road, Bronx, NY 10468. Devoted to photographers of color. Lists grant, exhibition, and job and internship opportunities

throughout the United States. Each issue incorporates the photographic journal *Nueva Luz*. Published four times a year. Web site: www.enfoco.org

Dialogue: Art in the Midwest, P.O. Box 2572, Columbus, OH 43216-2572. Lists exhibitions and competitions in Illinois, Indiana, Kentucky, and Ohio. Published bimonthly. Web site: www.dialoguearts.com

Digital Fine Art Magazine, P.O. Box 420, Manalapan, NJ 07726. A quarterly publication dedicated to the fine-art digital print market. Web site: www.giclees.com

Dpict, 55–57 Tabernacle Street, London EC2A 4AF, England. Bimonthly photography magazine with news, reviews, project pages, and exhibition listings. Web site: www.dpict.org

Eyeline, Eyeline Publishing Ltd., c/o QUT Visual Arts, Victoria Park Road, Kevin Grove, Brisbane QLD, Australia 4059. Australian visual-arts magazine with reviews, news, and artists' pages. Published quarterly. Web site: www.qut.edu.au/eyeline

Fiberarts, 50 College Street, Asheville, NC 28801. Includes, news, reviews, artists' profiles, and international opportunities. Published bimonthly. Web site: www.larkbooks.com

Frieze, 21 Denmark Street, London WC2H 8NA, England. Covers international contemporary art and culture. Published bimonthly. Web site: www.frieze.co.uk

Fuse Magazine, 401 Richmond Street West, Suite 454, Toronto, Ontario M5V 3A8, Canada. Contemporary arts and culture. Published quarterly. Web site: www.fusemagazine.org

FYI, New York Foundation for the Arts, 155 Avenue of the Americas, New York, NY 10013-1507. Provides information of interest to artists and arts organizations in New York City and New York State. Published quarterly. Web site: www.nyfa.org

Glass Quarterly, UrbanGlass, 647 Fulton Street, Brooklyn, New York 11217. Provides a critical voice for glass art within the contemporary art world. Includes essays, reviews, artist profiles, news, and more. Published quarterly. Web site: www.urbanglass.com

Graphic Artists Guild Newsletter, 90 John Street, Suite 403, New York, NY 10038-3202. Focuses on graphic-arts news throughout the country and features legal and financial advice, book reviews, and conference reports. Published monthly. Web site: www.gag.org

Hand Papermaking, Hand Papermaking, Inc., P.O. Box 77027, Washington, DC 20013-7027. Irregularly published. Repository of information on the art and craft of hand papermaking. Web site: www.handpapermaking.org

Hand Papermaking Newsletter, Hand Papermaking, Inc., P.O. Box 77027, Washington, DC 20013-7027. Includes information and listings for national and international exhibitions, lectures, workshops, and other events. Published quarterly. Web site: www.handpapermaking.org

Handwoven, Interweave Press, Inc., 201 East Fourth Street, Loveland, CO 80537-5655. Devoted to handweavers. Includes articles, profiles of weavers, tips and techniques, product information, and book reviews. Published five times a year. Web site: www.interweave.com/weave/handwoven.cfm

The Independent, Association of Independent Video & Filmmakers, 304 Hudson Street, 6th Floor, New York, NY 10013. Serves independent videomakers and filmmakers. Lists professional opportunities. Published ten times a year. Web site: www.aivf.org

Insider, International Sculpture Center, 1529 18th Street, NW, Washington, DC 20009. A supplement to *Sculpture* that is only available to International Sculpture Center members. Lists national and international opportunities for sculptors. Published ten times a year. Web site: www.sculpture.org

Intelligent Agent, Hyperactive Corporation, P.O. Box 661, New York, NY 10012. A quarterly newsletter reporting on the use of interactive media and technology in arts and education. The e-zine edition is published monthly and includes selected articles from the printed newsletter, reviews, and news items. Web site: www.artnetweb.com

Leonardo: Journal of the International Society for the Arts, Sciences and Technology, 425 Market Street, San Francisco 94105. Covers contemporary visual art and new media art and new technology. Web site: http://mitpress.mit.edu

Live Art Magazine, P.O. Box 501, Nottingham NG3 5LT, England. A bimonthly publication and on-line magazine devoted to hybrid artforms. Includes news, reviews, listings, and opportunities. Web site: liveartmagazine.com

Make: The Magazine of Women's Art, Women's Art Library, Fulham Palace, Bishops Avenue, London SW6 6EA, England. Quarterly magazine of contemporary women's art, including critical analysis, news, and listings. Web site: www.make-magazine.org.uk

Modern Painters, Universal House, 5a Bermondsey Street, 3rd Floor, London SE1 3UD, England. Quarterly journal with features, reviews, and interviews. E-mail: modernpainters@BTinternet.com

New Art Examiner, Chicago New Art Association, 314 West Institute Place, Chicago, IL 60610. Provides an alternative viewpoint to those of New York–based art publications. Includes reviews of shows throughout the country. Published monthly. Web site: www.newartexaminer.org

Ontario Craft Magazine, Ontario Crafts Council, Designers Walk, 170 Bedford Road, Toronto, Ontario M5R 2K9, Canada. A biannual publication that focuses on contemporary craft artists, their work and accomplishments. Also covers exhibitions and includes book reviews. Web site: www.craft.on.ca

Parachute, 4060 Boulevard Saint-Laurent, Bureau 501, Montreal H2W 1Y9, Canada. Focuses on contemporary visual and performing art. Published quarterly in French and English. Web site: www.parachute.ca

Parkett, 155 Avenue of the Americas, New York, NY 10013. Contemporary visual arts. Published three times a year. Web site: www.parkettart.com

The Photo Review Journal, The Photo Review, 140 East Richardson Avenue, Suite 301, Langhorne, PA 19047-2824. Contains exhibition reviews, essays, interviews, portfolios, and book reviews. Published quarterly. Web site: www.photoreview.org

The Photo Review Newsletter, The Photo Review, 140 East Richardson Avenue, Suite 301, Langhorne, PA 19047-2824. Lists exhibitions in the mid-Atlantic region, including New York, Philadelphia, Pittsburgh, Baltimore, and Washington, D.C. Also lists exhibition opportunities nationwide and abroad. Published eight times a year. Web site: www.photoreview.org

Photography in New York International, 64 West 89th Street, #3F, New York, NY 10024. Lists photography exhibitions in New York City, as well as national and international exhibitions. Also publishes news items and articles about photography. Published bimonthly. Web site: www.photography-guide.com

Printmaking Today, Farrand Press, 50 Ferry Street, Isle of Dogs, London E14 3DT, England. Devoted to contemporary international printmaking, including reviews, interviews, information, and resources. Published quarterly. E-mail: farrandprs @aol.com

Professional Craft Journal, P.O. Box 1585, Palo Alto, CA 94302. Features news, commentaries, and opinions by and for the American craft community. Published quarterly.

Raw Vision, c/o 163 Amsterdam Avenue, #203, New York, NY 10023-5001 and 42 Llanvanor Road, London NW2 2AP, England. An international journal of intuitive and visionary art. Published quarterly. Web site www.rawvision.com

Reviewwest.com. The Critical State of Visual Art, P.O. Box 1875, Murray Hill Station, New York, NY 10156. Published eleven times a year. Also available on-line. Web site: www.reviewwest.com

Sculpture, International Sculpture Center, 1529 18th Street, NW, Washington, DC 20036. Covers international contemporary sculpture. Published monthly. Web site: www.sculpture.org

Sculpture, Royal Society of British Sculptors, 108 Old Brompton Road, London SW7 3RA, England. A quarterly publication that includes news, reviews, and exhibition listings. Web site: www.rbs.org.uk

Sculpture Review, National Sculpture Society, 237 Park Avenue, New York, NY 10169. Published quarterly. Web site: www.nationalsculpture.org

Shuttle Spindle & Dyepot, Handweavers Guild of America, 3327 Duluth Highway, #201, Duluth, MN 30136-3373. International magazine for weavers, spinners, and dyers. Contains technical and historical articles as well as marketing and business information. Published quarterly. Web site: www.weavespindye.org

Source, Photo Works North, 3 Botanic Avenue, Belfast BT7 1JG, Ireland. Quarterly review of contemporary Irish photography. Web site: sourcemagazine.demon. co.uk

Southwest Art, 5444 Westheimer, Suite 1440, Houston, TX 77056. Lists opportunities for artists living in the Southwest. Published monthly. Web site: www.southwestartmag.com

Spot, Houston Center for Photography, 1441 West Alabama, Houston, TX 77006. Focuses on news and criticism of photography in the South and Southwest. Published three times a year. Web site: www.hcponline.org

Studio Potter, The Studio Potter, Box 70, Goffstown, NH 03045. A professional journal of ceramists, educators, historians, and collectors. Focuses on critical issues of asethetics, technology, and personal development. Published biannually. Web site: www.studiopotter.org

Studio Pottery, Ceramics Society, 2 Bartholemew Street West, Exeter EX4 3AJ, England. Features contemporary ceramics in the United Kingdom, including artist's profiles, news, and exhibition listings. Published quarterly. Web site: www.ceramic-society.co.uk

studioNOTES, P.O. Box 502, Benicia, CA 94510-0502. An artist-to-artist journal that reports on what artists are doing and thinking. Also includes interviews with artists, dealers, and others in the art world about practical issues. Published five times a year. Web site: www.studionotes.org

Surface Design, Surface Design Association, 83 Ivy Lane, Englewood, NJ 07631. Quarterly publication of a professional organization of artists involved in surface design, textiles, weavings, quilts, and other forms of fiber art. Web site: www.art.uidaho.edu/sda

Untitled, 20 Poets Road, London N5 2SL, England. Reviews of contemporary art. Published quarterly. E-mail: flecha@compuserve.com

Westart, P.O. Box 6868, Auburn, CA 95604. Provides an overview of the West Coast arts community. Published bimonthly.

Wildlife Art: The Art Journal of the Natural World, 1428 East Cliff Road, Burnsville, MN 55337. The largest journal on wildlife art. Published seven times a year, including an annual yearbook. Web site: www.wildlifeartmag.com

Women Artists News Book Review, Midmarch Arts Press, 300 Riverside Drive, New York, NY 10025-5329. Published annually. Reviews books and exhibition catalogs on women artists and writers.

Women in the Arts, National Museum of Women in the Arts, 1250 New York Avenue, NW, Washington, DC 20005. A quarterly publication devoted to promoting the achievements of women in the visual and performing arts and literature. Web site: www.nmwa.org/pubs/pubs.htm

World Sculpture News, 28 Arbuthnot Road, Ground Floor, Central Hong Kong. An international sculpture journal. Published quarterly. Web site: www.worldsculpturenews.com

Web Magazines

Art Access (www.artaccess.com). Reviews and articles about visual art.

ArtCommotion (www.artcommotion.com). Focuses on the Los Angeles area and features commissioned art, interviews, weekly news columns, reviews, and classifieds.

ArtDaily (www.artdaily.com). Specializes in exhibition news from around the world.

Artist Help Network (www.artisthelpnetwork.com). Founded by Caroll Michels, this site is devoted to all aspects of career development, including contact information for organizations, periodicals, publications, software, audiovisual aids,

Web sites, and service providers. See heading "Other Resources" and subhead-
ings "Design and Architecture Publications" and "Periodicals." Also see heading
"Career" and subheading "Press and Publicity."

Arts4all newsletter (www.arts4all.com/newsletter). A free magazine with feature
articles about artists and their work.

Feed (www.feedmag.com). Covers the arts, media, technology, science, and pop
culture.

FineArtforum (www.msstate.edu/Fineart_Online/home.html). Newsletter of the
Fine Art, Science and Technology Network.

Frigatezine (www.frigatezine.com). Essays, book reviews, and reviews and articles
about art that has a relationship to literature.

Intelligent Agent (www.artnetweb.com). Reports on the use of interactive media and
technology in arts and education.

Leonardo On-line (http://mitpress.mit.edu). An on-line version of *Leonardo. Journal
of the International Society for the Arts, Sciences and Technology.* Covers contemporary
visual and media art and new technology.

Live Art Magazine (www.liveartmagazine.com). Devoted to hybrid art forms. In-
cludes news, reviews, listings, and opportunities.

Resource Library Magazine. American Art Online (www.tfaoi.com/resourc.htm). De-
voted to American representational art. Includes articles, news, and information.

Reviewny.com. The Critical State of Visual Art (www.reviewny.com). Reviews ex-
hibitions in New York. Published twice monthly most of the year.

Reviewwest.com. The Critical State of Visual Art (www.reviewwest.com). Reviews
exhibitions in California. Published eleven times a year. A printout version is
also available.

World of Watercolor (www.worldofwatercolor.com). Devoted to watercolor and
acrylic artists, with articles on painting, motivation, techniques, and resources.

Also see "Career Management, Business, and Marketing," and "Press Relations and
Publicity."

PHOTOGRAPHING ARTWORK
Publications

How to Photograph Paintings by Nat Bukar. Art Directions Books, 456 Glenbrook
Road, Glenbrook, CT 06406, 1996.

How to Photograph Works of Art by Sheldan Collins. New York: Watson-Guptill Publica-
tions, 1992. Covers all aspects of photographing art, including lighting and light-
ing techniques, film, filtration, and more. Web site: www.watsonguptill.com

How to Photograph Your Art by Malcolm Lubliner. Beverly Hills, Calif.: Pomegranate
Press Ltd., 1997. Web site: www.pompress.com

How to Photograph Your Artwork by Kim Brown. Canyonwinds, 28 North Rim Road,
Ransom Canyon, TX 79366, 1995. A step-by-step guide to photographic princi-
ples and techniques necessary in photographing artwork. Equipment types and
films are also discussed. E-mail: brownies4@earthlink.net

Perfect Portfolio. Visual Arts Ontario, 1153A Queen Street West, Toronto, Ontario M6J 1J4, Canada, 1995. Includes information on how to photograph two-dimensional artwork. Web site: www.vao.org

Photographing Your Artwork. Chicago Artists' Coalition, 11 East Hubbard Street, 7th Floor, Chicago, IL 60611, undated. A step-by-step guide on how to take slides of artwork. Web site: www.caconline.org

Photographing Your Artwork: A Step-by-Step Guide to Taking High-Quality Slides at an Affordable Price by Russell Hart. Cincinnati: North Light Books, revised 2000. Provides examples of the results of various types of lighting and camera angles; discusses the photographing of challenging artwork, including three-dimensional pieces, miniatures, and installations, and the masking and cleaning of slides. Web site: www.artistsnetwork.com/nlbbooks

Small Scale Photography: How to Take Great Shots of Your Work by Charles J. Lewton-Brain. Brain Press, Box 1624, Suite M, Calgary, Alberta T2P 2L7, Canada, 1996. Provides instructions on how to take magazine-quality slides and photographs of small arts and crafts, including jewelry, ceramics, and other objects under two feet in any direction. This book is also available as a video. Web site: www.ganoksin.com/kosana/brain/brain.htm

Taking the Leap: Building a Career as a Visual Artist by Cay Lang. San Francisco: Chronicle Books, 1998. See "Basic Photographic Procedures" and "Photographic Equipment." Web site: www.chronbooks.com

Audiovisual Resources

How to Photograph Your Art Using Natural Light. Idaho Commission on the Arts, P.O. Box 83720, Boise, ID 93720-0008, 1995. An instructional video on photographing visual art for artists needing quality images of their work. Also includes information on how to create 35mm slides. Web site: www2.state.id.us/arts

Small Scale Photography: How to Take Great Shots of Your Work by Charles J. Lewton-Brain. Brain Press, Box 1624, Suite M, Calgary, Alberta T2P 2L7, Canada, 1996. An eighty-eight-minute video that provides instructions on how to take magazine-quality slides and photographs of a variety of small objects, including jewelry, ceramics, and other objects under two feet in any direction. This video is also available as a book. Web site: www.ganoksin.com/kosana/brain/brain.htm

Web Sites

Artist Help Network (www.artisthelpnetwork.com). Founded by Caroll Michels, this site is devoted to all aspects of career development, including contact information for organizations, periodicals, publications, software, audiovisual aids, Web sites, and service providers. See heading "Presentation Tools" and subheadings "Photographers," "Photographing Artwork," "Photo-Processing Labs," and "Slide Labels."

BetterPhoto.com (www.betterphoto.com). Provides advice on how to photograph paintings without a flash.

Organizations

Kodak. Offers free advice on the phone and in the form of printed material on how to photograph artwork. Contact Kodak at 800-242-2424. Web site: www.kodak.com

PRESENTATION TOOLS
Publications

The Artists' Survival Manual: A Complete Guide to Marketing Your Work by Toby Judith Klayman with Cobbett Steinberg. Originally published by Charles Scribner's Sons, the book is now being published by Toby Judith Klayman and Joseph Branchcomb, revised in 1996. See various chapters titled "What to Bring to a Viewing." Web site: www.goldwarp.com/klayman. Also available from California Lawyers for the Arts, attention Book Ordering, Fort Mason Center, C-255, San Francisco, CA 94123. Web site: www.calawyersforthearts.org

Perfect Portfolio. Visual Arts Ontario, 1153A Queen Street West, Toronto, Ontario M6J 1J4, Canada, 1995. Five art professionals discuss the fundamentals of portfolio presentation. Web site: www.vao.org

Presentation Power Tools for Fine Arts by Renée Phillips. Manhattan Arts International, 200 East 72nd Street, Suite 26L, New York, NY 10021, 1997. Provides ideas and tips on writing résumés, biographies, business letters, and more. Samples are included. Web site: www.manhattanarts.com

Taking the Leap: Building a Career as a Visual Artist by Cay Lang. San Francisco: Chronicle Books, 1998. See "Creating Your Artist's Packet." Web site: www.chronbooks.com

Web Sites

Artist Help Network (www.artisthelpnetwork.com). Founded by Caroll Michels, this site is devoted to all aspects of career development, including contact information for organizations, periodicals, publications, software, audiovisual aids, Web sites, and service providers. See heading "Presentation Tools" and subheadings "Graphic Designers," "Photographers," "Photographing Artwork," "Presentation Media," "Printers," "Videomakers," and "Writing Consultants." Also see heading "Other Resources" and subheadings "Art Frame Shops" and "Art Supplies."

Self Promotion (www.selfpromotion.com). A free service that automatically lists Web sites on search engines and indexes.

Also see "Career Management, Business, and Marketing," "Photographing Artwork," and "Web Site Design."

Organizations

Citizens Photo, 709 SE Seventh Avenue, Portland, OR 97214. Produces high-quality slide duplicates at affordable prices. Web site: www.citizensphoto.com

PRESS RELATIONS AND PUBLICITY
Publications

Bacon's International Media Directory. Chicago: Bacon's Information, Inc. Revised annually. A comprehensive list of newspaper and magazine contacts throughout Europe. Web site: www.baconsinfo.com

Bacon's Internet Directory. Chicago: Bacon's Information, Inc., revised regularly. Includes the on-line editorial staff of more than one thousand daily and weekly newspapers; thousands of consumer magazines; on-line-only news sites and e-zines; and television, radio, and cable network stations and shows. Web site: www.baconsinfo.com

Bacon's Magazine Directory. Chicago: Bacon's Information, Inc. Revised annually. A comprehensive list of magazine contacts throughout the United States, Canada, Mexico, and the Caribbean. Web site: www.baconsinfo.com

Bacon's Metro California Media. Chicago: Bacon's Information, Inc. Revised annually. Comprehensive list of press contacts in California, including newspapers, magazines, broadcast and cable television, radio networks and programs, syndicated writers, and news bureaus. Web site: www.baconsinfo.com

Bacon's New York Publicity Outlets. Chicago: Bacon's Information, Inc. Revised biannually. A comprehensive list of press contacts in the New York metropolitan area, including those in Long Island; Putnam, Rockland, and Westchester Counties; northern New Jersey; and southwestern Connecticut. Includes newspapers, magazines, broadcast and cable television, radio networks and programs, syndicated writers, and news bureaus. Web site: www.baconsinfo.com

Bacon's Newspaper Directory. Chicago: Bacon's Information, Inc. Revised annually. A comprehensive list of newspaper contacts throughout the United States, Canada, Mexico, and the Caribbean. Web site: www.baconsinfo.com

Editor and Publisher Directory of Syndicated Services. New York: Editor and Publisher Company, revised annually. Lists syndicates serving newspapers in the United States and abroad with news and feature articles. Web site: www.mediainfo.com

Encyclopedia of Associations. Farmington Hills, Mich.: Gale Group. Revised regularly. Offers the following editions organized by speciality: International Organizations; National Organizations of the U.S.; Regional, State, and Local Organizations; and Women's Associations Worldwide. Indexed by title and subject. Each entry includes address, purpose, programs, and publications. Web site: www.galegroup.com

Fine Art Publicity: The Complete Guide for Galleries and Artists by Susan Abbott and Barbara Webb. New York: Allworth Press, revised 1996. Explains how to organize

an effective public-relations plan. Includes sample forms, letters, and press releases. Web site: www.allworth.com

Fine Artist's Guide to Marketing and Self-Promotion by Julius Vitali. New York: Allworth Press, 1996. Web site: www.allworth.com

Getting the Word Out: An Artist's Guide to Self Promotion, edited by Carolyn Blakeslee. Art Calendar Publishing, Inc., P.O. Box 2675, Salisbury, MD 21802, 1995. See "Getting into Print" and "Personal Appearances." Web site: www.artcalendar. com

The Internet Publicity Guide: How to Maximize Your Marketing and Promotion in Cyberspace by V. A. Shiva. New York: Allworth Press, 1997. Includes strategies for publicizing, marketing, and promoting projects or services on the Web. Web site: www.allworth.com

The National Resource Guide for the Placement of Artists, edited by Cheryl Slean. The National Network for Artist Placement, 935 West Avenue, Suite 37, Los Angeles, CA 90065, revised regularly. Lists more than one thousand trade publications of interest to artists. Web site: www.artistplacement.com

Presentation Power Tools for Fine Arts by Renée Phillips. Manhattan Arts International, 200 East 72nd Street, Suite 26L, New York, NY 10021, 1997. See chapter "The Publicity Campaign." Web site: www.manhattanarts.com

Promotion for Artists. Queensland Artworkers Alliance, Level 1, 381 Brunswick Street, Fortitude Valley 4006, Queensland, Australia. A guide to promotion, with more than 230 national media contacts in Australia. Web site: www.artworkers.asn.au

Publicity. Chicago Artists' Coalition, 11 East Hubbard Street, 7th Floor, Chicago, IL 60611. Part of a series of self-help guides published by this art service organization. Web site: www.caconline.org

The Publicity Handbook: How to Maximize Publicity for Products, Services and Organizations by David R. Yale. Lincolnwood, IL: NTC Business Books, 1991. A step-by-step guide on how to organize a publicity and public relations campaign, with tips on writing press releases. Web site: www.ntcbb.com

Publicity on the Internet: Creating Successful Publicity Campaigns on the Internet and the Commercial Online Services by Steve O'Keefe. New York: John Wiley & Sons, 1996. Provides step-by-step information on how to draw attention to your Web site. Includes sample publicity campaigns and strategies for creating successful e-mail new releases. Web site: www.wiley.com

Six Steps to Free Publicity and Dozens of Other Ways to Win Media Attention for Your Business by Marcia Yudkin. New York: Penguin Books USA, 1994. Provides excellent tips and information. Web site: www.penguinputnam.com

Talk Show Selects, edited by Mitchell P. Davis. Washington, D.C.: Broadcast Interview Source. Revised regularly. Profiles more than seven hundred radio and television talk shows in the United States. Each listing contains the name of the producer, host, or programming executive responsible for deciding what gets on the air. Addresses and fax and phone numbers are also provided. Web site: www.yearbooknews.com

Ulrich's International Periodicals Directory. New Providence, N.J.: R. R. Bowker. Revised annually. Includes the names, addresses, and descriptions of periodicals published throughout the world. Web site: www.bowker.com

Writer's Market. Cincinnati: Writer's Digest Books. Published annually. Web site: www.writersdigest.com

Web Sites

ArtBulletins (www.artbulletins.com). Publishes announcements free of charge of upcoming art exhibition to 65,000 readers each day on-line. Internet galleries, Web sites, or Web-based exhibitions are not eligible.

Artist Help Network (www.artisthelpnetwork.com). Founded by Caroll Michels, this site is devoted to all aspects of career development, including contact information for organizations, periodicals, publications, software, audiovisual aids, Web sites, and service providers. See heading "Career" and subheadings "Art World Mailing Lists," "Press and Public Relations," and "Public Relations Agencies." Also see heading "Other Resources" and subheading "Periodicals."

International Association of Art Critics (www.artfocus.com/critics.htm). Provides e-mail addresses of Canadian art critics.

International Association of Art Critics (AICA) (www.artfocus.com/AICAIntnl.html). Provides e-mail addresses of art critics from all parts of the world.

Mahler's Practical Guide to Promoting Your Web Site (www.1x.com/promote). Provides tips and advice on promoting Web sites, including the most important places to be listed.

Mediafinder (www.mediafinder.com). The Web site of Oxbridge Publications. You can search for and link to target market trade publications, newsletters, and magazines and directories.

NewsDirectory (www.ecola.com). Links more than 6,500 English-language print and broadcast media from around the world.

Pressbox (www.pressbox.co.uk). Posts press releases free of charge on the Internet.

Regional Art Critics of the Greater Washington, D.C., Area (www.geocities.com/Paris/Musee/9650/critic.html). Provides background information on various art critics, including the names of publications for which they write.

Organizations

Bacon's Clipping Bureau, 332 South Michigan Avenue, Chicago, IL 60604. Monitors thousands of weekly and community papers; business, trade, and consumer magazines; and news stories on wire services. Web site: www.baconsinfo.com

eReleases, MEK Enterprises, 824 South Milton Avenue, Baltimore, MD 21224. Delivers press releases to general and targeted media contacts by e-mail. Web site: www.ereleases.com

Gebbie Press, P.O. Box 1000, New Paltz, NY 12561. Provides links to thousands of newspapers, magazines, and radio and television stations that are on the Internet. Web site: www.gebbieinc.com

iMediafaxFaxes, P.O. Box 6726, Kennewick, WA 99336. Faxes press releases to editors and producers nationwide. Web site: www.imediafax.com

International Association of Art Critics, Canadian Branch, c/o *Art Focus Magazine*, P.O. Box 1063, Station F, Toronto, Ontario M4Y 2T7, Canada. Provides Web sites and e-mail addresses of members of the Canadian branch, and Web sites and e-mail addresses of some international members. Web site: www.artfocus.com/critics.htm

International Association of Art Critics (AICA), c/o Accès Local, 15 rue Martel, 75010 Paris, France. Professional membership organization of art critics from regions throughout the world. Web site: www.aica-int.org

PRWeb, 2827 Panorama Drive, Carrollton, TX 75007. Posts press releases free of charge on the Internet. Web site: www.prweb.com

Also see "Mailing Lists" and "Periodicals."

PRICING ARTWORK
Publications

The Artists' Survival Manual: A Complete Guide to Marketing Your Work by Toby Judith Klayman with Cobbett Steinberg. Originally published by Charles Scribner's Sons, the book is now being published by Toby Judith Klayman and Joseph Branchcomb, revised in 1996. See chapter "Getting Ready: Pricing Your Work." Web site: www.goldwarp.com/klayman. Also available from California Lawyers for the Arts, attention Book Ordering, Fort Mason Center, C-255, San Francisco, CA 94123. Web site: www.calawyersforthearts.org

The Basic Guide to Pricing Your Craftwork by James Dillehay. Torreon, N.M.: Warm Snow Publishers, 1997. Suggests formulas for setting prices to achieve maximum profits. Includes a step-by-step record-keeping system and sample forms. Web site: www.craftmarketer.com

Graphic Artists Guild Handbook: Pricing and Ethical Guidelines. Graphic Artists Guild, 90 John Street, New York, NY 10038-3202. Revised biannually. Contains essential information on business, pricing, and ethical standards for nearly every discipline in the visual communications industry. Web site: www.gag.org

InformArt: The Limited Edition Print Price Journal. Westown Publishing Company, Inc., P.O. Box 220, Bethel, CT 06801. Publishes information about market values of limited edition prints, including the names of artists, titles of prints, and high and low selling prices. Published bimonthly. Web site: www.informartmag. com

Pricing Photography: The Complete Guide to Assignment & Stock Prices by Michal Heron and David MacTavish. New York: Allworth Press, 1993. Although geared for commercial photographers, this book will be very helpful to fine artists for establishing fees when photographs of your artwork are used in such media as newspapers, magazines, annual reports, books, posters, and calendars. Web site: www.allworth.com

Web Sites

Artist Help Network (www.artisthelpnetwork.com). Founded by Caroll Michels, this site is devoted to all aspects of career development, including contact information for organizations, periodicals, publications, software, audiovisual aids, Web sites, and service providers. See heading "Money" and subheading "Pricing Artwork."

PRINTS AND PRINTMAKING
Publications

Art Marketing Sourcebook. ArtNetwork, P.O. Box 1360, Nevada City, CA 95959. Revised regularly. Includes a list of print publishers. Web site: www.artmarketing.com

Art on Paper: The International Directory of Prints, Drawings, and Photography. Fanning Publishing Company, 39 East 78th Street, New York, NY 10021. Covers information on prints, photographs, works on paper, and artists' books. Published bimonthly. Web site: www.artonpaper.com

The Book Arts Directory. Page Two, Inc., P.O. Box 77167, Washington, DC 20013-7167, 1996. Primarily a resource for artists working in the book-arts field, it also includes information for printmakers. Web site: www.bookarts.com

Contemporary Impressions. The American Print Alliance, 302 Larkspur Turn, Peachtree City, GA 30269-2210. Includes articles, reviews, and interviews related to printmaking. Published biannually. Web Site: www.printalliance.org

Digital Fine Art Magazine, P.O. Box 420, Manalapan, NJ 07726. A quarterly publication dedicated to the fine-art digital print market. Web site: www.giclees.com

The Fine Artist's Career Guide by Daniel Grant. New York: Allworth Press, 1998. See section "Developing a Print Market." Web site: www.allworth.com

Guide to Print Workshops in Canada and the United States. The American Print Alliance, 302 Larkspur Turn, Peachtree City, GA 30269, updated every two years. Lists more than five hundred places to make prints, paperworks, and artists' books. Web site: www.printalliance.org

InformArt: The Limited Edition Print Price Journal. Westown Publishing Company, Inc., P.O. Box 220, Bethel, CT 06801. Provides information about the market value of limited edition prints, including the names of artists, titles of prints, and high and low selling prices. Published bimonthly. Web site: www.informartmag.com

Marketing Plans for Print Artists by Sue Viders. Marketing Solutions, 9739 Tall Grass Circle, Littleton, CO 80124-3108, 1999. Includes sample marketing plans and details on how to get prints into magazines, gift shops, and mail-order catalogs. Web site: www.sueviders.com

PRINTthoughts. Mel Hunter Graphics, Box 1530, Route 7, Ferrisburgh, VT 05456. A quarterly newsletter devoted to printmaking. Contains articles and discussions on various forms of printmaking.

Producing and Marketing Prints by Sue Viders. Marketing Solutions, 9739 Tall Grass Circle, Littleton, CO 80124-3108, revised 1997. A guide to getting started in the

print market. Covers preprinting decisions, information on how a print is made, and marketing suggestions. Web site: www.sueviders.com

Smith's Printworld Directory, edited by Selma Smith. Printworld International, Inc., P.O. Box 1957, West Chester, PA 19380. Published annually. Web site: www.printworlddirectory.com

Audiotapes

Hints on Prints, narrated by Sue Viders. Marketing Solutions, 9739 Tall Grass Circle, Littleton, CO 80124-3108, 1996. A seventy-five-minute tape that includes information on color, pricing, and cover letters. Accompanied by a resource booklet. Web site: www.sueviders.com

Web Sites

Artist Help Network (www.artisthelpnetwork.com). Founded by Caroll Michels, this site is devoted to all aspects of career development, including contact information for organizations, periodicals, publications, software, audiovisual aids, Web sites, and service providers. See heading "Other Resources" and subheadings "Fine Art Printers," "Print Publishers," and "Prints and Printmaking."

Woodblock (www.woodblock.com). Forum for woodblock printmakers that includes information on tools, materials, suppliers, technical tips, information exchange, and printmakers' Web sites.

Organizations

The American Print Alliance, 302 Larkspur Turn, Peachtree City, GA 30269-2210. Not-for-profit alliance of artists' organizations involved in printmaking. Publishes *Contemporary Impressions* and *Guide to Print Workshops in Canada and the United States.* Web site: www.printalliance.org

International Association of Fine Art Digital Printmakers, 570 Higuera Street, Suite 120, San Luis Obispo, CA 93401. A membership organization that supports the development of the fine-art digital printmaking industry, and the development of standards, definitions, and practices to promote the orderly integration of digital technology into the fine-art industry. Web site: www.iafadp.org

Northwest Print Council, 922 SW Main Street, Portland, OR 97205. Juried membership organization for printmakers throughout the Northwest United States and Canada. Sponsors a newsletter and other programs. Web site: www.art2u.com/NWPC

Also see "Artists' Books."

PUBLIC ART
Publications

Art in Other Places by William Cleveland. New York: Praeger Publishers, 1992. Features accounts of artists working in the community, addressing social ills, or bringing creative solutions to everyday environments. Topics include projects that focus on the elderly, prisons, people with disabilities, hospitals, and youth at risk. Web site: http://infogreenwood.com

Art in Transit . . . Making It Happen. Wendy Feuer, project director. Federal Transit Administration, 400 Seventh Street, SW, Washington, DC 20590, 1996. A comprehensive report on public art as part of transit facilities. Includes listings of current and soon-to-be-instituted programs. Also available on-line. Web site: www.fta.dot.gov/library/program/art/

Art Opportunities Monthly. P.O. Box 502, Benicia, CA 94510-0502. A listing of opportunities for artists, including public-art commissions. Published eleven times a year. Available via e-mail or U.S. mail. Web site: www.webgalleries.com/studionotes

Arts Management Bibliography and Publishers, compiled by Dyan Wiley and edited by Sarah Elliott. Arts Extension Service, Division of Continuing Education, University of Massachusetts, P.O. Box 31650, Amherst, MA 01003, 1995. Topics include public art. Web site: www.umass.edu/aes

Competitions. The Competitions Project, Inc., P.O. Box 20445, Louisville, KY 40250. Quarterly magazine devoted to articles on public-art, architecture, and landscape-architecture competitions in the United States and abroad. Web site: www.competitions.org

Competitions Hotline. The Competitions Project, Inc., P.O. Box 20445, Louisville, KY 40250. Quarterly newsletter that lists public-art, architecture, and landscape-architecture competitions in the United States and abroad. Web site: www.competitions.org

Critical Issues in Public Art: Content, Context, and Controversy, edited by Harriet F. Senie and Sally Webster. Washington, D.C.: Smithsonian Institution Press, 1998. Artists, architects, historians, critics, curators, and philosophers explore the role of public art in creating national identity. Web site: www.si.edu/sipress

Dialogues in Public Art by Tom Finkelpearl. Cambridge, Mass.: M.I.T. Press, 2000. Interviews with people active in the American public-art movement. Includes a history and overview of public art in the United States. Web site: www.mitpress.mit/edu

Directory of Percent-for-Art & Art in Public Places Programs, compiled by Rosemary M. Cellini. Mailing List Labels Packages, P.O. Box 1233, Weston, CT 06883-1233. The most up-to-date and comprehensive directory of percent-for-art and public-art agencies. Lists public-art programs sponsored by city, county, state, and federal agencies, including transit and redevelopment agencies, private and not-for-profit organizations, colleges and universities, and sculpture gardens and parks. The directory, related mailing labels, and postcards for contacting the

programs are available as packages or separately. Web site: http://home.
att.net/~mllpackage_information.htm

Going Public: A Field Guide to Developers in Art in Public Places by Jeffrey J.
Cruikshank and Pam Korza. Arts Extension Service, Division of Continuing Education, University of Massachusetts, P.O. Box 31650, Amherst, MA 01003, 1995. Provides an overview of current issues, policies, and processes in the administration and preservation of public art. Web site: www.umass.edu/aes

Guidebook for Competitions and Commissions. Visual Arts Ontario,1153A Queen Street West, Toronto, Ontario M6J 1J4, Canada, 1991. Step-by-step guide to the process of commissioning art. Includes sample call-to-enter and competition briefs, budget analysis, procedures for sponsors and artists, and practical advice and a technical manual. Web site: www.vao.org

Mapping the Terrain: New Genre Public Art, edited by Suzanne Lacy. Seattle: Bay Press, 1994. In this anthology of twelve essays, eleven artists, curators, and critics forge a critical framework for understanding and interpreting the new public art that has emerged over the last two decades. Web site: www.baypress.com

Public Art Commissions. Chicago Artists' Coalition, 11 East Hubbard Street, 7th Floor, Chicago, IL 60611. Revised regularly. Provides information on public-art commissions throughout the United States and describes how artists can apply. Web site: www.caconline.org

Public Art Journal. Public Art Forum, The National Association for Public Art, Halfpenny Wharf, Torrington Street, Bideford EX39 4DP, England. Published twice a year. E-mail: p.art.forum@dial.pipex.com

Public Art Program Directory. Americans for the Arts, 1000 Vermont Avenue, NW, Washington, DC 20005, 2000. Lists public-art programs throughout the United States. Web site: www.artsusa.org

Public Art Review. Forecast Public Artworks, 2324 University West, Suite 102, St. Paul, MN 55114. A magazine that provides a wealth of practical information on public-art programs. Also lists opportunities in public art and competitions. Published twice a year. Web site: www.forecastart.org/parb.htm

Public Commissions Contract for Artists. CARFAC-National, 401 Richmond Street West, Suite 442, Toronto, Ontario M5V 3A8, Canada. Three-page sample contract for visual artists involved in public commissions with federal, provincial, or municipal governments in Canada. Web site: www.carfac.ca

Web Sites

Art in Transit . . . Making It Happen (www.fta.dot.gov/library/program/art). A report on public art in transit programs and a list of programs nationwide.

Art Public (www.art_public.com). Subscription service with information about events, opportunities, public artworks, and artists, mainly in Europe with some in United States and in other countries. Searchable database of more than six thousand artists, publications, and public-art works in Europe.

Artist Help Network (www.artisthelpnetwork.com). Founded by Caroll Michels, this site is devoted to all aspects of career development, including contact information for organizations, periodicals, publications, software, audiovisual aids, Web sites, and service providers. See heading "Exhibitions, Commissions, Sales" and subheadings "Competitions and Juried Shows" and "Public Art."

Greater Boston Arts (www.wgbh.org/gbarts). A public-art site that highlights twenty projects in the Boston area.

Public Art on the Internet (www.zpub.com/public). Includes various types of information about the field of public art: essays, articles, projects, links to other related sites, and an e-mail group for those interested in public art.

Public Art Online (www.publicartonline.org.uk). Comprehensive and well-thought-out site. Includes advice, opportunities, and dialogues about public art. Hosted by Public Art South West in England.

Public Art Web Links (http://www.shu.ac.uk/services/lc/slidecol/weblinx.html). Public art resources provided by Sheffield Hallem University in England.

Organizations

Art in the Urban Landscape, Capp Street Project, 525 Second Street, San Francisco, CA 94107. A program that commissions artists to create semipermanent art installations in the San Francisco area.

Art-in-Architecture Program, Public Buildings Service, General Services Administration, 1800 F Street, NW, Room 2308, Washington, DC 20405. A federal public-art program. Sponsors a slide registry.

Chicago Public Art Group, 1259 South Wabash Avenue, Chicago, IL 60605. Maintains a public-art slide registry. Web site: www.muralart.org

Creative Time, 307 Seventh Avenue, Suite 1904, New York, NY 10001. Helps visual artists, architects, and performing artists bring their new work to a variety of public spaces in New York City. Web site: www.creativetime.org

Mailing List Labels Packages, P.O. Box 1233, Weston, CT 06883-0233. Publishes the *Mailing List Labels Packages for Percent-for-Art and Art in Public Places Programs*. The package includes a *Directory of Percent-for-Art and Art in Public Places Programs* in the United States, and related mailing labels, postcards, and forms that can be used to make cost-effective and systematic contact with the programs. Web site: http://home.att.net/~mllpackage_information.htm

Precita Eyes Muralists, 2981 24th Street, San Francisco, CA 94110. Educates communities about the history of public and community mural art. Initiates mural projects and sponsors workshops. Web site: www.precitaeyes.org

Project for Public Spaces, Inc., 153 Waverly Place, New York, NY 10014. Specializes in public-space planning, design, and management; assists city agencies, community groups, private developers, and planners in selecting and placing art in public spaces. Maintains a slide registry and offers workshops and conferences on public space planning. Web site: www.pps.org

Public Art Forum, the National Association for Public Art, Halfpenny Wharf, Torrington Street, Bideford EX39 4DP, England. Provides a focus for information exchange, research, and debate on the role of artists and craftworkers in public spaces. E-mail: p.art.forum@dial.pipex.com

Public Art Fund, 1 East 53rd Street, New York, NY 10022. Promotes the integration of art into the urban landscape. Sponsors art installations in public spaces throughout New York City and provides educational and informational services. Web site: www.publicartfund.org

Public Art Network, Americans for the Arts, 1000 Vermont Avenue, NW, Washington, DC 20005. Provides professional services and networking opportunities for public-art professionals, visual artists, design professionals, and organizations planning public-art projects and programs. Web site: www.artsusa.org

Social and Public Art Resource Center (SPARC), 685 Venice Boulevard, Venice, CA 90291. Sponsors exhibitions, workshops, and mural production. Preserves public artwork. Web site: www.sparcmurals.org

Art-in-Transit Programs

ARIZONA

Sky Harbor Art Program, Aviation Department, Phoenix Sky Harbor International Airport, 3400 Sky Harbor Boulevard, T3 L3, Phoenix, AZ 85034. Sponsors a slide registry open to all artists, with preference given to Arizona artists. Web site: www.phxskyharbor.com

Art in Public Places Program, Tucson Airport Authority, Tucson International Airport, 7005 South Plumber, Tucson, AZ 85706. For artists in Pima, Pinal, Cochise, and Santa Cruz Counties.

CALIFORNIA

MTA Metro Art Department, Los Angeles Metropolitan Transportation Authority, County of Los Angeles, One Gateway Plaza, 19th Floor, Los Angeles, CA 90012-2952. Sponsors a slide registry. Residency requirements vary by project. Web site: www.mta.net

Public Art Program, Port of San Diego, Board of Port Commissioners, P.O. Box 120488, San Diego, CA 92111-0488. Sponsors a slide registry. Residency requirements vary by project. Web site: www.portofsandiego.org

Visual Arts Program, Santa Cruz Metropolitan Transit District and the Cultural Council of Santa Cruz, 370 Encinal Street, Suite 100, Santa Cruz, CA 95060. Program only open to Santa Cruz artists. Web site: www.ccscc.org

COLORADO

Art at the Stations, 1600 Blake Street, Denver, CO 80202-2123. Open to all artists.

Percent-for-Art Program for the City and County of Denver, Denver International Airport Art Program, Department of Aviation, 8500 Pena Boulevard, 9th Floor AOB, Denver, CO 80249.

GEORGIA

MARTA Art Program, Metropolitan Atlanta Rapid Transportation Authority, 2424 Piedmont Road, NE, 4th Floor, Atlanta, GA 30324-3320. Sponsors a slide registry. Program is open to all artists.

MISSOURI

Arts in Transit, Bi-State Development Agency, 707 North First Street, 4th Floor, St. Louis, MO 63102. Program is open to all artists. Web site: www.bi-state.org/artsintransit.html

NEW JERSEY

Atlantic City International Airport, 100 Atlantic City International Airport, Egg Harbor Township, Atlantic City, NJ 08234. The program is open to local artists. Web site: www.acairport.com

NEW YORK

Art and Architecture Program, Port Authority of New York and New Jersey, One World Trade Center, Room 82 West, New York, NY 10048. Sponsors a slide registry.

Arts for Transit, Metropolitan Transit Authority, 347 Madison Avenue, 5th Floor, New York, NY 10017-3739. Some artists are selected from the Percent-for-Art Registry sponsored by the New York City Department of Cultural Affairs. Residency requirements vary by project. Web site: www.mta.nyc.ny.us/mta/aft/aftsplash.html

PENNSYLVANIA

Philadelphia International Airport, Terminal E, Philadelphia, PA 19153. Program open to artists in the Philadelphia area. Web site: www.phl.org/index2.html

TENNESSEE

Arts in the Airport, Nashville International Airport, c/o Metro Nashville Airport Authority, One Terminal Drive, Suite 501, Nashville, TN 37214. Open to Tennessee artists. Sponsors rotating exhibitions and commissions permanent works. Web site: www.nashintl.com

TEXAS

Austin Image Program, Department of Aviation, City of Austin (Austin-Bergstrom International Airport), 3600 Presidential Boulevard, Suite 411, Austin, TX 78719. Open to all artists. Web site: www.abia.org

WASHINGTON

Exhibitions and Acquisitions Program, Seattle-Tacoma International Airport, Port of Seattle, Aviation Marketing Office, Room MT6649, P.O. Box 68727, Seattle, WA 98168.

STart, Sound Transit Public Art Program, Sound Transit Regional Transit Authority, 401 South Jackson Street, Seattle, WA 98104-2826. Sponsors a slide registry.

Program is open to all artists. Web site: www.soundtransit.org/stbusiness/start/start.htm

Also see "Competitions and Juried Exhibitions."

SLIDE REGISTRIES
Web Sites

Artist Help Network (www.artisthelpnetwork.com). Founded by Caroll Michels, this site is devoted to all aspects of career development, including contact information for organizations, periodicals, publications, software, audiovisual aids, Web sites, and service providers. See heading "Exhibitions, Commissions, Sales" and subheadings "Public Art" and "Slide Registries."

VSA arts Online Gallery (www.vsarts.org). VSA arts, 1300 Connecticut Avenue, NW, Suite 700, Washington, DC 20036. Features the work of artists with disabilities who are members of the VSA arts Artist Registry.

Organizations

Artists Space, 38 Greene Street, 3rd Floor, New York, NY 10013. One of the largest registries in the country. A digitized-image database and slide registry. Web site: www.artistsspace.org

ArtSpace, 216 Alaskan Way South, Seattle, WA 98104. Open to artists in the Seattle area. Web site: www.artspaceseattle.org

The Center for Women and Their Work, 1710 Lavaca Street, Austin, TX 78701. Promotes the work of women artists. Web site: www.womenandtheirwork.org

Delaware Center for the Contemporary Arts, 200 South Madison Street, Wilmington, DE 19801. Web site: www.thedcca.org

Delta Axis, P.O. Box 11527, Memphis, TN 38111. Presents work created in the South or by contemporary Southern artists. Web site: www.deltaaxis.com

Friends of Fiber Art International, P.O. Box 468, Western Springs, IL 60558. Sponsors a fiber-art registry.

Georgia Artists Slide Registry, Atlanta College of Art Library, 1280 Peachtree Street, NE, Atlanta, GA 30309. Features the work of more than five hundred Georgia artists.

Hallwalls Contemporary Arts Center, 2495 Main Street, #425, Buffalo, NY 14214. Slide registry of artists living in western New York. Web site: www.hallwalls.org

Hand Papermaking, Inc., P.O. Box 77027, Washington, DC 20013-7027. A not-for-profit organization dedicated to advancing traditional and contemporary ideas in the art of hand papermaking. Sponsors a slide registry. Web site: www.handpapermaking.org

Houston Center for Photography, 1441 West Alabama, Houston, TX 77006. Web site: www.hcponline.org

Jersey City Museum, 472 Jersey Avenue, Jersey City, NJ 07302. Open to artists living and working in New Jersey.

Lesbians in the Visual Arts, 870 Market Street, Suite 618, San Francisco, CA 94102. An international organization that advocates visible lesbian inclusion in the art world. Sponsors a slide registry and publishes *Pentimenta Art Journal.* Web site: www.lesbianarts.org

Maryland Art Place, 218 West Saratoga Street, Baltimore, MD 21201. Maintains a slide registry of more than 1,500 regional artists. The work of participating artists is featured on-line. A program of the Maryland State Arts Council. Web site: www.mdartplace.org

Mexic-Arte Museum, P.O. Box 2632, Austin, TX 78768. A registry of contemporary Latino/Mexican artists. Web site: www.main.org/mexic-arte

Minnesota Artist Exhibition Program, The Minneapolis Institute of Arts, 2400 Third Avenue South, Minneapolis, MN 55404. Slide registry of Minnesota artists. Web site: www.artsmia.org/maep_how.html

National Museum of Women in the Arts, Archives on Women Artists, The Library and Research Center, 1250 New York Avenue, NW, Washington, DC 20005-3920. A registry open to women who have had at least one solo show in a museum or gallery. Web site: www.nmwa.org

New Jersey State Council on the Arts, P.O. Box 306, Trenton, NJ 08625. Sponsors a slide registry that features the work of New Jersey artists. Selections from the registry are made available on-line. Web site: njartscouncil.org/program8.html

NURTUREart, 160 Cabrini Boulevard, PH 134, New York, NY 10033-1145. A not-for-profit organization dedicated to helping promising visual artists. Organizes group exhibitions. Sponsors a slide registry. Web site: www.nurtureart.org

Oklahoma Visual Arts Coalition, P.O. Box 54416, Oklahoma City, OK 73154. Slide registry for visual artists living and working in Oklahoma.

Ontario Crafts Council, Designers Walk, 170 Bedford Road, Toronto, Ontario M5R 2K9, Canada. Sponsors a slide registry of craft artists. Web site: www.craft.on.ca

Organization for Independent Artists, 19 Hudson Street, Suite 402, New York, NY 10013. Provides artists with exhibition opportunities throughout New York City. Maintains a slide registry for members.

UrbanGlass, 647 Fulton Street, Brooklyn, NY 11217-1112. Registry is open to artists working in glass. Web site: www.urbanglass.com

VSA arts National Artists Registry, 1300 Connecticut Avenue, NW, Suite 700, Washington, DC 20036. A computer database open to visual artists with disabilities. Web site: www.vsarts.org

White Columns, 320 West 13th Street, New York, NY 10014. An alternative space with a slide registry open to artists throughout the United States. Web site: www.whitecolumns.org

Wisconsin Women in the Arts, 8700 South 15th Street, Oak Creek, WI 53154. Web site: www.execpc.com/~wwiagww

Woman Made Gallery, 1900 South Prairie Avenue, Chicago, IL 60616-1321. A not-for-profit organization that maintains a slide registry of art by women from all parts of the United States and abroad. Web site: www.womanmade.org

Women Artists Archive Collection, Special Collections/Archives, Ruben Salazar Library, Sonoma State University, 1801 East Cotati Avenue, Rohnert Park, CA 94928. Open to women artists who have had at least one solo exhibition in a museum or gallery. Web site: http://libweb.sonoma.edu/special/waa

Women's Art Registry of Minnesota (WARM), 2402 University Avenue, 2nd Floor, St. Louis, MO 55114-1701.

STUDIO INSURANCE
Publications

The Business of Art, edited by Lee Caplin. Englewood Cliffs, N.J.: Prentice-Hall Direct, revised 2000. See "Insuring Artwork and the Artist" by Huntington T. Block. Web site: www.prenhall.com

Caring for Your Art by Jill Snyder. New York: Allworth Press, revised 1996. Provides information on insuring art in the studio, home, or gallery; while in transit and on display. Web site: www.allworth.com

Insurance by Hamish Buchanan. Canadian Artists' Representation Ontario (CARO), 401 Richmond Street West, Suite 443, Toronto, Ontario M5V 3A8, Canada, 1985. A basic introduction to insurance for artists, including studio and artwork insurance, with examples of rates. Web site: www.caro.ca

Insurance: A User-Friendly Guide for the Arts and Nonprofit World. Texas Accountants and Lawyers for the Arts, 1540 Sul Ross, Houston, TX 77006. Covers general insurance issues, including special considerations for the performing and visual arts. Provides advice about buying insurance. Web site: www.talarts.org

Web Sites

Artist Help Network (www.artisthelpnetwork.com). Founded by Caroll Michels, this site is devoted to all aspects of career development, including contact information for organizations, periodicals, publications, software, audiovisual aids, Web sites, and service providers. See heading "Creature Comforts" and subheading "Studio Insurance."

Organizations

American Craft Council, 72 Spring Street, 6th Floor, New York, NY 10012. Offers studio insurance for work-in-transit insurance and liability policies to its members. Web site: www.craftcouncil.org

Artist/Craftsman Protection Plan, P.O. Box 2510, Rockville, MD 20852-0510. Offers all-risk insurance. Offers individual artists' liability insurance and all-risk property protection for artwork at home or studio, on exhibition, and in transit.

Chicago Artists' Coalition, 11 East Hubbard Street, 7th Floor, Chicago, IL 60611. Offers studio insurance to members. Web site: www.caconline.org

Connell Insurors, Inc., P.O. Box 1840, Branson, MO 65615. Offers a craft package policy that covers general liability, products and completed operations liability, fire liability, medical payments, and the value of contents while work is on display. Web site: www.connellinsurance.com

Flather Perkins, Inc., 888 17th Street, NW, Suite 508, Washington, DC 20006. Insures fine art and crafts on premises, in transit, and in shows. E-mail: info@flatherperkins.net

Huntington T. Block, 1120 20th Street, NW, Suite 600, Washington, DC 20036. Offers individual artists' studio insurance and business-package insurance. Web site: www.aon.com

Ohio Arts and Crafts Guild, P.O. Box 3080, Lexington, OH 44904. Offers business and liability insurance to members in Ohio, Pennsylvania, Indiana, and Michigan. Web site: www.cg-tinsmith.com/oacg

Trinder & Norwood, Inc., 2 Gannett Drive, White Plains, NY 10604. Offers a fine-arts insurance program covering art while it is being created, while it is in transit, and while it is on exhibition.

WEB SITE DESIGN
Publications

Arts Wire Web Manual, New York Foundation for the Arts, 155 Avenue of the Americas, New York, NY 10013, 1999. With years of experience on the Internet and a pioneer of an arts information Web site, Arts Wire gives advice and tips on setting up a Web page. Web site: www.nyfa.org

The Digital Imaging Dictionary by Joe Farace. New York: Allworth Press, 1996. A reference to terminology used in acquiring, enhancing, and outputting digital images. Web site: www.allworth.com

Learning Web Design: A Beginner's Guide to HTML, Graphics, and Beyond by Jennifer Niederst and Richard Koman. Cambridge, Mass.: O'Reilly & Associates, 2001. Helps beginners build a solid foundation in HTML, graphics, and design principles needed for crafting effective Web pages. Explains the nature of the medium and unpacks the Web design process from conceptualization to the final result. Web site: www.ora.com

The Photographer's Internet Handbook by Joe Farace. New York: Allworth Press, 1997. Includes information on building a home page. Web site: www.allworthpress.com

Re-Engineering the Photo Studio: Bringing Your Studio into the Digital Age by Joe Farace. New York: Allworth Press, 1998. Guides readers through every aspect of converting a photographic studio into digital technology, including choosing equipment, launching digital services, and more. Web site: www.allworth.com

Sams Teach Yourself HTML and XHTML in 24 Hours by Charles Ashbacher and Dick Oliver. Indianapolis, Ind.: Macmillan USA, 2001. Provides a basic understanding

of the Web's architecture, general Web-page design issues, and multimedia components. Web Site: www.mcp.com

Selling Art on the Internet by Marques Vickers. Marques Vickers, 331 Howard Avenue, Vallejo, CA 94589, 2000. An e-publication that addresses topics related to art marketing on the Internet, including Web site design. Available in several formats. Web site: www.marquesv.com

Web Sites

Artist Help Network (www.artisthelpnetwork.com). Founded by Caroll Michels, this site is devoted to all aspects of career development, including contact information for organizations, periodicals, publications, software, audiovisual aids, Web Sites, and service providers. See heading "Presentation Tools" and subheadings "Web Site Design" and "Web Site Designers."

Open Studio: The Arts Online (www.openstudio.org). A national network that provides training, resources, and leadership to help artists and arts organizations use the Internet. Sponsored by the Benton Foundation and the National Endowment for the Arts.

Selfpromotion (www.selfpromotion.com). A free service that will automatically list Web sites on search engines and indexes.

Web Pages That Suck (www.webpagesthatsuck.com). If you are contemplating designing a Web site or are having one designed, this Web site presents information on the dos and don'ts of Web site design.

Notes

Chapter 1, Launching or Relaunching Your Career: Overcoming Career Blocks

1. From *A Life in the Arts* by Eric Maisel, 83. Copyright © 1994 Eric Maisel. Reprinted by permission of The Putnam Publishing Group/Jeremy P. Tarcher, Inc.

2. Excerpts from *The Painted Word* by Tom Wolfe, 14. Copyright © 1975 Tom Wolfe. Reprinted by permission of Farrar, Straus & Giroux, LLC.

3. From *The Artist's Guide to the Art Market*, 4th edition, by Betty Chamberlin, 18. Copyright © 1970, 1975, 1979, 1983 Watson-Guptill Publications, New York. Reprinted by permission.

4. Ralph Charell, *How to Make Things Go Your Way* (New York: Simon & Schuster, 1979), 149.

5. Ronald H. Silverman, "Art Career Education: The Third Imperative," *School Arts*, vol. 79, no. 6, February 1980, 42.

6. Ibid.

7. Comment by Barbara Price, academic dean and vice president for academic affairs, Maryland Institute, College of Art, Baltimore, published in "Support for Artists by Institutions: Comments and Discussion," *The Modern Muse: The Support and Condition of Artists*, ed. C. Richard Swaim (New York, 1989), 126. Reprinted with permission by Americans for the Arts (AFTA).

8. Jo Hanson, *Artists' Taxes, the Hands-on Guide: An Alternative to "Hobby" Taxes* (San Francisco: Vortex Press, 1987), 24.

9. From *Has Modernism Failed* by Suzi Gablik, 68. Copyright © 1984 Suzi Gablik. Reprinted by permission of Thames and Hudson.

10. Stephen Driver, "Teach Them to Swim . . . ? How Long Can They Tread Water?," presented at the panel "Teach Them to Swim or Let Them Sink," Southeastern College Art Conference and Mid-American College Art Association, October 18–21, 2000, Louisville, Kentucky. Unnumbered.

11. Ibid.

12. Gary Keown, "Packaging the Art Student for Life," presented at the panel "Teach Them to Swim or Let Them Sink," Southeastern College Art Conference and Mid-American College Art Association, October 18–21, 2000, Louisville, Kentucky. Unnumbered.

13. Ibid.

14. Annette Lieberman and Vicki Lindner, *The Money Mirror: How Money Reflects Women's Dreams, Fears, and Desires* (New York: Allworth Press, 1996), 56.

15. Ibid., 54.

16. Selected excerpts from *Creating a Life Worth Living* by Carol Lloyd. Copyright © 1997 by Carol Lloyd. Reprinted by permission of HarperCollins Publishers, Inc.

17. Ibid.

18. Tad Crawford, *The Secret Life of Money: How Money Can Be Food for the Soul* (New York: Allworth Press, 1996), 42.

19. Press release issued by Allworth Press, announcing publication of *The Secret Life of Money: How Money Can Be Food for the Soul* by Tad Crawford, 1996.

20. Carol Duncan, "Who Rules the Art World?" *Socialist Review*, vol. 70, July–August 1983, 111. Copyright © 1983 Institute for Social Research and Education, Reprinted by permission of the Institute for Social Research and Education.

21. Ted Potter, "Introduction," *The Modern Muse: The Support and Condition of Artists*, ed. C. Richard Swaim (New York, 1989), 9. © American Council for the Arts. Reprinted by permission.

22. Excerpts from *The Practical Handbook for the Emerging Artist* by Margaret R. Lazzari, 11. Copyright © 1996. Reprinted by permission of Harcourt, Inc.

23. Ibid., 12.

24. From *Art & Fear* by David Bayles and Ted Orland, 47. Copyright © 1993. Reprinted by permission of the Image Continuum Press, Santa Cruz, Calif., and Eugene, Ore.

25. Excerpted from *Work with Passion* by Nancy Anderson, 143. Copyright © 1994. Reprinted by permission of New World Library, Novato, Calif.

Chapter 2, Launching or Relaunching Your Career: Entering the Marketplace

1. Jo Hanson, *Artists' Taxes, the Hands-on Guide: An Alternative to "Hobby" Taxes* (San Francisco: Vortex Press, 1987), 26.

2. Ibid.

3. Laura Whitworth, Henry Kimsey-House, and Phil Sandahl, *Co-Active Coaching: New Skills for Coaching People Toward Success in Work and Life* (Palo Alto, Calif.: Davies-Black Publishing, 1998), 23.

4. Judith Appelbaum and Nancy Evans, *How to Get Happily Published* (New York: Harper & Row, 1978), 12.

5. Tad Crawford, *Legal Guide for the Visual Artist* (New York: Allworth Press, 1999), 1.

6. Patrick Moore, *Future Safe: The Present Is the Future* (New York: The Estate Project for Artists with AIDS, The Alliance for the Arts, 1992), 2.

7. Crawford, *Legal Guide for the Visual Artist*, 205.

8. Ibid., 205–6.

9. Hanson, *Artists' Taxes, the Hands-on Guide: An Alternative to "Hobby" Taxes*, i.

10. Barbara A. Sloan, *Do-It-Yourself Quick Fix Tax Kit: General Tax Guide for Visual Artists* (Scottsdale, Ariz.: AKAS II, 1995), 2.

Chapter 3, Presentation Tools and Packages

1. From brochure advertising the book *How to Photograph Paintings* (Glenbrook, Conn.: Arts Directions Books, 1996) by Nat Bukar.

2. Ibid.

3. Shannon Wilkinson, "The Art of Self-Promotion: The Hum Below the Radar: News from the Art Front," *Art Calendar*, April 1996, 6.

4. Ibid.

5. Ibid.

6. Telephone interview with Dick Termes.

7. From *Conquering the Paper Pile-Up* by Stephanie Culp (Cincinnati: Writer's Digest Books, 1990), 2. © Stephanie Culp. Used with kind permission of Writer's Digest Books, an imprint of F&W Publications, Inc. All rights reserved.

Chapter 4, Pricing Your Work: How Much Is It Worth?

1. Carol Lloyd, *Creating a Life Worth Living* (New York: HarperPerennial, 1997), 103.

2. Ibid.

3. *Artists Gallery Guide for the Chicago and Illinois Region*, Chicago Artists Coalition, 1990.

4. Ibid.

Chapter 5, Public Relations: Keep Those Cards and Letters Coming In and Going Out

1. From a press release issued by Laura Foreman and John Watts for *Wallworks*, New York, N.Y., May 1, 1980.

2. Ibid.

3. Jack Anderson, "'Sold Out' Performances That Never Actually Took Place," *New York Times*, July 12, 1981, 13. Copyright © 1981 The New York Times Company. Reprinted by permission.

4. Daniel Grant, *The Business of Being an Artist* (New York: Allworth Press, 1995), 195.

5. Shannon Wilkinson, "Promoting Fine Art: New Developments: A Behind-the-Scenes View," *Art Calendar*, July–August 1995, 9.

6. From a press release issued by the Integral Consciousness Institute for *Synthesis*, an exhibition at the Soho Center for the Visual Arts, New York, N.Y., June 1979. (N.B., the Soho Center for the Visual Arts no longer exists.)

7. From a press release issued by the Rotunda Gallery, Brooklyn, N.Y., for the exhibition *Sculptors' Drawings*, February 17, 1983.

8. From a press release issued by Adelphi University, Garden City, N.Y., for a one-person exhibition by Francine Fels, *Happy Birthday, Rev—A Dancework in 50 Paintings*, May 31, 1988.

9. From a press release issued by the Right Bank Gallery, Brooklyn, N.Y., for a group exhibition *The Wedding Dress Show: Recycling the Ultimate Souvenir*, undated.

10. From a press release issued by the Bruce R. Lewin Gallery, New York, N.Y., for a one-person exhibition by Peter Anton, *Chocolate Throughout the Land*, April 1996.

11. "Barbara Rose," interview by Eva Cockroft, *Artworkers News*, April 1980, 13.

12. Interview with Nina Pratt, New York, N.Y., 1990.

13. *Review: The Critical of Visual Art in New York*, February 1, 1998.

14. Mark Daniel Cohen, "Abstraction: A Pleasured Reticence," *Review: The Critical State of Visual Art in New York*, February 1, 1998, 35.

15. Tom Wolfe, *The Painted Word* (New York: Farrar, Straus & Giroux, 1975), 6. Copyright © Tom Wolfe. Reprinted by permission of Farrar, Straus & Giroux, Inc.

16. From interview with Ingrid Sischy in the article "Profiles: A Girl of the Zeitgeist—II," by Janet Malcolm, 51–52. Copyright © 1986 Janet Malcolm. Originally appeared in *The New Yorker*, October 27, 1986. Reprinted by permission of The Wylie Agency, Inc.

17. Nancy Stapen, "The Thorn in Culture's Side," *Art New England*, July–August 1988, 9.

18. "John Perrault," interview by Walter Weissman, *Artworkers News*, April 1980, 19.

Chapter 6, Exhibition and Sales Opportunities: Using Those That Exist and Creating Your Own

1. Edit de Ak and Walter Robinson, "Alternative Periodicals," *The New Artspace: A Summary of Alternative Visual Arts Organizations*, prepared in conjunction with a conference held April 26–29, 1978 (Los Angeles: Los Angeles Institute of Contemporary Art, 1978), 38.

2. Suzanne K. Vinmans, *On Opening an Art Gallery* (Madison, Wis.: Suzanne K. Vinmans, 1990), 30–31.

3. Donna Marxer, "Report from New York: A History Lesson—and a Primer on Vanities," *Art Calendar*, April 1995, 13.

4. Lisa Gubernick, "I Was an Artist for *The Village Voice*," *The Village Voice*, October 7–13, 1981, 71. Reprinted by permission of the author and *The Village Voice*.

5. Elizabeth Bram, "Zero Gravity: Diary of a Travelling Artist," Baldwin, N.Y., 91–92.

6. Ibid., 92.

7. Joan Altabe, "They Should Change the Audience, Not the Artists," *Sarasota Herald-Tribune*, April 10, 1994, 2G. Copyright © 1994 *Sarasota Herald-Tribune*. Reprinted by express permission of the *Sarasota Herald-Tribune*.

8. Ibid.

9. Ibid.

10. Ibid.

11. "Recommended Guidelines for Juried Exhibitions," (Washington, D.C.: National Artists Equity Association, 1991).

12. Carolyn Blakeslee, "Entry Fees," *Art Calendar*, June 1991, 3.

13. Altabe, op. cit.

14. Letter from Richard S. Harrington to executive editor of NoBIAS Gallery in Bennington, Vt., dated May 19, 1998.

15. Ellen Baum, "The Whitney: Acquisitions Policies and Attitude Toward Living Artists," *Artworkers News*, December 1980, 13, 19.

16. Ibid.

17. Brenda Bradick Harris, "The Benefits of Working with Art Advisors," *Art Calendar*, April 1990, 5.

18. Drew Steis, "Interview with Françoise Yohalem—Art Consultant," *Art Calendar*, May 1990, 4.

19. "Commissioned Artwork in the Mid-1990's: A Survey of GUILD Users," *The Designer's Sourcebook 11: Art for the Wall, Furniture & Accessories* (Madison, Wis.: THE GUILD, 1996), 201–2.

20. Carolyn Blakeslee, "Buying Ad Space in Artists' Sourcebooks," *Getting the Word Out: The Artist's Guide to Self Promotion* (Upper Fairmount, Md.: Art Calendar Publishing, Inc.), 164.

21. Ibid., 166–68.

22. Anne Barclay Morgan, "Getting Better: Art and Healing," *Sculpture*, September–October 1994, 26.

23. Bram, op. cit., 87.

24. From an undated press release issued by Pratt Institute, Brooklyn, N.Y., for an exhibition, *Empty Dress: Clothing as Surrogate in Recent Art*, 1996, curated by Nina Felshin and organized by Independent Curators, Inc., New York, N.Y.

25. From a press release for an exhibition entitled *A, E, Eye, O, U, and Sometimes Why*, May 15–June 20, 1980, curated by Deborah Gardner and Karen Loftus and organized by the Organization of Independent Artists.

26. An exhibition held at Ronald Feldman Fine Arts, New York, N.Y., March 1981.

27. From a press release issued by Ronald Feldman Fine Arts, New York, N.Y., for an exhibition entitled *Top Secret: Inquiries into the Biomirror*, March 1981.

28. Donna Marxer, "Career Doldrums? Consider the Open Studio," *Art Calendar*, October 1995, 7.

29. Excerpted from Kathy Borrus, "Museum Stores: Your Next Market," *The Crafts Report*, October 1995, 14. Reprinted by permission of *The Crafts Report*.

30. Ibid.

31. Ibid.

32. Nina Pratt, *How to Sell Art: A Guide for Galleries, Art Dealers, Consultants, and Artists' Agents* (New York: Succotash Press, 1992), 6.

33. Ibid., 26.

34. Ibid.

35. V. A. Shiva, *The Arts and the Internet* (New York: Allworth Press, 1996), 18.

36. The New York Foundation for the Arts, *State of the Digital Arts Survey*, 1995.

37. Marques Vickers, "Click Me! $teering Traffic to Your Web$ite," *Art Calendar*, January 2001, 9.

Chapter 7, Dealing with Dealers and Psyching Them Out

1. Ivan C. Karp, "The Artist and the Dealer: A Curious Relationship," *Art in America*, March 1989, 51.

2. Ibid., 53.

3. Interview with Nancy Hoffman, "How to Succeed (By Really Trying)," by Paul Gardner, *ARTnews*, February 1990, 134.

4. Edward Feit, "Securing Gallery Representation," *American Artist* business supplement, June 1989, 69. Copyright © 1983, 1989. Reprinted by permission of BPI Communications, Inc. All rights reserved.

5. Jana Jevnikar, "An Incredible Journey: The Search for a Gallery," *American Artist*, September 1989, 12. Copyright © 1983, 1989. Reprinted by permission of BPI Communications, Inc. All rights reserved.

6. Interview with Walter Wickiser, "Artists' Career Development," by Daniel Grant, *American Artist*, September 1989, 12. Copyright © 1983, 1989. Reprinted by permission of BPI Communications, Inc. All rights reserved.

7. Interview with Judy Levy in *Artists Observed*, edited and photographed by Harvey Stein (New York: Harry N. Abrams, Inc., 1986), 61.

8. Interview with Tony Delap in *Artists Observed*, edited and photographed by Harvey Stein (New York: Harry N. Abrams, Inc., 1986), 70.

9. Mark I. Rosen, *Thank You for Being Such a Pain: Spiritual Guidance for Dealing with Difficult People* (New York: Three Rivers Press, 1998), 39.

10. Interview with Nina Pratt, New York, N.Y., 1990.

11. Ibid.

12. Ibid.

13. Ibid.

14. Ibid.

15. Interview with André Emmerich in *The Art Dealers: The Powers Behind the Scene Tell How the Art World Really Works*, by Laura de Coppet and Alan Jones (New York: Clarkson Potter, 1984), 62.

16. Missy Sullivan, "Artist Power," *Forbes Best of the Web*, May 22, 2000.

17. Grace Glueck, "Gallery Etiquette: A Duel of Dealers and Browsers," *New York Times*, March 8, 1991, C1.

18. Hilton Kramer, "The Case Against Price Tags," *New York Times*, March 20, 1988, Sect. 2, 33.

19. Letter to the editor by Alvin S. Lane, *New York Times*, April 24, 1988, Sect. 2, 15.

20. Letter to the editor by Roy Bohon, *New York Times*, April 24, 1988, Sect. 2, 15.

21. Prepared by the Task Force on Discrimination in Art, a CETA Title VI project sponsored by the Foundation for the Community of Artists in conjunction with Women in the Arts, 1979.

22. Nancy Jervis and Maureen Shild, "Survey of NYC Galleries Finds Discrimination," *Artworkers News*, April 1979, A7.

23. Ibid., A8.

24. Alice Goldfarb Marquis, *The Art Biz: The Covert World of Collectors, Dealers, Auction Houses, Museums and Critics* (Chicago: Contemporary Books, Inc., 1991), 3–4. Copyright © 1991 by Alice Goldfarb Marquis. Reprinted by permission.

25. "Richard Lerner," interview by Jean E. Breitbart, *Artworkers News*, March 1981, 29.

26. Dan J. Martin, ed., *Guide to Arts Administration Training and Research 1995–97* (San Francisco: Association of Arts Administration Educators, 1995), 11.

27. "Lucy Lippard," interview by David Troy, *Artworkers News*, April 1980, 16.

28. Dianne Lawrence, "John Baldessari: The Coagula Interview," *The Coagula Art Journal*, Issue 32, March–April 1998, 26.

29. Benny Shaboy, "Ask studioNOTES," *studioNOTES: The Journal for Working Artists*, August–October 2000, 30–39.

30. Ibid.

31. Ibid.

32. Peter H. Karlen, "The 'Droit de Suite' Revisited," *Art Calendar*, July–August 1991, 11.

Chapter 8, The Mysterious World of Grants

1. Jane C. Hartwig, "Betting on Foundations," in C. M. Kurzin, J. B. Steinhoff, and A. Bonavoglia, *Foundation Grants to Individuals* (New York: The Foundation Center, 1979), xiii.

2. Funding guidelines of the John F. and Anna Lee-Stacey Scholarship Fund.

3. Deborah A. Hoover, *Supporting Yourself as an Artist: A Practical Guide*, second edition (New York: Oxford University Press, 1989), 136. Copyright © Oxford University Press. Used by permission.

4. Hartwig, op. cit.

Chapter 9, Generating Income: Alternatives to Driving a Cab

1. Toby Judith Klayman with Cobbett Steinberg, *The Artists' Survival Manual* (New York: Charles Scribner's Sons, 1984), 186.

2. Caryn R. Leland, *Licensing Art and Design* (New York: Allworth Press, 1998), 95.

3. Ibid.

4. From exhibition proposal by Molly Heron, New York, N.Y.

5. From artist statement by Molly Heron, New York, N.Y.

6. Annie Dillard, *The Writing Life* (New York: HarperCollins Publishers, 1989), 33. Copyright © 1989 Annie Dillard. Reprinted by permission.

7. From artist statement by Molly Heron, New York, N.Y.

Chapter 10, Rationalization, Paranoia, Competition, and Rejection

1. Bruce M. Holly, "Choices," *Art Calendar,* May 1990, 7.

2. Gail McMeekin, *The Twelve Secrets of Highly Creative Women: A Portable Mentor* (Berkeley, Calif.: Conari Press, 2000), 152.

3. Jane Madson, *The Artist's and Critic's Forum 1,* 1, 1982.

4. Billy Curmano, "Rejecting Rejection," *Artworkers News,* January 1981, 34.

5. Ibid.

6. Ibid.

Index

About the Author

Caroll Michels has helped hundreds of emerging and established visual and performing artists and writers develop their careers. She has served as a career coach and artist's advocate since 1978.

Her artwork has been exhibited in museums in the United States and abroad, including the Georges Pompidou Museum in Paris; the Kunsthalle in Vienna; the Walker Art Center in Minneapolis; and the Institute for Contemporary Art, the Clocktower, in New York City.

Caroll Michels has received numerous grants, including those awarded by the National Endowment for the Arts, the New York State Council for the Arts, the New York Council for the Humanities, and the International Fund for the Promotion of Culture/UNESCO. She has also received a fellowship from the Alden B. Dow Creativity Center in Midland, Michigan.

She is the chairwoman of the Fine Arts Advisory Board of the Fashion Institute of Technology in New York City. She conducts career workshops for artists throughout the United States and in Canada that are sponsored by arts councils, arts organizations, and colleges and universities.

Michels offers in-person and phone consultations to artists and writers in all disciplines. She is now based in East Hampton, New York, and can be reached at the following address:

Ms. Caroll Michels
19 Springwood Lane
East Hampton, NY 11937-1169
Telephone: (631) 329-9105
Fax: (631) 329-9107
E-mail: carollmich@aol.com
Web site: www.carollmichels.com
Web site: www.artisthelpnetwork.com